VELÁZQUEZ

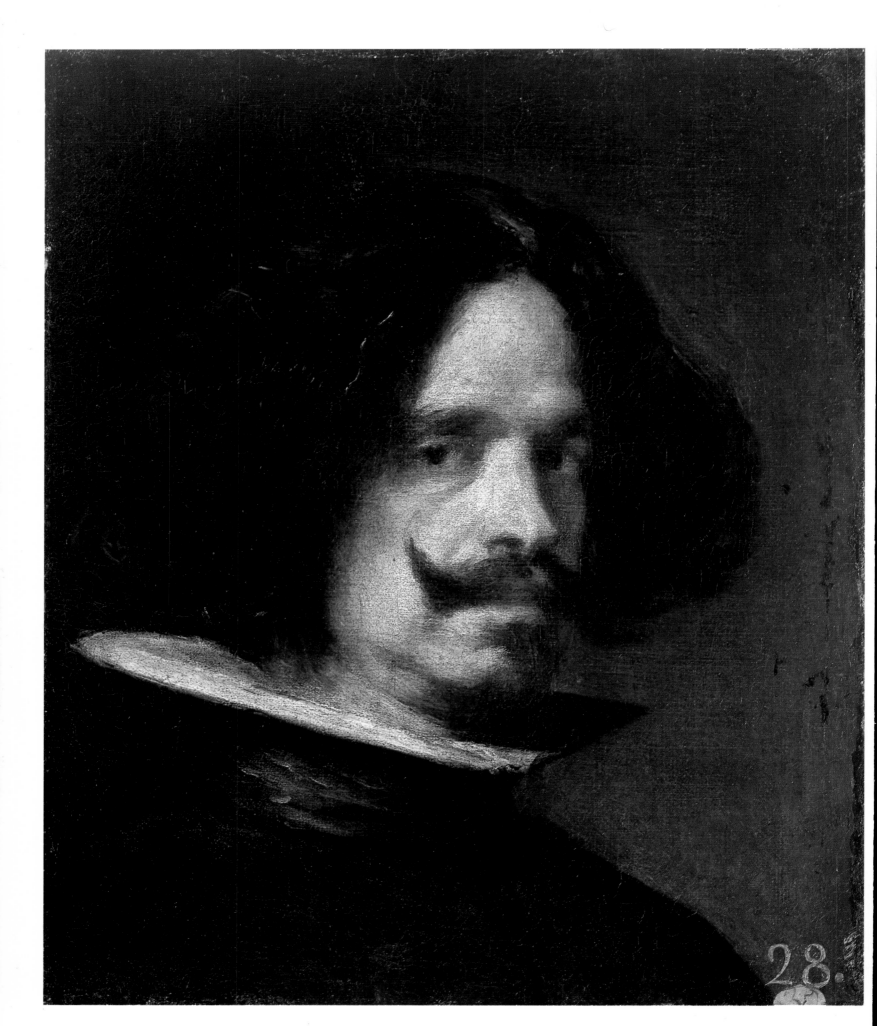

28.

José López-Rey

VELÁZQUEZ

PAINTER OF PAINTERS
THE COMPLETE WORKS

TASCHEN

WILDENSTEIN
INSTITUTE

COMITÉ D'HONNEUR
Daniel Wildenstein
Benedikt Taschen
Dr. Angelika Taschen
CONCEPTION
Gilles Néret
GENERAL COORDINATION
Marie-Christine Maufus
SCIENTIFIC CONSULTANCY
Odile Delenda
TYPOGRAPHIC DESIGN
Mark Thomson, London

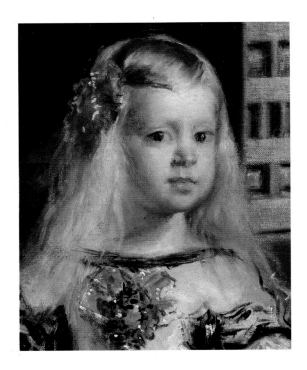

PAGE 2:
Self-Portrait
c. 1640
Cat. no. 96

RIGHT:
Velázquez and the Royal Family
or *Las Meninas* (detail)
1656–1657
Cat. no. 124

700.92 VEL

Contents

Updated edition by
Odile Delenda

7	Foreword
9	Interpretation and catalogue
21	Velázquez: Painter of Painters
21	Family and name
22	Education and apprenticeship
24	The teacher and the pupil
29	Young Velázquez and Caravaggio
33	Early success and higher ambition
34	Men, objects and art realities
35	The young master of *bodegón* painting
38	*Bodegón*-like biblical compositions
42	Early portraits
42	The human and the divine
46	First stay at the Court
47	Painters and painting in Madrid
52	Death of Villandrando and Velázquez' success
53	The likeness of the King
57	Other portraits
59	The crucial years
64	Rubens at the Spanish Court
65	True-to-life and conceptual traits
71	The painter's Italian journey
75	Titian's greatness and Velázquez' freedom
80	The return to the Court: work, chores and rewards
81	The brushwork as the painter's medium
84	The Prince and the dwarf
84	Portraits of Queen Isabel
88	Light upon black
89	Portraits of the King
91	The Great Hall of the Buen Retiro
100	The equestrian royal portraits
101	The King and the Prince, equestrian
106	Olivares, equestrian

107	Velázquez' portrayal of military victory
116	The traditional portrayal of military victory
119	The royal hunting lodge
120	The royal hunting portraits
125	The portrayal of antiquity
129	Sheer depiction of human nature and quirks
137	The artist as a creator
140	The person of the King – and the redundancy of allegory
147	Reality of painting
153	The diaphanous world of Christianity
155	The luxuriant world of the fable
160	Velázquez' naturalism
167	Velázquez and iconographical dicta
169	Two measures of Velázquez' stature at the Court
173	Italy again: the Master's success
180	The Roman portraits
184	The return to the Court: Chamberlain and painter
185	Velázquez' workshop
189	Velázquez' imitators
193	Life, fashion and painting
200	Last portrait of the King
204	The Master and the follower
208	Velázquez at work in his world
219	Velázquez knighted
221	The Hall of Mirrors
225	Last works
226	Last service to the King, and death
230	Notes
244	Bibliography
249	Supplementary bibliography (since 1980)
254	Index of proper names
257	Summary catalogue

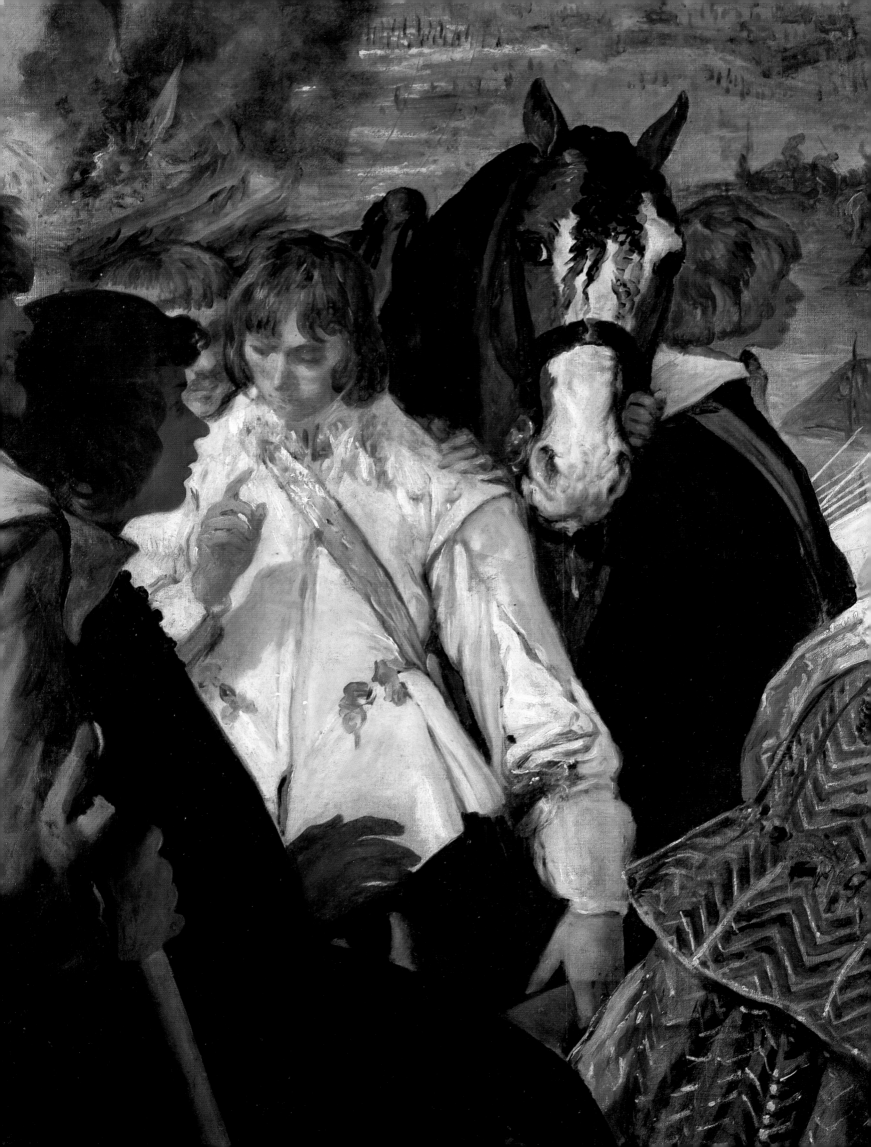

FOREWORD

Before his death in 1991, José López-Rey had chosen to publish both English and French versions (1979 and 1981) of his detailed catalogue of Velázquez' work produced by the Bibliothèque des Arts, and supported by the patronage of the Wildenstein Foundation. This important reference work remains unequalled to this day as a world authority. A new updated edition in colour, using impressive modern production techniques, now seems appropriate. In order to offer this vital reference work to both art historians and a very broad public, the Wildenstein Institute Has joined forces with Benedikt Taschen, a young publisher of international repute, to re-edit a selection of the Institute's detailed catalogues in the form of high quality art books at a price everyone can afford. *Velázquez, Artist and Creator* by José López-Rey, accompanied by his *Summary Catalogue* will be the first fruits of this collaboration.

We would like to thank Madame López-Rey, the author's wife, and Monsieur Daniel Arroyo-Bischop, his uncle, who generously made valuable documents available to the Wildenstein Institute for use in the compilation of the new edition. As a result, the additions and modifications desired by Professor José López-Rey have been integrated into this edition. Fifteen years later, knowledge has grown – measurements have been retaken, paintings have been cleaned and restored, some works have changed location, the bibliography has increased in abundance, notably due to the contribution made by the extensive and important *Velázquez* exhibition (New York, Madrid, 1988-1990). Odile Delenda has undertaken this vital updating.

This new colour presentation reveals innumerable details which enable the reader to appreciate the incredible modernity of Velázquez' genius, and to understand the unconditional admiration of later artists, like Goya, Manet, Renoir and, more recently, of Picasso.

DANIEL WILDENSTEIN
for the *Institute*

LEFT PAGE:
The Surrender of Breda (Las Lanzas) (detail)
1634–1635
Cat. no. 73

Interpretation and catalogue

The purpose of this book is twofold: to provide a critical biography of Velázquez alongside a summary catalogue of his extant works. Both are, of course, interrelated; I could hardly have applied myself to one without tackling the other.[1]

My study of Velázquez' life and work appeared first in 1963 as the introduction to my catalogue raisonné of his œuvre, paintings from his workshop and other derivative pieces. In 1968, I published an enlarged version, in monograph form, which incorporated many revisions in the light of documentary evidence that I had uncovered and of my further research.[2] The version that I now offer has been revised again, mainly on the basis of data brought to light here for the first time; some of the new data gives additional support to my earlier conclusions.

Once more I have benefitted from the work of other art historians, whose contributions I have duly acknowledged. I have taken issue with their conclusions only when I thought that such discussion clarified issues that had been raised. In a few cases I have limited myself to summarizing or just noting these opposing viewpoints. I have mentioned only occasionally the kind of derivative or trifling publications to which Molière alone could have done justice.

I have changed the title of my study of Velázquez' life and work. Some sections have been rewritten, while others have been added, to make the ideas which underlie my interpretation of his art as clear as possible.

As some reviewers of the earlier versions of this study perceptively noted, Velázquez is, in my view, one of the few painters whose work can best be read as a result of his creative intention. It follows that the meaning of any of his paintings ought to be sought precisely where it was achieved, in the painting itself. The opposition between tradition and modernity, the role of artistic theories, and the language of iconography – alongside ways of life and thought which were current in Velázquez' time or with which he may have been acquainted – were, of course, part of his world, and I have delved into them. They form the common background from which he starts as a maker of new art realities.

Velázquez learned from other painters, notably Titian, but the lessons that he took from their works, even from Titian's, were developed in so creative a manner that efforts to pinpoint them have proven futile. The ransacking of 16th and 17th century paintings as well as engravings for the purpose of finding the sources of Velázquez' works has so far yielded rather insubstantial results.

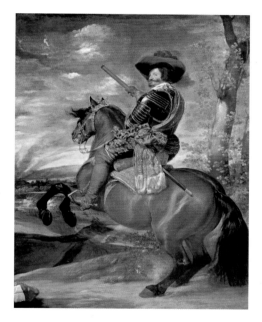

Count-Duke of Olivares on Horseback
1634
Cat. no. 66

LEFT PAGE:
Detail of no. 66

9

Throughout my discussion of Velázquez' works, I have paid attention to their essential compositional elements: the significance of the harmonies or contrasts of light, shade, texture and hue, as well as variations of his brush-stroke. I have also underlined – with the help of X-rays – how the process of composition was, for him, often one united with that of execution.

Unfortunately, a relatively large number of Velázquez' works have come down to us in poor condition, as noted in the corresponding catalogue entries. Some were enlarged, cut down, or folded over to fit within a larger or smaller wall space, or to meet standards of taste alien to Velázquez. Sometimes, in the case of portraits, Velázquez' off-centre composition would be changed so that the figure of the sitter would be centred. These liberties seem to have been common practice in the 18th century, though they did not begin or end with it. In 1772, after the newly built Royal Palace at Madrid had been furnished and decorated, the size of several Velázquez paintings was recorded as substantially larger than in earlier inventories of the royal collections; those differences in size resulted from the fact that additions had been made to the original canvases, as is today quite plain to the naked eye (see cat. nos. 44, 72 and 127).

The fire that gutted the Madrid Royal Alcázar in 1734 destroyed at least ten or twelve Velázquez paintings and damaged many others, including such masterpieces as the so-called *Bacchus* and *Las Meninas* (see cat. nos. 41 and 124). At all times, damaged paintings have been cut off without much regard for their composition, and so has been the case with some of Velázquez' works.

Velázquez' paintings have occasionally suffered from rubbing or abrasion, notably in thinly painted areas. Restorers have sometimes failed to understand that, for him, changes in the texture of pigment were as essential as changes in hue, and that he purposely brushed certain areas lightly and thinly while laying the pigment thickly, though not uniformly, on the rest of the canvas.

As for drawings, though it is known that Velázquez made many, especially during his apprenticeship and his 1629–1631 Italian journey, only a few are extant that can reasonably be ascribed to him in the light of available evidence. In fact, the valid comparative material that we have for them consists mainly of paintings from various periods of his art. Consequently, our knowledge of his work as a draughtsman remains rather fragmentary and tentative.[3]

Lately, a few Velázquez paintings have suffered at the hands of restorers, partly as a result of overconfidence in the growing technological means at their disposal, partly owing to opinionated aims (see cat. nos. 7 and 106). Nevertheless, other Velázquez works have been impeccably cleaned and returned, as nearly as possible, to their pristine condition by restorers who had a full command of the available technological means coupled with a sound understanding of the pertinent scholarly data; as a result, stylistic traits which had been hidden for a long time have come back to light.

The Velázquez works at the Prado – over one third of his extant paintings, and a larger proportion of his masterpieces – have fared badly during the last twenty years or so, owing mainly to continuous exposure to pollution, common to all the Prado's galleries. To refer only to one Velázquez masterpiece, the grey background of the portrait of the buffoon Pablo de Valladolid was so subtly hued that Manet wrote in 1865: the background "disappears" and "it is the air that surrounds" the sitter, clad in black.[4] The background remained grey until about 1960, but it has since turned ochre – and a foul ochre at that. Some art-historians have taken this ochre background – a compound of old varnish and grime – to be one of the portrait's remarkable stylistic features,[5] which has naturally impaired their understanding of a work that Manet held to be "perhaps the most astonishing piece of painting" ever done (cat. no. 82).

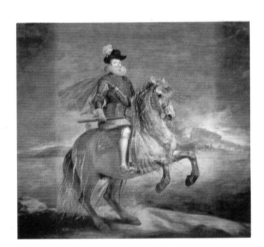

Philip III on Horseback
1634–1635
Cat. no. 68

RIGHT PAGE:
Detail of no. 68

I call attention to so depressing a matter because readers will probably find that my references, or those of earlier scholars, to colour, light, texture and even overall composition, are sometimes at variance with the present appearance of certain Velázquez works, especially though not exclusively those at the Prado Museum. I am fully aware that pigments do not remain unalterable even under the best system of conservation. I am also aware that, in the process of cleaning paintings, original nuances of colour are sometimes lost, and Velázquez' works have been no exception. However, the situation at the Prado, which houses a collection of paintings of universal worth, goes beyond anything that could reasonably be explained.

I should parenthetically note that in March 1976 work was begun for the installation of an air-conditioning system and other conservation equipment in the Prado; it is to be hoped that the project will be completed soon and that proper care will be taken of those paintings which have been subject to incessant pollution or to other unsuitable conditions for too long.

As for the catalogue raisonné, in revising matters of attribution and dating, I have been guided by my conviction that connoisseurship depends on, and is the result of, finely attuned intuition that is controlled by critical thought, and that knowledge is subject to rational change. Hence, the rectifications, additions or omissions in this catalogue are based on an examination or re-examination of the works concerned[6] (including those recently attributed to Velázquez), on an evaluation of old and recent scholarly views, as well as on the study of stylistic, documentary or technological data that has recently come to light – a significant part of which is published here for the first time.

The catalogue includes those paintings and drawings which, in my opinion, are either totally or partly by Velázquez, or that can be ascribed to him; it does not include the large body of workshop pieces and other derivative works, some of which are, however, occasionally referred to for the sake of elucidation or illustration.

Since I do not share the belief that denying the authenticity of a work of art by a great master is a lesser error than attributing a spurious work to him, I have included works in the catalogue whose state of preservation makes their attribution to Velázquez less than conclusive. I have done so notably when discerning scholars who have regarded the work as by Velázquez before the painting reached its present condition, as well as when documentary data, distinguishable stylistic traits, or both, make the attribution to Velázquez tenable in spite of the painting's condition.

Indeed, even works seriously damaged by accident or restoration are not necessarily dispossessed of every vestige of authenticity, and whenever such vestiges are evident an effort ought to be made to identify the master's hand. Naturally, the stylistic evidence found in seriously damaged works is of limited range, and it is not always possible to arrive at a firm conclusion. Nor can the conclusion be made safer by the expedient of attributing to the workshop of the master in question what is in fact the restorer's handiwork, as it is sometimes done. It is worth trying to distinguish a restorer's craft from that developed – for somewhat different purposes – in an old master's workshop.

I have noted in the corresponding catalogue entry the cleanings and restorations undergone by each painting whenever the information was available to me; this information, however, is far from exhaustive. I have also indicated, to the best of my knowledge, the paintings' condition up to the time when I last examined them – which in most cases means within the last two or three years.

I have travelled far and wide, back and forth, in Europe and America for the purpose of this book. Nearly everywhere I have received kind assistance

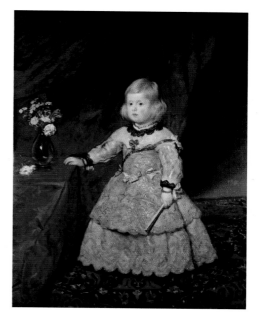

Infanta Margarita
1653
Cat. no. 122

LEFT PAGE:
Detail of no. 122

from museum curators, archivists, librarians, art collectors, dealers and historians. It would be impossible to try to mention all of them without falling into unwitting omissions. Throughout the book though I have expressly acknowledged my indebtedness to those who have provided, or helped to obtain, specific data on certain points.

Lausanne, 14 April 1978

Some additions have been made to the first part of this work, to develop or clarify certain points regarding either Velázquez' life or our interpretation of his art. As in the original edition, the first part does not refer to those works included in the catalogue which have been seriously damaged, either due to an accident or after restoration, with the exception of very well known paintings, whose discussion seemed vital to a full understanding of the scope of Velázquez' art. There is no reference to works whose attribution to Velázquez is questionable, as indicated in the catalogue.

Unless otherwise stated, the text of each of the documents relating to the family, life and work of Velázquez mentioned in the first part of this work, in chronological order, appear in *Varia velazqueña* (Madrid, 1960, vol.II, pp. 211–413). I have also omitted specific references to publications preceding these sources, as in the original edition. For fuller details of the works of Velázquez, see the corresponding catalogue entries.

The documentation in the catalogue has been abridged, but information has been added on the basis of recently published documents (nos. **32, 43, 66** and **106**).

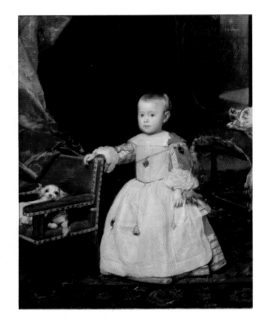

Prince Felipe Próspero
1659
Cat. no. 129

In the original edition of this book, I was unable to mention publications which came to light after the proof-reading stage, in February 1978, except in relation to the date of the first performance of the *Siege of Breda* by Calderón. In this edition, I have taken those publications into consideration which provide new information or indicate points of view worthy of comment.

My comments on the deplorable condition of the majority of Velázquez' works in the Prado are unfortunately still valid. However, I should add that in April 1980, some time after the publication of the first edition of this book (October 1979), the Prado management and the Spanish Minister for Culture expressed their concern over the poor state of conservation of the works of Velázquez in their charge. The paintings were then transferred to four museum galleries specially refurbished and fitted with air conditioning and new lighting. Unfortunately the colour chosen for the walls of the new rooms was deep red. Its vividness further affects the original tones of Velázquez' paintings, already damaged by layers of old varnish, dust and other harmful substances.

Finally, I would like to thank Mrs. Elizabeth Servan-Schreiber, who translated the English text into French with accuracy and sensitivity. She also helped me to abridge the catalogue entries without unduly reducing the references to documentary, technical and other documentation.

31 January 1981 *José López-Rey*

RIGHT PAGE:
Detail of no. 129

During his long and brilliant career as a historian of Spanish art, Professor López-Rey undertook a body of research into the life and work of Diego Velázquez which has noticeably modified, and inevitably deepened, our knowledge of this painter who is justly looked upon as one of the greatest artists of all time.

José López-Rey first published a very complex catalogue entitled *Velázquez, Work and World* in London in 1963. It contained 650 entries including not only works considered to be by the master's hand plus the apocryphal ones (i.e. 276 paintings plus 9 drawings), but also all the lost paintings mentioned in sources, old texts and inventories. A new version with a revised introduction appeared under the same title in London in 1968, followed by a collection of reproductions of only those works considered to be autograph. This monograph, published in English in 1979 with the title *Velázquez, the Artist as a Maker,* and then in French with some additions and corrections by the author (*Velázquez, Artiste et Créateur,* Lausanne–Paris, 1981) with an improved general study, was accompanied by a summary catalogue of authentic works only, either entirely or partially by the master's hand. The apocryphal paintings, by pupils or imitators, were left out of this catalogue, and it is still necessary to refer to the 1963 work for information on these. The information on authentic works has been developed into the *Catalogue raisonné* of 1996, without systematic bibliography (the technical record for each work is a straightforward reference to the principal old Velázquez catalogues). Specific bibliographical details, usually limited to critical studies and historical documents, are prudently referred to in the notes for the text. This has the effect of suitably tailoring a monograph study so that it can reach a wide public while also appealing to specialists.

Since the middle of the nineteenth century, the large number of books on Velázquez has continued to increase, though only a dozen or so include a catalogue. The majority are too old and have become out of date, as so much more is now known about the artist. Other more modern works have proved to be too liberal in demarcating the extent of the artistic output as a whole. For these reasons this detailed catalogue by José López-Rey remains an unequalled reference work in its rigour and erudition. It first appeared in a de luxe and necessarily limited edition, and incontestably deserved a new modern edition with luxury colour reproductions at a reasonable price, without losing the scientific qualities which have made it a classic in Hispanic art.

In order to retain the intrinsic qualities of the book, it was necessary to update it bearing in mind the corrections made by Professor López-Rey before he died, as well as possible modifications in terms of knowledge of the individual works.

One of the great virtues of the author lies in his appraisals which are made on the basis of a direct and attentive examination of the canvasses, coupled with the appropriate use of modern science, particularly X-ray photography, in analysing the genesis of a work. Unlike some less precise historians, he takes account in his study of the state of conservation of a work and restorations undergone. Since 1980, the date when the proofs of the last version of the López-Rey catalogue were corrected, several of Velázquez' paintings have been restored or simply cleaned, mainly on the occasion of the vast 1990 exhibition, during which three-quarters of the works catalogued here were on view. Many have been carefully remeasured, some have changed owners, and all such information has been included in this publication.

New editions of books considered to be milestones in art history need little modification. In the text of the new edition *Velázquez: Painter of Painters* we have limited ourselves to changing locations of paintings where necessary,

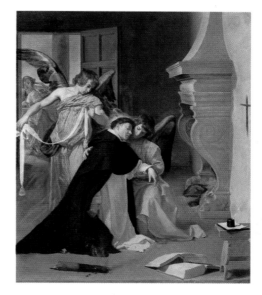

The Temptation of St. Thomas Aquinas
1631–1632
Cat. no. 130

LEFT PAGE:
Detail of no. 130

adding notes (numbered a to k) as the author wished, completing bibliography since the appearance of the French version, and modernising the vital indices.

To preserve the numbering of the catalogue, which is used by all historians, we have kept no. [2] which had been rejected, and included no. 130, the fine *Temptation of St. Thomas Aquinas,* from the Diocesan Museum of Orihuela, finally accepted by the author in the light of new discoveries.

The main difference in comparison with previous editions lies in the illustrations. These are all in colour, and show many details which reveal the innovatory genius of Velázquez.

To assist the reader, additions to the text have been printed in italics.

Paris, 15 February 1996 *Odile Delenda*

Velázquez:
Painter of Painters

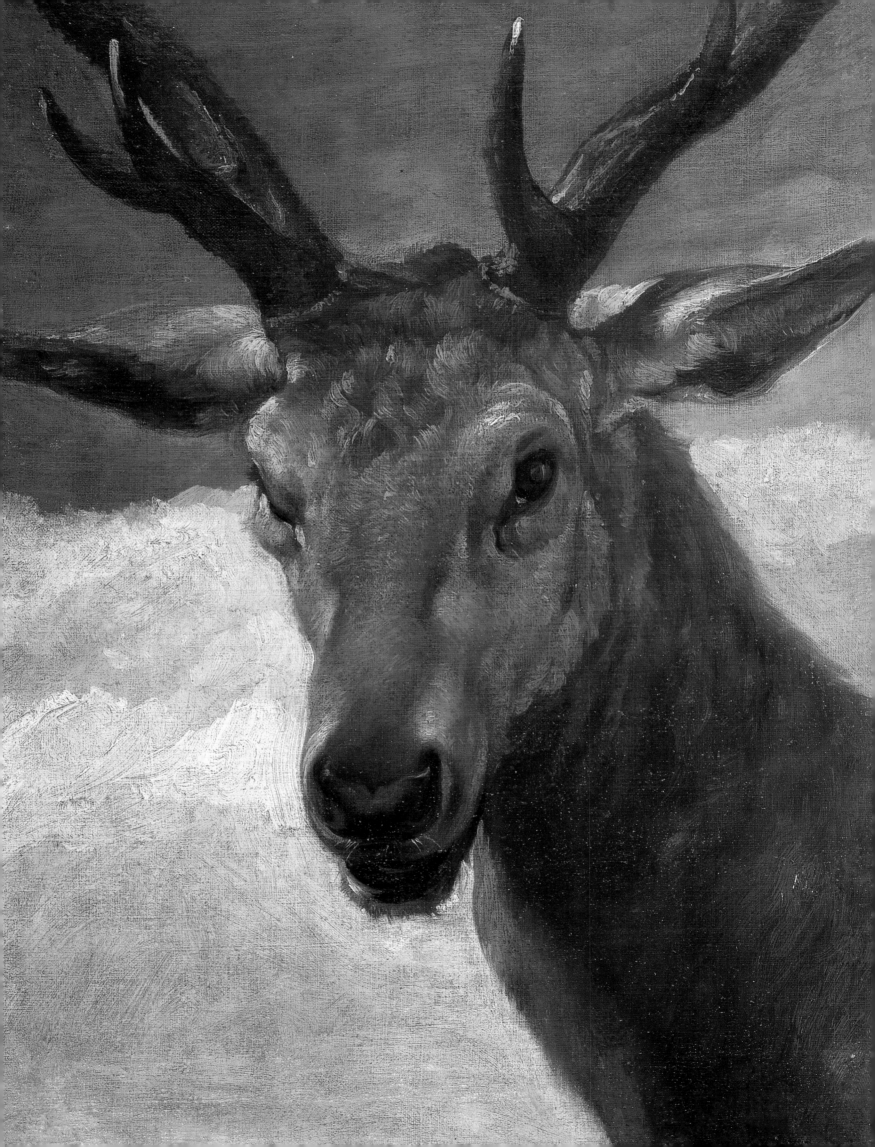

Velázquez: Painter of Painters

Family and name

On Sunday, 6 June 1599, Diego, the first child of Juan Rodríguez de Silva and Jerónima Velázquez, was baptized at the church of St. Peter, in Seville, with Pablo de Ojeda as godfather. The christening must have followed the baby's birth by no more than a few weeks, or perhaps only a few days.[7]

The boy's grandparents, Diego Rodríguez de Silva and María Rodríguez, had moved to Seville from their native Porto, probably within the previous two decades, at a time when the political boundaries between Spain and Portugal had been removed by the expansion of the Spanish monarchy. The Portuguese crown was then held by the Spanish king, who would lose it, together with much of his power over the world, within Velázquez' lifetime.

As for Juan Rodríguez de Silva and his wife, both were born in Seville, and were married, also at the church of St. Peter, on 28 December 1597. They came from the lesser nobility and were accorded the privileges generally enjoyed by the gentry. Diego was their first child and was followed by three brothers Juan, Fernando, and Silvestre, a sister, Juana, and finally by two more brothers, Roque and Francisco. The last was born on 28 May 1617, when Diego had just passed the guild's examination and was starting on his own as a painter. Of Velázquez' brothers and sister we know little more than their names and the dates of their christenings.

With the freedom in the adoption of family names then prevailing, it was as Diego Velázquez that the lad was apprenticed at twelve to the painter Francisco Pacheco by his father. Some five years later, when the young man was admitted to the painter's guild, he gave and signed his name as Diego Velázquez de Silva. Whether he did this out of affection for his father or simply to assert his gentle birth, the fact is that he immediately went back to the name of his apprenticeship, plain Diego Velázquez, as his signatures on paintings and documents up to the late 1640s show. Even the church registries where his marriage and the baptisms of his two daughters were entered, consistently record his name as just Diego Velázquez, while that of his brother, godfather to his second daughter, is given as Juan Velázquez de Silva.

Obviously, though, he remained sensible of his gentle birth, and from 1634 on, when his renown as a painter and his steady advancement at the Court underscored each other, Velázquez, moving as he did in an aristocratic society, sought to be known by the more genteel name of Diego de Silva Velázquez.

Democritus (detail)
1628–1629
Cat. no. 40

LEFT PAGE:
Head of a Stag
1626–1627
Cat. no. 33

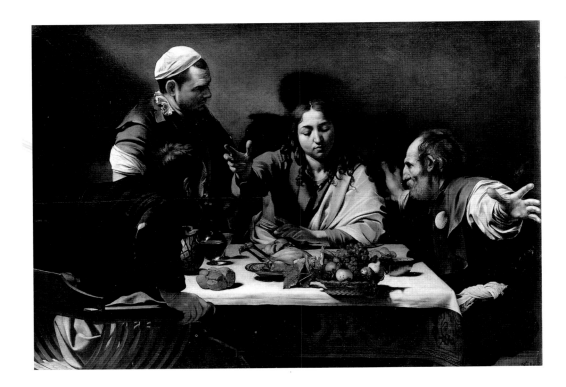

Caravaggio
The Supper at Emmaus
1596–1599
London, The National Gallery

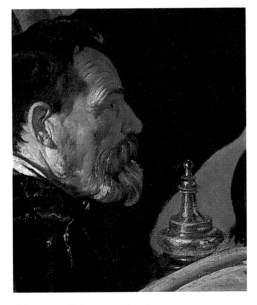

Adoration of the Magi (detail)
1619
Cat. no. 13
Portrait of Pacheco?

This wish of his, which several documents and the one painting that he signed after 1640 make obvious, was on occasion complied with at the royal offices.

Pacheco, in the manuscript of his *Arte de la Pintura,* finished in January 1638, mentioned five times the man who was then his son-in-law as Diego Velázquez de Silva; three of the references occur in the narrative of the artist's life, and the other two elsewhere in the text. Eleven years later, when the book was published posthumously, the painter's name had been changed to Diego de Silva Velázquez in all three passages concerning his life, though not in the other two. The changes may well have been made in deference to Velázquez' own preference.

In any event, even though one of the corrections was entered in the manuscript, it seems unlikely that the change originated with Pacheco who, in his testament, drawn one and a half years after the completion of the manuscript of *Arte de la Pintura,* still repeatedly gave his son-in-law's name as Diego Velázquez de Silva.[8]

Plain Velázquez, however, remained the name by which the artist was readily known in the Royal Palace and elsewhere, except to those of his friends and colleagues at Madrid who called him just "the Sevillian",[9] and when in 1627 he signed the painting, now lost, by which his superiority over the other painters to the King was conclusively acknowledged at the Court, he added *Hispalensis,* Latin for Sevillian, to his name.

Education and apprenticeship

The boy's early education was, in the fashion of the time, grounded on the study of the humanities, in which he did very well. He had a skill for languages – which must have included Latin – and philosophy, the taste for which he kept throughout the years as the books he gathered in his library show.[10] Nevertheless, his vocation for painting led him to enter a painter's workshop at the then not unusual age of eleven. His own statement, when he petitioned in 1617 for admission to the guild of St. Luke, that he had "learned the painter's

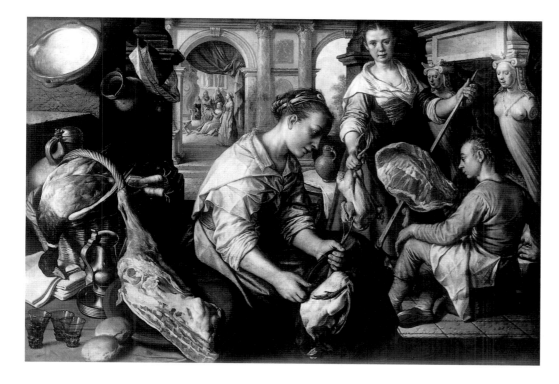

Joachim Beuckelaer
Christ in the House of Martha and Mary
1565
Brussels, Musées royaux d'art et d'histoire

art" in Seville from "qualified teachers", clearly indicates that he owed his training to more than one. According to Palomino – whose life of Velázquez is largely based on one written by a pupil of the artist – Francisco de Herrera the Elder (c. 1590–1656), and Francisco Pacheco (1564–1644) were those teachers.[11] As the story has been developed by other writers, the lad seems to have entered Herrera's workshop only to be soon frightened away by the unbearable temper of the master, whom he left for Pacheco.

We know from Pacheco himself that he gave "five years of education and training" to Velázquez.[12] This statement coincides with another contained in the contract by which the boy's father apprenticed him to Pacheco, on 17 September 1611. Like similar agreements entered into by Pacheco and other masters of the time, it called for a six-year apprenticeship; it was, however, stated that the agreed period of time had "begun to run on 1 December, of the past year, 1610". Consequently, the contract was actually binding for little more than five years from the date of signature – which happens to be the length of time that Pacheco remembered Velázquez had spent with him as an apprentice.

Pacheco was away from home on an extended journey during a good part of 1611, and it is possible that he had left Seville before 1 December 1610, when Velázquez began his apprenticeship. Indeed, for all we know, Pacheco may have started on his journey any time after 7 October 1610, when he signed a document as security for a fellow artist in Seville;[13] the following year, according to his own testimony, he was in Madrid, the Escorial and Toledo[14] and the earliest reference to his being back in Seville is provided by the contract for Velázquez' apprenticeship, which he signed on 27 September, ten days after the boy's father had done so.

There are therefore two alternative explanations. It is possible that the lad came to Pacheco's workshop on 1 December 1610, as the master was about to leave, or had already left, on his journey, and was entrusted to an assistant, leaving the final decision for Pacheco to make on his return. It might also be that, on that date, the boy entered Herrera's or some other master's workshop and left it within ten months to study with Pacheco, who would then have given him credit for the time he had served his apprenticeship elsewhere.

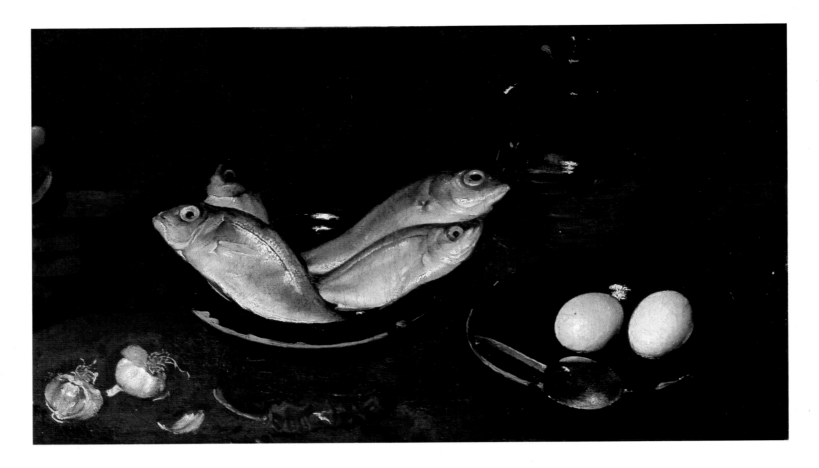

Christ in the House of Martha and Mary (detail)
1618
Cat. no. 7

Pacheco in his *Arte de la Pintura* denounced the "audacity" of someone – whom he chose to leave unnamed – who claimed to have been Velázquez' teacher. Whether this "someone" was Herrera, one of Pacheco's former assistants, or some other painter, he may have had some basis for his claim, which would make all the more understandable both Pacheco's indignation and his factual statement as to the "five years of education and training" that he had given to Velázquez.

In formally accepting Velázquez as an apprentice, Pacheco undertook to teach him the art of painting as well and as thoroughly as he knew how – this was the "training" that he imparted to the boy during those five years of apprenticeship. As for the "education" which, though unmentioned in the contract, went with it, this must have come about in a spontaneous manner, since both the pupil and the teacher had a penchant for humanistic studies.

The teacher and the pupil

Pacheco's workshop was a meeting place not only for painters but also for poets and scholars. Most of them were men of substantial attainments, as recorded in *Arte de la Pintura*, they enjoyed discussing, among other subjects, the achievements and techniques of outstanding artists, and the significance of their works. Pacheco's references to other authors show that he was well read in the humanities and up to date in the literature on art. He must have owned a sizeable library, and probably from it Velázquez derived the interest which led him to accumulate that substantial number of books listed among his possessions at the time of his death.

It would be idle to try to ascertain what topics young Velázquez heard discussed at Pacheco's workshop during his apprenticeship there. The evidence

provided by *Arte de la Pintura* is hardly conclusive. Pacheco did not complete the manuscript until some twenty years after Velázquez had left his workshop, a period during which he remained very much alive to new experiences. During a two-year stay in Madrid, he witnessed the early success of his former apprentice, and, furthermore, they corresponded throughout the years.

Certainly Velázquez must have heard Pacheco expound the importance of copying from antique sculptures, and Michelangelo's or Raphael's works, in order to achieve mastery in painting.[15] Pacheco, who confessed to having always striven to imitate Raphael, owned for many years what he described as an original wash drawing for *The School of Athens,* over which he very likely pored with his friends, and perhaps with Velázquez too.

Pacheco tells us that Velázquez, during his first Italian journey in 1629–1630, made many drawings from Michelangelo's *Last Judgement* and Raphael's frescoes at the Vatican, as well as from antique sculptures at Villa Medici, in Rome. Unfortunately none of these drawings have come down to us, and we cannot even surmise the nature of his response to the two masters whom Pacheco admired above all others. We know, of course, that some twenty years later he emphatically declared that Raphael did not interest him, and that Venetian painting, particularly Titian's, occupied the focus of his attention.

Titian, who had for decades been regarded as a paragon by leading painters at the Spanish Court, must have come up for discussion at Pacheco's workshop

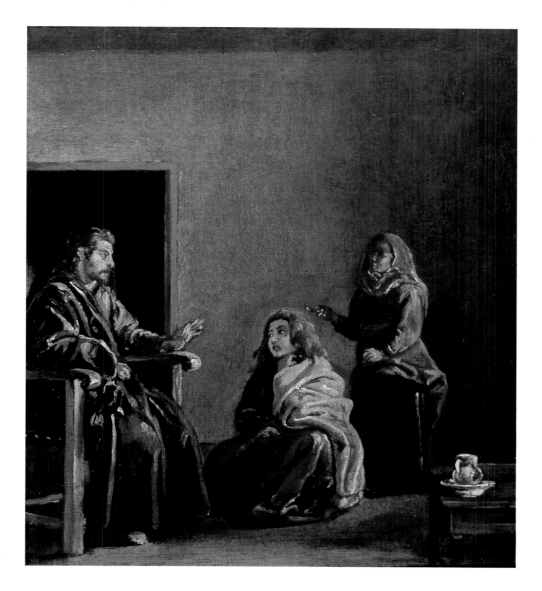

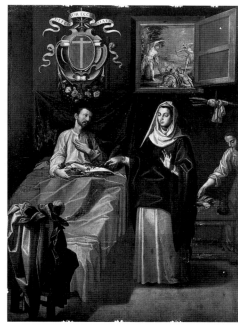

Francisco Pacheco
St. Sebastian Nursed by St. Irene
1616 (destroyed in 1936)
Alcalá de Guadaira, Hospital

LEFT:
Detail of no. 7

FOLLOWING PAGES:
Christ in the House of Martha and Mary
1618
Cat. no. 7

THE TEACHER AND THE PUPIL · 25

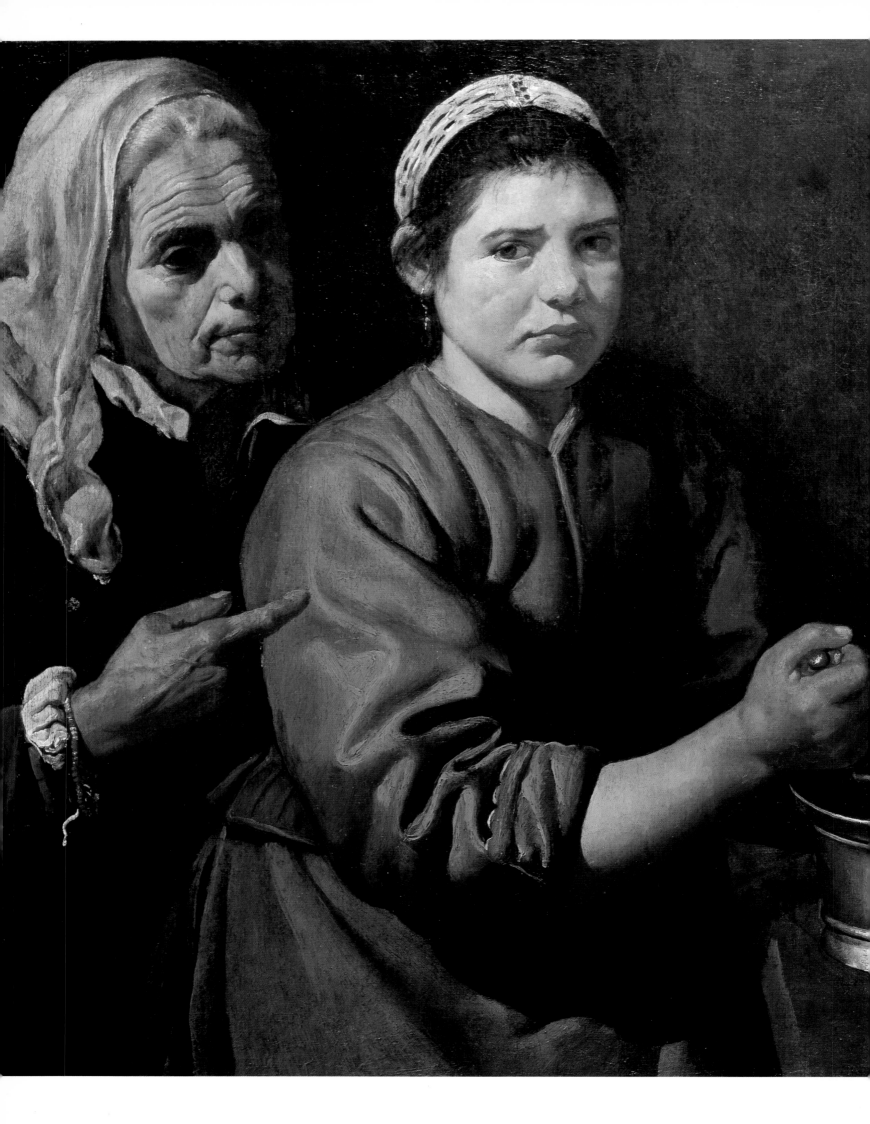

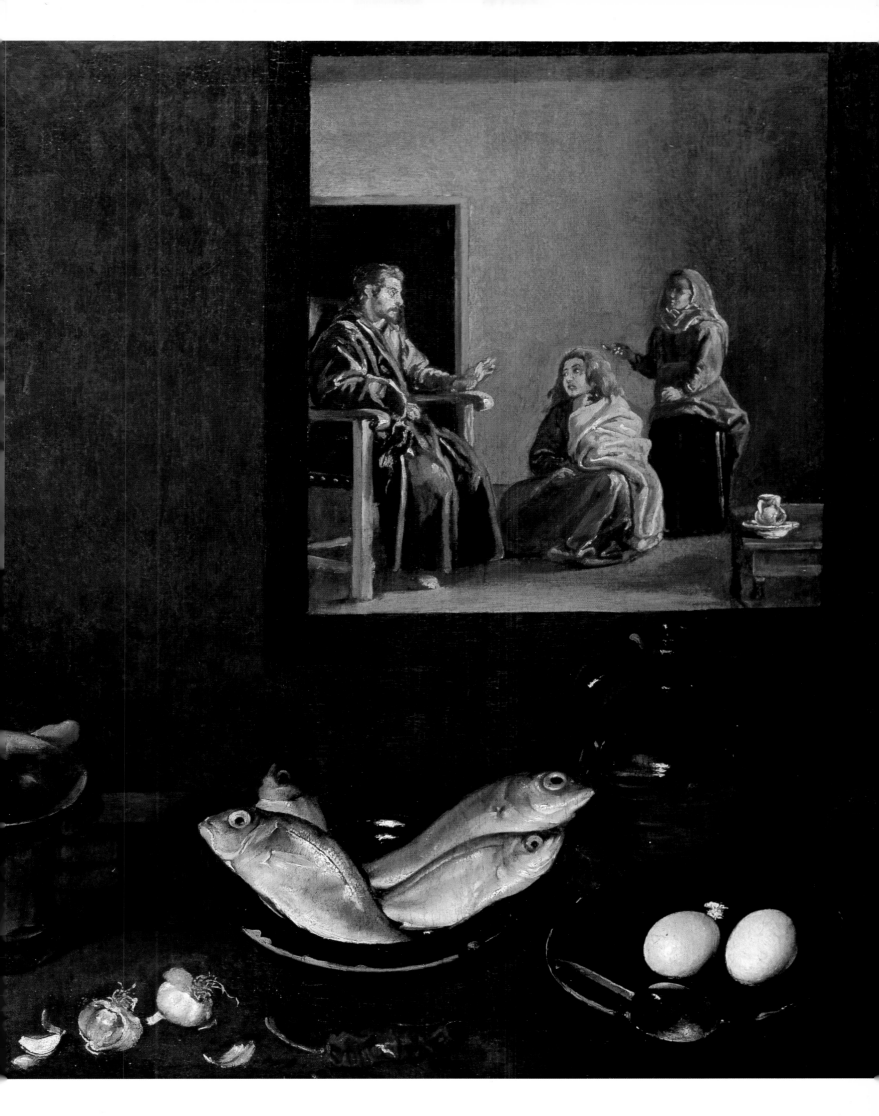

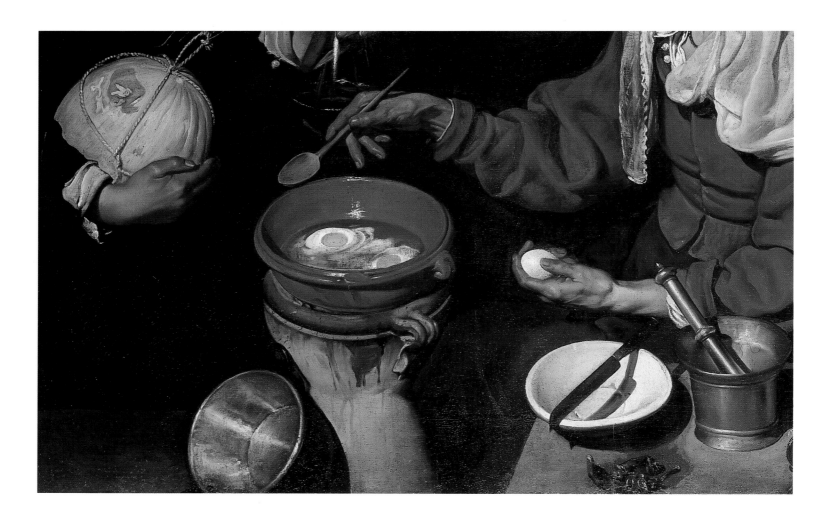

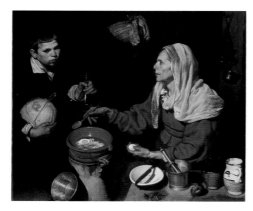

Old Woman Frying Eggs
1618
Cat. no. 6

Detail from no. 6

at the time when he signed up Velázquez as an apprentice. Pacheco was then fresh from his visits to the royal collections, rich in masterpieces by the Venetian master, whom he extols in *Arte de la Pintura* as one of the greatest colourists, even making an effort to explain the "unfinished" nature of his works.[16]

Pacheco must also have mentioned his astonishment at hearing from Dominico Greco, whom he had visited in Toledo, that Michelangelo was a good man who did not know how to paint. That was probably the first time that young Velázquez had heard about that "singular" painter who, according to Pacheco, was a great master in spite of his paradoxes and rages.[17]

If the subjects touched on in *Arte de la Pintura* are any guide, the lad most likely listened to discussions on such favourite topics of the time as *ut pictura poesis,* the superiority of painting over sculpture, the hierarchy of the different kinds of subject matter in painting, or the comparison of naturalist painting with the images of things or men reflected in full colour and motion on shining surfaces, like water or mirrors.

Out of the stream of these conversations young Velázquez must have seized a distinct idea of the world into which he was born. Before long he must also have arrived at a divination of his own purpose in the midst of the sentiments, ideas, tastes, achievements and traditions which he encountered or which were revealed to him. It was then and there that he reached out for the world of painting that was to be his own.

Pacheco, in discussing the ideas on portraiture in which Velázquez had been taught, tells how the lad, while still an apprentice, devised a method of his own to "attain assurance in portraying". He used a peasant-boy apprentice –

presumably one of menial rank – to sit for him "in different gestures and poses, now crying, now laughing, without shrinking from any difficulty", and, on blue paper, would draw from him a good many heads and other parts of the body in charcoal with white chalk for the highlights.[18] Unfortunately, none of these drawings has been preserved.

Young Velázquez and Caravaggio

By the early seventeenth century most European artists had been influenced by Caraveggesque naturalism. During this period Giulio Mancini wrote that, "our time is much indebted to Michelangelo de Caravaggio for the colouring that he has brought out and which is now followed quite generally".[19]

Velázquez' generation would have seen works by Caravaggio, or copies after them, in Seville and elsewhere in Spain.[20] Pacheco praised Caravaggio, together with Jacopo Bassano, Ribera and El Greco, as a painter whose works could be lacking in beauty or polish but not in relief. In Pacheco's view, Caravaggio effected a lifelike reality by painting from nature not only the human face limbs or nude body, but also clothing, whether of wool or silk, and everything else, as could be seen in the pictures of *The Crucifixion of St. Peter,* "even though they are just copies".[21] Pacheco's offhand mention of these copies, of which at least one was in Seville, indicates that they were widely known.

The *Arte de la Pintura* reveals a conflict between Pacheco's theoretical views, which were rooted, as his marginal notes acknowledge, in treatises of the *Cinquecento,* and the taste that he had developed at the end of his life for Caravaggesque naturalism. It is hard to decide whether Pacheco had acquired

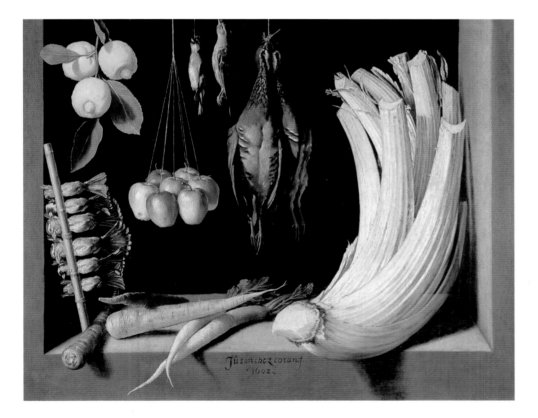

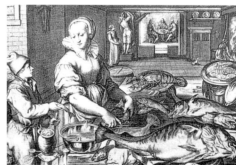

Jacob Matham
Jesus at Emmaus
Engraving after a composition by Pieter Aertsen

Fray Juan Sánchez Cotán
Still Life
1602
Madrid, Museo del Prado

that taste by the time he signed up Velázquez as an apprentice or had developed it later. His praise of Caravaggio could not have been written before 1631. Indeed, the paragraph includes a mention of the pictures by Ribera in the collection of the Duke of Alcalá, who had been Viceroy of Naples until that year, when he returned to Spain, bringing with him the works that he had acquired directly from Ribera. It might, of course, be that Pacheco had not actually seen these paintings, even though he described them as looking "alive" compared with the rest of the Duke's collection. If so, Pacheco might have echoed his son-in-law, for Velázquez was in Naples in December 1630, when he portrayed the Infanta Maria at the Viceregal Palace (cat. no. 48). This would have given him the opportunity to see the Duke's collection. Even in that event, Pacheco could not have written the paragraph in question before 1631.

There is a distinct connection between young Velázquez' device of drawing from his model "in different gestures and poses, now crying, now laughing" and what, to Mancini, was the limitation and achievement of Caravaggism: the portrayal of human figures "laughing or crying, moving or still", even if lacking in the refinements of gracefulness and sentiment.[22] It is to Pacheco's credit that his knowledge, rooted in past traditions, did not dull him to the present. Both as a

Alejandro de Loarte
The Fowlmonger
1626
Madrid, private collection

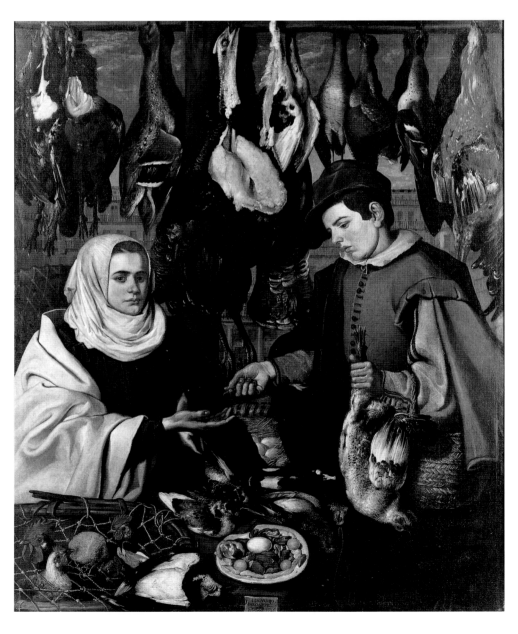

connoisseur and as a teacher he was excited by the new naturalism, to which that bright lad, Velázquez, was so much in thrall. Velázquez had a creative outlook. He took hold of the modernity of his day, seeing in it not an aim, but an exhilarating point of departure, which he soon left behind.

Caravaggio's vivid chiaroscuro was fundamental to his followers. He had achieved it by the use of a sheer light which draws men and objects out of shadow, accentuating their shapes and colours with an unvaried sheen. Neither the quality of the brushwork, nor the texture of pigment, nor the intensity of light varies significantly within any one of Caravaggio's works, not even in *The Supper at Emmaus* (London, National Gallery, p. 22), where he uses the same brushwork for the figure of Christ and for those of the Apostles, the pilgrim, the food or the tableware. In this, Caravaggio worked within the tradition from which he had otherwise departed by his adoption of naturalism that was as creative as it was offensive to others. In his portrayal of men and objects direct light sculpts the corporeal, out of shadow, in an airless space.

If Caravaggism was the main tenet of modernism to Velázquez' generation, his early works show that he soon went beyond it. Indeed, unlike Caravaggio, the youthful Velázquez uses a diffused light, with a greenish tinge, that sets men

Juan Van der Hamen y León
Still Life
1622
Madrid, Museo del Prado

and objects in a fluid environment, whilst also foregrounding differences of texture. Much as he may have had Caravaggio at the back of his mind, Velázquez achieved a sensuous depiction that was alien to Caravaggios naturalism,[23] as was his achievement of an atmospheric rendition of spatial depth, and a distinct expression of the polarity of the divine and the human.

In achieving this Velázquez revealed a commanding feeling for both the texture of whatever he depicted and the texture of the pigment itself. This led him to a fluid handling of light and shade and the use of a variety of brushstrokes, rough or smooth, filmy or thick, always vigorous, more akin to Titian's than to Caravaggio's.

At this date Velázquez was impelled by his own disposition to admire Titian's sketchy strokes and the chiaroscural effects which gave sensual depth to his compositions.[24] It may well be that he imparted his enthusiasm to his father-in-law, whose praise of Titian, admittedly based on Lodovico Dolce's *L'Aretino* (1557), appears greater than his understanding of the Venetian master's works.

Pacheco, in extolling a "famous" self-portrait, now lost, executed by Velázquez in Rome in 1630, pointed out that it "was painted in the manner of the great Titian, and if it is permissible to say so, not inferior to his heads". Pacheco was, of course, aware that his former pupil had attained the freedom of an individual creator, and he must have had that in mind when he proudly wrote that "the teacher's honour is greater than the father-in-law's".[25]

Early success and higher ambition

On 14 March 1617, Velázquez was made a member of the Guild of St. Luke, after having passed a qualifying examination. His examiners were Pacheco and Juan de Uceda, another painter. Once admitted to the guild the eighteen-year-old artist was entitled to have his own workshop, to take in apprentices and to paint for churches or public places – privileges of which he lost no time in availing himself.

He advanced smoothly into comfort and recognition. On 23 April 1618 he married Juana Pacheco who was three years younger than he. As part of the dowry, her father gave them "some houses" in the city which they sold ten years later. Pacheco had favoured the marriage, induced by Velázquez' "virtue, purity of blood, and good parts, and by the hopes of his natural and great intellect".[26]

The wedding took place in the church of St. Michael, with the poet Francisco de Rioja (1583–1659), who was soon to become influential at the Court, among the official witnesses. At the bountiful wedding banquet, in Pacheco's house, the occasion was made the more festive by the wit of the learned guests and by the singing and dancing which followed.[27]

Within less than three years, two daughters were born to the young couple – Francisca, who was baptized on 18 May 1619, and Ignacia, baptised on 29 January 1621, with her uncle Juan Velázquez de Silva as godfather. Ignacia died in childhood and Francisca remained the painter's only child.

Young Velázquez seldom signed or dated his works – a custom which he followed throughout his whole life and which he sometimes emphasized by depicting a folded-out piece of blank paper in one of the composition's lower corners.[28] *Christ in the House of Martha and Mary* and *Old Woman Frying Eggs*, neither of which is signed, bear the date 1618 (cat. nos. 6 and 7). The following year he dated but again did not sign *The Adoration of the Magi*, a work which he probably painted on commission and must consequently have personally felt it to be a great success (cat. no. 13). In 1620 he exceptionally signed and dated two portraits of *Mother Jerónima de la Fuente* (cat. nos. 20 and 21).

On 1 February 1620, Diego de Melgar, a thirteen- or fourteen-year-old boy, entered into a six-year bond of apprenticeship with Velázquez, whose works had made an impact on the Sevillian painters of his generation, and possibly on older ones too. This was particularly true in the field of *bodegón* painting, on which many painters then still active had partly built their reputation, in Seville as elsewhere. According to Pacheco, young Velázquez soon stood head and shoulders above every other painter of *bodegones*.

Of the twenty-odd extant works which he painted at Seville between 1617 and 1622, nine are *bodegones*. These include *Christ in the House of Martha and Mary* and *The Supper at Emmaus*, which lend themselves to this classification in spite of their Biblical subjects (cat. nos. 7 and 17). A large number of copies or imitations of Velázquez *bodegones* have come down to us; many appear approximately to date back to those years. These early derivative works reveal an eager acceptance of the young master's achievements. Some evince a desire for emula-

Vincencio Carducho
Colossal Head
Madrid, Real Academia de Bellas Artes de San Fernando

LEFT PAGE:
Mother Jerónima de la Fuente (detail)
1620
Cat. no. 20

Francisco Pacheco
The Immaculate Conception
1624
Seville, Church of San Lorenzo

Eugenio Caxés
The Fall of the Rebel Angels
1605
Copenhagen, Statens Museum for Kunst

tion which gives them the appearance, though not the aim, of creative intent. Most of them though are without significance other than the begrudging or open admiration which they betray, as is so frequently the case with the work of imitators.

As imitators pressed the young master's style into lifelessness, he continued to invent new forms of expression. He vigorously asserted the freedom and cogency of his art, not only in his *bodegones,* but in his portraits and religious compositions as well. By the spring of 1622 he was confident enough to set out for Madrid, "desirous" – as Pacheco put it – "of seeing the Escorial", which housed a wealth of pictures by great masters, however, he also travelled with the ambition of portraying young Philip IV, who had recently come to the throne.

Men, objects and art realities

In art terminology *bodegón* is nowadays almost synonymous with still-life. In Velázquez' day *bodegón* – a low eating place – generally meant, in painting, a composition keyed to the portrayal of one or more common people and to the depiction of food, drink, tableware or the like.

Bodegón painting had for long been a challenging subject throughout Europe. Juan Pantoja de la Crúz (1553–1608), renowned at the Spanish Court for his portraits and religious compositions, tried his hand at it in 1592, when he painted three large *"bodegones de Italia"*.[29] The reference to an Italian manner or sense of composition is too vague to identify it with that of any particular master or school.

Pacheco clearly distinguished *bodegones* from the genre composition then known in Italy as *bambocciatta* and in Spain first as *bamboche* and later as *bambochada*. He made an equally clear distinction between *bodegón* paintings and paintings of victuals such as fruit, fish, fowl, meat, vegetables and the like. This was a genre which had been widely cultivated in Spain and elsewhere since the turn of the century, and for which the term *stilleven* was coined in Holland about 1650. Still-life is clearly of Dutch origin as an art term though not as an art form.[30]

The suggestion has been made that still-life sprang as an independent subject for easel painting in Holland about 1600 as a manifestation of the national élan which pervaded the country in the wake of the recently won democratic freedom and independence and her ensuing prosperity and recognition as a colonial and world power; positive forces to which, so the argument runs, one should add the opposition of the Dutch Church to any form of figural decoration in the House of God.[31]

The difficulty with this view is that still-life became an art form in its own right in Spain at the same time. The country, under absolute monarchical rule, was declining as a world power, her empire was threatened by the Dutch among others, and her finances were in a ruinous state. Nevertheless, Spanish churches and convents were being decorated with large altarpieces and other series of figural compositions. In fact, still-life sprang as an independent subject for easel painting late in the sixteenth or early in the seventeenth century in Italy, Spain, Flanders, Holland, France and Germany – countries then separated from one another not only by their political boundaries, but also because of bitter religious differences, divergent social structures, and even conflicting views on the purpose of life, whether national or individual. It was in that torn Europe that the artist turned from the idea of man and nature to the accidents of appearance of men and things.

New schools of painting, national or local, evolved here and there, each with their own identifying characteristics. Naturalism was the common universal trait, and so was the naturalistic painter's penchant for letting the brushstroke accent the very texture of the pigment while shaping his vivid images on the canvas. That was the painter's way to emphasize the superiority of the work of art over both the medium used and the natural appearances which were portrayed. Similarly, writers such as Shakespeare, Cervantes, Marino, Quevedo and Molière used conceits, puns and wordplay that often involved vulgar expressions to underscore the very structure of words – the writer's medium – while also striking literary images of reality. Naturally, the lower the subject, the greater the challenge, which explains the fascination that *bodegón* or still-life painting held even for painters who did not make a practice of either.[32]

Pacheco was among those who at least once tried his hand at *bodegón* painting – in 1625, at Madrid, induced by his son-in-law's achievements. He also expressed his views, admittedly based on Velázquez' works and on discussions with him, on what a painter of *bodegones* must achieve to win recognition: he ought to depict men and women in a realistic way, and make equally vivid the objects with which they are grouped.[33]

The young master of *bodegón* painting

Velázquez' earliest extant paintings are two *bodegones, Musical Trio* and *Three Men at Table* (cat. nos. 1 and 3); both are related in different ways to a small canvas, showing on the surface the head of a man in profile, while underneath X-rays reveal the full face of another man. The latter looks like a discarded partial sketch for *Musical Trio* or a fragment of a similar painting that depicts the full face of the musician at the centre of the group, turned to his right rather than to his left. The head of a man in profile, visible to the naked eye, is obviously a study for Velázquez' transformation of *Three Men at Table* into a new *bodegón* composition. Unfortunately, *Musical Trio* has come down to us in a poor state of preservation, and the condition of *Three Men at Table,* is little better.

In these two *bodegones,* there is a close portrayal of human expression which brings to mind the time when Velázquez applied himself to a depiction of elementary moods, modelled for him by that hireling apprentice at Pacheco's workshop. It is safe to assume that Velázquez painted them in 1617 or early in 1618, either when he was completing his training or just after he had passed his examination for admission to the painters' guild – all the more so since *Old Woman Frying Eggs* and *Christ in the House of Martha and Mary*, both 1618, appear to mark a dividing line with the next group of his youthful works.

In *Musical Trio* and *Three Men at Table,* three half- or three-quarter length figures sit or stand around a table laid with food and drink. The viewpoint is high. The lighting accentuates the shape of edibles and tableware and stresses the grimacing faces and gesturing hands which are well modelled, as opposed to the figures which are not so substantially set in space. Spatial depth is principally achieved by the multiplicity of points of distance marked off by hands, faces and inanimate objects. This is particularly true of *Musical Trio,* a rather tentative work which seems to have exercised Velázquez' sense of composition.

This way of defining space, fairly common in the late *Cinquecento,* had been handed down to Velázquez and would not serve his method for long in portraying the live and the transient. He achieved, nonetheless, a sort of equilibrium. The vivid depiction of the grimaces and gestures of the figures, which do

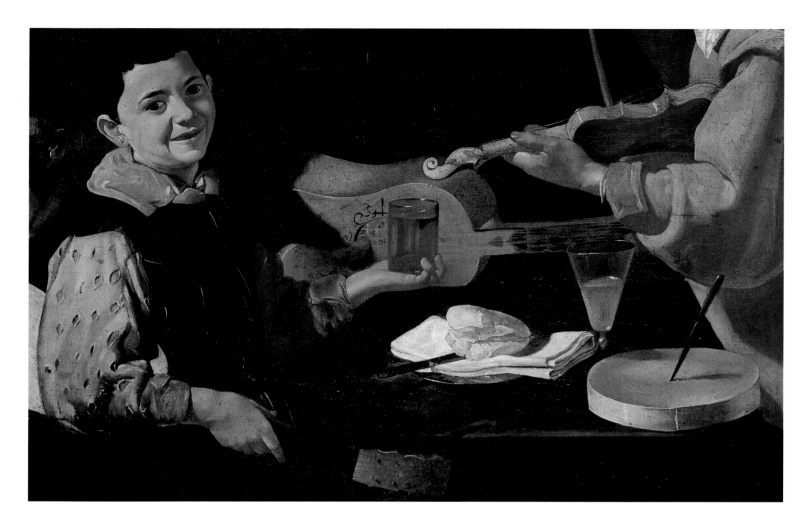

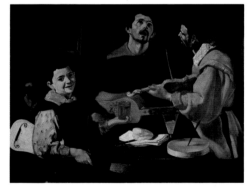

Musical Trio
1617–1618
Cat. no. 1

ABOVE:
Detail of no. 1

not quite occupy the space plotted by the table, vies with the depiction of victuals or tableware which underlying shadows make all the sharper.

Three Men at Table (cat. no. **3**) displays a variety of yellow hues in the costume of the youth at the right, the rinds of the pomegranate, the loaf of bread and the wine in the glass or in the bottle held by the boy. A purplish tinge on the old man's grey sleeve enhances the purple hue of the turnip he is eating, while white touches light up both the buckle of the boys' dark brown costume and the mussels and herring in the bowl in front of him. The shadow which keenly duplicates the shape of the sword hanging on the wall reveals Velázquez' gift for the depiction of aerial depth, which he was soon to master.

Old Woman Frying Eggs, dated 1618, shows a surer sense of composition than either of Velázquez' extant earlier *bodegones*. Even so, his hand still appears fettered under the restraint of study. The point of the knife bends down, shadowlike, and the boy's forearm is seen distorted through the glass in too studied a manner (cat. no. **6**). Velázquez represented more objects in this picture than in either *Musical Trio* or *Three Men at Table*. Yet gone is the fussiness of local definitions of objects which make both of these compositions somewhat unstable; gone also is the emphasis on human expressions and motions. Now there is a subtle interplay of light and shade which rounds human figures and objects into a quiet atmosphere. Both the woman and the boy truly occupy space, beyond and above the victuals and kitchenware which build the foreground plane. The gestures of both converge around the reddish frying pan where the eggs are seen in the very process of coalescing. Yet the expressions of the two are unrelated, vacant of thought or aim. Both are as much early presences as the fully-hued things they are handling.

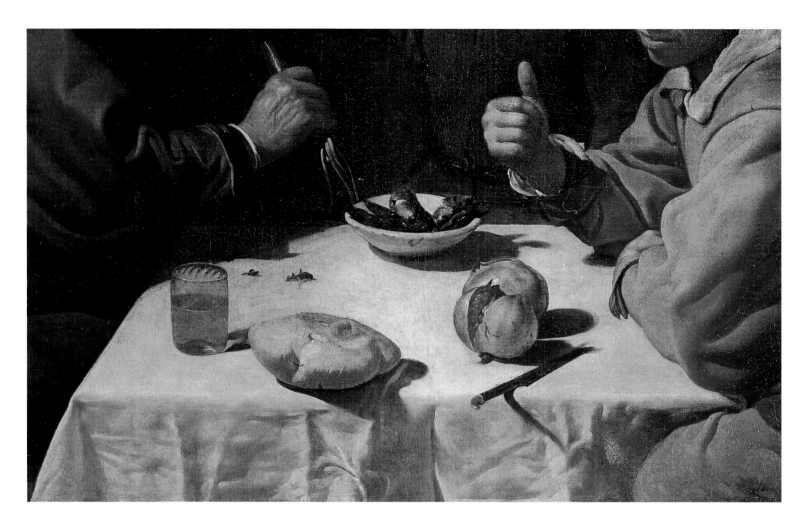

The figure of the old woman, with her head but not her bust in profile, somehow makes one realize the problem which exercised young Velázquez' sense of composition when he transformed one of the figures in *Three Men at Table,* in or about 1618, into that of the young man in *Peasants at Table* (cat. no. **9**), dateable to 1618–1619.

These two *bodegones* are based to a large extent on the same studies of men and objects. The glass and the loaf of bread on the table are almost identical in both paintings, and so seems to have been, except for the hands, the figure of the old man, now extensively restored (see cat. no. **9**). The young man's arms and trunk are also nearly identical in both works, but not his head – for which Velázquez used in the later composition the study of facial expression now at the Hermitage (cat. no. **8**).

Peasants at Table has been extensively damaged and restored. Nonetheless, a comparison with *Three Men at Table,* which is in better condition, shows that in the later work the width and depth of the composition has been underscored. The figure of the young man has been pushed more to the side, to disencumber the foreground edge of the table, and the figure of the girl in the background has been made to bend over slightly. Velázquez built the composition on fewer diagonals but of a greater range.

The young master achieved a compelling depiction of the stillness of the ʾearthly in *The Waterseller,* datable to about 1620, and in *Two Young Men at Table,* painted some two years later. Live but quiescent diagonals build the breadth and depth in each composition. The figures are related to one another by their poses rather than by their vacant expressions. Though the subject of only one of them could be said to require it, both works appear to be portrayals

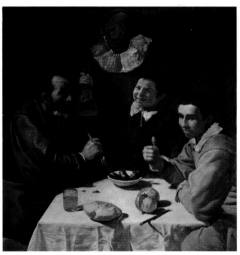

Three Men at Table
c. 1618
Cat. no. 3

ABOVE:
Detail of no. 3

of slumber, accentuated in *Two Young Men at Table* by the lustre of the mortar, of the pieces of earthenware – some with green, some with a white glaze – and of the fully textured orange which sits in the mouth of a jug.

In *The Waterseller* – Velázquez' earliest masterpiece – the subtlest of greenish tints tinge men and objects, notably those in the foreground. The vendor hands a glass of water with a fig for freshening it at the bottom to a lad, while coming out of shadow, another youth drinks from a jar. The shapes and expressions of the three men are not more vivid, or less quiet, than the watery film shimmering on the stopper of the jug, or the three drops of water which trickle down its side, or the interplay of transparencies which intensely define the glass, the water and the fig within.

Indeed, as young Velázquez went on mastering the art of *bodegón* painting, he put less and less emphasis on the portrayal of human expression or gesture. In *The Waterseller* and *Two Young Men at Table* he finally depicted men and objects as much of the same clay and solidified them into a quiet visual whole, where the narrative counts for little or nothing.[a]

Bodegón-like biblical compositions

Two Velázquez *bodegón*-like paintings also include biblical scenes framed in the background (cat. nos. 7 and 17). Their composition stems from a sixteenth-century Flemish tradition which originated with Peter Aertsen (1508– 1575).[34] Many of this master's works were destroyed by iconoclasts in his own day and there is no reason to conclude that Velázquez had actually seen any paintings by him or by Joachim Beuckelaer, Aertsen's nephew and follower (c. 1535–1574). Even if Velázquez had not seen any of these paintings, there is no reason not to think he was acquainted with such a compositional scheme from derivitive paintings, drawings or engravings – or even from oral descriptions.

Many of Aertsen's and Beuckelaer's extant works usually represent the interior of a merchant's stall open on all sides, where pots, vessels and baskets with fruits, vegetables, raw or cured meats, cheese, game, or fish fill the foreground; their profusion underlined by bright local colours and the somewhat jerky manner in which the various planes recede. Often there are figures in the foreground, the middle distance, or both. Even if not handling food, they are related to the narrative, or at least to the sense, of the smallish figure-scene from the New Testament which an architectural structure frames in the far background.

Several of these paintings take *Christ in the House of Martha and Mary* as their subject (cat. no. 7). And so does the earlier of the two extant Velázquez *bodegón*-like Biblical pictures, dated 1618. Though the condition of this much-restored painting is poor, the main lines of its composition remain visible as a somewhat tantalizing suggestion of what it originally was. The foreground is taken up by the three-quarter figures of an old woman and a girl who is busy with mortar and pestle at a table where other pieces of kitchenware, some fish and other food are displayed. The girl, identifiable as Martha, looks into the space outside the field of the composition. In the background, in what appears to be a reflection in a mirror,[35] there is the scene of Jesus seated with Mary at His feet and another woman behind her. The sides of the mirror, seen as the rest of the composition in a diagonal perspective, are naturally of unequal apparent width and height.

The other Velázquez *bodegón*-like painting of a subject taken from the New Testament, *The Supper at Emmaus*, shows a finer interplay of light and shade.

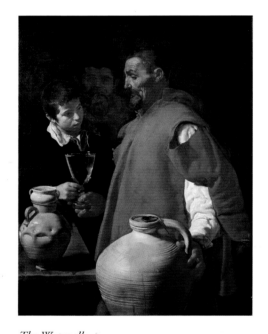

The Waterseller
c. 1620
Cat. no. 16

RIGHT PAGE:
Detail of no. 16

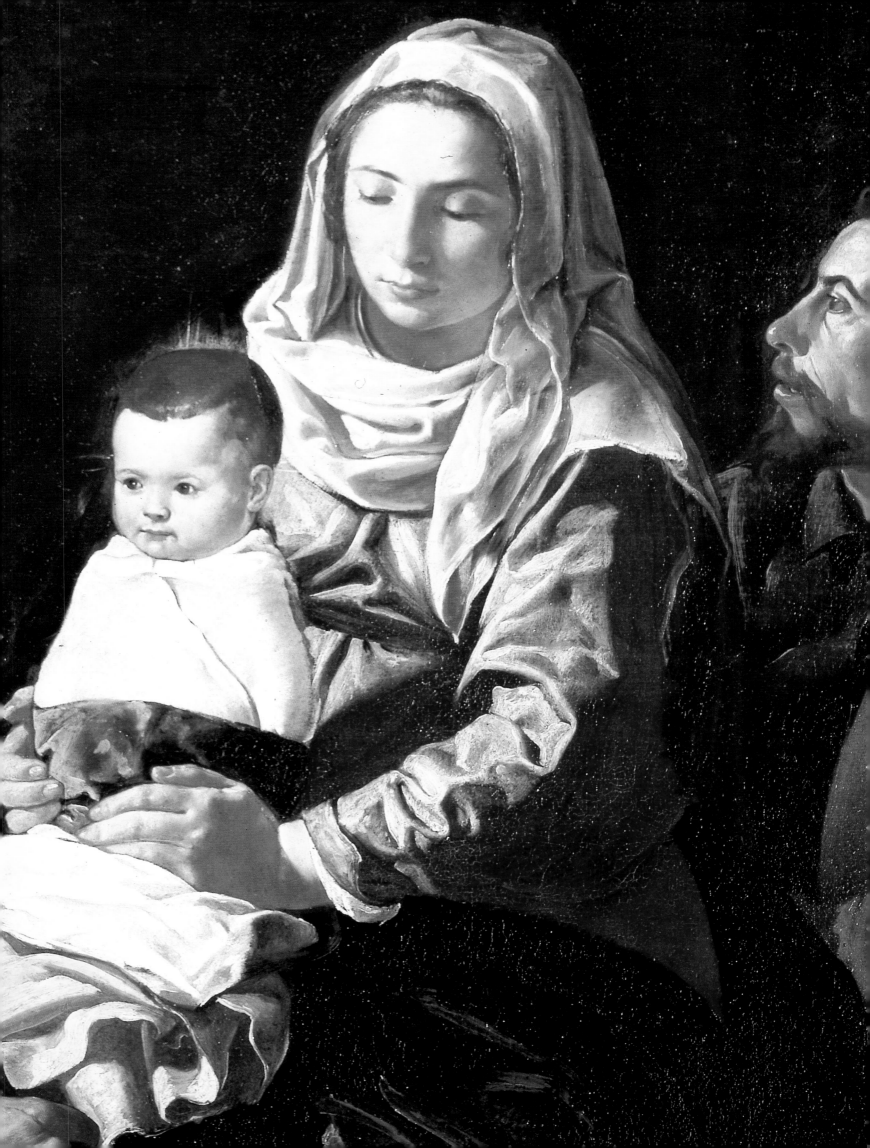

This suggests that it was painted later, probably 1620–1622 (cat. no. 17). The composition – which originally was wider than at present – also has two foci. It represents a kitchen interior. In the foreground a mulatto servant goes about his work in a desultory fashion (cat. no. 17). In the background, Velázquez has depicted an open hatch, with its door plainly visible, which gives upon another room where Christ and his two companions are seated at table. The canvas has been cut down and, as a result, the left arm is all that remains of the man that Velázquez represented at the right of Christ.

The analogies between either of the two *bodegón*-like Biblical paintings by Velázquez and works by Aertsen or Beuckelaer are evident but of limited significance. In Velázquez' paintings, as in those by the earlier Flemish masters, the food and kitchenware take up most of the foreground, where together with some human figures they form the outstanding scene, related to the smallish one in the background. However, in Velázquez' works there is neither the galaxy of comestibles to which the figures are rather ancillary in both Aertsen's and Beuckelaer's compositions, nor the sense of bustling activity which fills them. To begin with, in Velázquez' pictures the victuals and pieces of kitchenware are few in number, and, striking though they are, they do not dominate the composition. Secondly, instead of the many bright local colours which make luxuriant the perspective-heavy space of the Flemish pictures, there is in Velázquez' works a unifying atmospheric tint which makes the textures of food, brass and earthenware pieces glow one against the other. This achieves a sensual expression of disarray with just a few objects without overpowering the human figures, to whose pose and prominence the overall composition is keyed. The relation between the large and the small, more luminous, background scene is vividly enhanced rather than lessened by the impact of the main figures.

A plainer and closer analogy is to be found between Pacheco's *St. Sebastian Nursed by St. Irene* (p. 25), of 1616, and the later Velázquez *bodegón*-like Biblical compositions. In Pacheco's painting – destroyed by fire in 1936 – St. Sebastian was seen in an interior, the blood-stained arrows hanging on the walls. A window framed the view of a landscape with St. Sebastian tied to a tree and the archers aiming their arrows at him.[36] Unlike Pacheco, however, Velázquez does not represent two moments of the same narrative in either *Christ in the House of Martha and Mary* or in *The Supper at Emmaus*. In composition, moreover, Velázquez differs as much from Pacheco as from Aertsen or Beuckelaer. His is a different sense of space: the stare of Martha – and for that matter, the gaze of the mulatto servant – suggests a diagonal leading to the outlying space from where the viewer encompasses both foreground and background scenes as a dynamic whole.

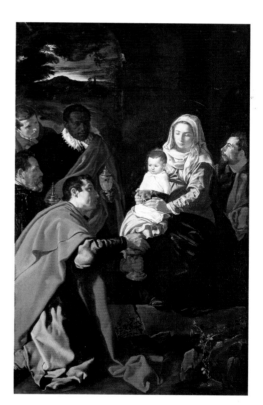

Adoration of the Magi
1619
Cat. no. 13

LEFT PAGE:
Detail of no. 13

Early portraits

Half a dozen likenesses of those who sat for Velázquez or whom he portrayed from memory in his early Sevillian years, have come down to us. Two drawings, each of a young girl, both datable to about 1618 (cat. nos. 4 and 5). A posthumous full-length portrait of the priest *Don Cristóbal Suárez de Ribera,* godfather to Velázquez' wife, probably painted in 1620 (cat. no. **19**). The two full-length portraits of *Mother Jerónima de la Fuente,* both dated 1620 (cat. nos. **20** and **21**), and the head-and-shoulders portrait of *A Man with a Goatee,* dateable to 1620–1622 (cat. no. **23**).

In each of these portraits, Velázquez brings out the sitter's mettle and earthiness, that is his or her human nature, letting the individual expression emphasize age and character traits. It is so in the two portraits of *Mother Jerónima de la Fuente,* whose commission apparently called for the inclusion of a scroll with a given Latin text around the crucifix held by the sitter. Although he overcame it, this must have been an odd challenge to young Velázquez' sense of composition. In the two portraits, the scroll around the crucifix originally had an architectural, space-creating quality that endowed the effigy of Christ on the Cross with a fit sense of heroic monumentality, as one could still see in the 1960s in the version at the Fernández de Araoz collection before the painting had darkened to its present dullness (cat. no. **21**). In the version at the Prado, the scroll was erased soon after its acquisition by the museum in 1944 on the random assumption that it was a later addition. Now the crucifix held by the sitter looks awkward and devoid of its intended monumentality, as a comparison of its original and present condition reveals (cat. no. **20**).

The human and the divine

Young Velázquez' compelling rendering of the mundane and transient, whether a light-permeated cord round the rind of a melon, a few drops of water trickling down the side of a jug, or a human face on which age and character traits are emphasized, exists side by side with his portrayal of the divine persons in *The Adoration of the Magi,* dated 1619 (cat. no. **13**). This composition is quite different from the *bodegón*-like Biblical paintings which Velázquez painted before and after that year (cat. nos. **7** and **17**). The religious scene is not framed in the background as a meaningful sketchy counterpoint to the portrayal of the earthly. Instead, in a somewhat more traditional vein, the young master of *bodegón* painting has centred the composition of *The Adoration of the Magi* around a vivid portrayal of the divine nature of the Virgin and the Infant Christ. Light models the faces of the Virgin and the Child into unblemished shapes while the facial characteristics of the nondivine persons – St. Joseph, the Three Kings and their manservant – are emphasized by live contrasts of light and shade.

The same distinction in the depiction of human and divine persons is evident in *The Immaculate Conception of the Virgin* and *St. John at Patmos* with the vision of the woman followed by the dragon (cat. nos. **11** and **12**). These two works must also have been painted around 1619 as suggested by their composition and execution. Their subjects are closely related, and the paintings are of identical size and have the same provenance – the Chapter Room of a Carmelite convent in Seville. However, as the difference in the scale of the figures indicates, they were not intended to be on the same wall or altar, or at least not at the same level.

St. John at Patmos (detail)
c. 1619
Cat. no. 12

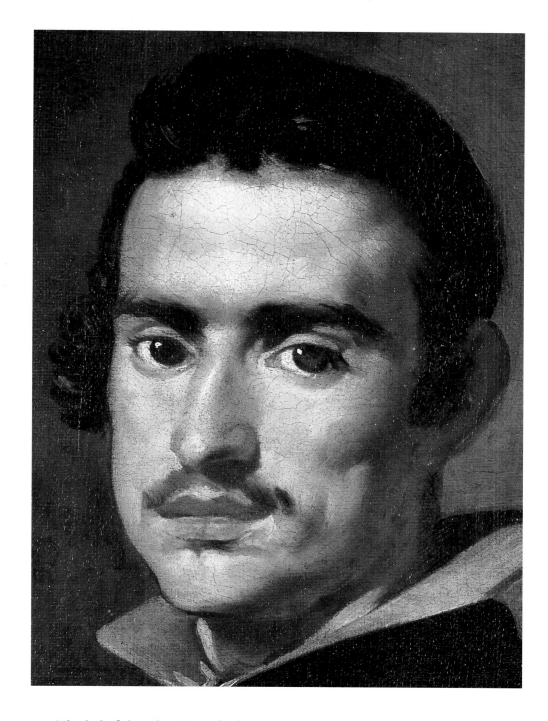

A Young Man (detail)
1623-1624
Cat. no. 27

The belief that the Virgin had conceived without taint of original sin did not become Catholic dogma till 1854. Debated for centuries, it aroused a great deal of feeling among its upholders in the first decades of the seventeenth century, especially in Seville. In 1615, the Carmelites of this city urged all the Spanish prelates to request from the Pope an affirmative declaration on the matter. Two learned treatises furthering the point were published in Seville that very year.[37] By 1619 the number of such books printed in Spain was at least thirty-eight.[38] On 1 January 1620, Pacheco completed a paper on the subject.[39]

Though Pacheco's paper on the immaculate conception of the Virgin did not touch upon matters of iconography, such matters must have been discussed at his workshop when he was writing it, all the more so since at precisely that point Velázquez undertook to paint the two companion pieces on the subject.

In *Arte de la Pintura,* Pacheco discusses the iconography of the Immaculate Conception of the Virgin as related to the vision of the woman chased by the dragon described in the *Apocalypse.*[40] He advises the painter that, though the

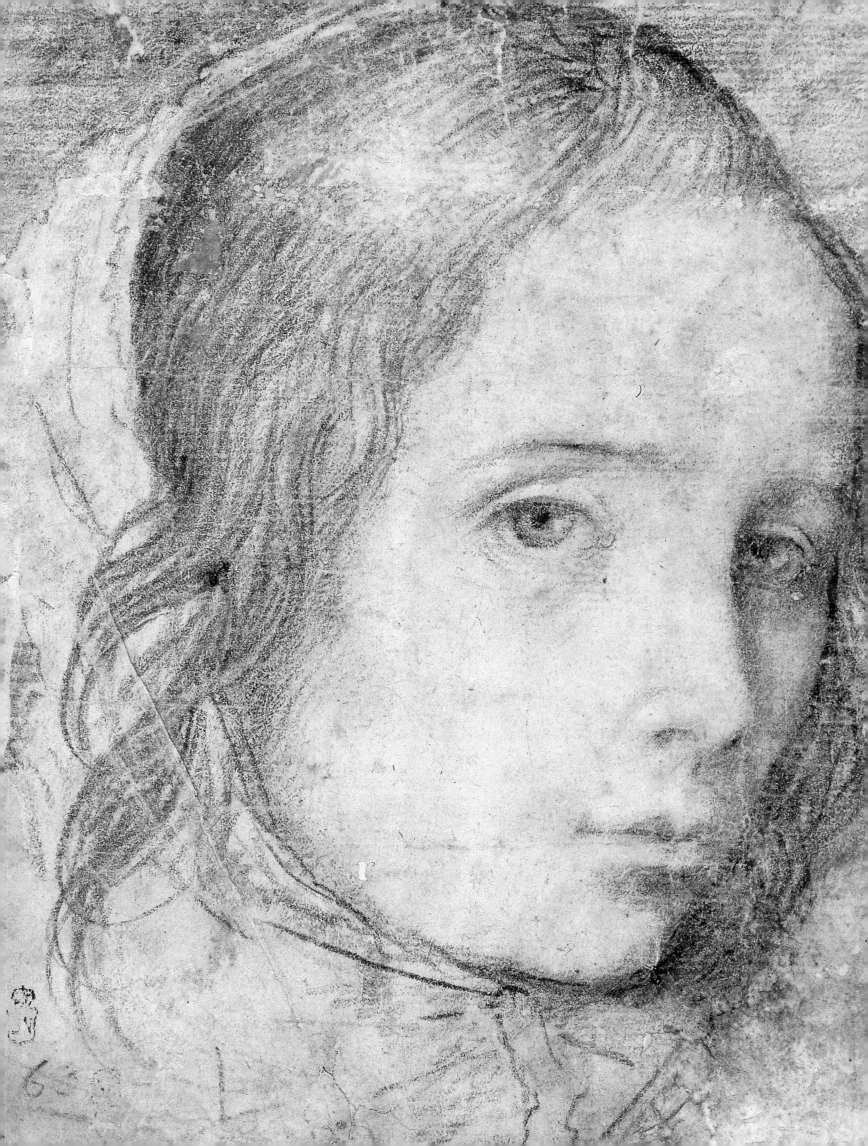

youth of St. John when he joined Jesus signifies his perpetual virginity, pictures of him writing the *Apocalypse* ought to represent him as the old man that he then was. As for *The Immaculate Conception,* Pacheco says that the Virgin ought to look twelve or thirteen years old, have twelve stars around her head, and wear an imperial crown on golden hair. She must be dressed in a white tunic and blue mantle. Her feet should rest on the moon, depicted with its points downward. She must also be enclosed in the sun, represented as an oval shape in ochre and white.

Obviously Pacheco did not arrive at the final formulation of these views before 1626, a date which he mentions as significant for his argument. Nor did he, as far as it is known, paint *The Immaculate Conception* before 1621, when he signed two pictures of the subject, in both of which the Virgin wears a crown (Seville, Cathedral and collection of the Marqués de la Reunión de Nueva España). In 1624 he signed another *Immaculate Conception* (Seville, Church of San Lorenzo) that shows the Virgin in a red tunic and with no crown, contrary to his earlier depictions of the subject, as well as to his final views on the matter (pp. 34 and 35).

As indicated above, Velázquez' *The Immaculate Conception of the Virgin* is earlier than any of the pictures of the same subject painted by Pacheco or than the latter's formulation of his iconographical views on the matter. In Velázquez' painting the Virgin wears no crown but has twelve stars round her head. Her white tunic is shadowed by purplish tints as she stands against the sun, painted in ochre within luminous white clouds. The moon is positioned under her feet, and the symbols of the litanies built into the landscape below. Her face is framed by her golden-brown hair. Her hands are flawless, limpid shapes, washed by the smooth brushwork. It is a masterpiece, alive with a naturalism which is as much visual as conceptual.

In the companion piece, Velázquez represented *St. John at Patmos* as a young, brown-haired, man in a white tunic and umber-rose mantle, his shape roughened by shadow and gesture which the uneven impasto makes sharper. The saint's vision of the winged woman and the three-headed dragon is seen in the upper left corner. His half-open mouth and the quill, suspended over the page, embodies the wondrous experience of the Revelation and the contemplative pause needed to put it into words.

One cannot fully understand Velázquez' art unless one realizes the differentiation he makes between the portrayal of the divine and that of the human, which extends to the textural quality of the brushwork that is revealed not only between companion pieces, such as *The Immaculate Conception of the Virgin* and *St. John at Palmos,* but even within one single work, as in the case of *The Adoration of the Magi.*

Throughout his life, Velázquez made use not only of the variety of hues but also of the variety of textures that pigments afforded to express pictorially the divine-human polarity which makes his world of painting cogent. Had he been a poet, he might likewise have coupled, balanced, aligned, opposed, reflected, contrasted, or subdued the various, at times diverging, connotations and shades of words. Pigments though, were the materials for his work, and he used them with a fullness of meaning which we can grasp today – provided, of course, we do not mistake the lines of our understanding for a programme to which the artist would have worked.[41]

LEFT PAGE:
Head of a Girl
c. 1618
Cat. no. 5

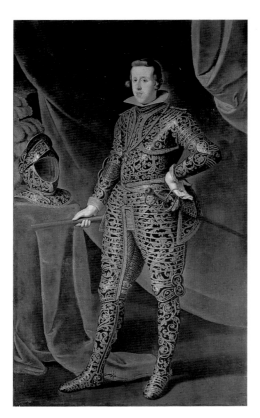

Juan Bautista Maino
Philip IV in Parade Armour
c. 1625
New York, The Metropolitan Museum of Art

Vincencio Carducho
Self-Portrait
1633–1635
Glasgow, The Sterling Maxwell Collection,
Pollock House

First stay at the Court

Young Velázquez started from Seville on his journey to Madrid in the second half of April 1622.[42] As we know, he had wanted to see the Escorial, a marvel of architecture, where a great many masterpieces, mainly paintings, were displayed. Another of his ambitions was to portray the new sovereigns, a venture which might have sped his success.

Philip IV, now seventeen, had come to the throne just one year earlier and had left the cares of state to the Count of Olivares who, as a prince, had a household of his own. Rodrigo de Villandrando, Bartolomé González, Eugenio Caxés, and Vincencio Carducho, all of whom had served his father, the late Philip III, were all retained as court painters.

It is likely that Velázquez' work was known to Olivares. In 1619, as he was toying with the idea of withdrawing from the Court, he had spent several months at Seville, surrounding himself with scholars, poets, artists and connoisseurs. One of these was Francisco de Rioja, a close friend of Pacheco, who had the year before acted as a witness at Velázquez' wedding, and might have mentioned the promising young painter to the Count, whose sense of power sharpened his interests as an art patron. Pacheco also knew the Count, whose portrait he had painted in 1610,[43] and he surely would not have let his son-in-law, painter of such pieces as *Old Woman Frying Eggs* and *Christ in the House of Martha and Mary,* go unnoticed by so important a Maecenas as Olivares.

Those whom Pacheco mentioned as having taken care of his son-in-law in Madrid came from Seville. Particularly obliging was Don Juan de Fonseca, a canon from the Cathedral of Seville and writer on art, who was now a chaplain to the new King; he was fond of Velázquez' paintings and decided to further his success at the Court. He failed though in his effort to secure an opportunity for his protégé to portray the sovereigns. It was instead with the portrait of the famous poet Don Luís de Góngora that Velázquez first won recognition in Madrid (cat. no. **25**). The likeness of Góngora – his eyes and hair black, clad in a black cassock and a white collar permeated by light – is quite vivid. His head, half in the light and half in the shadow, stands out against a greenish background, half of which is dark while the rest is lit up. The rose and yellowish flesh tones, the blackish shade on the shaven face, and the grey moustache, taken together, suffuse the painting in a golden glow.

Besides the royal collections at the Madrid Alcázar, the Escorial and other nearby palaces, Velázquez would naturally have seen some of the outstanding private collections in Madrid. It is likely that he also stopped at Toledo on his way from or to Seville, as Pacheco would probably have urged him to do so. That he went there is all the more likely since admirers of El Greco were still prominent in Madrid intellectual life. Góngora (1561–1627) had written a sonnet on the occasion of his death. Similarly, the subtle poet and fashionable Trinitarian preacher, Fray Hortensio Félix Paravicino (1580–1633), then at the peak of his reputation, was the author of four sonnets exalting the meaning of El Greco's art. Young Velázquez must have admired the old master's handling of pigment, sure and free, and the naturalism of his portraits.

Since El Greco's day, Toledo had been a more vital art centre than the Escorial. It was in Toledo, in El Greco's circle, that Pedro de Orrente (1580–1645), sometimes referred to as the "Spanish Bassano", acquired the mastery in the handling of light and texture that was to make of him a naturalist painter, admired and imitated at the Court and other Spanish art centres.

On 10 August 1603, when Juan Sánchez Cotán (1561–1627), then in his forties, closed up his workshop at Toledo to enter monastic life, he left behind a

number of still-lifes in which sheer space intensified the reality of things to a degree that no other seventeenth-century painter would surpass (p. 29). By the 1620s, Alejandro de Loarte, after spending some time in Madrid, had returned to Toledo to become recognised as a master of still-lifes and *bodegones;* he signed the last one in 1626, when he died, apparently still a young man (p. 30).

Painters and painting in Madrid

As for the painters influential at the Court, most of them had been brought up in the tenets of mannerism which, from the 1570s until early in the 1600s, had radiated from the Escorial. Spanish masters such as Juan Fernández de Navarrete (1526–1579) and Alonso Sánchez Coello (c.1532–1588) had executed paintings for the church, the monastery or the royal chambers there, and so had a good many Italian painters, including Luca Cambiaso (1527–1585) and Federico Zuccaro (1542–1609).

When Bartolomé Carducho (1554–1608) left his native Florence to become an assistant to Zuccaro at the Escorial, he took with him his fifteen-year-old brother, Vincencio (1570–1638).[44] Zuccaro himself was less than a success at the Escorial and he returned to Italy scarcely three years later. Bartolomé Carducho, however, remained in Spain in the service of Philip II, who in 1598 appointed him Court painter, a position which at his death was granted to his brother Vincencio by the new king, Philip III. Eugenio Caxés (1573 or 1574–1634), another Court painter, owed his training to his father, Patricio (c.1544–1612), who in his early twenties had come from Rome to Spain, where he remained in the royal service till his death.

Vincencio Carducho and Eugenio Caxés had won recognition and influence at the Court during the reign of Philip III, who came to the throne in September 1598. When Rubens visited the Spanish Court, at Valladolid in 1603, he commented that the painters there were pathetically incompetent or sloppy.

By the 1620s painters and connoisseurs in Madrid, where the Court had been moved back, generally followed a trend towards naturalism. Orazio Borgianni (1575–1608), whose naturalistic outlook was more akin to Carracci's than to Caravaggio's whom nonetheless he strove to imitate, had contributed initially to this current. He had been early in the century at the Valladolid Court and elsewhere in Spain. His success is attested to by the important commissions which he carried out there. Moreover, there is reason to surmise that his works continued to find a market in Spain after he returned to Rome sometime around 1608.[45]

Much more spirited, though also derivative, was Antonio de Lanchares (d. 1630),[46] who at least in his *Adoration of the Shepherds*, of 1612, had carried his naturalism, rooted, like Orrente's, in the Bassanesque tradition, somewhat closer to Caravaggio's use of sheer light for dramatic composition.

Other Spanish painters had seen Caravaggio's works in Italy. Paintings by him, or copies of them, had certainly arrived in Spain by the time of his death. In any case, by 1622, they could be seen in churches and private collections in Madrid, Seville and elsewhere.[47] In 1610, on retiring as Viceroy of Naples, the Count of Benavente had brought with him to his palace in Valladolid a "very large" *Crucifixion of St. Andrew* by the hand of Caravaggio.[48]

The popularity of Caravaggio in Spain is documented by many, often eulogistic references found in contemporary accounts. Evidence is also provided by the sarcasm with which Vincencio Carducho, influential as a painter and as a connoisseur in the Madrid of the 1620s, retold the story of the success of that

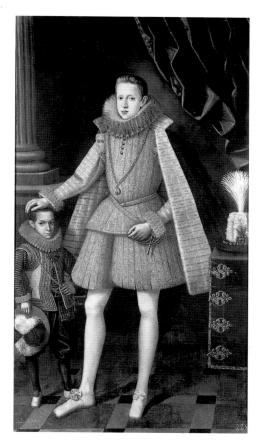

Rodrigo de Villandrando
Philip IV with the Dwarf Soplillo
1619–1620
Madrid, Museo del Prado

Juan Van der Hamen y León
Don Francisco de la Cueva
1625
Madrid, Real Academia de Bellas Artes de San Fernando

"Antichrist" or "Antimichelangelo", in his *Diálogos de la Pintura*. Carducho's prose is weighted with images of food, gluttony, digestion, and indigestion as he despairingly describes the naturalism of Caravaggio and his followers, even contriving to bring in "natural" as a noun in an awkward effort to suggest the picture of a simpleton.[49]

As a painter, Vincencio Carducho developed a cautious approach to naturalism. In his work, mainly of religious or historical subjects, he used line and shading to define the individual features without in the least aiming at an expression of the momentary such as Caravaggio and like-minded painters had achieved by their striking use of light.

Still later, in the early 1630s, Carducho would define painting as "a likeness and portrayal of anything visible, as represented to our eye, composed by lines and colours on a surface"; he further explained that lines ought to "determine and circumscribe" the areas "within" which colours "imitate shades and lights".[50]

Carducho's views must have carried weight in the Madrid of the 1620s for he was a knowledgeable man, well read on art and other subjects, and counted among his friends distinguished men of letters, including the much admired Lope de Vega (1562–1635). Moreover, like other artists of his day, he engaged in buying and selling sculptures, paintings and drawings by old masters, as well as works by living, sometimes anonymous, painters – an activity that considerably enlarged his social circle.[51]

More sensitive and responsive to the new art trends – and fortunately closer to the new King – was Fray Juan Bautista Maino (1578–1649). He had practised the art of painting at Toledo during El Greco's last years. Around 1611 he apparently spent some time in Italy. Two years later, at thirty-five, he entered the Dominican Order at Toledo, and by 1619 he was in Madrid as drawing master to Prince Philip, who after ascending the throne kept him on at the Court, where he died. Much of his painting before 1620 reveals his awareness of Caraveggio's sense of light and hue, yet his art as a whole appears generally oriented to that of the Carracci.[52]

Truly creative was the Madrilenian Juan van der Hamen y León (1596–1632), whose work as a still-life painter was rooted in that of Juan Sánchez Cotán (1561–1627). Though Sánchez Cotán's activity as a painter had since 1603 been limited to conventional works, his still-lifes – only a few of which are extant[53] – had a lasting impact on younger painters, for whom he seemed to have discovered the very appearance of things by depicting them against sheer space. He cast an ordinary vegetable, a cardoon, into so compelling an art reality that other painters emulated it time and again in their still-life compositions (p. 29).

Van der Hamen's earliest recorded work is a still-life, now lost, painted in 1619 for the Royal Palace at El Pardo, near Madrid. Though he also painted portraits and other figure-compositions, his contemporaries admired him mainly for his still-lifes, rather to his annoyance. Yet they were right for, as can be seen in the one extant portrait by his hand, *Don Francisco de la Cueva*, of 1625 (p. 47), Van der Hamen, not unlike Carducho, effected a naturalist portrayal of the human figure chiefly by the overdrawing of details, which, without the flux of light, appear stark, almost lifeless.

Curiously, the one recorded contemporary stricture on Velázquez as portrait-painter comes from an Italian antiquarian and connoisseur of great learning and deep-seated taste, who thought that Van der Hamen was excellent as a painter of portraits, flowers, fruits, and the like. Cassiano dal Pozzo (1588–1657), who was in Madrid in July 1626, disapproved of a portrait that Velázquez painted then of Cardinal Francesco Barberini "with a melancholy and severe

El Greco
St. Paul
1608–1614
Toledo, Casa y Museo del Greco

RIGHT PAGE:
St. Ildefonso Receiving the Chasuble from the Virgin (detail)
c. 1620 (?)
Cat. no. 22

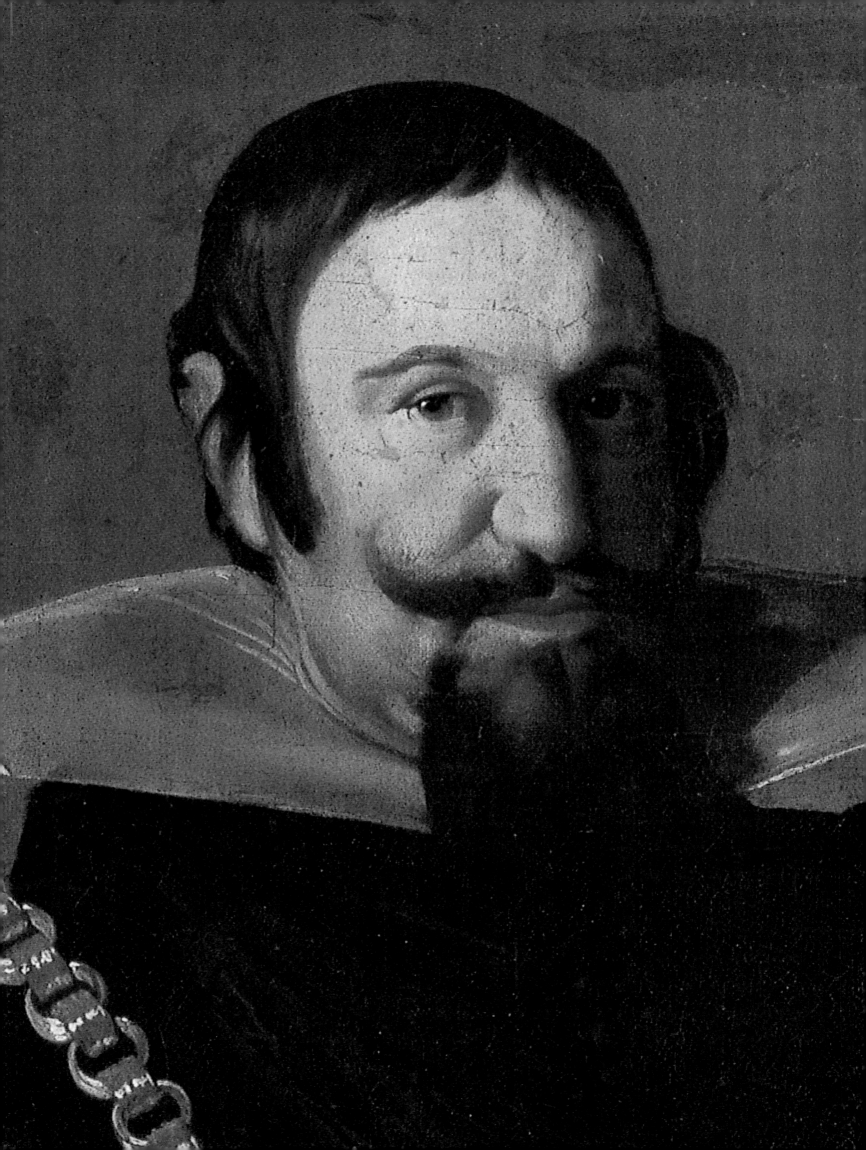

air", and suggested to the Cardinal that he should sit for Van de Hamen. The Cardinal agreed, and Van de Hamen painted his portrait, of which Dal Pozzo only said that it done "well enough". Van de Hamen's still-lifes, however are unique for the architectural quality with which he endows the spaces between the various objects represented – a quality which brings order into the disarray of fruits, sweetmeats and tableware (p. 31).[55]

Young Philip IV favoured Rodrigo de Villandrando (d. 1622) over the other Court painters – González, Caxés and Carducho – whom he found at his service when he came to the throne. A few months later, on 5 July 1621, he granted Villandrando's ambition to be Usher of the Chamber, at the time a much coveted distinction.[56]

In 1620 or thereabouts Villandrando had portrayed Philip IV, then still a Prince, and his wife, Princess Isabel.[57] Velázquez probably saw these two portraits at the Royal Palace during his first stay in Madrid (both are now in the Prado). At the same time, it is also likely that he saw the portraits of the late sovereigns, Philip III and Queen Margarita, as well as those of Philip IV's brother and sister, the Infante Don Fernando and the Infanta Doña María, all by the hand of Villandrando, and all now lost or unidentified.

Villandrando's portrait of Philip IV depicts the king resting his right hand on the head of the dwarf *Soplillo* (p. 47). As a work of art, it shows the refinement of a tradition which for some sixty years, since the time of Alonso Sánchez Coello (1531/2–1588), had been kept alive by a few masters of succeeding generations at the Spanish Court.

Such was the world of art in which Velázquez' portrait of Góngora, a keen admirer of El Greco, was "much praised", as Pacheco wrote without indicating either the nature or the source of the praise. The view was by then current in Madrid intellectual circles that the highest achievement of a portrait painter was to endow his work with a true-to-life likeness that would cause the sitter to doubt whether his true self was the painted image or his own being. This view, strikingly expressed early in the century by Giambattista Marino in Italy and by Fray Hortensio Félix Paravicino in Spain,[58] had since become commonplace.

Velázquez painted the portrait of Góngora at the request of Pacheco, who had probably intended to draw from it a likeness of the poet for his *Libro de Retratos.* Eight of the portraits made by Pacheco for this book, and left unfinished, represent poets or humanists crowned with laurel wreaths. Velázquez originally depicted Góngora in the same way. However, at an unknown later date, he painted over the wreath, still noticeable under X-ray examination, casting the portrait into a fully naturalistic image (cat. no. **25**).

While in Madrid, Velázquez would surely have heard that Philip IV had in the previous year, rewarded Rodrigo de Villandrando with the appointment to the position of Usher of the Chamber. On his way back to Seville, the young painter probably mused over the high recognition and honours that an artist could attain only at the Court.

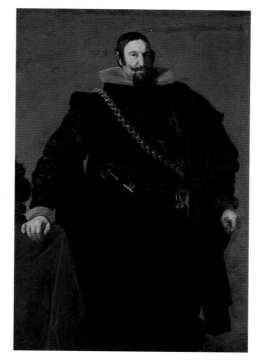

Count-Duke of Olivares
1624
Cat. no. 30

Don Luís de Góngora y Argote
1622
Cat. no. 25

Left page:
Detail of no. 30

Death of Villandrando and Velázquez' success

Don Juan de Fonseca, that early and presumably keen admirer of Velázquez, kept a watchful eye on the Court scene, waiting for a new opportunity for the young painter. He did not have to wait long, for within a matter of months, in December 1622, Rodrigo de Villandrando died, and in the spring of 1623 Fonseca conveyed to Velázquez the Count of Olivares' command to come to the Court.

Velázquez set out again for Madrid, this time with brighter prospects.[59] Fonseca left nothing to chance and lodged the young painter in his own home. Even more, he sat for him, and as soon as the portrait was finished, Don Gaspar de Bracamonte, also a Sevillian, and chamberlain to the King's brother, Cardinal Infante Don Fernando, took it to the Royal Palace. Within an hour of its arrival everybody – the courtiers, the Infantes, and even the King – had seen and admired it.

Velázquez was directed to paint the portrait of the Cardinal Infante but "it was thought more advisable" that he should first portray His Majesty – which gives the full measure of the painter's and Fonseca's success – even though it was necessary to wait till Philip could spare the time for the sittings.

According to Pacheco, Velázquez painted the portrait of the King on 30 August 1623. Needless to say, in one day, the painter could hardly have done more than a sketch of the head. It is, however, more likely that Pacheco meant that the portrait was finished on the mentioned date.[b]

The King was pleased with the portrait. Olivares said that until then no one had really portrayed Philip IV and all the noblemen felt the same way. The young master's highest expectations were fulfilled as Olivares commanded him to move his home to Madrid and promised him that from then on he would be the only painter to portray the King and that such other portraits of the sovereign as existed would be withdrawn.

Those were days of both concern and festivity at the Spanish Court where the Prince of Wales, later Charles I, was discussing his contemplated marriage to the Infanta María, Philip IV's sister. At the time when Velázquez painted the portrait of the King he also did a colour sketch, now lost, of the Prince of Wales, who rewarded him with one hundred *escudos*.[60] The Prince's visit, which had at the beginning appeared promising for both countries, came to a dead end, and on 9 September 1623 the Spanish King accompanied his royal visitor from Madrid to the Escorial where they said their adieus.

Velázquez was formally admitted into Philip IV's service on 6 October 1623 at a salary of twenty ducats a month with the obligation of painting such works as might be ordered. Before the month was over,[c] Philip IV bettered these financial terms ordering that, in addition to his salary, Velázquez was to be paid for whatever paintings he should paint as painter to the King.

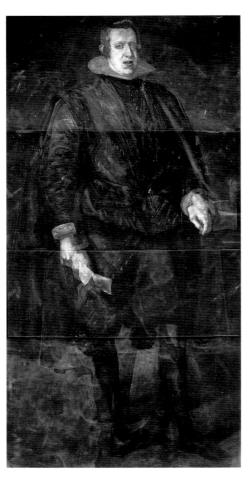

Philip IV, Standing
1623
X-ray photograph showing the portrait of the King originally painted by Velázquez on this canvas, which he later repainted

The likeness of the King

Neither the portrait of Fonseca, which opened the way for the success of Velázquez at the Royal Palace, nor that of the Prince of Wales, which was probably taken back to England, has been identified.[61] As for the portrait of the King that won for Velázquez the appointment as Court painter, it has been preserved though only underneath another likeness of the sovereign painted by Velázquez a few years later.

In fact, X-ray photographs made in 1960 show, although only in black and white, what appears to be the first portrait of Philip IV painted by Velázquez (cat. no. 36) The King is seen standing by a table, his right hand holding a petition while the left one rests on the sword hilt. He has a flabby face, roundish at the chin, and a short neck – the same features that he has in the portrait painted from life by Rubens some years later (p. 101).

Such was the portrait with which Velázquez won his decisive success at the Court, where even the King admired it. Yet, the young master soon became dissatisfied with it, as he set out to portray the august nature of the person of the King rather than the reality of his physique. Hence, in 1626–1628, he painted out that true-to-life likeness of Philip, substituting for it another in which the royal sitter's natural characteristics were not his subject (cat. no. 36).

The earliest portrait of Philip IV executed by Velázquez which has come down to us in visible pigments is bust-length. The young master painted it probably still within 1623, and certainly no later than 1624, when he used it for a full-length portrait which was finished by 4 December.

In the bust portrait, Philip is seen clad in black with a greyish-white collar, against an olive-grey background. A quiet light bathes his countenance, thinning the shadows to the faintest veil. The face is firmly modelled in ivory and rose hues with redder touches for the ear and eyelids, the gleam in the blue-grey eyes as still as the highlights on the crimson lips. The broad outline of the shoulders adds to the quiet monumentality of the composition (cat. no. 28). Velázquez achieved in this portrait a sentient image of the King which was to remain his own, as even his last portrait of Philip, painted some thirty years later, shows (cat. no. 120).

A full-length portrait of Philip IV and another of the Count of Olivares, painted by Velázquez in 1624, are extant. Both were commissioned, or at least paid for, by the widow of Don García Pérez de Araciel, Professor of Law at the University of Salamanca and a member of the Council of Castille. Ever since coming into power, Olivares had had Pérez de Araciel at his elbow, having appointed him to some of the most demanding positions, such as the commission of judges instituted to investigate the conduct of the former Viceroy of Naples, the Duke of Osuna.[62]

A document signed by Velázquez on 4 December 1624 shows that he had received, from the widow of Pérez de Araciel, a payment on account for the portraits of Philip IV, the Count of Olivares and the deceased professor.[63] Since the latter had died only a few months earlier, it might be that he, rather than his widow, had commissioned the three portraits, of which only those of the King and his chief minister are known today.

It is unlikely that Philip IV would have sat for a portrait commissioned by a royal servant or his widow. It is more probable that Velázquez painted the head after the bust I have just discussed, while he used the full-length portrait of 1623, now visible only under X-rays for the rest of the figure.

Unfortunately, the portrait of Philip IV executed in 1624 has been restored here and there, notably around the face and in the background (cat. no. 29).

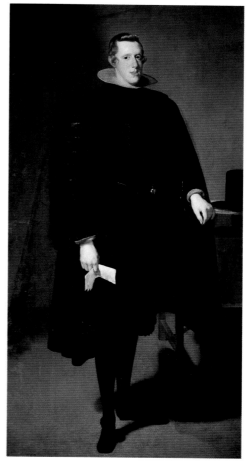

Philip IV, Standing
Redone c. 1628
Cat. no. 36

Both eyes, particularly the left, have been redone to cover losses of pigment. Yet, it is still noticeable that Velázquez shaped the head and hands by dint of light with shading used most sparingly. The sitter, clad in black with greyish-white collar and cuffs, stands against a light background. The space around him has been constructed from the floor line, the shadows and by the table in the middle distance. The quiet rhythm of the King's figure is underscored by the gold chain falling in a long curve from his shoulder and by the badge of the Golden Fleece hanging from a black ribbon. There is no emphasis on his natural characteristics. His kingly power is embodied in an effortless gesture, one hand on the sword hilt and the other holding a petition.

For a contrast, we may look at another full-length portrait, of approximately the same size, representing *Philip IV in Parade Armour*, probably painted by Juan Bautista Maino, not before January 1623, when the king adopted the simple collar he is seen wearing, and perhaps even some time after 30 August.

In this portrait, the blond Philip is seen in black, gold-inlaid full armour, with red at the edges of the main pieces. His face is painted in grey and pink hues. He stands, baton in his right hand, against the red velvet curtain and the red velvet-draped stand where his helmet rests. The brushwork is smooth throughout the whole composition, and the highlights, whether on the subject's face, the armour, or the drapes, bring about a soft sheen. The design of the armour, the folds of the drapes reaching the floor, the sitter's formal and yet animated pose, and the interplay between his idle left hand and his sword hilt (both dynamically shaped) imbue the composition with a brisk rhythm that binds together the figure of Philip IV with his royal attributes.[64] The contrast between these two portraits, both now at the Metropolitan Museum of Art, reveals the originality of Velázquez, in portraying the person of the King in a casual pose, dispensing with outward signs of power, and yet still as the very embodiment of the Majestic.

In 1625 he achieved another resounding success at the Court with an equestrian portrait of Philip IV. This portrait, painted entirely "from nature, even the landscape", won praise from courtiers and poets and aroused envy among the painters, as Pacheco, who was then in Madrid, recorded. The King rewarded Velázquez with three hundred ducats plus a life annuity in the same amount[d], and allowed the portrait to be displayed at the favourite spot of the Madrilenian cognoscenti: a public walk which went through the convent of San Felipe.

That equestrian portrait is now lost. However, there is at the Prado Museum a bust portrait of *Philip IV in Armour* painted by Velázquez, probably also around 1625, though he later repainted it. An X-ray photograph reveals that, as originally executed, this portrait still represented the King with a round chin and a short neck (cat. no. **38**).

Some years later, most likely between 1626 and 1628, Velázquez repainted the full-length portrait of the King which he had executed in August 1623 and which, as X-ray photographs show, had been somewhat damaged. It was not a restoration, though, that Velázquez undertook. Rather, he repainted the whole composition, substantially altering the royal sitter's pose, introducing changes in his costume, and, more significantly, endowing him with distinctly different features, going even further in that than in the other likenesses of 1623–1624 (cat. nos. **28** and **29**). In the resulting new portrait, there is no floor line and the sense of space is achieved by a subtle interplay of light and shade (cat. no. **36**). The King's face and hands are unmarked by shadows or any natural flaw. His chin is somewhat pointed, and his neck quite elongated. The verticality of his figure has been enhanced by the change in his stance and the omission of the looped gold chain; yet his gesture is as effortless as in the earlier portrait.

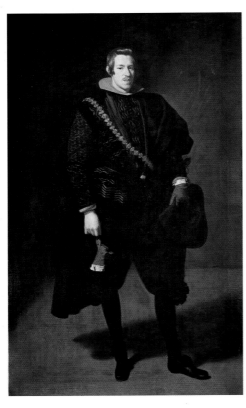

Infante Don Carlos
1628
Cat. no. 37

RIGHT PAGE:
Detail of no. 37

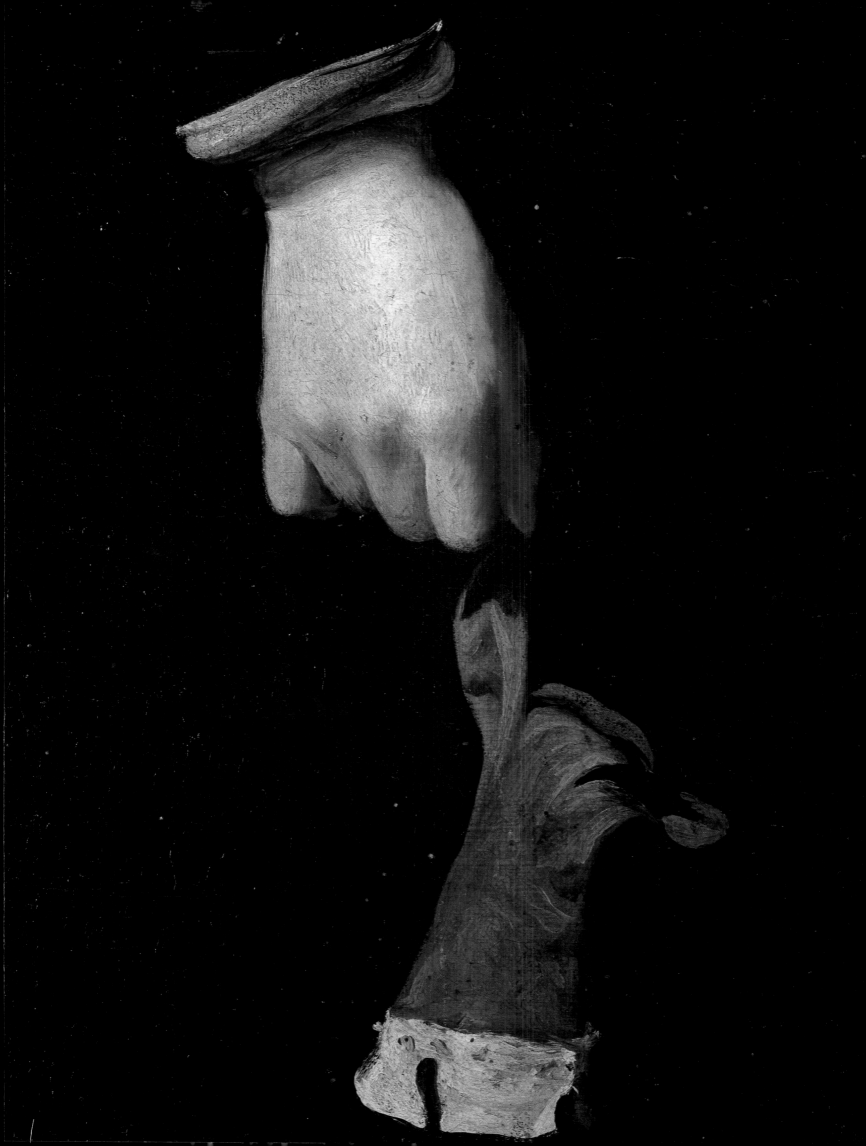

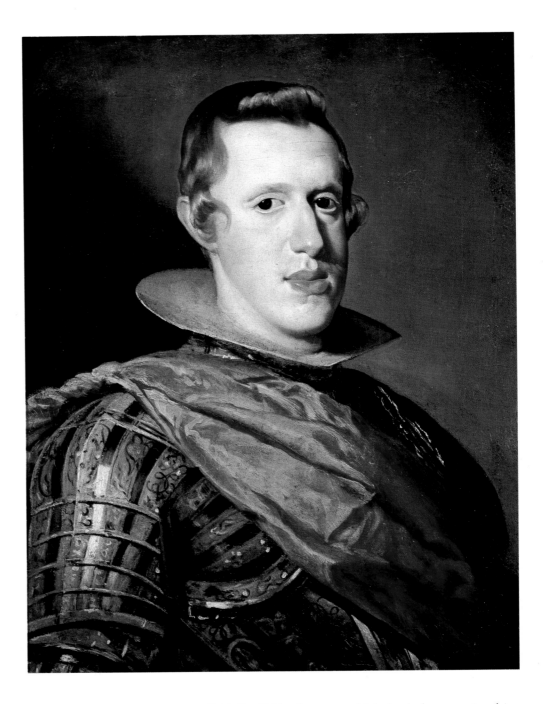

Philip IV in Armour
c. 1628
Cat. no. 38

As for the bust portrait of *Philip IV in Armour*, which had also remained in the royal collection, Velázquez repainted it in much the same spirit and presumably about the same time. He made the King's chin pointed, his neck elongated and he also added a red scarf across the King's armour. The brushwork texture of this scarf, made of vivid highlights and a variety of red hues, underscores the rose tones of the sovereign's face and the serene light that bathes it (cat. no. **38**).

In the bust portrait of 1623 or 1624, as well as in the full-length of the latter year, Velázquez had still depicted Philip's chin as round and his neck as short (cat. nos. **28** and **29**). Yet, in those painted after 1624, he made the King's chin look somewhat pointed and his neck long (cat. nos. **36** and **38**). This appears more obvious if one compares the portrait of 1626–1628 with either of those of 1623–1624 since in all three the King wears identical collars and his face is seen from the same viewpoint (cat. nos. **28**, **29** and **36**).[65]

Similar devices had been used for the purpose of improving the sitter's appearance long before Velázquez' time. For him, they became another means to refine the likeness of the King. Flattery could hardly have been his motive, as

he had won his first and astonishing success at the Court precisely with a true-to-life likeness of Philip which was praised to the utmost by the King himself, Olivares and all the courtiers. Moreover, if the portraits of Philip IV executed throughout the years by other painters,[e] even in the workshop of Velázquez, are any indication, the prevailing taste at the Court continued to favour likenesses of the King which were truer to life than those that came from Velázquez' hand – a preference that Philip himself seemingly came to share in his melancholy last years. Velázquez always left it for his assistants to meet that taste.

Diego de Saavedra Fajardo (1584–1648), a leading intellectual who was rather keen on the matter of artistic creation and on the "idea" of the monarch and the monarchy, described at an unknown date an imaginary city where artists, mostly from the past, were seen at work. Only two artists then living were included – Bernini and Velázquez. Bernini was seen in the act of completing the statue of Daphne being changed into a laurel tree. The viewer was kept in suspense, waiting for the bark to entirely cover the nymph's body and for the wind to stir the leaves into which her hair was turned. As for Velázquez, he was portraying Philip IV, endowing the likeness of the King with such a graceful air and achieving so compelling an expression of the "majestic and the august" in the depiction of the face that Saavedra felt overwhelmed and knelt down, lowering his eyes, in an act of reverence. This fictional episode reflected a deep-seated sentiment. In those days it was not uncommon for some of the best minds of the time to regard the King as a quasi-divine person, as a "deity" or "demi-god on earth" as it was occasionally said.[66] Velázquez' portraits of Philip IV suggest that he shared that view.

Other portraits

The portrait of the Count of Olivares painted by Velázquez in 1624 at the same time and for the same person as the standing portrait of Philip IV has also survived. They differ from one another in the sitter's pose, and even more so in the painter's depiction of mien and costume (cat. nos. 28 and 30). Even though both sitters are clad in black, Olivares' dress, contrary to the King's, is sharply highlighted. His corpulent figure is made rather ponderous by the vivid display of the red cross of Calatrava, the heavy gold chain, drawn firmly across the chest – instead of falling in the light curve of the King's – and the other symbols of his high offices, the key of the Lord of the Bedchamber and the spurs of the Master of the Royal Horse, dangling from his belt. His forceful gesture emphasizes the mundane nature of his power, as his left hand rests on the sword hilt under the weight of the cloak draped on the shoulder, and the right one upon the table top – the fingers curved over the edge. Though the head has been somewhat damaged, the portrait is still impressive. The light that falls on the face, leaving the left side in shadow, brings forth Olivares' reality of appearance without relieving it of the accidental.

The indicated differences between these two companion portraits are so obvious that they had led some scholars to cast doubts on the authenticity of one or the other, or even of both pictures. Such doubts arise from the idle assumption that Velázquez' sense of composition and handling of pigment was unvaried within any one given time, and that such dissimilarities in execution as are noticeable between any two paintings bearing his name are evidence either that they were painted at different periods, or that at least one of them is not by his hand. Assumptions of this kind, often made in relation to great masters, overlook the complexity of a creative artist's work and lead to conclusions

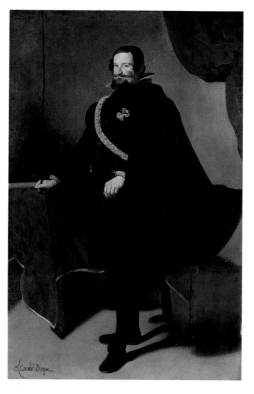

Count-Duke of Olivares
1622–1627
Cat. no. 32

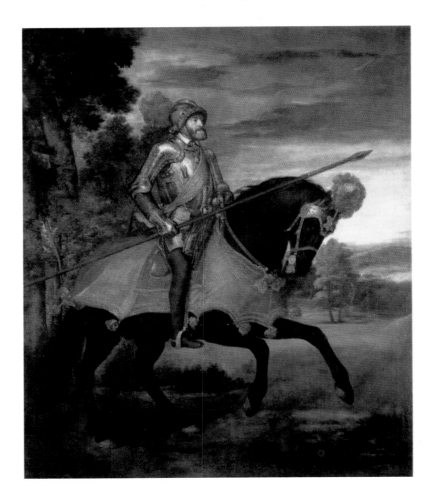

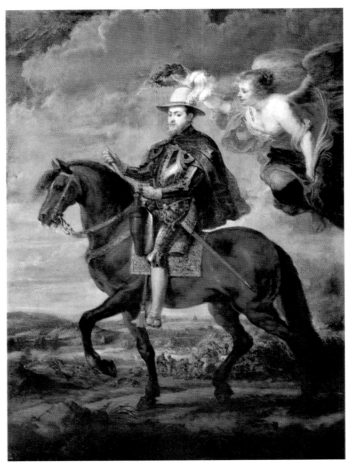

Titian
Charles V at Mühlberg
1548
Madrid, Museo del Prado

Peter Paul Rubens
Philip II on Horseback
1628
Madrid, Museo del Prado

which are not more convincing for the simplicity of argument to which they lend themselves. In the case of Velázquez, available data make such simplifications untenable.

Dissimilarities in execution appear quite early in Velázquez' art. These are apparent not only in companion pieces, such as *The Immaculate Conception of the Virgin* and *St. John at Patmos*, but also within one single picture, as in *The Adoration of the Magi* (cat. nos. **11, 12** and **13**). Rather than being disconcerting, such dissimilarities reveal the consistency of Velázquez' work. He made use of dissimilarities in the treatment of light and shade, or in the quality of the brushwork, for various expressive purposes, often to emphasize the artistic reality of the images that he put on canvas. He consistently used them to express the polarity of the human and the divine or the contrast that he saw between the King as the embodiment of a divine right and the King's minister as the personification of worldly power. As in the portrait of Olivares, Velázquez used contrast of light and shade to emphasize the peculiarities of appearance of the unidentified *Young Man*, datable to approximately the same time (cat. no. **27**).

Around 1628, when Velázquez re-painted his early full-length portrait of King Philip IV (cat. no. **36**), he also portrayed the Infante Don Carlos, who was two years younger than his brother, the King. The portrait of the Infante, though, is quite different from that of the monarch. The light on his face is intermingled with shadows which deepened a sense of his character. Highlights made the wrinkles and textural qualities of his black costume and gold bandolier more vivid as with a worldly gesture he nonchalantly holds a glove in his right hand and his hat in his left (cat. no. **37**).

The differences I have been illustrating between Velázquez' depiction of the person of the King and that of other sitters, including the Infante Don Carlos,

runs through the whole of his art, and a cursory glance is in danger of ignoring them, or might explain them away as casual or without significance.

The crucial years

By his appointment in 1623 as salaried titular painter to the King, the twenty-four-year-old Velázquez joined the exclusive company of three painters who were at least double his age and who had achieved recognition in the preceding reign: Bartolomé González (1564–1627), Vincencio Carducho (1570–1638), and Eugenio Caxés.

Bartolomé González had mainly been engaged in painting portraits of the royal family. Although he was older in years than either Carducho or Caxés, he was more attuned to the times, for he had grown up in the Titianesque tradition of his master, Juan Pantoja de la Cruz (1553–1608), and had later been attracted to Caravaggism (p. 35). Carducho and Caxés had been trained in the taste and routine of mannerism, which had ceased to be a creative force well before they became fully fledged artists. Like other painters of their background, in Spain and elsewhere in Europe, they groped or forged ahead into the new taste by casting naturalist images, usually as secondary counterthrusts, within the linear framework of their compositions.

Velázquez' success at the Court had been based on his mastery as a portrait painter. Even so his *bodegones* were also admired in Madrid. According to Pacheco, Velázquez' "forceful example" had led other painters to paint *bodegones*. Pacheco himself had felt compelled to paint a *bodegón* piece when he was in Madrid in 1625.

Velázquez thought very highly of his painting of *The Waterseller*. Don Juan de Fonseca, who owned it, died in Madrid early in 1627, leaving a sizeable number of paintings which Velázquez appraised at the request of the heirs on 28 January. The portrait that Velázquez had painted of his early protector was not among them. Included, though, was *The Waterseller*, which Fonseca had acquired directly from his protégé, perhaps as a gift.

Velázquez appraised *The Waterseller* at four hundred *reales*, higher than any other painting in the collection. It was bought by Don Gaspar de Bracamonte, another of the courtiers instrumental in securing Velázquez' early success, for three hundred and thirty *reales;* an amount that was equalled only by two anonymous portraits, one of the King and the other of the Cardinal Infante Don Fernando, and was surpassed by no other painting in the sale.[67]

As Pacheco saw it, Velázquez had achieved a "true imitation" of nature in both his *bodegones* and his portraits. Vincencio Carducho, however, looked down on *bodegones* and naturalist portraits as not quite proper subjects for Painting. He very likely had Velázquez' works in mind when he chastised men of letters, art lovers and wealthy individuals who praised, and paid high prices for, paintings which faithfully imitated everything, cloth, linen, "the pitcher, the knife, the bench, the loaf of bread, the fruit", animals and even rational man – all these done without the benefit of intellectual labour, reflective drawing or study.[68]

Carducho's ideas on art did not appear in print until 1634. However, they must have been widely known in Madrid in the mid-1620s, when Velázquez came to the fore as a Court painter. Carducho, as a writer on art, hovered inconclusively between the mannerist doctrine learned in his youth, and the baroque concepts which he seems to have acquired from some of his literary friends. His book embodied the crosscurrents of faded convictions, persistent

routines, vested interests and carping recognition which faced Velázquez and which, from all we know, he just ignored.

One of the main aims of Carducho's *Diálogos de la Pintura* was to prove that Painting was a liberal art, and that, consequently, painters ought to be exempted from taxation. El Greco and other artists had argued for this early in the century and Carducho, Angelo Nardi, Eugenio Caxés and other painters had requested the proper authorities to acknowledge this as a matter of law in 1625. Apparently, Velázquez was not among the petitioners.[69] In 1629, Carducho's *Memorial Informatorio por los Pintores* was published. This contained seven briefs written in support of the painters' claim by authors of varying literary persuasions, including Lope de Vega (1562–1635), one of the outstanding literary figures of the time. In the *Diálogos*, Carducho reprinted those briefs as an appendix, along with the decision rendered by the Royal Council of Finance on 11 January 1633 that granted the exception requested by Carducho and his fellow petitioners. Facing the text of the decision there was an endpiece that exalted theory as requisite to the act of painting – an act regarded by some as purely manual and, hence, as a valid objection to the inclusion of Painting among the liberal arts.

Diálogos de la Pintura has the appearance of a collective undertaking, even though the main body of the book, eight *dialogues,* is undoubtedly the work of Carducho. A poem by one of his friends is printed at the end of each dialogue, except the first, and there is after every one of them an engraving with an allegory of Painting. Both the poems and the engraved allegories bear on matters which the corresponding dialogue also touches upon.[70]

Carducho makes no claim to the design or invention of any of the engravings in the book. It is likely that some of the men of letters who contributed poems or essays to the *Diálogos,* as well as other learned men from his wide intellectual circle, made suggestions for the allegorical engravings. Therefore, it is hard to guess what Carducho's contribution actually was to the ideas, some of them novel, embodied in the engravings. It should be borne in mind that Carducho, like most mediocre people, was truer to his prejudices than to the ideas that he appropriated from others. For instance, he favoured the traditions of formal portraiture in which conventional attributes emphasized the pre-eminence, deeds or achievements of the royal or otherwise illustrious sitter, and scorned portraits of ordinary men or women dressed or otherwise represented as if they belonged to a higher class, which in his view only the sitter's vanity and the painter's lack of self-esteem could explain. Thus, he portrayed himself as both painter and writer, pen in hand, the *Diálogos* open before him, an inkwell, a palette, brushes and other painter's instruments on his right, and a background curtain for decorum (p. 46).

Carducho found particularly aggravating the naturalist portrayal of lowly people which he lumped together with paintings of *bodegones* and similar subjects such as topplers, ruffians, *pícaros* or hussies.[71]

It is likely that Pacheco, during his stay in Madrid in 1624–1626, discussed such matters with his "intimate" Vincencio Carducho, who was his junior by six years.[72] Both artists had equal admiration for Michelangelo and Raphael, and yet Pacheco's understanding of the new artistic trends – which had led him to paint a *bodegón* – must have been disconcerting to Carducho.

Seven or eight years later, the *Diálogos de la Pintura* would betray Carducho's realization that his most cherished ideas about art had been overtaken to become past history, even if it was a history to which hardly any one would take exception. To him, Michelangelo remained unsurpassed as a painter, particularly with regard to drawing, and Titian, though not as great an

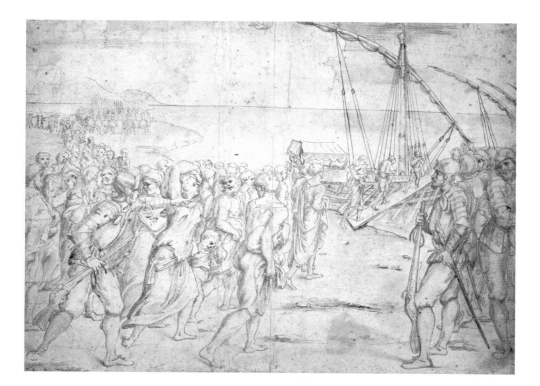

Vincencio Carducho
The Expulsion of the Moors
Drawing
Madrid, Museo del Prado
As seen at the 1627 competition won by
Velázquez

artist, still deserved to be called the master of colour (*dueño de los colores*). These
views, rather close to those of Pacheco, were not likely to meet with sharp dis-
agreement, not even among those who shared El Greco's opinion of
Michelangelo qua painter. On the other hand, Carducho's fear that the art of
painting might be rapidly declining was obviously not widespread.

Indeed, there was a general feeling of gratification at the fact that "some
modern" painters, to use Carducho's own words, "excelled" in the live depic-
tion of landscapes, fruits, animals and like subjects which the old masters
regarded as of "little consequence".[73] Furthermore, the naturalist portrait that
heightened the actual appearance of the sitter without making it conform to an
idea of beauty or decorum was acclaimed as a telling expression of the superior-
ity of art over nature.

I have discussed at some length Carducho's ideas because he was a promi-
nent figure in the Madrid art world of the mid-1620s, when he and other
painters of his persuasion regarded Velázquez as an upstart who ought to be
checked. Indeed, in 1625, the success Velázquez had acheived as a result of his
equestrian portrait of Philip IV, now lost, aroused great envy among the
painters at Madrid, as Pacheco had noted, adding that he had been a witness to
the fact.

This animus, which turned the mid-1620s into Velázquez' crucial years,
came to a head in 1627 when, at Philip IV's command three of his four salaried
painters, Carducho, Caxés, and Velázquez, plus Angelo Nardi – probably filling
in for the fourth, Bartolomé González, apparently ill – each painted "a large
canvas with the portrait of Philip III and the unexpected expulsion of the
Moriscos decreed by him in 1609".

Angelo Nardi (1584–mid-1660s) was born in Florence, but spent seven for-
mative years in Venice, from 1600 till 1607, before going to Madrid where he
established his workshop and became one more salaried "painter to the King".[74]
He was the sort of uncreative fellow who, being as receptive to his elders' ideas
as to those of the younger generation, is regarded as a promising man by nearly
everyone even though his work steadily blurs out of interest. The compositions

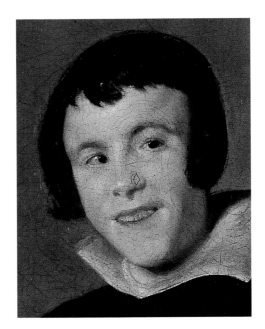

The Buffoon Calabazas (Calabacillas) (detail)
c. 1628–1629
Cat. no. 39

which he had executed in Madrid up to the mid-1620s show his dependence on the work of Titian and other Venetian masters.

Philip IV appointed Juan Bautista Maino and the Roman architect Giovanni Battista Crescenzi as a two-man jury and they both found Velázquez' picture superior to the others. The King agreed with their verdict and as a reward he appointed Velázquez Usher of the Chamber. It was the same position that six years earlier, shortly before Velázquez' first stay in Madrid, Philip IV had awarded to Rodrigo de Villandrando, distinguishing him above all the other Court painters. For Velázquez, it was the first in a long series of royal distinctions that he was to receive throughout his life.[f] Philip was six years younger than Velázquez. In that year of 1627, both were in their twenties.

On 7 March 1627 Velázquez was sworn in. His new office, regarded by Pacheco as a great honour, entailed the use of a rent-free apartment and the services of a physician and chemist. It was, moreover, in the wake of that success that the Master was able to reach a settlement with the treasury of the royal household which had fallen behind in making the payments due to him. As it was finally worked out, in documents dated 18 and 27 September 1628 and 8 February 1629, he was to receive a daily allowance of twelve *reales* in return for foregoing his claims and as payment for the "original portraits" which the King might command him to paint.[75]

According to Pacheco, Philip IV, who had several times promised to grant Velázquez' wish to visit Italy, was impelled by the painter's success in the 1627 competition to make good his promise. Velázquez, however, did not set out for Italy till July 1629, perhaps because he wanted first to have spelt out his settlement with the treasury, which took close to two years, perhaps too because he did not want to miss the impending visit of the famous Peter Paul Rubens to the Spanish Court.

Before the end of 1627 Velázquez clashed again with Carducho and Caxés. This time the issue was the position of salaried titular painter to the King left vacant by the death of Bartolomé González. There were twelve applicants for the position, and Carducho, Caxés and Velázquez were commanded to examine their qualifications and to submit a list of candidates in order of merit. Van der Hamen, a friend of Carducho, was among the eight applicants unanimously excluded because, in spite of his efforts at figure-composition, he was primarily considered a still-life painter and, as such, not really qualified for the position. Unanimously excluded too was Pedro de las Cuevas, whose major, and true, claim was his long experience as a teacher of drawing and painting.

Though Velázquez, Caxés and Carducho placed Antonio de Lanchares first, the wording of Caxés and Carducho's joint recommendation suggests that they rather favoured Félix Castelo (1602–1656), a former pupil of Carducho, whom they placed second, listing Angelo Nardi as their third choice and Pedro Núñez del Valle (born in the 1590s), then held to be a painter of promise, as the fourth choice. Velázquez wrote somewhat acidly that he had no knowledge of Félix Castelo's competence, while he knew about Nardi's, whom he therefore listed as his second choice, giving the third place to Castelo, and the fourth place to Núñez del Valle.

Lanchares was certainly a better painter than either Nardi or Castelo (p. 218). Nevertheless, none of the three was worthy of an affirmative choice, and Philip IV, whose sense of values was high when it came to art, decided not to fill the position for reasons of economy, adding that the same should be done whenever other positions of salaried painters became vacant since the stipends paid were of no use owing to the fact that the painters were still paid for every work they were commanded to do. There the matter rested till Lanchares' death

in 1630. Less than a year later, early in 1631, Philip IV appointed Velázquez' protégé, Nardi, though rather parsimoniously, to the vacant position which he still coveted. As for Carducho and Caxés, they kept losing ground with the King, who consistently denied their petitions, despite the open support lent to them by the corresponding royal office. Indeed, even though Caxés petitioned time and again for an appointment as Usher of the Chamber, pointing out that Philip IV had so honoured both Villandrando and Velázquez, his wish remained unfulfilled.[76]

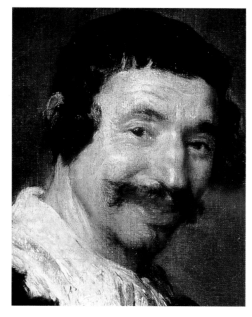

Democritus (detail)
1626–1628
Cat. no. 40

BELOW:
Supposed study for the angel in *Christ and the Christian Soul*
Charcoal drawing on paper, destroyed in 1936
Gijón, Instituto Jovellanos

BELOW LEFT:
Christ and the Christian Soul
1626–1628
Cat. no. 35

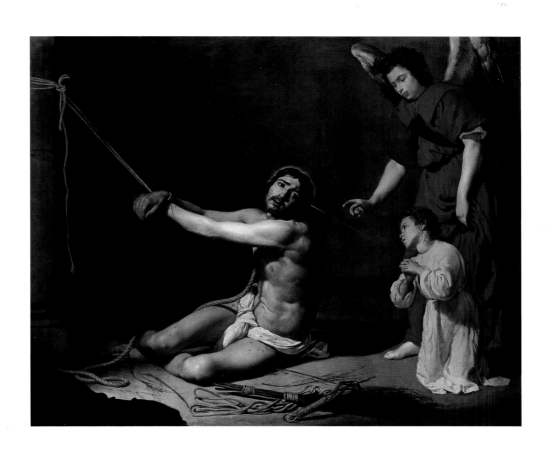

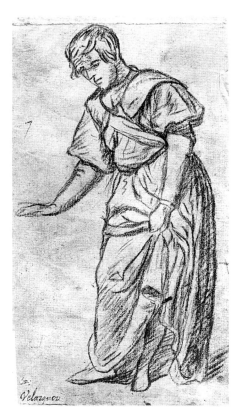

Peter Paul Rubens
The Origin of the Milky Way
1628
Madrid, Museo del Prado

Peter Paul Rubens
Adam and Eve
Madrid, Museo del Prado

Rubens at the Spanish Court

Rubens arrived in Madrid in August 1628. Even though he made this second trip to Spain in the political service of his sovereign, Philip IV, it was his personality as a painter which was to the fore at the Court. He brought with him eight of his own paintings for the King who had them hung in the "new chamber" over the entrance hall of the Royal Palace among other outstanding pictures – one of which was Titian's allegory of Philip I after the victory of Lepanto (Prado, no. 431). Then, since the political matters relative to the contemplated peace between the Catholic Spanish King and the Protestant monarch of England, who as Prince of Wales had been in Madrid a few years earlier, did not take much of his time, he gave himself to his art. He had been given a studio at the Royal Palace, where Philip IV often visited him, and it is safe to assume that Velázquez would not have missed the opportunity of seeing the famous master at work. Among the many paintings that Rubens executed either for the King or for private individuals, there were a considerable number of copies after Titian and quite a few portraits. Velázquez, with his admiration for Titian and his own mastery of portrait painting, must have been particularly interested in those facets of Rubens' art. This interest may even have been increased by the fact that Rubens painted no fewer than five portraits of Philip IV (p. 101), as well as several of the Queen and other members of the Royal family.

In spite of the promise, if it was a promise, made by Olivares to Velázquez that he would be the only painter to portray Philip IV, the young master could not be jealous of the great Rubens. On the contrary, after his daily contacts with his shallow colleagues at the Court he must have found refreshing the challenge offered by the older master's works, success, and words.

We know from Pacheco,[77] who probably learnt it from his son-in-law himself, that during the nine months that Rubens stayed in Madrid he had hardly any contact with other artists, except Velázquez. They had corresponded before, possibly in 1626 when the Fleming was instrumental in Paul Pontius' commis-

sion to engrave an allegorical portrait of Olivares after a likeness of the head by Velázquez. It was the young Court painter who accompanied Rubens to the Escorial. Pacheco also relates how the great Flemish master spoke favourably of his younger colleague's works.

In closing his encomium of Rubens, Pacheco praises "the greatness, beauty and richness of his intellect", which shines in his paintings as the mainstay of his success with Kings and Princes, though, Pacheco explains, it is only the painter's own hand which truly helps him and which earns all the honours that he receives. These words probably reflect, or are a commentary, on Velázquez' own feelings about a painter's creative and social success which he saw embodied in Rubens. The paragraph with which Pacheco closed his eulogy of Rubens significantly precedes his enthusiastic narrative of Velázquez' life. Yet, it is also significant that Velázquez' aims and achievements as a painter were then, and remained, clearly different from Rubens.

Concerning the portraits of Philip IV painted by Rubens in Madrid, Pacheco singles out for praise one showing the sovereign on horseback "with other figures, very striking". It depicted the twenty-two-year-old monarch on a chestnut horse, holding the baton in his hand. In the upper part, Faith was seen offering a laurel wreath to him and holding a cross on a globe supported by two angels, while Divine Justice was hurling a thunderbolt at her enemies. On the ground an Indian, representing Philip IV's kingdoms in the New World, carried the royal helmet.

This allegorical portrait was greatly admired at the Court then and in later years. As for Velázquez, he went on representing Philip IV as the quintessence of kingly power, dispensing with what was doubtless to him the redundancy of allegory – and in so doing he also won acclaim.

Velázquez' admiration for Rubens' creative power and resplendent success had a short-lived impact on his work, noticeable in *Bacchus* and *Democritus*, both painted in 1628–1629 (cat. nos. **41** and **40**). These two paintings appear to be consistent with *Head of a Stag*, a fragment of a painting, restored in some areas, possibly executed somewhat earlier. In it Velázquez used rough impasto to achieve a sweeping contour line that makes the animal's head stand out as a dynamic shape against a grey blue sky. It is nonetheless likely that, as Velázquez came to realize the unfettered aim of Rubens' copies after Titian, his own response to the Venetian master's handling of pigment, light and space grew warmer and freer, as can be surmised from the pictorial handling of the fabric wrapping Bacchus' loins.

True-to-life and conceptual traits

On 22 July 1629 Philip IV ordered that Velázquez – whom he had just formally granted leave to go to Italy – be paid one hundred ducats for "a picture of Bacchus that he has done on my service" (cat. no. **41**). Obviously the painting had been delivered by the artist after 9 February of that year when he agreed to the financial settlement covering all the works he had painted for the King up to that date. It is likely, however, that he had started work on so large a composition much earlier, probably some time in 1628.

Since about 1828 the prevailing view has been that this work, known as "the painting of Bacchus" in Velázquez' day, depicts an actual event which calls for a title such as "The Drinkers" or the like. That of *The Triumph of Bacchus in Burlesque*, recorded by Palomino in 1724, reflected a real understanding of the painting and was certainly more apt. In more recent times the discussion of the

Peter Paul Rubens
Self-Portrait
Engraving on black stone with white highlights
c. 1638–1640
Paris, Musée du Louvre, Cabinet des dessins

Caravaggio
Bacchus (detail)
1593–1595
Florence, Galleria degli Uffizi

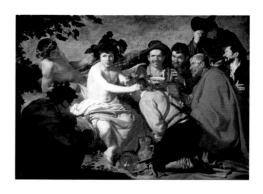

Bacchus
1628–1629
Cat. no. 41

ABOVE RIGHT:
Detail of no. 41

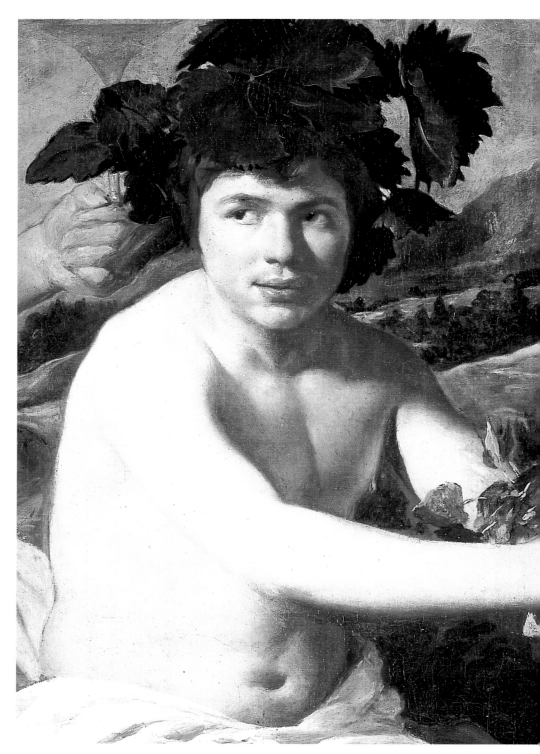

picture has been rather unrewarding probably on account of the idle points on which it has centred. The point has, for instance, been made that, though the composition with its nine life-size figures is an open-air scene, it was painted in the artist's studio rather than on the slopes of the Guadarrama Mountains, at some distance from Madrid. The question has also been raised as to whether it represents a Flemish fête, which Rubens would have described to Velázquez, or some popular scene that he had come across. Moreover, the variety in the handling of various figures has been taken as evidence that Velázquez painted each one separately, the corollary being that he failed to bring about a sense of impressionist unity – a kind of unity which was anyway alien to Velázquez' art, much as the Impressionist painters were to admire him. The suggestion has also

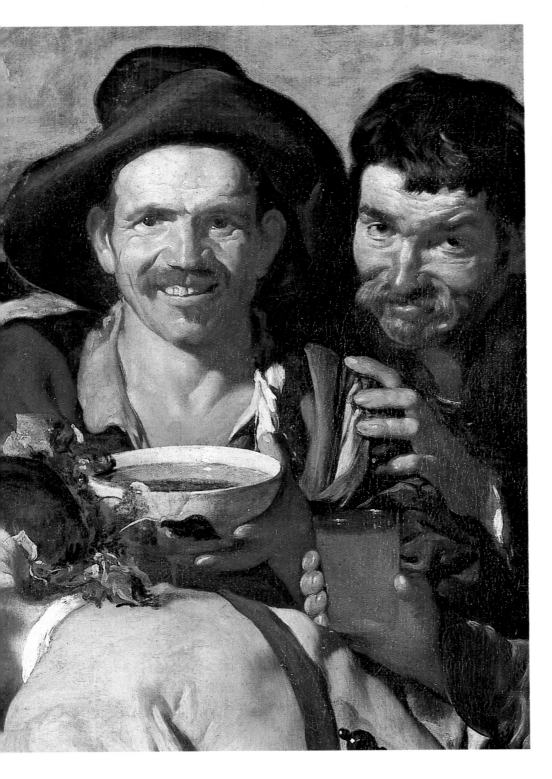

José de Ribera
Archimedes (detail)
1630
Madrid, Museo del Prado

been made that such differences in handling argue in favour of the assumption that Velázquez partly repainted the composition after his return from Italy in 1631.

Before proceeding further it must be said that the picture was damaged in the fire that gutted the Royal Palace in 1734. As a result, the composition darkened considerably and unevenly. Furthermore, the canvas was cut down at the sides. The vine-crowned man sitting in the left foreground has been blurred into a brown shape that hardly fulfils its intended repoussoir function. It fails to add to the dynamic intercrossing of diagonals, now mainly supported by the man being crowned and the nude youth holding a glass. This intercrossing of diagonals underscores the heads of Bacchus and of the hatted drinker as two

Detail of no. 41

off-centre focal points. It also builds a unifying rhythm that runs from the roomy area where the god officiates, across the huddle of drunkards, up to the standing beggar – identified as such by his open palm – at the back of the group.

As the reveller clad in a yellow jacket and dark breeches kneels in a communion-like pose by a brown earthen jug and a greenish glass, his face sinks away in shadows under the vine wreath which Bacchus is crowning him with. Blotches of shadow make both the flabby god and his soft-muscled nude attendant more clodlike. Similar shadows and rather rougher impasto emphasize the grimacing features of the four revellers bunched together on the other side, in contrast to the face of the standing beggar which Velázquez has portrayed half in shadow. The composition is made the more dynamic by the lusty counterpoise of the vine-crowned Bacchus to the drunk in the shapeless hat, and by the white bowl of red wine which, by its vivid textures and reflections, marks another centre, and an intense one, in the *bodegón*-like composition.

The picture is, of course, a baroque, double-edged parody of the world of the fable and of sinful human ways, and the humour is made heartier, healthier, and more fruitful, as the clowning drunkards vie in their bearing with the loutish nudes of Bacchus and his attendant. The underlying religious sentiment is keyed to the figure of the beggar who, lightly sketched, looms in the background over the drunkards who ignore him.

The virtue of Charity, then readily identified with alms-giving, almost invariably led the Catholic mind to the contemplation of the Cross where Jesus shed His blood for the redemption of Mankind. In Velázquez' burlesque of

Bacchus and his soulless fellows, the beggar is made to underplay his part in a pithy baroque manner, while the false god emphasizes this, as does his counter-figure, the drunkard, who holds up a bowl, his dull senses still responsive to the wine's pungency, his mind obviously blank to its symbolic meaning.

There is no need to suppose that Velázquez made sketchier or less distinct the figure of the beggar, or any other, after he returned from Italy. In around 1629, when he was paid for this painting, a perceptive mind's eye discerned "distant blobs of colour" as particularly significant in Velázquez' art, a view which could hardly have been limited to this painting.

Two of Velázquez' religious compositions are roughly datable to the late 1620s, before his departure for Italy. Both show similarities in point of execution with the painting of *Bacchus,* from which at the same time they differ owing to the explicit religious intent.

In *The Supper at Emmaus,* representing the moment when Christ breaks the bread and His divine nature is revealed to His astonished companions, Velázquez once more rendered the difference between the divine and the human. Luminous tints and smooth brushwork model the figure of Jesus, whose humanity, which connotes His humility, is expressed by weightless shadows on the faint rose tones of His face. A rosy glare that lights up His pink tunic sets Him apart as an unearthly presence from the reality of His gesturing companions, whose coppery-brown flesh tones harmonize with the yellows, dusky browns and darkish blue of their surroundings and heavily-textured costumes. The natural characteristics of age and expression are depicted on the disciples' faces, modelled by energetic strokes and shadows but without the heavy impasto which weighs down the faces of the drunkards – one of whom resembles the disciple in the background (cat. nos. 41 and 42).

Christ and the Christian Soul also appears to have been painted by Velázquez before he left for Italy, probably some time between 1626 and 1628. The torso of Jesus, with His arms stretched toward the column, and that of Bacchus, with his hands extended to the kneeling reveller, are rather alike in execution and shape. Both, markedly curved at the back, are modelled by a similar interplay of light and shade (cat. nos. 35 and 41). However, contrary to *Bacchus,* Christ looks monumental in relation to the other figures in the composition, the Christian Soul and the guardian angel. Velázquez has achieved a subtle depiction of the humanity of Christ as the measure of both His humility and the immensity of His sacrifice. The readiness with which the Redeemer submits to torture and humiliation is not lessened either by the rope which ties His hands together or by the blood, a vivid red, which drips from His body and limbs onto the ground. The harmonious rhythm that pervades Jesus' serene face, shackled arms and sprawling legs has as a foil the nervous modelling of the plaintive Christian Soul.

It is worth underlining that around 1628 Velázquez painted out the true-to-life likeness of Philip IV with which he had won his signal success of 1623, and substituted for it, on the same canvas, a new image of the King, making his roundish chin somewhat pointed, elongating his short neck, and depicting his face and hands as luminous shapes. This image of Philip IV was to remain Velázquez' own. Indeed, no other painter seems to have grasped it, and certainly none imitated it. As already noted, in the portrait of the Infante Don Carlos, also of 1628, Velázquez accentuated the interplay of light and shade on the face (cat. no. 37).

Francisco de Quevedo (1580–1645) was a most uncompromising and worldly intellectual. In Italy and Spain he had acquired an extraordinarily broad knowledge and a penchant for contemplation and had, apparently, in 1629,

Villa Medici in Rome (Pavilion of Ariadne)
1630
Cat. no. 46

written two or more drafts for a poem, *The Brush*, which he then left unfinished. In one of the drafts he praised Velázquez' skill and intellectual gift to enliven the beautiful and to imbue human flesh with meaning by "distant blobs of colour" which "are truth", not likeness, in his depiction of sentiments: "... el gran Velázquez ha podido, diestro cuanto ingenioso, ansí animar lo hermoso, ansi dar a lo mórbido sentido con las manchas distantes que son verdad en él, no semejantes, si los afectos pinta."[78]

For all we know, Quevedo was the first to see, or at least to write, that Velázquez' naturalism did not merely aim at the by then familiar true-to-life likeness, and that, indeed, he could endow his vivid depiction of the human figure with conceptual traits.

The painter's Italian journey

In August 1629 Velázquez left for Italy preceded by letters of recommendation to the Spanish ambassadors in the states he was to visit.[79] The King had advanced, on account, three hundred ducats to him for paintings not yet completed, and ordered that he should continue to receive all his emoluments for the duration of his absence, the length of which was not even indicated. The Count-Duke of Olivares secured a royal order by which Don Juan de Velilla, Secretary of State, requested the ambassadors from the Italian states in Madrid to provide Velázquez with passports and letters of recommendation. The request was complied with, not without some apprehension that the true aim of the painter's visit to Italy might be espionage. The suspicion probably arose from the knowledge that Velázquez' position at the Court was far superior to that which his office of Usher of the Chamber might suggest. The young painter was not only a favourite of the King, who often watched him painting, but of the King's chief minister as well. He was, moreover, sailing with the famous General Spínola, who had been appointed governor of the State of Milan and was to take command of the Spanish armies in Italy. If the petty ambassadors suspected, as they might have been expected to do, that politics rather than art was the true aim of Velázquez' trip to their lands, they were at least aware that it was as a portrait-painter that he was well known, and this they recorded in their cautious dispatches.

Landing at Genoa on 19 September, Velázquez proceeded a few days later to Milan, probably still in the company of Spínola. He then set out for Venice, presumably making a halt at Verona, to whose *Capitano,* or governor, he had a letter of introduction.

In Venice he stayed at the home of the Spanish ambassador, Don Cristobal de Benavente y Benavides. Since there was unrest, and Spaniards were unpopular in the city, the ambassador ordered that some of his men should accompany his guest whenever he left the house. "Leaving that unquietness", as Pacheco put it, Velázquez started with his servant on his way to Rome. The first stop was Ferrara, where he spent two days, and was extended many courtesies by the papal legate, Cardinal Giulio Sachetti, who had been nuncio in Spain. The Cardinal insisted that Velázquez should stay at the palace and have his meals with him, which the painter courteously declined with the excuse that he did not keep regular meal hours. Sachetti then assigned one of the Spanish gentlemen on his service to look after Velázquez, and to show him the sights of major interest in the city.

The last evening of his stay Velázquez went to take leave of his host, who then kept him waiting for more than three hours, while he talked about various

matters, and then ordered the gentleman who had been attending Velázquez to accompany him the following day "to a place called Cento" sixteen miles away. Velázquez' visit to Cento only lasted a short time. Although he was "very well entertained", he dismissed his guide, and decided to proceed immediately to Rome, through Bologna. Here he did not stop, not even to present the letters he had for the Archbishop, Cardinal Ludovico Ludovisi, or for the papal legate, Cardinal Bernardino Spada, though he understood that they were in the city.

It might be that, as some scholars have suggested, Velázquez visited Guercino at Cento. It is, indeed, conceivable that Cardinal Giulio Sachetti, a patron of Guercino, would have prevailed upon Velázquez to go to Cento for that purpose. If so, some significance ought to be attached to the fact that Pacheco, who undoubtedly follows Velázquez' own account of the journey, does not refer to Guercino either in this passage or anywhere else in his *Arte de la Pintura*. Guercino was then carrying on "an extremely successful mail-order business in large altar-pieces", as has been aptly recorded.[80] Maybe Velázquez, whose aims and achievements as a painter differed essentially from Guercino's, might have found that the latter overbuilt his compositions and that his brush-stroke was jejune. This might have had some bearing on his decision not to visit Cardinals Spada and Ludovisi, since the latter, like Sachetti, was an admirer of Guercino.

It is most likely that he stopped in Florence as he had intended to do when he secured letters of introduction from Averardo Medici, the Florentine ambassador in Madrid. He was a protocol-minded individual whose main concern, according to a dispatch that he wrote on 22 September 1629, was that Velázquez, the "favourite painter" of both Philip IV and Olivares, should not be treated with either too much or too little courtesy. It is probably to this stay in Florence that Don Gaspar de Fuensalida referred in 1658.[81]

In Rome, where he was to stay for about a year, Velázquez was lodged in the Vatican Palace. He was given the keys to several rooms, the main one of which was decorated in fresco by Federico Zuccaro. There is no indication though that the Pontiff, Urban VIII, or anyone at the Papal court, showed any particular interest in his work. Finding his lodging too lonely and isolated he left it, first assuring himself, however, that the Vatican guards would let him return whenever he wished to draw after Michelangelo's *Last Judgment* or from Raphael's works. And he spent a good many days so occupied.

Pacheco's statement that his son-in-law left his lodging at the Vatican Palace because it was out-of-the-way and he did not wish to be so lonely, reveals that Velázquez enjoyed city life. It is well documented that throughout his life he won the friendship of a good many men who, by reason of their background, profession and social station, must have been rather discriminating in their choice of friends.

Much as he cared for city life, he feared the heat of the Roman summer. Hence late in April 1630, he set eyes on the Villa de' Medici, thinking that it would be a convenient place to spend the summer. The villa had a high, breezy, location. Many antique statues, which he studied, adorned its walls and gardens. The Spanish ambassador, the Count of Monterrey – Olivares' brother-in-law – took care of the matter, and within a few days, on 4 May, the reply came that a room had been made available for Velázquez at the villa. For more than two months he stayed there, most likely glad of the opportunity to study antique sculpture, which he had learned to admire in his Sevillian days, by copying from the fine pieces he had at hand, among them reliefs from the Ara Pacis, and the Niobe and Niobide now at the Uffizi. Unfortunately all these drawings are lost.

It was an illness, a tertian fever, that forced the painter to move back down into the city. He lodged near the residence of the Count of Monterrey who provided him with the services of his own physician, as well as with medicines, and also sent him sweets and specially cooked meals. The Count, moreover, frequently sent someone from his own household to call on the sick painter.

From Pacheco's narrative, it appears that, while in Rome, Velázquez spent most of his time making "studies", one of them being "a famous self-portrait". It is also known that the Countess of Monterrey, on the advice of her brother, the Count-Duke of Olivares, had her portrait painted by Velázquez. Neither of these portraits has been convincingly identified among the Master's extant works.

On his way back to Spain he decided to stop at Naples where his older fellow-countryman, José de Ribera (1591–1652), was the outstanding painter. The sister of the Spanish monarch, the Infanta María, had stopped at the vice-regal court in April, and stayed there till 18 December, when she resumed her journey to Hungary. Here she was to join her husband, Ferdinand III, whom she had married by proxy in Madrid. Velázquez made a portrait of her to be taken back to Philip IV (cat. no. 48).

The painter must have left Naples around the same time as the Infanta – about 18 December – for he was in Madrid in January 1631. The Count-Duke of Olivares received him cordially. He ordered him to go at once to kiss the hand

Villa Medici in Rome (Façade of the Grotto-Logia)
1630
Cat. no. 47

Christ on the Cross
c. 1632
Cat. no. 59

ABOVE RIGHT:
Detail of no. 59

of His Majesty and thank him, for Philip had not let himself be portrayed by another painter during Velázquez' absence and had waited for him to paint the first portrait of Prince Baltasar Carlos, who had been born shortly after the painter's departure for Italy.

ABOVE LEFT:
Infanta Doña María, Queen of Hungary (detail)
1630?
Cat. no. 48

ABOVE RIGHT:
Frans Luyck
Doña María of Austria, Queen of Hungary
Madrid, Museo del Prado

Titian's greatness and Velázquez' freedom

Of the works painted by Velázquez in Italy, Pacheco mentions only "a famous self-portrait", now lost, and the "fine portrait" of the Infanta María (cat. no. 48). Palomino, writing early in the eighteenth century, adds that the Master painted in Rome in 1630 both *The Forge of Vulcan* and *Joseph's Bloody Coat Brought to Jacob* (cat. nos. 44 and 43). Palomino states further that Velázquez, in the days that he spent in Venice, made many drawings, especially from Tintoretto's large *Crucifixion,* at the Scuola di San Rocco, and that he painted a copy of another work by the same master, "where Christ is depicted giving the communion to His disciples", possibly the one at the Scuola di San Rocco, too.

Velázquez had most likely been acquainted with Tintoretto's *Crucifixion* since his apprentice days, for Pacheco owned what he described as part of a pre- liminary cartoon for it, and was familiar with the whole composition from an engraving, probably the one made by Agostino Carracci in 1589. Pacheco admired the dexterity and daring of Tintoretto, whom, however he could not recommend as an example to follow.

A painting of *The Last Supper* (listed as by Velázquez in the inventory of the Madrid Royal Palace drawn up in 1666 by Mazo, the Master's son-in-law) may have been the copy after Tintoretto's painting which, according to Palomino, Velázquez presented to Philip IV, and which has not come down to us.

From what Pacheco reported, obviously on the basis of Velázquez' own account – and from what Palomino added, seemingly borrowing information collected in the 1650s by Alfaro, one of the Master's pupils – Velázquez spent a good deal of his time in Italy drawing or painting after old masters' works, particularly Tintoretto's, Raphael's and Michelangelo's, while also trying his hand at some "studies" in oils. Pacheco mentioned only the subject of one of these studies, that "famous self-portrait", painted "in the manner of the great Titian", which, as he put it, he kept for the admiration of true connoisseurs and to the honour of art.

As Pacheco came to see it – most likely through Velázquez' eyes – Titian's greatness lay in his masterly use of sketchy strokes to achieve relief and depth by dint of light and shade. Velázquez used sketchy strokes in *The Forge of Vulcan* and in *Joseph's Bloody Coat Brought to Jacob,* and more markedly in the two small studies of *Villa Medici*, probably painted during his summer stay there (cat. nos. 46 and 47). In execution there is a similarity between these studies, which are fluidly painted with an impasto used for luminous accents of form, and the landscapes in the two large compositions, particularly the one in *The Forge of Vulcan.*

In both *The Forge of Vulcan* and *Joseph's Bloody Coat Brought to Jacob*, there is a live contrast between well-drawn figures and those shaped as blobs. Such contrast also exists in *Bacchus,* painted earlier in Madrid (cat. no. 41). There are, however, outstanding differences between the works executed by Velázquez before his Italian journey and those which he painted in Rome. In these the space is deeper and the colouring richer in hues and glow. Another difference brings tantalizingly to mind Velázquez' lost studies after Raphael, whom he later came to dislike. The proportion of the human figure in both *Joseph's Bloody Coat Brought to Jacob* and *The Forge of Vulcan* is more slender than in either *Bacchus* or *Christ and the Christian Soul*, painted by Velázquez before he left Madrid (cat. nos. 41 and 35). This is also the case with *Christ on the Cross,* datable to about 1632, shortly after the Master's return from Italy (cat. no. 59).

It would be idle to try to retrace Velázquez' thoughts as his mind's eye ran through Raphael's and Michelangelo's works and seized upon the peculiarities of Titian's brushstroke. Since his apprentice days he had been working towards the confrontation which took place in the Vatican when he started drawing from Michelangelo's and Raphael's frescoes. Pacheco, true to his convictions, must have advised his young apprentice to take the path of Michelangelo, Raphael and their followers as the way to master drawing and to achieve smoothness, beauty, profundity, and power of expression. He must also have warned him against the sort of sketchy and indistinct painting which imitates neither the manner of the ancients nor the truth of nature.

It was in Madrid that Velázquez learned to admire Titian's painting and the works of other Venetian artists. This admiration was heightened when he saw the enthusiasm and freedom with which Rubens made copies after Titian's works at the Spanish Court, and later by the copies after Tintoretto that he himself made at Venice. In Rome, he finally faced the achievements of Raphael and Michelangelo, whose greatness had been impressed on him, and he came to grips with them. It is a thousand pities that the drawings he then made are lost for they might have revealed to us the interplay of his understanding of those great masters as much as his own creative disposition.

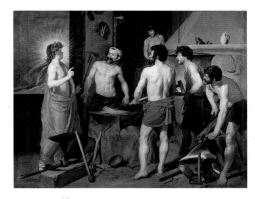

The Forge of Vulcan
1630
Cat. no. 44

Louis Le Nain
Venus in the Forge of Vulcan
1641
Reims, Musée Saint-Denis

LEFT PAGE:
Study for the Head of Apollo in *The Forge of Vulcan*
1630
Cat. no. 45

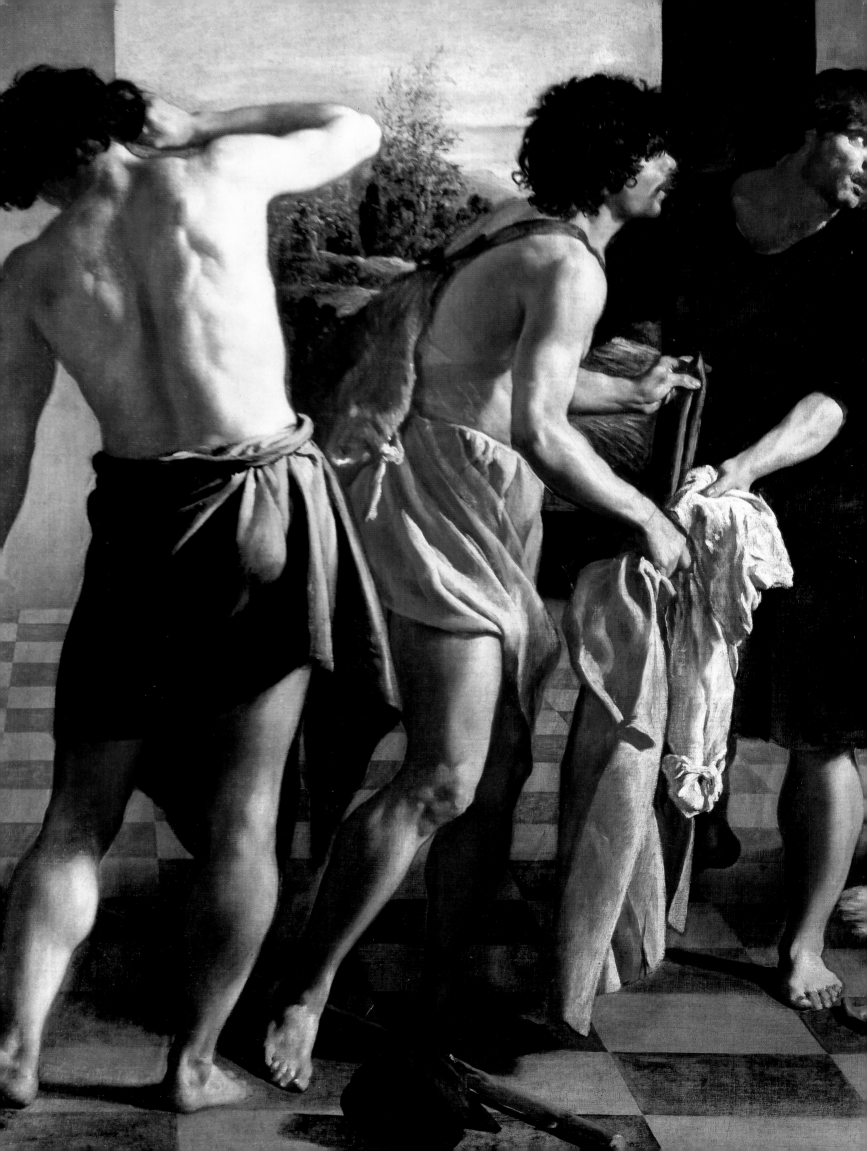

Another grievous loss is that of the self-portrait painted by Velázquez in Rome in 1630 "in the manner of the great Titian". It must have been significantly different in execution from the "fine portrait" of *Infanta Doña María*, which he painted probably later the same year (cat. no. **48**).

Scholars of various persuasions have commented that the modelling of the Infanta María's well-drawn face is somewhat dry, though her blond hair is fluidly painted.[82] A contrast of this kind can also be found in the larger and more elaborate compositions of 1630, *The Forge of Vulcan* and *Joseph's Bloody Coat Brought to Jacob*, neither of which could be described as painted in the manner of Titian, in spite of the sketchy passages common to both. Pacheco was a discerning connoisseur. His characterization of Velázquez' self-portrait as a Titianesque masterpiece confirms that the quality of Velázquez' brushwork was not invariably uniform at any one period, not even at any one year, of his creative life.

Either whilst in Italy or soon after his return to Spain, Velázquez must have written to Pacheco of his enthusiasm for Titian, whom he very probably regarded as the stem of creative freedom. As some of Velázquez' works painted in the early and mid-1630s reveal, it was after his return to Madrid that his kinship with Titian became more noticeable. It was, however, a vital kinship that precluded imitation and quickened the sense of individual creation.

Joseph's Bloody Coat Brought to Jacob
1630
Cat. no. 43

LEFT PAGE:
Detail of no. 43

BELOW:
Detail of no. 43

The return to the Court: work, chores and rewards

Soon after his return to Madrid, Velázquez began to work on the portrait of *Prince Baltasar Carlos with a Dwarf,* which the King had been waiting for him to paint and that he finished in March 1631 (cat. no. **51**). Sometime later, in 1631–1632, he entirely repainted a portrait of *Queen Isabel, Standing* which he had painted before leaving for Italy, modifying the costume and the hairdo in accordance with the new fashion of the day (cat. no. **53**). He also painted in those years, probably over an extended period of time, the full-length of *Philip IV in Brown and Silver* (cat. no. **52**).

Portraits of the sovereigns and other royal figures were in great demand among people of various social stations, and were sold at painters' and dealers' shops, as well as on the streets and in other public places. Most of them were, of course, perfunctory works, copies of copies, so many steps removed from the original that they neither bore a resemblance to the sitter nor showed any sense of royal decorum. One of Velázquez' occasional chores as a Court painter was to determine whether these paintings were offensive on either point.

In October, 1633, Velázquez and his colleague, Carducho, had to view over eighty such portraits that had been confiscated from various painters. They let twelve of the portraits pass, and recommended that the others be returned to their painters, instructing them to erase and paint anew the heads of the sitters in every one, as well as the rest of the figure in a few. A portrait of Philip IV was singled out as particularly offensive because it represented the King wearing green breeches and hose.

Don Jerónimo de Villanueva, Protonotary of the Kingdom of Aragon, stated in 1634 that Velázquez had received several payments, totalling one thousand ducats, for the following eighteen pictures acquired for Philip IV: "Cambiaso's *Susannah,* an original by Bassano, Titian's *Danae,* the picture of *Joseph,* the picture of *Vulcan,* five flower pieces, four small landscapes, two *bodegones,* a portrait of *Our Lord, the Prince,* and another of *Our Mistress, the Queen".*

The listings "the picture of *Joseph"* and "the picture of *Vulcan"* sound as if they referred to well known, readily identifiable works. As is generally held, they can only be *Joseph's Bloody Coat Brought to Jacob* and *The Forge of Vulcan,* which, according to Palomino, Velázquez painted in Rome.

As for the portraits of Prince Baltasar Carlos, and the Queen, these were probably replicas or workshop copies after Velázquez' originals. According to the terms of the royal order of 9 February 1629, Velázquez was to receive no payment in addition to his regular emoluments for the "original portraits" that the King might command him to paint. It is improbable that the Protonotary of Aragon would have bought original portraits of the Queen and the Prince for the King, just to get round a royal order which, needless to say, was not too binding on the monarch.

The pictures had been evaluated by Francisco de Rioja, a friend of both Pacheco and Velázquez. Cruzada held that one thousand ducats for a group of paintings, which included a "masterpiece by Titian" was a rather paltry sum. Yet, if we read carefully, it is notable that the one painting mentioned as "original" is Bassano's and it would appear that the references to the Cambiaso and the Titian are to copies. As Cruzada pointed out, Velázquez was often paid under one hundred ducats, plus his regular emoluments, for pictures executed for the King.

Consequently, one thousand ducats for the lot, though not a generous price, was not unusual. Apart from two, or perhaps four, paintings by

Alonzo Sánchez Coello's student
Isabel Clara Eugenia with Magdalena Ruis
c. 1585
Madrid, Museo del Prado

Velázquez' workshop
Portrait of the Infanta Doña María
Berlin, Staatliche Museen
Preußischer Kulturbesitz

Velázquez, the lot included only one original work, by one of the Bassani, which was probably not regarded as exceptional, since its title or subject is not mentioned. Furthermore, it is unlikely that any of the other pictures was by any well-known master. Also, at least half of the pictures – five flower-pieces and four small landscapes – would at the time have commanded low prices on account of their subject or their size.

The possibility cannot be excluded that Velázquez made the copies of Cambiaso's and Titian's works, perhaps while in Italy. One of Titian's *Danae,* now in the Naples Museum, was then in the Collection Farnese in Rome, and another had been in the Spanish royal collection since the 1550s (Prado Museum)[83]. Yet, as neither of the copies is extant, and the document is itself unclear, speculation on this point would be idle.

As for the five flower-pieces, it is safe to assume that Velázquez had purchased, rather than painted, them for the King. Pacheco regarded flower-pieces as a trifling subject, and cited only Van der Hamen as a painter who had succeeded in painting them with vigour and art. Had Velázquez painted flower-pieces, it is unlikely that Pacheco would not have mentioned it.

The four small landscapes and the two *bodegones* might have been by Velázquez, as far as subject matter is concerned, though of course they might also have been by some other painter. It is in any case worth underlining that in the 1630s *bodegones,* whose validity as an art form Velázquez had so powerfully asserted, were in favour at the Spanish Court.

On 21 August 1633, Velázquez' fourteen-year-old daughter, Francisca, married Juan Bautista Martínez del Mazo, a painter about whom nothing is known before this date. Their wedding was at the church of Santiago in Madrid. As his daughter's dowry, Velázquez passed on to his son-in-law the position of Usher of the Chamber. The King's permission to do so had been preceded by granting to Velázquez the privilege of designating, for a financial consideration, an individual to be appointed constable of justice. At the time, this old lucrative privilege had been stopped, but, after some legal quibbling, this interdiction was waived in favour of Velázquez with the stipulation that it would, however, remain in force for others.

The brushwork as the painter's medium

Five paintings datable to the time of Velázquez' 1629–1631 Italian journey have come down to us: two large compositions, each including six figures, a colour sketch for one of these and two small landscapes of *Villa Medici.* The large compositions, *Joseph's Bloody Coat Brought to Jacob* and *The Forge of Vulcan,* have at least one of the models in common (cat. nos. **43** and **44**). There is no reason to conclude that they were intended as companion pieces nor that they were originally identical in size. Moreover, there is no indication that they ever hung in the same room.

In 1667 Fray Francisco de los Santos noted that, in *Joseph's Bloody Coat Brought to Jacob,* Velázquez depicted not only Joseph's blood-stained coat, as described in the Bible, but also his bloody shirt, thereby heightening the dramatic intensity of the scene.[84] In *Joseph's Bloody Coat Brought to Jacob* Velázquez cleared the space around the human figures by emphasizing the geometric pattern of the brown and white floor tiles. He had used this perspective device in just one other painting, the portrait of the jester *Don Juan de Austria,* painted soon after his return to Madrid (cat. no. **65**). Gerstenberg has plausibly suggested that this device closely conforms to the manner discussed and illus-

Rodrigo de Villandrando
Queen Elisabeth of Bourbon
1615–1620
Madrid, Museo del Prado

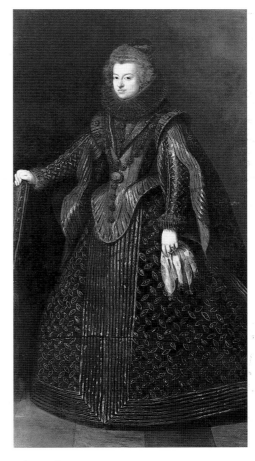

After Velázquez
Infanta Doña María, Queen of Hungary
Prague, Národni Muzeum

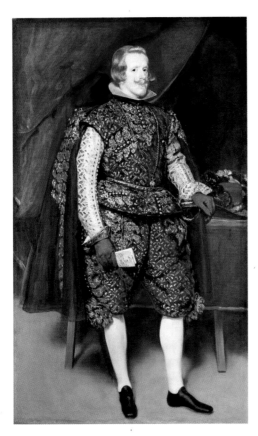

Philip IV in Brown and Silver
c. 1631–1632
Cat. no. 52

trated in Daniello Barbari's *Pratica della Prospetiva* of 1568,[85] a copy of which was in Velázquez' library at the time of his death. It may, however, be that Velázquez learned its use for dramatic effect from Tintoretto's works at Venice and that it had exercised his imagination during his Italian journey and even for a while after his return to Spain. Yet, it is significant that, if he painted *Joseph's Bloody Coat Brought to Jacob* at Rome in 1630, he had also painted *The Forge of Vulcan* at the same time, and in this painting he did not emphasize the geometric design of the interior and yet still achieved a spatial airiness.

Velázquez, well read as he was in architecture – if his library is any indication[86] – persevered in what, from early in his career as a painter, appears as his aim: the joining of his depiction of a figure or group with that of spatial depth, as he did, for instance, in *The Fable of Arachne* (cat. no. 107).

It is worth pointing out here that an art treatise can throw about as much light on a painter's paintings as a book of rhetoric can on a poet's poems. Both may express what earlier creative men were understood to have achieved, or what the painter or poet was admonished to do on the authority of past achievement or current speculation. Books of rhetoric or art treatises can provide us with a clue to the views that a creative artist may have learned in his youth, grown up with, or come to know in later years. On the other hand, whatever the time and circumstances of an artist's acquaintance with a book of rhetoric or art treatise may have been, the meaning of his work is not necessarily to be found in them.

As in the case of *Bacchus* (cat. no. 41), it has become customary to assume that *The Forge of Vulcan* and, to a lesser degree, *Joseph's Bloody Coat Brought to Jacob*, were repainted by Velázquez after 1630, the reason given being that in each composition there is at least one figure which is more "impressionistic" than the others.

It is a fact, conclusively proved by X-ray photographs and at times made all too clear by overzealous restoration, that Velázquez substantially repainted a large number of his works after the pigment he had originally laid on the canvas had dried and hardened, but to determine the length of the intervening time, which may have been a matter of months, or years, is, however, not always possible.

Even when radical changes are evident, one should not jump to the conclusion, lacking other evidence, that Velázquez made the changes after having regarded the painting as finished. *The Surrender of Breda* is a case in point (cat. no. 73). We know that Velázquez often worked at a leisurely pace. It is, moreover, documented that there were times when he was working at more than one picture – and it would be in the nature of his baroque imagination to find in the unfinished canvas an invitation to change.

Beruete is mainly responsible for the view that the differences in the handling and texture of pigment noticeable within a number of individual paintings can be explained as the result of later repainting carried out by Velázquez himself. In the case of *The Forge of Vulcan*, he was convinced that Velázquez had repainted it "towards the end of his life" since "there are in the head, and also in the body" of Vulcan "a boldness, a freshness of touch, and a happiness of execution at which the Master only arrived in his latest works".[87]

A good many of the pictures which Beruete included among Velázquez' latest works are now known to have been painted one or two decades earlier; some, indeed, not later than the mid-1630s, which cuts the ground from under his argument.

As in the case of other creative painters, the structure, texture, sweep and hue of Velázquez' brushstrokes vary within a single work, subject to his intent

as a maker. The changes of hue and of brushwork texture could be deployed as a compelling means of expression.[88]

In *The Forge of Vulcan* and in *Joseph's Bloody Coat Brought to Jacob* the stature of most of the figures is accentuated by a light which comes from high-up outside the composition. In both paintings a sense of airy depth is achieved by the fluid landscapes in the distance and by the blobs into which the background figures are shaped: the shadowy figures of the two youths standing beside Jacob against a light wall in the Biblical scene, or the lit-up half-length nude seen against the shadow at the chimney corner in the mythological painting (cat. nos. **43** and **44**).

Velázquez, who made many studies in Rome, must have made at least a few for these large paintings. Unfortunately, only one, a colour sketch for the head of Apollo, has come down to us (cat. no. **45**). Portrayed in full light, it shows the god's youthful countenance contoured by a filmy shadow which, in the final composition, covers the whole face. This sketch corresponds more closely to the outline of Apollo's face and neck as first painted by Velázquez in *The Forge of Vulcan* before he modified the contour of his face, a change which is clearly visible in an X-ray photograph made in 1960.

Apollo's figure, clad in an earthy-yellow mantle, is as fleshy and dappled with shadows as that of Bacchus in the earlier and considerably less airy composition. His shadowed face stands against a thickly textured yellow light as he uncovers Venus' and Mars' infidelity to Vulcan, who is as thick-skinned a blacksmith as his assistant Cyclopes. The cuckolded Vulcan stops in his work, the surprise on his face made the more bumpkin-like by his bushy moustache and by his fast grip on the hammer. The comedy is maintained by the gestures of the three Cyclopes in full view and by the intent stare of the one in the background, whose figure keys the diagonals that fan the composition open.

While in Italy or soon after his return to Spain, Velázquez painted, mainly in earth-yellow and grey hues, the profile of a woman – probably a sibyl – whose face is finely built by the light and shade (cat. no. **49**).

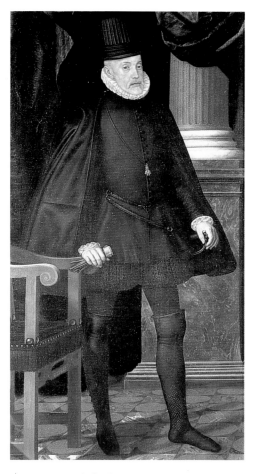

Juan Pantoja de la Cruz
Philip II as an Old Man
c. 1590
El Escorial, Patrimonio Nacional, Monasterio de San Lorenzo

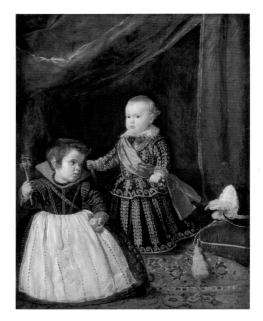

Prince Baltasar Carlos with a Dwarf
1631
Cat. no. 51

BELOW:
Detail of no. 51

RIGHT:
Detail of no. 51

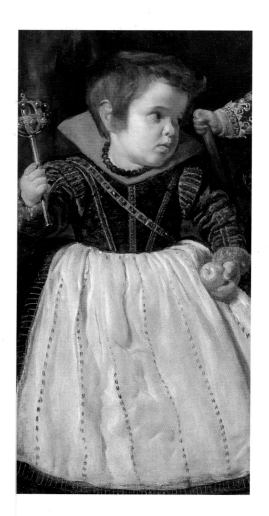

The Prince and the dwarf

In March 1631 Velázquez finished the portrait of *Prince Baltasar Carlos with a Dwarf* (cat. no. **51**). The blond, sixteen-month-old prince, wearing a gold-embroidered dark-green costume, stands majestically on a dais, his right hand on a baton and his left one on the sword hilt. In the foreground, to the left, there is a chestnut-haired female dwarf in a dark-green dress lined in red and a white apron. Holding a silver rattle in one hand and an apple in the other, she turns her head as she looks intently across the composition.

The smooth modelling of the Prince's luminous face contrasts with the uneven handling of the shadowed visage of the dwarf; a contrast repeated in their bearing and pose. Where the dwarf's glance and gesture tie her to her surroundings, the Prince towers over everything around him. The varying hues of purplish red, dominating the composition, are particularly luminous on the sash across his formal costume.

Painters in Spain and elsewhere had, for a long time, included dwarfs in their royal portraits, even when there was only one royal sitter. In 1619 or soon after Villandrando had represented Philip IV, then a Prince, resting his right hand on the head of *Soplillo*, his favourite dwarf (p. 47).

In Villandrando's portrait, there is no contrast, except for the figure's stature, between the figure of Philip and that of *Soplillo*, not even in their stance or gesture, much less in the brushwork used to depict them. The dwarf quietly merges into the Prince's regalia as just another pictorial attribute. Although the Prince and the dwarf are about the same height in Velázquez' portrait, he is still able to create a strong contrast in their stance and gesture, especially by his handling of pigment. It is mainly this contrast that makes the child-dwarf appear as a foil to the majesty that is embodied in the figure of the child-Prince.

Before leaving for Italy, Velázquez had portrayed a misshapen Court fool, *Calabazas* (cat. no. **39**), and throughout the succeeding years he made at least eight more individual portraits of such jesters, though only once more – in the so-called *Las Meninas* – did he represent one in the entourage of a royal figure. Any of those portraits of dwarfs or jesters, if compared with those of either the Prince or the King painted at the same time, reveal the sort of difference in the brushwork treatment which distinguishes the person of Baltasar Carlos from that of his dwarf in the portrait of 1631.

Equally significant is the contrast offered by two works executed by Velázquez at roughly the same time: the portrait of *Doña Antonia de Ipeñarrieta y Galdós with one of her Sons*, of about 1631, in which the faces are finely modelled in light and shade (cat. no. **54**), and that of *Prince Baltasar Carlos* painted in 1632 (cat. no. **60**). In the latter, the three-year-old Prince is seen alone, resting his right hand on a baton and the left on the sword hilt, his face as luminous as in the portrait of 1631. It portrays a child imbued with a compelling sense of majesty.

Portraits of Queen Isabel

Possibly in 1632, and certainly sometime after Velázquez had completed the portrait of *Prince Baltasar Carlos with a Dwarf,* he painted out a likeness of Queen Isabel which he had executed years earlier, and substituted for it, on the same canvas, a new portrait of her. He did much the same as he had done, before leaving for Italy, with his earliest portrait of Philip IV. However, with the Queen's portrait the main changes did not concern the sitter's physical

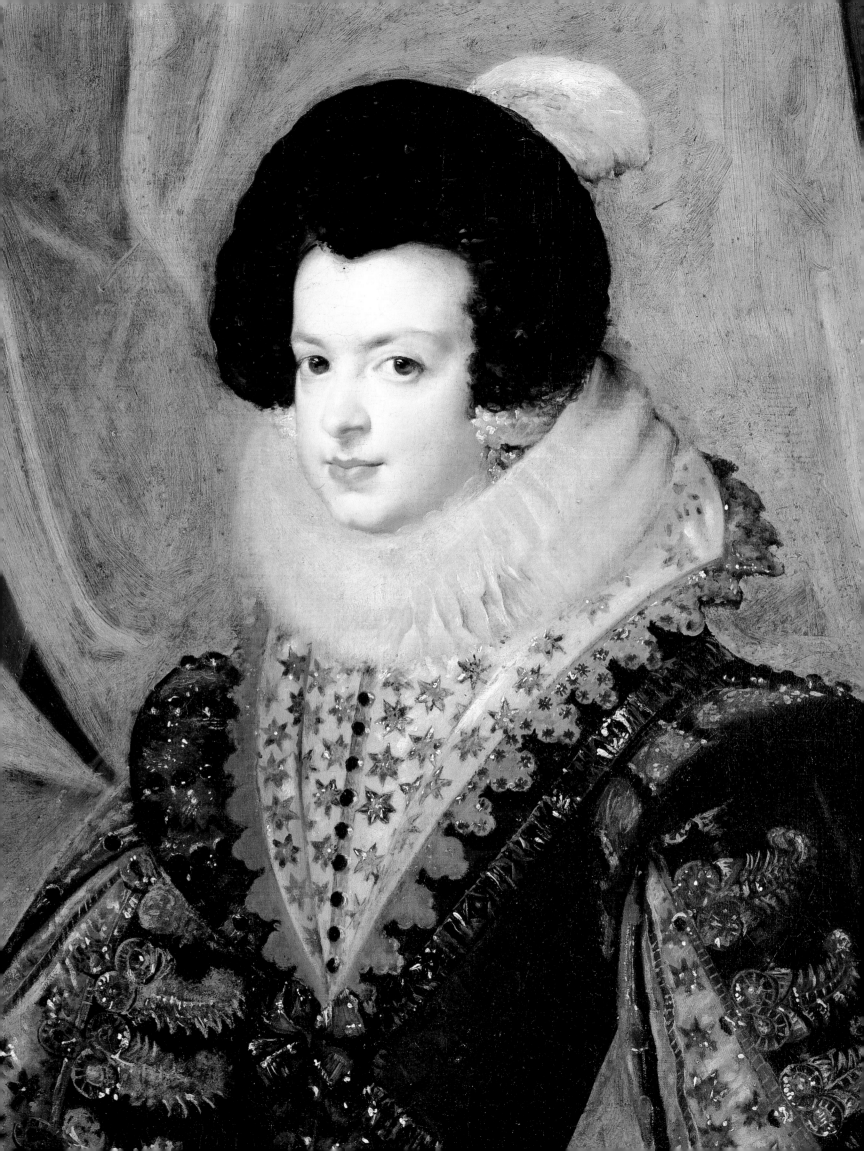

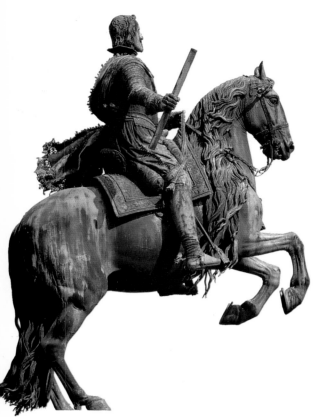

Pietro Tacca
Philip IV
c. 1635
Madrid, Plaza de Oriente

appearance but her costume (cat. no. 53). These two reworked royal portraits were later to be paired at the Buen Retiro Palace.

The portrait of Queen Isabel, as it has come down to us, shows Velázquez' absolute mastery of light and texture, and not only in the comely face, where the hues vividly blend in a white-pink luminosity. He has achieved a full range of luminous hues on the black silk of the sitter's costume, the luminosity of which effortlessly matches that of the yellows used for the gold embroidery on the dress, and the highlights on the curtain's pinkish red.

A replica of the Queen's face appears in another portrait of her, now cut down to three-quarter length, painted by Velázquez and an assistant no later than September 1632 (plate 142). Just as in 1634 or 1635, when Velázquez reworked extensively the equestrian portrait of Queen Isabel (executed by an unknown hand) here he repainted the head and most of the dress, from the waist up, after his portrait of the Queen standing of 1631–1632 (cat. no. 53). There has been speculation – so far inconclusive – concerning the fact that Queen Isabel sat so infrequently for Velázquez. Apparently she did so just twice, and for the same canvas. This leaves us with only one likeness of her in visible pigment painted from life by the Master's hand.

Light upon black

Velázquez had a keen eye for the nuances of light upon black, in much the same way as did Rembrandt and Frans Hals among his contemporaries and Renoir among his later admirers. Stevenson, one of Velázquez' most perceptive critics and among the first to comment on the matter, pointed out that it took Velázquez some time to really master the "chromatic nuances" of light upon black.

Stevenson described the blacks in the portrait of the *Infante Don Carlos*, datable to 1628, as "hard" and "scarcely obedient to the light" (cat. no. 37).[89] The remark, though a trifle exaggerated, could also apply to other works painted by Velázquez before 1631, in which he had not yet attained the wide range of black hues noticeable in the portrait of *Queen Isabel* (cat. no. 53).

It seems that Velázquez achieved his absolute mastery in the depiction of light upon black after his return from Italy. But it also seems that this cannot be explained as the result of any specific Italian influence since no particular painter or work can be identified as a likely source. Nor does any of the works which he painted in Italy disclose this penchant for luminous black hues. There can, however, be no doubt that Velázquez, while in Italy, reflected upon the works of art which he saw and admired there, and probably too upon those, including Titian's, El Greco's and Rubens', which he had seen and admired elsewhere. It is also likely that he reflected upon the works which he had painted so far and the challenges that he had encountered, and on what his ambition might be from then on. His mind's eye must certainly have been open and at work throughout the journey. We know that he studied Michelangelo, Raphael and Tintoretto, and that his admiration for Titian grew increasingly. However, he did not "borrow" anything from other artists' works while still enlarging the scope of his own work.

For one thing, his palette, notably his blacks, became more luminous, as can be seen in the royal portraits we have just discussed. The same is the case with *Doña Antonia de Ipeñarrieta y Galdós with one of her Sons*, of 1631–1632 (cat. no. 54), *Don Diego de Corral y Arellano*, of the same date, and *Don Pedro de Barberana y Aparregui*, of 1631–1633 (cat. nos. 55 and 57).

The portrait of *Doña Antonia de Ipeñarrieta y Galdós with one of her Sons* has been somewhat marred by restoration, but it still shows stylistic similarities with the other two, notably in the quality of the black hues of the dress, the fluid contour line that is rather luminous round the sitter's head, and the interplay of light and shade that models her face.

Don Diego del Corral and Don Pedro de Barberana did not resemble each other as individuals. However, their portraits, which emphasize their different appearance are undeniably similar paintings. The figures of both sitters stand with casual aplomb, while their faces are animated by the broad strokes of lights and shade. Both paintings are quite similar in the configuration of the forehead and temple, the bridge of the nose, and the eyesockets – all shaped by dint of light and shade. The purposeful play of light upon black underpins the strength of hue in both portraits, making the image of each sitter even more individual.

Velázquez' mastery of the nuances of light upon black is evident throughout his career. It is, indeed, a touchstone of his art, as shown by the portrait of *Philip IV*, of 1652–1655, which for all its simplicity, none of his pupils or assistants could convincingly imitate (cat. no. **120**).

Portraits of the King

Queen Isabel on Horseback (detail)
1634–1635
Cat. no. 70

Beruete suggested that it "is probable that on his arrival in Madrid, Velázquez hastened to paint the new portrait of the King, perhaps the one now in London's National Gallery".[90] It is reasonable to assume that Velázquez, on learning that, during his absence, the sovereign had allowed no other painter to portray him, should have been eager to paint a new likeness of Philip. There is moreover no stylistic reason to suppose that the portrait of the King in brown and silver in London was painted significantly later than the one of Prince Baltasar Carlos with a dwarf. It is, however, possible that the King's portrait was executed over an extended period of time in 1631–1632 (cat. no. **52**).

Substantial *pentimenti,* now quite noticeable, indicate that Velázquez was not quickly satisfied with this work. This is one of the only portraits of Philip IV (the other being the equestrian portrait of 1625) that Velázquez signed with his title, "painter to Your Majesty", appended to his name and as such it is reasonable to assume that he regarded the portrait as particularly successful.[91]

In this portrait, as in earlier ones, the likeness of Philip, though keen and quick, does not depend on the depiction of his age or on other distinguishing characteristics. The same is the case with later portraits of the sovereign, such as those in hunting costume (cat. no. **63**) or on horseback (cat. no. **71**), of the mid-1630s, the one in field uniform painted in 1644 (cat. no. **100**), or the bust from the years 1652–1655, where, though Philip was then rather infirm, Velázquez certainly did not emphasize the flaws of age or any other temporal accident (cat. no. **120**). This depiction of the august character of the person of the King was not grasped by Velázquez' assistants, followers and imitators. They more often than not emphasized the flaws of age and appearance in their derivative portraits of Philip IV. It may even be that some thought that by doing so they were in fact improving upon Velázquez' naturalism. The point of Velázquez' idealized and conceptual naturalism was often missed – even by those who advocated it.

Among Velázquez' pupils, assistants and followers, there were obviously some who assimilated one or more aspects of his art. Most, however, were not really aware of the scope of his naturalism which imbued the depiction of the human figure with conceptual traits. They could not realize that the differences

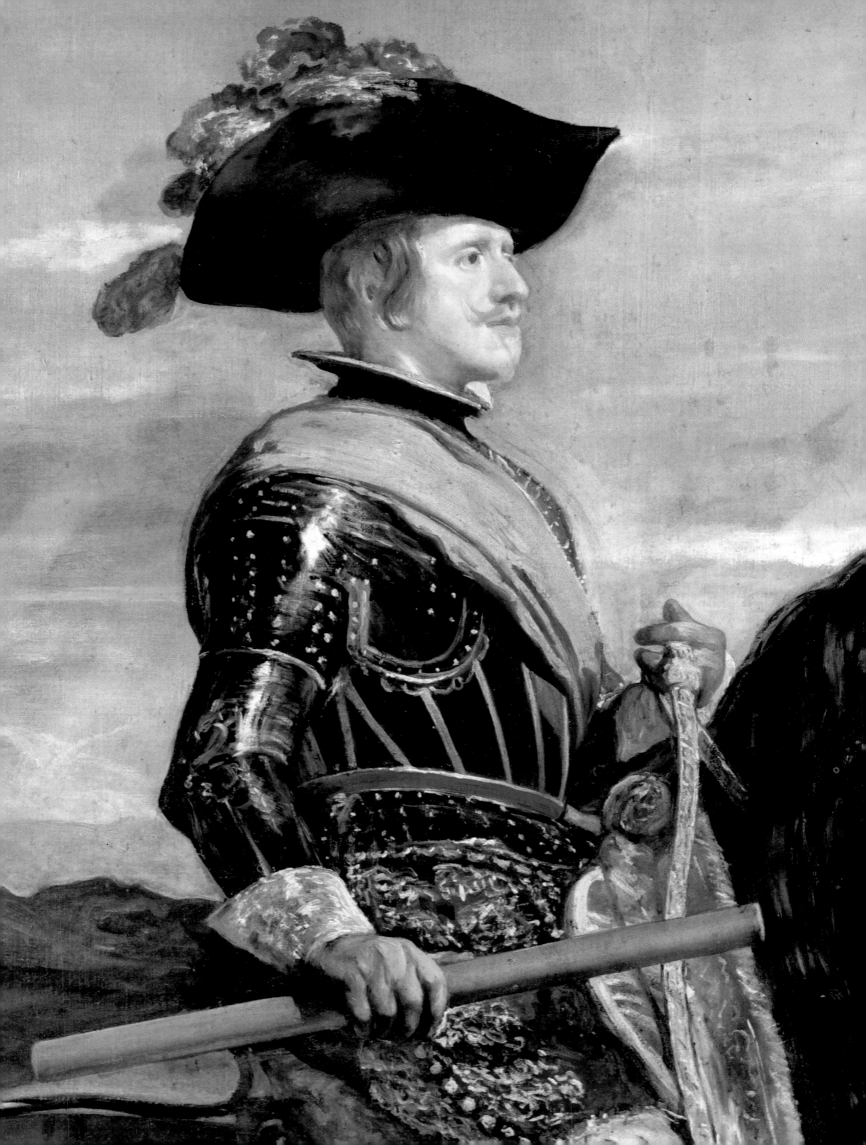

in his pictorial handling of figures were central to Velázquez' portrayal of human nature or temporality, or his depiction of man stirred by an appetite for lust (whether of the flesh or for knowledge), or even his portrayal of the humanity of Jesus or His Mother or in the creation of a likeness of the King refined out of the accidental, without recourse to symbols or allegories.

We have already compared in this light the portraits of Philip IV (cat. no. 36) and his brother, the Infante Don Carlos (cat. no. 37) both painted in 1626–1628. Equally meaningful for the 1630s is a comparison of the portrait of the King in brown and silver (cat. no. 52) with either that of Don Diego del Corral y Arellano (cat. no. 55) whose face is animated by broad brush strokes and vivid lights and shadows, or the portrait of the husky royal master of the hunt, Juan Mateos (cat. no. 58) whose character is emphasized by a nervous modelling in shadow, which the hands, sketched in with rough impasto, make the more emphatic. Likewise, if we look at the portraits of Philip IV (cat. no. 63) the Infante Don Fernando (cat. no. 64) and Prince Baltasar Carlos (cat. no. 77) – all painted between 1632 and 1636 for the royal lodge called Torre de la Parada and all clad in hunting dress – it becomes obvious that the King's face, as well as that of the heir to the throne, is more luminous and freer from shadows than that of the Infante. A consideration of Velázquez' three outstanding equestrian portraits gives further support to this view.

The Great Hall of the Buen Retiro

In 1630 the foundations were laid for a new Royal Palace, the Buen Retiro, in Madrid. Hastily, and it would seem poorly, built, it was partially in use late in 1633. But it was not until April 1635 that the decoration of the ceremonial *salón* or Great Hall was completed; later to be known as *Salón de Reinos*.

It was with Olivares that the idea of building a new palace on the outskirts of Madrid had originated. Here Philip and his Court could repair to an architectural setting brighter than the one provided by the old Alcázar.[92] Olivares' purpose was to keep the King amused and forgetful of the affairs of State which the Count-Duke was handling with more confidence than success. Such design has never been unusual at the seat of power. Nor is there anything uncommon in the fact that the new palace was intended to convey the greatness of the established political régime of absolute monarchy. The Count-Duke's gamble for more power would be just one more historical anecdote were it not for the fact that both Philip and Olivares valued Velázquez, who by then called himself "painter to His Majesty and to the Count-Duke".[93]

The decoration of the newly built palace was a vast artistic project in which Velázquez, high in office and highly regarded at the Court, probably played an active part. Many works were brought from the Madrid Alcázar and other royal palaces in Spain, as well as from Portugal and Flanders, and they were still coming as late as 1639 when both the King and his painter were already busy with another project, the Torre de la Parada.[94]

The Great Hall is about all that remains of the Palace of the Buen Retiro, except for the so-called *Casón,* a building which has undergone many recent changes. No longer part of a vast architectural complex, and divested of the ceremonial function for which it was intended, it barely conveys any idea of its original grandeur. Yet in 1635 when it was completed, with its paintings and decoration, the *Salón* was seen as the embodiment of majestic grandeur.

Nearly all the paintings that then decorated the Hall have found a permanent place at the Prado Museum. Unfortunately there is no surviving graphic

Philip IV on Horseback
1634–1635
Cat. no. 71

LEFT PAGE:
Detail of no. 71

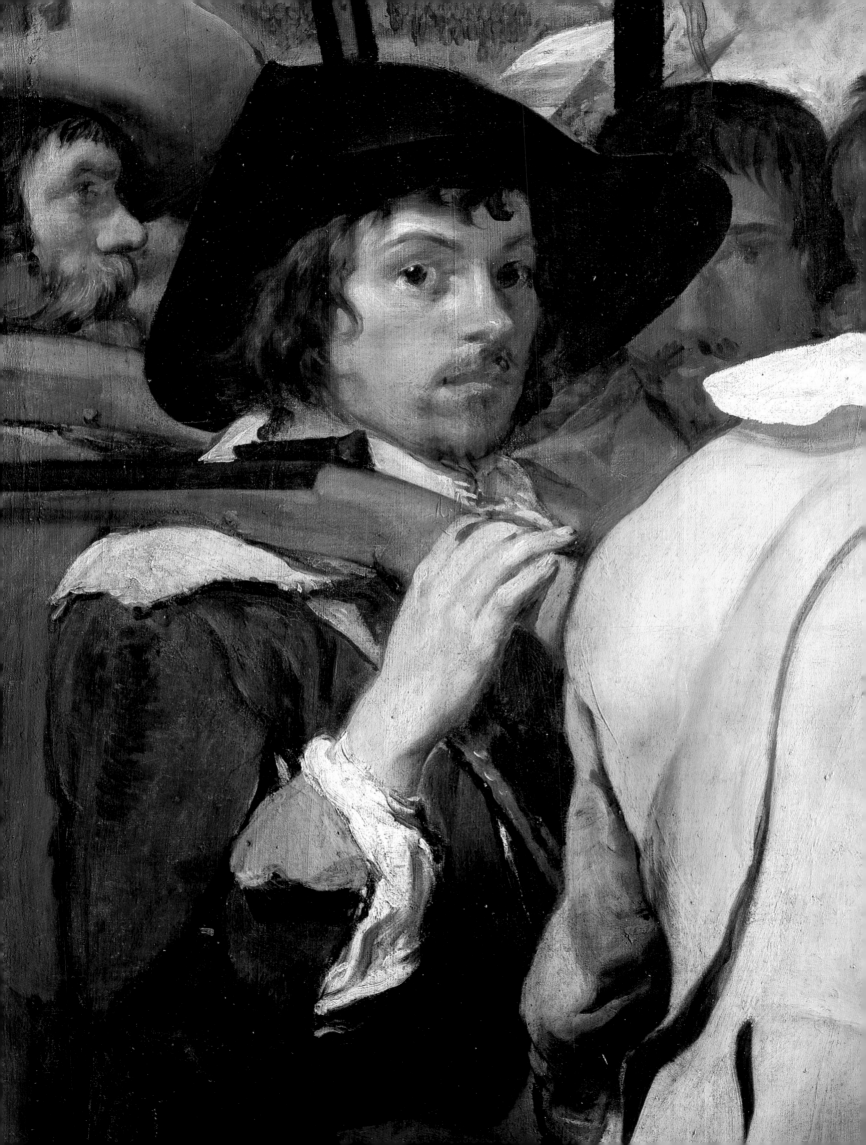

record of what must have been a magnificent decorative ensemble. However, the order in which the paintings were most likely arranged has been worked out by Tormo as convincingly as the references to them in a poem published in 1637 allow.[95] Curiously this poem, Manuel de Gallegos' *Silva topográfica* mentions as *in situ* every one of the pictures known to have been painted for the *Sálon*, except *The Surrender of Breda*. It is, however, known that two years earlier this painting was there because Don Francesco de' Medici, Commendatore de Sorano, the Tuscan Ambassador, in his report on the completion of the Buen Retiro Palace dated 28 April 1635, listed it as one of the paintings which decorated the *Sálon* (cat. no. 73).[96]

From at least August until December 1634, Velázquez was at work on paintings for the *Salón,* some of which were only finished by 28 March 1635, just one month before Sorano wrote his report on the Buen Retiro Palace. On 14 June 1635 he acknowledged receipt for a total of 2500 ducats for works (no details supplied) by himself and others intended for the Buen Retiro and, in particular, for the Great Hall. Those by other painters had been delivered in 1634, and those by Velázquez in 1634 and 1635. Entirely by him are *The Surrender of Breda* and the equestrian portraits of Philip IV and of Prince Baltasar Carlos (cat. nos. **71, 72** and **73**); his hand is also recognizable in the equestrian portrait of Queen Isabel, and, to a lesser degree, in those of the King's parents, which were mostly executed by other painters (cat. nos. **68, 69** and **70**).

The Surrender of Breda was one of twelve landscape-format life-size battle scenes intended to perpetuate victories won by Philip IV's armies since the beginning of his reign in 1621. Over these scenes of recent battles ran a frieze of the labours of Hercules.

The Hercules paintings, as well as two battle scenes were by Zurbarán, who was paid for all of them on 13 November 1634. Vincencio Carducho painted three battle pieces all bearing the date 1634. Eugenio Caxés, who had been commissioned to paint two of the military subjects, secured before his death (on 15 December 1634) the help of Antonio Puga to complete them. Puga, though, fell seriously ill, and another painter, Luis Fernández, was commissioned to finish one of the pictures, for which he was paid on 14 April 1635. Two weeks later, on 27 April, Félix Castela received a second payment, for a battle scene which he had signed and dated 1634.

Late in March 1635, Maino was still at work on the painting of *The Recapture of Bahía by Don Fadrique de Toledo,* a victory won by the Spaniards over the Dutch on 1 May 1625. Pereda and Jusepe Leonardo seem also to have delivered their works shortly before the opening of the Great Hall for, like Maino and Velázquez, they were not paid in full until mid-June.

There is no documentary evidence that any of the paintings which formed part of the decoration of the Great Hall were not *in situ* by the end of April 1635, when the Ambassador from Florence wrote his report. A collection of poems on the Buen Retiro Palace was published in 1635, at the time of the inauguration of the *Salón*. Its references to paintings have till now been overlooked or dismissed as inconsequential, perhaps because, unlike Gallegos', they are not of an enumerative or descriptive nature. Nearly all these poems were written by courtiers and express views and sentiments which were then readily acceptable. Two sonnets, one on the portrait of Philip IV and the other on that of Baltasar Carlos, must refer to the paintings in which Velázquez represented the King and the Prince on horseback, for no other independent portrait of either hung in the *Salón*.

It would indeed have been unthinkable to open the ceremonial hall without the portraits of the King and the Prince *in situ*. For the hall was conceived as a

Bernard Salomon
Abraham and Melchisedech
1553
Engraving taken from *The historical Quadrins of the Bible*

LEFT:
Detail of no. 73

FOLLOWING PAGES:
The Surrender of Breda (Las Lanzas)
1634–1635
Cat. no. 73

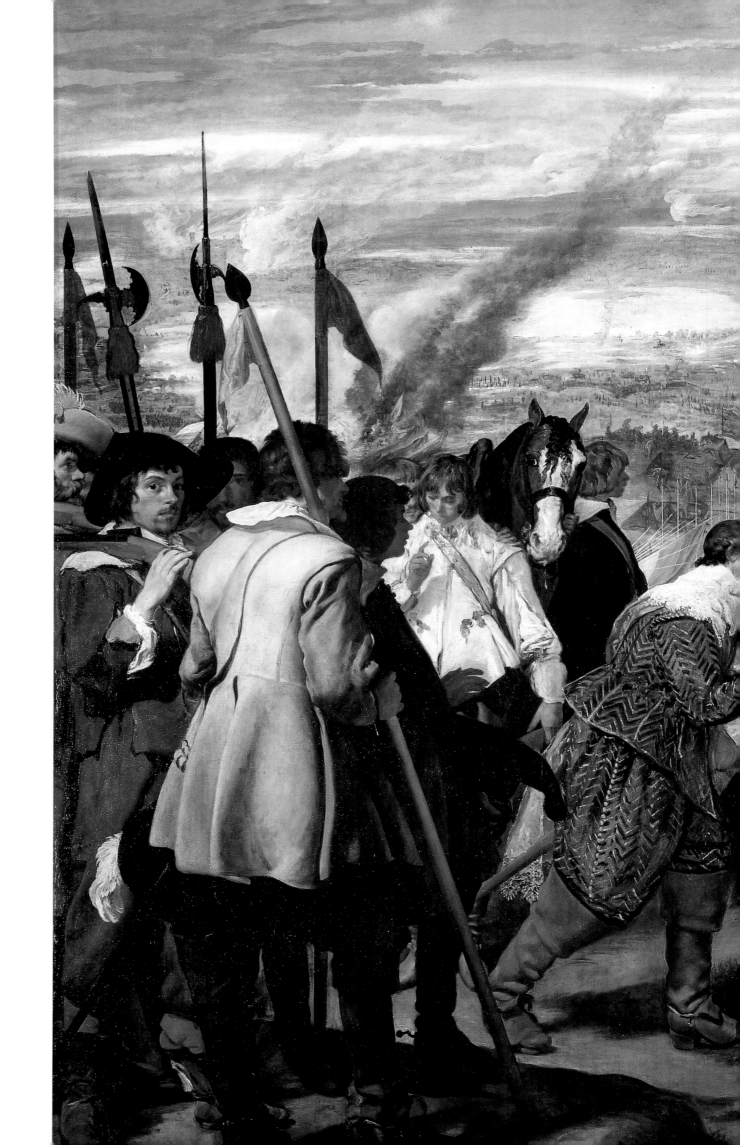

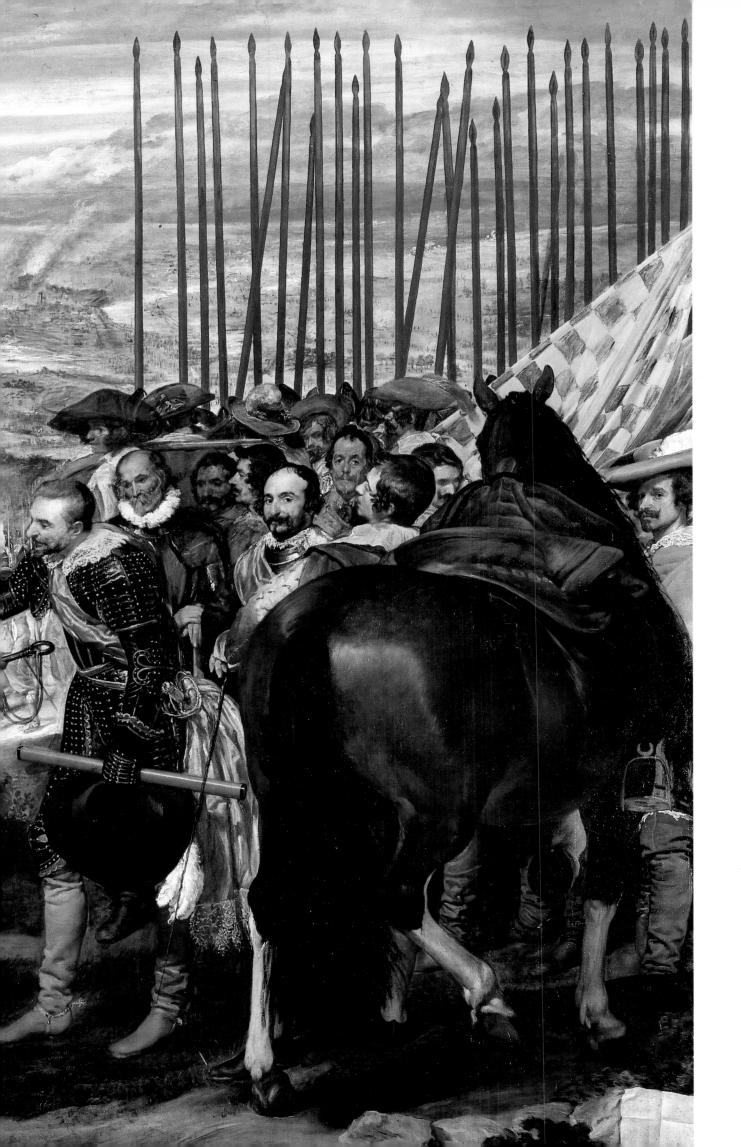

display – or *amphiteatro* to use the word then appropriate – of the Spanish monarchy, with the reigning sovereign and the heir to the throne at its centre. Such is the idea that runs throughout the collection of poems published for the Great Hall's opening – considerably more than half of which have the *Salón* for their specific subject.

Velázquez is mentioned in none of the poems. The sonnet on the portrait of Baltasar Carlos designates its painter as a "heroic man" whose style is "never rude" – a play on words which enhances the true grandeur of his art. As for the sonnet on the portrait of Philip, the strand of imagery which runs through it makes us see the painter displaying his own majesty in the presence of that of the King.[97]

There were two likenesses of Philip IV in the Hall: one was the equestrian portrait by Velázquez, the other, included in Maino's *The Recapture of Bahía*, was an allegorical portrait of the King as young and victorious. As we shall see, Velázquez dispensed with allegories in his equestrian portrait of the King, which is moreover unrelated to any particular event. If the book of poems is any indication, Maino's painting was praised above all others in the *Salón*.

In a manner not uncommon at the time, Maino intertwined the narrative of the event with allegorical images, to enhance the prodigious nature of the military victory. Set off against the rest of the composition by rocks, there is a large scene of a wounded man being tenderly cared for. The young matron sitting on the foreground, three children grouped with her, appears as a live embodiment of the virtue of Charity, her pose enhanced by her elongated statuesque neck (p. 110).

Though prominently set, this is just one episode in Maino's narrative and, in point of composition, rather a foil to the scene which fills the space at the right. There, Don Fadrique de Toledo, the victorious commander, displays a tapestry, with the image of the King, to the assembly of soldiers and civilians who pay homage. The King, looking the youth he was when that military success was achieved, is not pictured alone. Victory, helped by Olivares, is crowning him with a laurel-wreath, and while the goddess offers the sovereign a palm, the chief minister holds in his left hand his own sword and crushes underfoot, like the King, the bodies of Heresy, Envy and War (p. 100).

Maino's composition must certainly have satisfied Olivares' greed for self aggrandizement for it unmistakably depicts him as the maker of the King's military victories. That this point was not missed is attested by the book of poems on the Buen Retiro Palace referred to above. Maino is the only artist mentioned by name in it, and his painting is the only one whose war subject is identified, and repeatedly so.[98]

In the equestrian portrait of Philip IV, which was painted for the *Salón*, Velázquez achieved a telling image of the absolute monarch without relying on either allegorical figures or incidental narrative. Hence, whether by design or vital accident, there were in the new ceremonial hall two significantly different representations of Philip IV. In Velázquez' painting, he appeared alone, dominating the expanse of the earth, as the quintessence of kingly power. In Maino's painting he was seen as the source of political and military power in the turmoil of a narrative and allegoric world where his right-hand servant, Olivares, makes him victorious. Any interpretation of that lost baroque ensemble ought to take into account the meaningful difference between these two images of the King.

Likewise, in discussing the paintings of the labours of Hercules, which ran like a frieze above the depiction of the victories won by Philip IV's armies, one should bear in mind that one emblematic significance of Hercules current at the time concerned the antiquity of the Spanish monarchy. Olivares was even

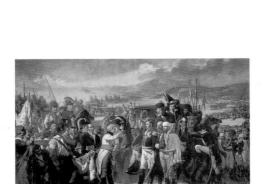

José Casado del Alisal
The Surrender of Bailén
1864
Madrid, Museo del Prado, Casón del Buen Retiro

RIGHT PAGE:
Detail of no. 73

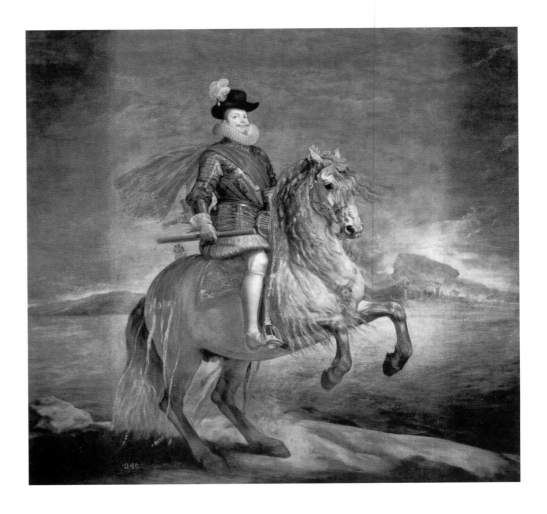

Philip III on Horseback
1634–1635
Cat. no. 68

regarded as the Hercules of Philip IV who was himself understood to be the Atlas of Castile.[99]

Word-play, in which one word might hold a plurality of significances, was a common and often very effective device of the baroque writer. Painters, too, were intent on expressing more than one meaning – not by just playing on the various emblematic meanings of a particular figure, but rather by fashioning on the canvas a more personal imagery. Other artists of the period appear to have done likewise, and it would seem that the spectators and readers had their ears, eyes, and minds open to such a device.

This digression may be useful for an understanding of the overall decoration of the ceremonial hall, obviously planned to express a plurality of meanings with the antiquity, the present power and the bright hopes of the Spanish monarchy at its centre. There is no evidence that Velázquez was entrusted with the planning of that pictorial ensemble. But his advice was probably sought at one point or another during the planning and execution of the project. As for the paintings which he painted for it, they stand unmistakably apart from those by other painters, showing that Velázquez gave new substance and shape to the world in which he lived.

Queen Margarita on Horseback
1634–1635
Cat. no. 69

The equestrian royal portraits

The equestrian portraits of Philip IV, his Queen, his parents – Philip III and Queen Margarita – and Prince Baltasar Carlos hung in the ceremonial hall of the Buen Retiro. Those of Philip IV and the Prince are entirely by Velázquez. He finished them by April 1635, and they were viewed as focal points for the display of the Spanish monarchy's splendour which the *Salón* was understood to encapsulate (cat. nos. **71** and **72**). Velázquez might have made studies for these two portraits though none has come down to us. The inventory drawn up at the time of his death included a *Prince Baltasar Carlos on Horseback* sketched in colour, most likely by his hand,[100] also listed in the same inventory was a *Philip IV on a Chestnut Horse*, roughly 0.835 m. in height.

The other three equestrian portraits were executed by a painter, so far unidentified, who was attentive to detail, and all were later reworked by a swifter hand. This must have been done in 1634–1635, when apparently nearly everything concerning the Buen Retiro was executed.

The unidentified painter's laboured manner still prevails in the portraits of Philip III and his Queen (cat. nos. **68** and **69**). In the first portrait, Velázquez and an assistant appear to have reworked the horse's head, chest, forelegs and tail, and to have done little else. Most of the repainting in the portrait of Queen Margarita is obviously the work of assistants. Velázquez probably only touched-up the horse in some areas of the painting. As for the portrait of *Queen Isabel*, it is clear that he reworked it extensively, painting her head and bust after the likeness he had painted in 1631–1632 – also over another portrait of her – and entirely repainting her white horse (cat. no. **70**).

Horses were a familiar sight in the seventeenth century when nearly everybody rode, Velázquez included. Though Pacheco noted in some detail the proportions of the horse, he commented that it was so common an animal that it would almost always be imitated from nature.[101]

When undertaking those equestrian portraits, or, for that matter, any of his major works, Velázquez must have looked to such similar compositions by other masters as were alive in his mind. He was by then acquainted with other artists' equestrian compositions, some of them outstanding. True, there is no indication that he had been to Padua, where he would have seen Donatello's *Gattamelata*. There is, however, reason to believe that, on his way from Venice to Rome, in 1629, he stopped at Florence, where he could hardly have missed seeing the pedestalled *condottieri* by Uccello and Castagno at the Cathedral. It is also possible that, as he walked about the streets of Venice, protected by the Spanish ambassador's men, he would have paused, forgetting for a while the unrest of the city, and looked up at Verrochio's *Colleoni*. Also, when in Rome, it is unlikely that he would have ignored the famous *cavallo* of Marcus Aurelius.

Furthermore, since his appointment to the Court, Velázquez had had at hand at the Royal Palace several equestrian compositions to use as a model. These included Titian's *Charles V at the Battle of Mühlberg* (Prado, no. **410**, p. 58), in which he achieved a masterful likeness of the Caesar as warrior, with no depiction of battle or troops, or any allegorical figures. Four paintings of horses, probably unfinished works by Ribera and others, were also at the Palace. Velázquez, as early as 1625, had won acclaim with a portrait of Philip IV the equestrian now lost.

Three years later before leaving for Italy, he had seen Rubens painting the equestrian portraits of the reigning Philip IV and of the long-dead Philip II (Prado, no. **1686**, p. 58). Both of these were allegorical compositions. While Velázquez was in Italy, an unidentified painter painted the equestrian portraits

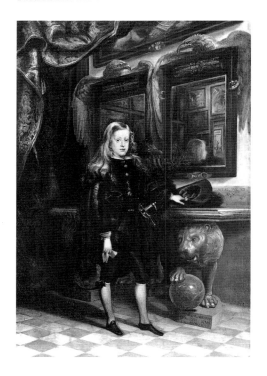

Juan Bautista Maino
The Recapture of Bahia (detail),
see illustration p. 110
Madrid, Museo del Prado

Juan Carreño de Miranda
Charles II in the Hall of Mirrors
1673
Berlin, Staatliche Museen
Preußischer Kulturbesitz

of Philip III, Queen Margarita and Queen Isabel that the Master and some assistants later reworked. At least the portrait of Philip III recalls Rubens' manner, notably in the design of the horse (cat. no. **68**). Nothing in Velázquez' equestrian portraits of Philip IV and Prince Baltasar Carlos brings to mind Rubens' works (cat. nos. **71** and **72**).

The King and the Prince, equestrian

As Velázquez was setting up the canvases for the equestrian portraits of Philip and Baltasar Carlos, he may well have thought of similar compositions by other artists or by himself, more intent – one would assume – on excelling than on imitating them. Nevertheless, the composition of both of these portraits was entirely new.

The one of the Prince was to hang over either a window or a door, in the Hall of the Buen Retiro (cat. no. **72**). This explains the exaggerated curve of the pony's barrel. It should be added that Velázquez made use of that circumscribing condition for his own expressive ends, and thus achieved a monumental perspective setting for the equestrian figure of the young Prince – a point that one misses at the height at which the picture now hangs in the Prado Museum.

All writers on the subject have remarked on the delicacy with which the painter achieved the likeness of the fair-haired, blue-eyed Prince, without any emphatic modelling of his features which as a result appear the more airy as highlights emphasize the fluidity of the head's contour. This has become one of Velázquez' luminous "distant blobs". The sitter's rose-and-ivory-hued face – where even the shadow cast by the brim of the hat is diaphanous – his green and gold dress, his pink flying scarf and his brown pony are all fully illuminated. Also thinly painted and brilliant, yet still gossamer-like, is the sloping landscape. Its green and blue hues deepen the space around and below the figure of the Prince, as his mount, in an arrested posture, paws the air above the brownish foreground, and so increase the monumentality of the composition.

As for the portrait of the King (cat. no. **71**), Beruete perceptively noted that its execution is "even freer" than that of the Prince, and that Philip IV is "here represented in the fullness of absolute power and grandeur, in the brilliancy of such triumph as the most fortunate heroes of ancient or modern times have seldom known". Since Beruete was censorious of Philip IV, he concluded that "Velázquez in this picture, more than in any other, seems to have wished to redeem by idealization of the outward form the unworthiness and moral ruin of his model".[102] The critic was certainly right in his views about Philip who, in a feeling of abject penance, considered himself weak-willed and a sinner, hopelessly incapable of making himself worthy of his royal task.

There seems to have been a friendly closeness between Philip and Velázquez from early in their association. Pacheco tells us that the King kept a key to Velázquez' studio – which was at the Palace – and had a chair there where he sat almost daily watching the painter at work. One can assume that Velázquez would not have gone on painting uninterruptedly during the King's visit, and that conversation took place between the two men. It is even likely that Philip, who was given to speaking or writing about his weaknesses to those he trusted, had a confidant in his painter. Whatever the depth of their relationship may have been, Velázquez must have realized, like any observant person who was close to Philip, the nature of the King's shortcomings that led him throughout his life to put up an ineffectual fight, made all the more agonising by the sincerity of his religious sentiments, against his personal sexual proclivities and the

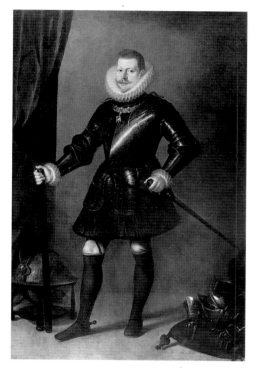

Pedro Antonio Vidal
Philip III
c. 1620
Madrid, Museo del Prado

Peter Paul Rubens
Philip IV
(Destroyed by the fire of 1985)
1628–1629
Zurich, Kunsthaus

heretics and dissidents who were the enemies of his kingdoms. Yet, in his portraits of the sovereign, beginning with the bust-length portrait of 1623 or 1624 (cat. no. **28**), Velázquez never aimed at a characterization of Philip's natural bents. Neither did he ever represent the King, allegorically or otherwise, as a warrior in either action or victory.

In 1628–1629, Rubens, at the peak of his success, was in Madrid, where he made several portraits of Philip IV.[103] One of them, now lost, was a religious allegorical composition, representing the King on horseback, victorious over his enemies. In those portraits which are extant, the Flemish master gave his royal sitter an animated though stately appearance, with strong contrasts of light and shade modelling the lively face. It has been quite rightly said that Rubens "painted the King as an elegant nobleman" (p. 101).[104]

Velázquez, whose prestige was then rising at the Court, had to reckon with these portraits of Rubens. He probably watched the famous master painting them, and certainly witnessed their success. Yet he never imparted any sensuous liveliness to his portraits of King Philip IV, Rubens-like or otherwise. Neither did he ever emphasize the luxury of the King's costume or adornments, not even when he portrayed him in magnificent attire, as he did in 1631–1632 and in 1644 (cat. nos. **52** and **100**). In this respect, a comparison of two portraits of Philip in black dress, one painted by Rubens in 1628–1629 and the other by Velázquez in 1626–1628, is enlightening. This shows that, contrary to Rubens (p. 101), Velázquez did not see the King as just one more nobleman (cat. no. **36**). Indeed, however close Velázquez may have been to the spectacle of Philip IV's melancholic moods and frustrating ways it was the august nature of the monarch that he put on canvas, leaving for others to record what was incidental in Philip IV's appearance, as well as the external attributes of his royal power.

Some time before 1638 Pacheco wrote, and he must have gained the information from his son-in-law himself, that when Velázquez made the equestrian portrait of Philip IV he had the monarch "seated for three hours at a time, all that élan and grandeur suspended". The Spanish expression, *"suspendido tanto brio y tanta grandeza"*, has a lilt which is somewhat startling in Pacheco's text and may well reflect Velázquez' own words.

It is obvious that Velázquez did not depend for the composition of this portrait on any of the works familiar to him. Unlike Rubens he had no use for allegories. He did not represent the King, as Rubens had done with Philip II, on a scale made colossal by the low horizon line and the diminutive figures that fill a battle-field in the middle distance (p. 58). Monumental though it is, there is nothing colossal about Velázquez' composition, which in just this regard bears comparison with Titian's *Charles V at the Battle of Mühlberg* (p. 58).

Titian represented Charles V at Mühlberg as a warrior in full armour, setting into the open from the lee of a tree's shadow. This forward motion is made more vivid where the Emperor grasps the lance and the prancing horse lowers its head and raises its forefeet off the ground. The strong diagonal of the lance enhances this sense of motion and strikes a strong contrast with the imposing figure of the Emperor who, his character traits emphasized, masters, with his bearing and mien, the action into which he stirs his mount. So unerring a live personification of the idea of the Caesar is what makes this one of the greatest portraits of all time. In its own day it led Pietro Aretino to fancy that, rather than by Titian, it had been painted "by the hand of that idea that Nature imitates in live andspiritual design" – a cogent expression of what the vying of art and nature was understood to mean in those years of the Renaissance.[105]

Velázquez' *Philip IV* is a flawless painting. The fluidly brushed surface and texture is luminous at every point, from the King's half-armour and the pink

Prince Baltasar Carlos on Horseback
1634–1635
Cat. no. 72

RIGHT PAGE:
Detail of no. 72

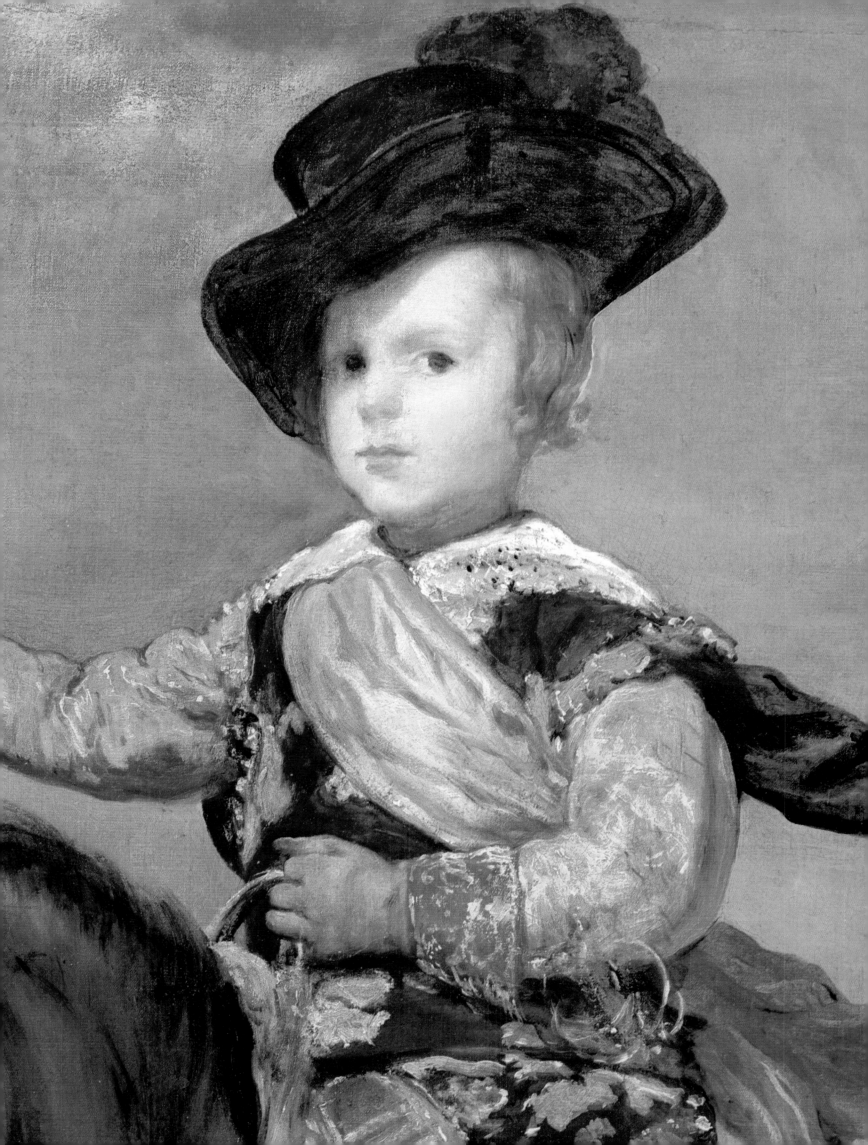

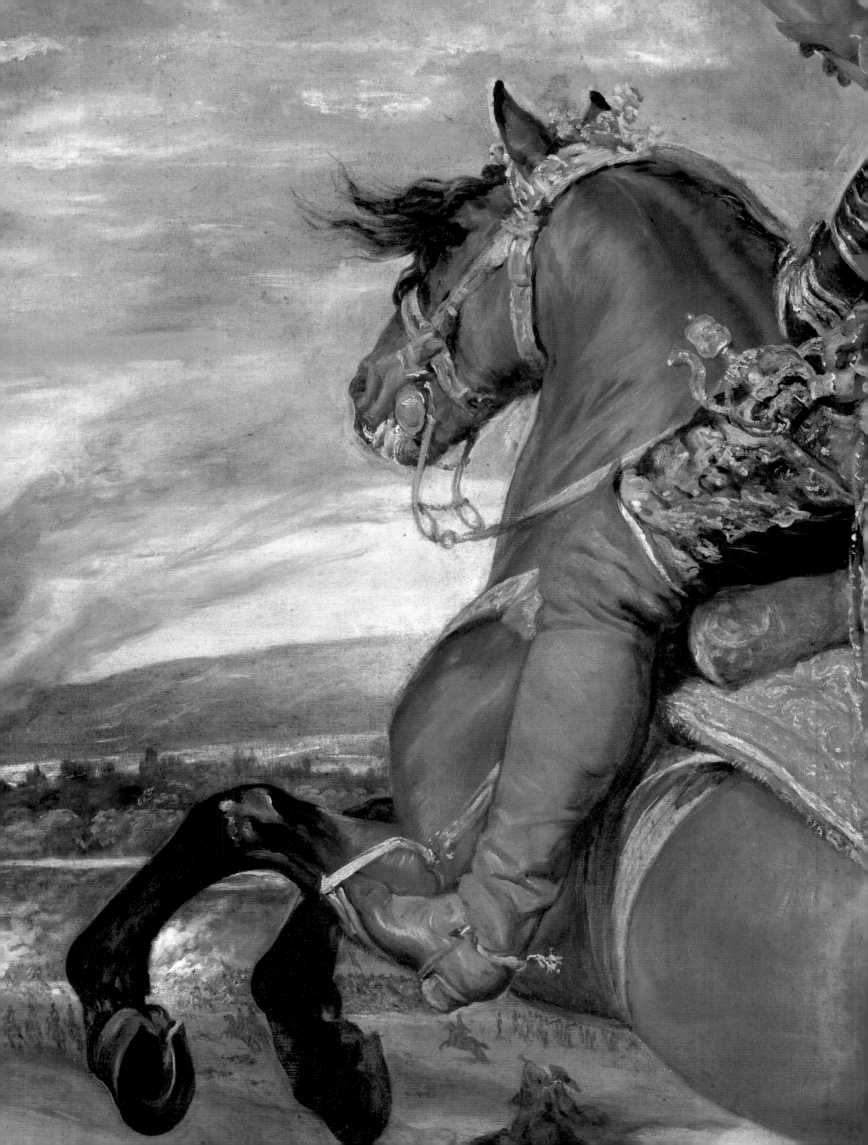

and gold of his costume, to the white and chestnut hues of the horse, and the greys, greens and blues that extend to the background in the landscape. This portrait must have appealed to those who held that the King's duty, unlike a captain's, was not to fight but to rule, as Gracián put it in 1640.[106]

The equestrian group is in full profile but for Philip IV's head, which is slightly turned to the right, thus adding to the effortless pose with which he holds the baton in one hand and the bridle in the other, while the spirited horse rears back in mid-gallop, arresting his own movement and that of the King's scarf, into a monumental pose. Lit-up from an invisible centre in front of him, the halcyon figure of Philip outshines the radiant expanse which spreads around and below into the horizon to form a limpid image of the absolute monarch.

More often than not, Western painters have achieved verisimilitude in their portraits. Yet a portrait's truth to the sitter's physique – seldom verifiable for long or by many – has rarely been of lasting consequence. What has always mattered, at the time the portrait was painted and ever after, is the self-sufficient image into which the painter has fashioned his sitter. The painting is all-important, even when minute likeness has been the painter's aim and achievement.

In *Philip IV, Equestrian*, Velázquez achieved a painting of monumentality that is unadorned either by allegorical array or by architectural pomp. In it, the person of the King is, at one and the same time, seen vividly on the earth and yet also transcends this position. When this painting is set beside compatible portraits of Philip IV, including copies of this one, or even the first likeness of him which Velázquez put on canvas in 1623 and painted out soon after (cat. no. **36**), it can be seen quite how divergent from all others, how compelling and inimitable was the image of the King achieved in the portraits by Velázquez' hand which have come down to us (cat. nos. **38, 52, 63, 100** and **120**). Where this image of Philip IV remains compelling, unique and vital those paintings that may have been closer likenesses of Philip appear today as of little more than anecdotal significance.

The Surrender of Breda
Detail of no. 73: Justin de Nassau

Workshop of J. A. van Ravesteyn
Justin de Nassau
Amsterdam, Rijksmuseum

LEFT PAGE:
Count-Duke of Olivares on Horseback (detail)
1634
Cat. no. 66

Olivares, equestrian

Most writers on Velázquez have observed that his portrait of Olivares on horse-back (cat. no. **66**) is as fluidly painted as those of Philip IV and Prince Baltasar Carlos, though it is less luminous than either of the others. The chief minister wears black half-armour inlaid with gold, gold-braided dark trunks, a purplish scarf and a grey hat with mauve plumes. He is seated on a chestnut horse at the edge of a cliff against a cloudy sky made sombre by the blue-grey smoke which rises high from a burning town in the background. Despite facing towards the spectator, both his commanding gesture – with the baton raised in his right hand – and his high-spirited mount are directed towards the battle raging below in the middle distance.

Cruzada, and others after him, have suggested that the battle depicted is the one fought in the autumn of 1638 at Fuenterrabía, where the French were defeated by the Spaniards.[107] Even though Olivares, never really a military man, had not moved from Madrid, the victory was credited to his strategy and leadership. As the King rewarded him with a great many honours, the Count-Duke seized the opportunity of re-establishing his political prestige, which had been on the wane for some time. It has been suggested that Velázquez painted his equestrian portrait at this triumphal time, late in 1638 or shortly thereafter.

Yet, as shown before, the role of Olivares as the architect of the monarch's military victories was current at the Court by 1635, finding pictorial expression in Maino's painting for the Buen Retiro Palace. Since, in point of execution, the equestrian portrait of Olivares admittedly resembles those of the King and the Prince painted about that time, there is no reason to suggest that it was painted significantly later. As for the military action that is depicted, no specific one was probably intended. The battle scene would have been the more expressive of Olivares' power and success by not referring to any particular event.

The dynamic, bold rhythm of the composition is carried by a number of lively diagonals – the horse, the sword, the baton, the smoke, the cliff – that are all keyed to Olivares' bearing. Slashing lights enliven the modelling of the horse. The textures of the rider's costume and of the mount's trappings look rich and weighty as they sparkle with Velázquez' sureness of touch. As in the equestrian portraits of Philip and his son, Olivares' head is vividly captured. It is, as Beruete noted, the highest light in the picture, even though the shadows on it are narrowed rather than thinned and in the face he has captured his character well. It is in this coherent composition that the Count-Duke embodies, in his gestures, of command and self-assertion, both the turmoil of the bloody battle depicted below and the bustle and glow of victory. This lusty image of worldly success is plainly different from Velázquez' portrayal of the King's absolute power and grandeur.

Any portrait, even a masterpiece, lends itself to anecdotal interpretations. It is not surprising that flattery has been found more than once to be the key to the understanding of Velázquez' three equestrian portraits. Flattery of the charming little heir to the throne, of the inept and profligate monarch, and of the ambitious chief minister. It is quite that likely Velázquez' equestrian portraits as well as others, gave rise, in his day, to some caustic remarks about the sitters not quite looking their parts. Yet it is unlikely that the portraits were held to be faulty on this score or suspected of flattery. That a majestic quality was observed in Velázquez' works is obvious in Gallegos' poem on the Buen Retiro Palace. This poem refers to, or describes and praises, a great many paintings, but the emphasis is on those by Velázquez, each one of which is given prominence at one time or another. Without entering into a full discussion of

The Surrender of Breda
Detail of no. 73: Don Pedro de Barberana

Don Pedro de Barberana y Aparregui
Detail of no. 57

Gallegos' views, I may point out that time and again he bestows on Velázquez' art the attributes of the monarchy, even if using some shopworn words; thus, Velázquez' brush is "sovereign", or "a sceptre" which attains a "miraculous monarchy". His painting summons up a deathless world in which the artist depicts in a "sovereign manner" all the affections of the soul. This world created entirely by Velázquez' mastery of the artifice of his craft, chooses Philip IV as monarch, and in this way offers him a "more lasting empire".

It might again be argued that Gallegos was just currying favour with both the King and his painter. Yet even those minded to regard Gallegos' poem as a piece of double-barrelled courting, must realize that some of Valázquez' contemporaries saw the world which he created and the one in which he lived as heightening one another and having the person of the King as their common centre – which the Master's portraits reveal by themselves.

Velázquez' portrayal of military victory

The Surrender of Breda (cat. no. **73**) represents Ambrosio Spínola (1569–1630) receiving the keys of the conquered city from Justinus of Nassau.[108] Spínola was one of the most able generals in the service of the Spanish monarchy during the course of the Thirty Years' War. He had served in the armies of the Spanish King since his youth, and had made a military reputation for himself in Flanders where, in 1604, he conquered Ostend; an action for which he was rewarded with the Golden Fleece. Later, in 1621, as he was besieging Jülich, Philip IV, who had just come to the throne, made him Marquis of los Balbases. In August 1624 he undertook to conquer Breda, the key fortress of Antwerp, which was defended by Justinus of Nassau.

The siege of Breda was a test of power between the Netherlands and Spain that was eagerly watched by the rest of Europe. It was also a decisive contest between two famous generals, both of whom were well versed in the arts of fortification, and had their reputations at stake. Spínola, reputed to be the foremost military engineer of his time was foiled, time and again, by Justinus of Nassau's ingenious schemes for breaking the siege. At one point Philip IV wrote to his great-aunt, the Infanta Isabel Clara Eugenia, governor of Flanders suggesting that she should consider "whether it would not be better to summon back Spínola from so lengthy a siege, of such doubtful an outcome". Finally, as the beleaguered city was entirely cut off from the outside, hunger forced Justinus to seek an honourable capitulation. Spínola, though the victory was already his, granted unusually generous terms.

The formal surrender took place on 5 June 1625. The citizens who so wished were allowed to leave the city with their possessions and the defeated army were granted the privilege of marching out carrying their arms and their colours. Spínola sat on horseback outside the city attended by some of the noblemen in his army. He had forbidden his troops to jeer at, or otherwise abuse, the vanquished Dutch. According to a contemporary report, he himself saluted Justinus, who came out of the city first, followed by his wife riding in a carriage, and the leaders of his defeated army, and they returned his salute with "composed countenances and voices, and with a modest movement of the banners".[109] Another account relates that the victorious general spoke words of encouragement and cheer to Justinus and his wife, and ordered some of his Spanish and Flemish officers to escort them.

Spínola's generosity was gratifying to the Spaniards and the terms of the surrender were ratified, even though some held that he had been overgenerous

The Surrender of Breda
Detail of no. 73: Spanish soldier

The Forge of Vulcan
Detail of no. 44

in granting the capitulation. Magnificence and magnanimity were at that time kindred sentiments. The christian belief in the fleeting nature of human splendour and glory made them more so, even during the course of bitter religious wars.

None of the accounts of the surrender published before Velázquez depicted it on canvas says that Justinus delivered the keys of the city to Spínola nor that the victor embraced the defeated general. However, Spínola's success and unusual clemency obviously lent a certain substance to the imagination of some such episode.

News of the surrender, brought by a special courier, reached the Spanish King at Madrid on 15 June.[110] Both Philip IV and Olivares rewarded the courier generously, and the victory was greeted with relief and cheer at the Court. On 9 August, Pope Urban VIII sent a letter to the Infanta Isabel Clara Eugenia expressing his delight at the "glorious victory" against an "iniquitous" and "cunning" enemy. He urged her to ensure that "heresy, the father of falsehood and sedition, should be torn from the heart of the inhabitants of Breda". At the same time the Pope wrote to Spínola that "Heaven rejoices at your victory, whose hands are bathed in the blood of the heretics".

Later, Calderón de la Barca wrote a play, *The Siege of Breda*, that was presented at the royal Alcazar in Madrid. It is likely that the young Velázquez, as the King's painter, would have seen this performance at Court. The play closes with the delivery of the keys by Justinus of Nassau who, in so doing, sees Fortune turning even the most powerful monarchies into dust, while at the same time Spínola tries to raise him from the gloom of defeat with the words, "the valour of the conquered makes the conqueror famous". With these words, in which there is self-regard though not self-complacency, the conqueror's stature is enhanced by that of the conquered and the banners of Spain are raised on the fortress to the accompaniment of victorious music and shouting.[111]

The Surrender of Breda differs essentially from the other extant pictures of military victories which hang at the Buen Retiro. Nearly all of them resemble one another in their compositional pattern except for Maino's *The Recapture of Bahia*. Whether their subject is a battle or an act of surrender, the victorious Spanish general is at one side on a rise above the area where a land or a sea battle is depicted on a markedly lesser scale, as if on a backdrop.

It is known that Velázquez made many drawings even though only a few, including two for *The Surrender of Breda*, are extant. It is most likely, however, that he made more for so important a work, whose process of execution appears to have been somewhat complex, hardly distinguishable, in fact, from that of composition.

X-ray photographs made in 1960 revealed the overlapping of many changes hitherto hidden to the naked eye. For instance, Velázquez altered more than once the view of the horse on the foreground, and the stance of several figures, including Spínola's. As for the lances, which were to become a cardinal compositional element, they were not initially included (cat. no. 73).[112]

The overall composition appears to have been "drawn in paint" on the canvas, to use an expression applied at the time of Velázquez' death to a painting left unfinished by him. As he then went on with his work, his mind's eye would time and again challenge the very shapes which he had brushed on the canvas and which he painted off, frequently with light strokes that now let them come through as live evidence of creation. He then brushed new shapes on the canvas, occasionally perhaps with the help of preparatory drawings or sketches.

By this technique he no doubt strayed from the teachings current in the 1630s with regard to composition and execution. As explained by Carducho, it

was usual for the master to begin with the composition's preparatory drawings. The sketch then had to be transferred to the canvas either by the master himself or by one of his assistants. Colour was then applied with brushes by either one of them, but the final and definitive touches had to be made by the master himself.[113]

X-ray photographs of this and other Velázquez paintings, along with the *pentimenti* that are plainly visible in many of them, help us to understand the process that shaped his works in responding to pictorial challenges of his own. In *The Surrender of Breda*, an aerial perspective organizes the whole composition in bringing together the essentials of the narrative, from the trenches, waterworks and blockhouses in the background, and the light-hued, pink, yellow or blue army dresses of the defeated men who march past with their arms and colours in the middle-distance, to the scattering of Dutch soldiers who wearily cluster together as a distant column of smoke rises higher than their pennons. The unwearied Spanish officers, bareheaded for the solemn occasion, are massed, behind their leader, around the flag of the Infanta Isabel Clara Eugenia, while their troops look on from under their slouched hats.

The gesture and bearing of the soldiers captures a variety of emotions and moods giving the otherwise anonymous groups of soldiers a human face. There are faces which are sharply illuminated and modelled in the round, while the features of others are distinctly shaped by graduated shadows, or others, still, are lit or shadowed by what Quevedo called distant blobs. This imaginative handling of light and pigment endows the whole composition with a sense of depth and airiness.

It is a full-toned picture, with a richness of yellow, ochre, blue, green, rose, and purple hues, fluidly brushed in. It portrays both the misery and the splendour of the scene of surrender as its brilliant tints draw into a luminous whole

Antonio de Pereda
Deliverance of Genoa by the Second Marquis of Santa Cruz
1634–1635
Madrid, Museo del Prado

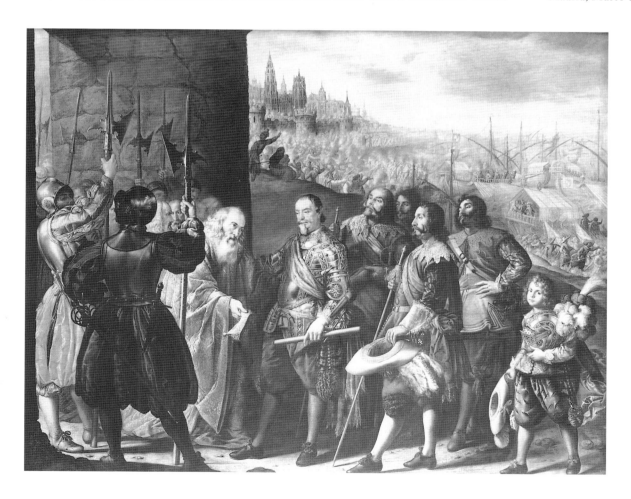

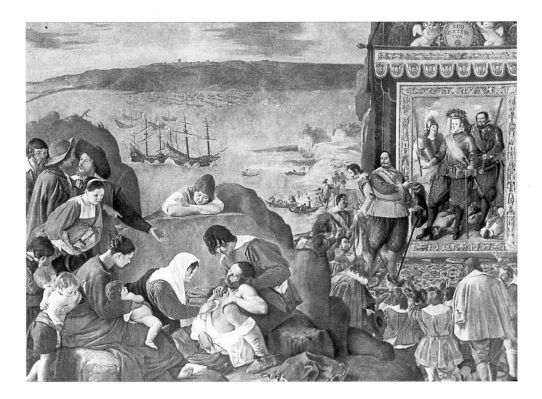

Juan Bautista Maino
The Recapture of Bahía
1634–1635
Madrid, Museo del Prado

the dust-hued colours that have been sparingly used in the depiction of the field and the defeated.

The group of Dutch soldiers comes to the fore, where a few stand on a mound, fatigue showing, both in their faces and in the manner in which they hold their pennons. Others are comely figures like the blobs, one in shadow, the other in light, of the two young men seen in profile – who recall Apollo in *The Forge of Vulcan* (cat. no. **43**) – or the light-splashed youth, clad in white and blue, who silences with a gesture of his right hand the fellow officer whispering at his ear.

The victorious and the defeated generals meet in a sort of clearing bounded by two slight elevations in the foreground. On one of these Spínola's horse stands restlessly, while Dutch soldiers wearily group themselves on the other. Spínola stands on a patch of green circled by the barren ground over which Nassau steps. Lively diagonals maintain the dynamic of the overall composition; intercrossing, running parallel, or meeting in the far-off distance. The most obvious of these diagonals is the one marked by the Dutch soldier standing, his back to the spectator, in the foreground and the Spaniard with the musket on his shoulder seen across him, which is itself intercepted by that established by the two horses. The shouldered weapons of the Spanish musketeers run parallel with those of the Dutch, and the lines which run along the front row of either group funnel through into distance.

As Justinus of Nassau, with a slow and heavy tread, steps out from his soldiers to surrender the key of the city, Spínola's arm – its broad, liquid contour a transparent tissue over the bright hues of the defeated troops marching past – bridges the distance between the two, a courtly smile on his pale, intelligent face directed at the mortified hurt on Justinus' weather-beaten visage, where the eyes are heavy with fatigue. The figure of the conquered is certainly not just a foil to that of the victor in this composition where Velázquez has swept even dusty hues into luminosity. Rather, as Spínola puts his arm on Justinus' shoulder, the bearing of the one enhances his human likeness to the other, and the victor's gesture joins in one image the Christian sentiment of charity, and hence of

humility, with the heroic sense of mercy, and hence of greatness – "noblesse" might have been the word for it.

It is possible that Velázquez painted from life some of the officers who had participated in the actual event some ten years before the painting was made. Yet none of the Spaniards or Dutchmen in the composition has been convincingly identified, except, of course, for Justinus of Nassau and Ambrosio Spínola. Some of the Spaniards resemble one another as if they were variations of the same image. The same is the case with the two young Dutchmen seen in profile mentioned above. Similarities, which do not bear on matters of identity, are also noticeable between some of the figures in *The Surrender of Breda* and those in other paintings by Velázquez.

The head of the young man apparently holding the reins of Spínola's horse obviously originated from that of one of the Cyclops in *The Forge of Vulcan*, painted by Velázquez in 1630. Both heads are of similar build, particularly in the shape of the forehead, the emphatic eyebrow, and the setting of the nose. Even though, contrary to the black-haired Cyclops, the blond young man does not have a moustache, their mouths appear rather similar. The young man's face has been executed in a more fluid manner. This handling of pigment enhances the imaginative handling of light in *The Surrender of Breda* and marks a turning point in Velázquez' art. Another such instance ought to be noted. The head of the chestnut-haired Spanish officer immediately behind Spínola – constructed from contrasts of smooth and rough impasto and dim and brilliant light – is clearly similar in proportion and configuration to that of *Don Pedro de Barberana* as portrayed by Velázquez in 1631–1633. This is most evident in the distinctive shape of the forehead and temple, even in the drooping left eyelid. It is plain though that it was not Velázquez' purpose to represent the same individual in both works because he gave a markedly different shape to the Spanish officer's eyebrows and nose. In both figures the interplay of pigments' textures – rough or smooth, bright or opaque – build the planes of the nose and cheeks, the depth of the eyesockets and the roundness of the head. As in the preceding case, there are some variations in point of execution. In the figure of the Spanish officer the contrast between rough and smooth impasto is more vivid and the contour around the head is somewhat broader. Yet, the balance between the rough and the smooth and between lights and darks is comparable in both heads. It is as if Velázquez had used his likeness of Don Pedro de Barberana as a starting point for the representation of the Spanish officer in furtherance of his naturalist intent, without aiming at duplicating the likeness. Even if the image of the Spanish officer were meant to be a portrait, which is rather doubtful, one would have to conclude that it evolved, qua painting, from that of Don Pedro de Barberana (cat. no. 57).

Coming now to the main figures in the composition, Spínola died in 1630 and consequently could not have sat for the painting. Yet, Velázquez had journeyed with him to Italy in 1629 – from Madrid to Genoa if Pacheco's report is accurate – and this has led to the suggestion that he may have sketched the likeness of the great general at that time. There is, however, no documentary reference to any portrait of Spínola that had been drawn or painted from life by Velázquez at that or any other time. It would have been unlike Pacheco, who made a point of recording his son-in-law's successes, not to mention that so famous a man had sat to Velázquez. In any case it is reasonable to assume that Spínola's traits, shape and bearing were alive in Velázquez' mind when he undertook to paint *The Surrender of Breda*.

As for Justinus of Nassau, Velázquez had never seen him in the flesh, nor is it likely that he had at hand a portrait of him. In fact, at the time of the surren-

der, Justinus was sixty-five years old, and Father Hugo then described him as "venerable on account of his white hair".[114] In an undated portrait from the workshop of Jan Anthonisz van Ravesteyn (1570–1657), Justinus of Nassau appears white-haired though somewhat bald (p. 105). However, Velázquez represented Justinus as a man in the vigour of age, with slightly greying hair, certainly not older than Spínola, who was ten years his junior, and whom Velázquez represented with silvery grey hair.[115]

Consequently the image of Nassau that Velázquez put on canvas must have been entirely imaginary or, less likely, based on an unknown portrait executed by another artist long before the date of the surrender in 1625. And yet although Velázquez did not paint Nassau and Spínola from life, both appear as alive in gesture and expression as if they had been. As I suggested long ago this fact should be taken into account by those who decide on the basis of the life-like quality of Velázquez' portraits or figure-compositions whether or not they are painted from life.

Velázquez, similarly, had never visited Breda. However, maps, descriptions and engravings of the city, the battle-field and the surrender were all available to him.[116] The background view of the painting reveals familiarity with, and freedom from, the details they provide (cat. no. 73). The truth of *The Surrender of Breda* is not truth to the physique of the various participants in the action, or to the location, circumstances or incidental details of what happened but rather to the play of sentiments that the painter discerned in the event.

Velázquez painted, in a lively naturalist manner, whatever he had seen, learned, or imagined, be it a popular, historical, mythological, or religious story. He painted as if the final image had emerged on the canvas directly from his mind. Certainly, he was steeped in a live pictorial tradition rooted in Spain and more deeply in Italy, as well as in a Catholic sense of life which was then particularly keen in Spain. Needless to say, such circumstances would not necessarily have turned him into the artist that he was. Still, his works bring them to mind. Nor should we assume that this is so because he worked to a fixed programme – which no true artist ever does. Yet the consistency of his *œuvre* reveals a polarity of the religious and the worldly which was of his day while also being his own creation, and it is because of this that his work has remained unique.

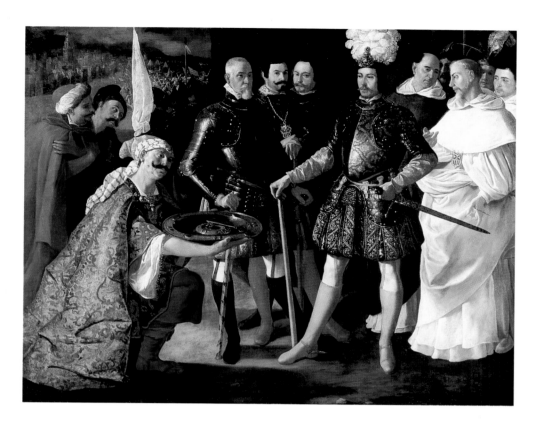

Francisco de Zurbarán
The Surrender of Seville
1634
UK, coll. His Grace The Duke of Westminster

FOLLOWING PAGES:
Detail of no. 78

The traditional portrayal of military victory

The sentiments that Velázquez embodied in *The Surrender of Breda* are unlike any other works of similar subjects. A comparison is provided by *The Surrender of Seville*, signed and dated by Zurbarán in 1634, when Velázquez was possibly painting or at least contemplating the subject of Spínola's victory. Zurbarán's work, probably painted for the Shod Mercederian Convent in Seville (plate 28)[117] represents Ferdinand III, the Saint, King of Castile and León, receiving the key to Seville from the Moors, against whom a decisive victory was won in 1248. This event remained charged with feeling throughout most of Philip IV's reign. As we know, an emotionally related event, the expulsion of the Moriscos, decreed by Philip III in 1609, was chosen as the subject for the competition in which Velázquez, Caxés, Carducho and Nardi took part in 1627 by royal command.

In Zurbarán's *The Surrender of Seville*, the gesticulating and gaudily garbed Moors contrast in both colouring and expression with the sedate figures of Ferdinand III and his religious and military cortege. The defeated Moors are made to look laughable by the over-done expression of obeisance which pervades their faces and gestures – all of which is in keeping with the climate of sentiment which prevailed at the time and which also coloured some of Lope de Vega's plays.

For another contrast, we may look at Jusepe Leonardo's *The Surrender of Jülich*, the city during the siege of which Spínola received the title of Marqués de los Balbases and which he succeeded in conquering on 3 February 1622. Jusepe Leonardo was approximately of the same age as Velázquez, having been born at Calatayud, Aragon, in 1601. He had studied with Pedro de las Cuevas at Madrid, where he then became a disciple of Eugenio Caxés, as his friend Jusepe Martínez wrote and as compositional elements in his works tend to confirm.[118] Yet, like other painters active in the Madrid of the 1630s, he tried without success to approximate Velázquez' manner and at least once lifted a figure from one of his works.[119] He became insane in 1648 and died at Saragossa four or five years later.

Like *The Surrender of Breda*, *The Surrender of Jülich* was painted for the Buen Retiro and it too represents Spínola receiving the keys of a city from a vanquished Dutch general, while the defeated troops march past with their arms and colours in the distance. The surrender takes place on a rise above a view of the battle-field, and the city is depicted on a much smaller scale as if on a drop curtain, with no aerial blending of the two spaces. That had been Leonardo's manner of emphasizing the main episode and detailing at the same time other incidents of the narrative. In the foreground scene, the Dutch general, fear showing on his face, kneels as a Spanish officer directs him to surrender the keys to Spínola who, sitting on a restless horse, bends slightly to receive them. The victorious general is the apex of a pyramid which has for sides the diagonal which leads to the kneeling Dutch general and the one leading to the Spanish officer firmly planted on the left. The contrast between the victors and the conquered is heightened as the two Dutch soldiers by their general's horse recoil at the hurt and shame of the surrender. It is a narrative of victory, with emphasis on incidental fripperies, dramatized for the victor's sake. Its composition, rather commonplace in the 1630s, conveys a crudity of feeling not unlike that which pervades many a still or motion picture which has recorded similar twentieth-century events.

Prince Baltasar Carlos with the Count-Duke of Olivares at the Royal Mews
c. 1636
Cat. no. 78

RIGHT:
Detail of no. 78

The royal hunting lodge

Hardly had the Buen Retiro Palace been completed when Philip IV started another project which kept Velázquez busy for several years. In January 1636 the King decided to enlarge a hunting lodge at El Pardo, near Madrid, known as the Torre de la Parada.[120] As part of the refurbishment he ordered a large number of paintings from Rubens, who, given the urgent nature of the commission, made over sixty colour sketches of subjects from antiquity, most of them taken from Ovid's *Metamorphoses,* in less than one and a half years. However, few of the final works were by his hand, as he entrusted the execution of most of them to his assistants and other painters, including Jacob Jordaens. On 24 October 1636, in a petition to the King for payment of back salaries Velázquez explained that the money would enable him to carry out the King's order to paint pictures for the Torre de la Parada.

The rebuilding of the Torre de la Parada was apparently completed by the end of March 1638. However, the paintings executed for it by Rubens, or by other painters after his sketches, did not arrive in Madrid until about two months later. Velázquez must have been occupied for a longer time with the decoration of the hunting lodge, not only selecting and hanging pictures by those and other painters, but also executing paintings for it himself.

Unfortunately there is no record of when, if ever, the decoration of the hunting lodge was regarded as finished in Philip IV's time. Nor is there any helpful contemporary description of it.[121] The earliest available record of the paintings which decorated the hunting lodge after its refurbishing by Philip IV is the inventory compiled on 7 April 1701 following the death of his successor, Charles II. It included one hundred and seventy-three paintings. This number might have been larger or smaller than the original amount; thirty-five years had elapsed since the death of Philip IV, and most of the royal residences had undergone changes, some due to mismanagement, during that time.

Together with the mythological and other subjects from antiquity painted by Rubens or executed by others after his colour sketches, there were many pictures of animals and hunting scenes by other Flemish masters, notably Paul de Vos. Velázquez' works included the portraits of King Philip IV, Prince Baltasar Carlos, and the Cardinal Infante Don Fernando, all three clad for the chase; the pictures of *Mars, Aesop* and *Menippus,* the portrait of the dwarf Francisco Lezcano, and that of *A Dwarf Holding a Tome on his Lap* (cat. nos. **63, 64, 77, 92, 93, 94, 99** and **102**). The three hunting portraits may have been taken to the Torre de la Parada in 1638 after the reconstruction was finished. The other five paintings, however, were not painted by Velázquez until later, most probably between the late 1630s and mid-1640s.

The decoration of the Torre de la Parada must have added to Velázquez' work and chores, but it also increased his stature at the Court. On 28 July 1636 an astute observer of life at the Court reported that the King had just appointed Velázquez "Gentleman of the Wardrobe, without duties", and commented that the painter's ambition went higher – that he aimed at becoming "gentleman of the Bedchamber" (as he, in fact, did seven years later) and at wearing the robe of a military order like Titian, which Velázquez also achieved late in life. As Ortega y Gasset noted, these predictions reveal not only the sagacity of he who made them, but also that neither did Velázquez pursue his ambitions for advancement at the Court, nor did the King grant them, in a haphazard manner, since, to both, royal preferment marked a *cursus honorum.*[122]

A White Horse
c. 1634–1635
Cat. no. 67

Philip IV as a Hunter
c. 1632–1633
Cat. no. 63

LEFT PAGE:
Detail of no. 63

Prince Baltasar Carlos as a Hunter
1635–1636
Cat. no. 77

RIGHT:
Detail of no. 77

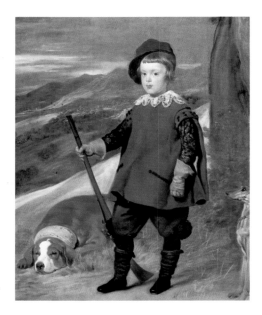

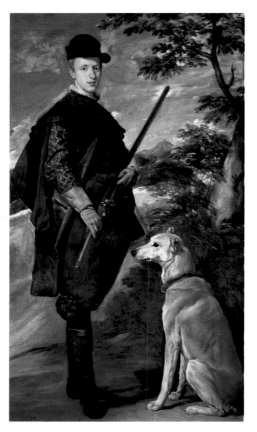

The Cardinal Infante Don Fernando as a Hunter
c. 1632–1633
Cat. no. 64

RIGHT PAGE:
Detail of no. 64

The royal hunting portraits

The three hunting portraits painted by Velázquez are life-size. Their heights vary from 1.89 m. to 1.91 m., but their widths differ markedly, the King's being the widest at 1.25 m., and the Prince's the narrowest, at 1.03 m. The latter, however, has been cut down on the right by at least ten or fifteen centimetres, and even more if the original composition included three dogs as three extant workshop replicas do. There is no indication that the portrait of Don Fernando was originally wider than its present 1.09 m. The original sizes of the canvases and the changes that they have undergone might eventually prove useful for ascertaining the place assigned to them when they were first hung in the Torre de la Parada.

The portrait of Baltasar Carlos bears the inscription *Anno aetatis suae VI* (cat. no. 77). Since he was born on 17 October 1629, the portrait must have been painted either late in 1635 or in the following year. The latter seems the more likely since it is documented that Velázquez was at work on paintings for the Torre de la Parada in 1636.

The dating of the portraits of Philip and his brother is a somewhat harder problem. The head of the King – who was originally bareheaded – is quite close to that in the portrait that Velázquez painted soon after his return from Italy, that is, in 1631 or 1632 (cat. nos. **52** and **53**). It looks, indeed, like a replica with no significant variations in point of execution. *Pentimenti* and major corrections are noticeable to the naked eye in the painting. Something of their sequence can be gathered from the early workshop copy in the Castres Museum. Velázquez,

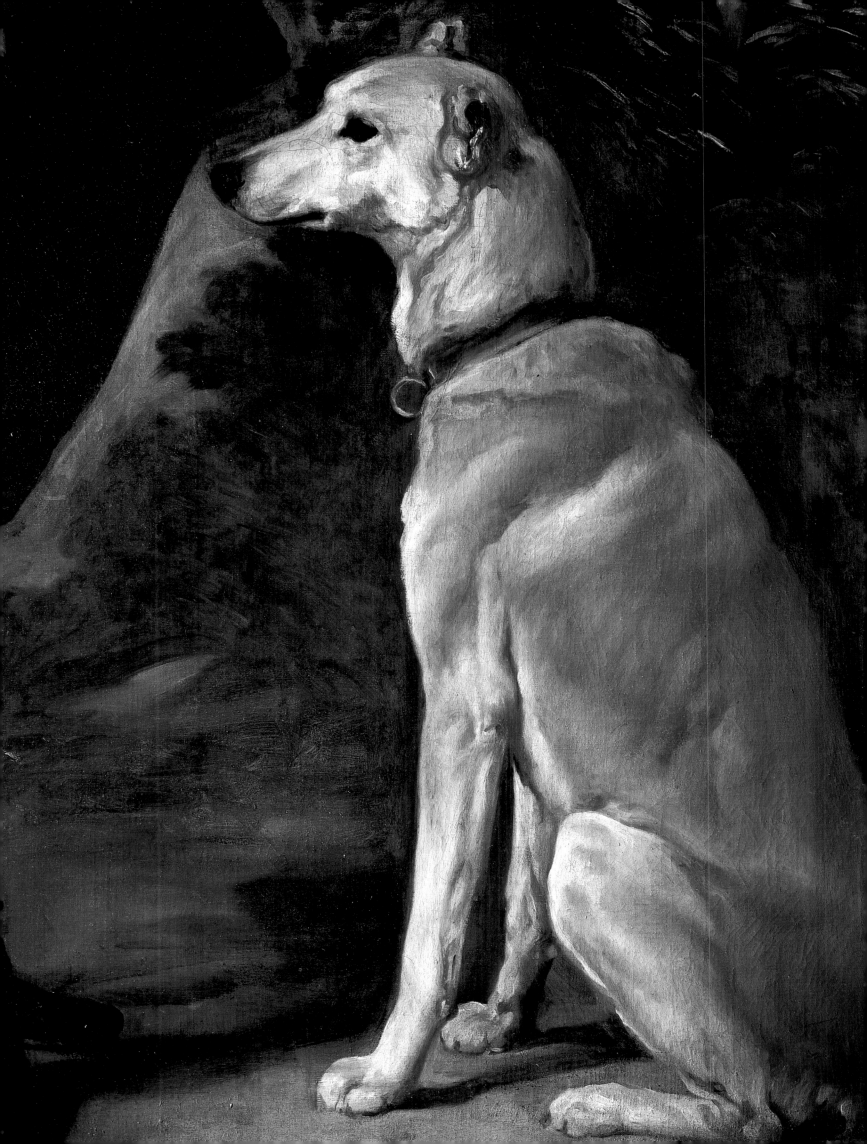

after sketching the figure on the canvas, altered its stance considerably, as revealed by the substantial *pentimenti* running from the waist to the feet. At that point in the process of composition, the King was represented holding the cap in his left hand, as he appears in the copy in the Museum of Castres. At a later date Velázquez painted out the cap – whose shape is now seen overlaying the earlier *pentimento* around the waist – and depicted the King wearing it. Laboratory tests might give an indication of the length of the interval between those two major changes. Yet the execution of the painting suggests a date rather close to the London portrait of Philip IV in brown and silver and that of Baltasar Carlos with a dwarf, and consequently it could not have been painted much later than 1632 or 1633. As for the copy at the Museum of Castres, it must have been executed by an assistant before Velázquez had entirely finished the original but surely before he altered the composition by representing the King wearing the cap, rather than bareheaded.

The portrait of Don Fernando is executed in very much the same manner as that of his brother except for the pictorial handling of the face which, as is always the case with Velázquez, is smoother in the King's (cat no. **64**). Don Fernando was not quite twenty-three years old when he left Madrid on 12 April 1632. He left with the King and his other brother Don Carlos, on a journey to various Spanish cities including Barcelona, where Philip left him as Governor. Two years later he was sent from there to Flanders, also as Governor. He died in Brussels in 1641 without ever having returned to Madrid.

It is quite likely, though by no means certain, that Velázquez, in his capacity as Usher of the Chamber, accompanied the King on this journey, in the course of which he could have portrayed Don Fernando in Valencia, Barcelona, or any other city where the royal party stopped. That Philip IV, even before his decision to refurbish the Torre de la Parada, would have liked to have a portrait of his brother Don Fernando clad for the chase, would seem quite natural since hunting was the favourite sport of both of them.

Pacheco tells us that it was in the entourage of the Cardinal Infante, the then fourteen-year-old Don Fernando, that Fonseca first succeeded in creating an atmosphere favourable to Velázquez at the Court in 1623. Indeed, Velázquez' initial success came when he was commissioned to paint the portrait of the Cardinal Infante, though, to his greater advantage, it was then thought more advisable that he should first portray the King. In consequence, it is likely that Velázquez painted a portrait of Don Fernando before the one in hunting costume – which, as the broad brushwork indicates, and the sitter's appearance confirms, must have been painted, not necessarily from life, in 1632 or 1633. This is the only likeness of Don Fernando unquestionably by Velázquez which has come down to us.

In this portrait, Don Fernando hardly looks older than his twenty-three years in 1632. Therefore, if Velázquez painted it later, he must have worked from memory or from a sketch made at about that time. As with the portrait of Philip IV, there is no stylistic reason to suggest a date later than 1632 or 1633. If we compare the landscape in either picture with that in the portrait of Baltasar Carlos as a hunter, painted late in 1635 or in 1636 (cat. no. **77**), we realize that the depth of the latter sets it apart from the others, and links it rather with those in the equestrian portraits painted by Velázquez for the Buen Retiro no later than 1635 (cat. nos. **71** and **72**). The conclusion suggests itself that the hunting portraits of Philip IV and his brother were executed about 1632 or shortly after, and that some four years later, when Philip IV thought of refurbishing the hunting lodge, he decided to take them there and to add the portrait of his six-year-old son who had already taken up hunting.[123]

Michelangelo
The Thinker
1520
Florence, Tomb of the Medici, new sacristy of San Lorenzo

RIGHT PAGE:
Mars (detail)
c. 1639–1641
Cat. no. 94

In the portrait of Don Fernando, the prevailing tints are grey and ochre, and these contrast with some light-green strokes as well as with the vivid, almost saturated, blue of the mountain in the background. In that of Philip IV, ochres, used in a wide range of hues, dominate over the greys and greens, so that the whole composition is filled with an amber warmth enhancing the luminous face of the King. The portrait of Baltasar Carlos, now extensively restored, is lighter in hue and evenly luminous, the greys and greens of the landscape being keyed to the blues of the sky.

As in other sets of royal portraits, Velázquez has rendered in a different pictorial manner the face of the King. Only the subtlest of shadings have been used in the modelling of Philip IV's face, which is lit up by a light coming from a source other than the one which falls on the dog by his side and finer than that on the landscape. Shadows, however, are used to accentuate the features of Don Fernando in much the same manner as in the portrait of the Infante Don Carlos, painted by Velázquez much earlier, in 1628 (cat. no. 37). Moreover, the lights on his face have the same source as those which fall on the dog beside him, and show the same vivacity of touch as those which light up the landscape.

The portrayal of antiquity

José de Ribera
Aesop?
1640–1650
Madrid, Museo del Prado

It seems rather likely that Velázquez' life-size pictures of *Mars, Aesop* and *Menippus* were painted for the Torre de la Parada (cat. nos. **92, 93** and **94**). They were included in the royal residence's inventory of 1701. This is, of course, too late a date to be regarded as evidence of the paintings' original destination but, as indicated above, there is no earlier available record concerning the decoration of the royal hunting lodge. Nor is there any indication that any of the mentioned Velázquez paintings had been elsewhere before 1701.

The three paintings are tall and narrow and rather close in size: *Mars* is 1.82 m. in height and 0.97 m. in width, and both *Aesop* and *Menippus* are just a bit smaller, 1.79 x 0.94 m. Their height, though not their width, coincides either exactly or within one or two centimetres with a dozen or so of the paintings executed by Rubens and other Flemish painters for the Torre de la Parada, a finding that lends additional support to the surmise that they too had been painted to hang on the walls of the hunting lodge.

The place allocated to them within the residence is another matter, and so is the role they may have been intended to play within a conceptual decorative programme if such a programme did exist. It seems rather evident that *Aesop* and *Menippus* were companion pieces. Beyond that there is little that we know or can reasonably guess since it is likely that paintings were moved about during the roughly a quarter of a century that Philip IV used the hunting lodge and during the thirty-five years which elapsed between his death, in 1665, and that of Charles II in 1700.

The inventory of 1701 groups together *Mars, Aesop* and *Menippus* in a single entry. The other paintings in the same room were a much larger composition by Jordaens *The Wedding of Peleus and Thetis* (1.81 x 2.88 m., Prado, 1634), as well as two over-door and two over-window smaller paintings representing animal subjects, possibly all of them by Paul de Vos (1596–1678).[124]

Aesop and *Menippus* have been variously dated from 1628, that is, before the Master's first Italian journey, to 1660, the year he died. The range of disagreement is narrower for *Mars,* for which the earliest date suggested is 1640–1642, and the latest 1653–1658. Aureliano de Beruete placed the three works in the painter's last years. The current catalogue of the Prado Museum suggests 1639–

LEFT PAGE:
Aesop (detail)
c. 1639–1641
Cat. no. 92

1640 for *Menippus* and *Aesop,* and some time between 1640 and 1642 for *Mars* –
which is plausible, though it would be more accurate, if less specific, to suggest
that the three were painted at roughly the same time, with 1639 as the pivotal
date. In pictorial treatment, and inherent meaning, *Aesop, Menippus* and *Mars*
show an analogy with the second portrait of the jester *Calabazas,* which there is
no reason to suppose was painted after 1639 when he died, and with that of the
dwarf *Francisco Lezcano* that dates from the early 1640s, and was at the Torre de
la Parada (cat. nos. **83** and **99**).

It has been repeatedly suggested that Mars shows a resemblance to an
antique statue in Villa Ludovisi, Rome, as well as to Michelangelo's *Lorenzo de'
Medici* in San Lorenzo, Florence, which Velázquez may have seen in 1629. It is,
indeed, conceivable that ideas of one or the other sculpture, or both of them, came
to his mind when he was at work on the painting. Be this as it may, Velázquez'
composition, in which an unheroic god of war sits on a couch propping himself
with his staff, is essentially different from either sculpture (cat. no. **94**).

Velázquez' *Mars* is a huge gawky figure, whose flabby torso, framed by
broad shoulders and brawny arms and legs, sinks in a shade as his uncouth, dull
and quite human features, touched up by light on the chin and the tip of his
nose, shadow forth under a glittering helmet. The god's slack pose is empha-
sized by the luminous rim of the tilted steel-blue helmet and the diagonal of the
glistening Moorish shield which tops a heap of pieces of armour in the fore-
ground.

The glittering armour and the rich textures of the blue loin-cloth and red
mantle which falls in folds to the floor underscore the weariness of the figure.
The highest light in the composition is the god's left hand, rather indolently
supporting his head, while the other, hidden under the mantle, props his shape
against the staff. It is a masterful scaling down of a god to a human shape – and
a worthless one at that – achieved by a pictorial play on his very attributes,
without detracting from the plastic integrity of the nude.[125] Indeed, Mars is
made into a jester by just the touches of light that underline his bushy mous-
tache and stolid features, by highlighting his hand, chin and the tip of his nose.

Scholars and other writers on the subject have seldom failed to emphasize
the rascally traits of *Mars* and the beggarly appearance of *Aesop* and *Menippus,*
the underlying idea, or even conclusion, being that Velázquez' zest for realism
carried him away from his subject to be true to the knave or the wretch posing
for it. Lately, however, Gerstenberg has convincingly shown that Aesop's lack-
lustre eyes, flattened nose, broad mouth, and thin underlip correspond rather
closely with an engraving illustrating Giovanni Battista Porta's physiognomical
comparison of man's traits with the ox's, and that the objects depicted by
Velázquez at the feet of the Greek fabler – a two-handled bucket with a piece of
leather across its edge, to his right, and a hide set up to dry on the other side –
are implements and materials of the tanner. They refer to Aesop's fable in which
the rich neighbour begins by finding the stink coming from the tannery unbear-
able till he finally becomes inured to it – the moral being the need to reach
equanimity by mastering discomfort (cat. no. **92**). Likewise, the books and
scroll lying on the ground at Menippus' feet in the companion picture point to
his contempt for conventional knowledge and vested interests, and the water
jug on a piece of board supported by two stones stands for his cynical philoso-
phy of freedom from human needs (cat. no. **93**).[126]

Consequently there can be no doubt that Velázquez kept to his intended
subject in each picture. But, of course, the subject of a painting is not the same
as its significance, which is embodied in the shapes brushed in by the painter
on the canvas.

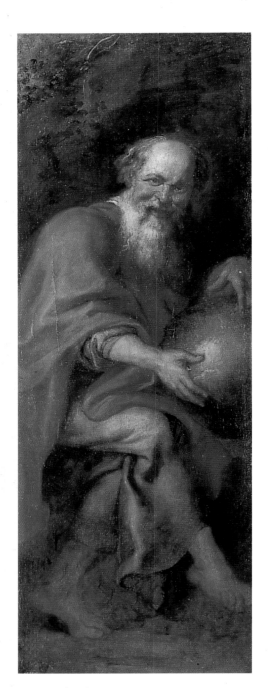

Peter Paul Rubens
Democritus
1603
Madrid, Museo del Prado

RIGHT PAGE:
Menippus (detail)
1639–1641
Cat. no. 93

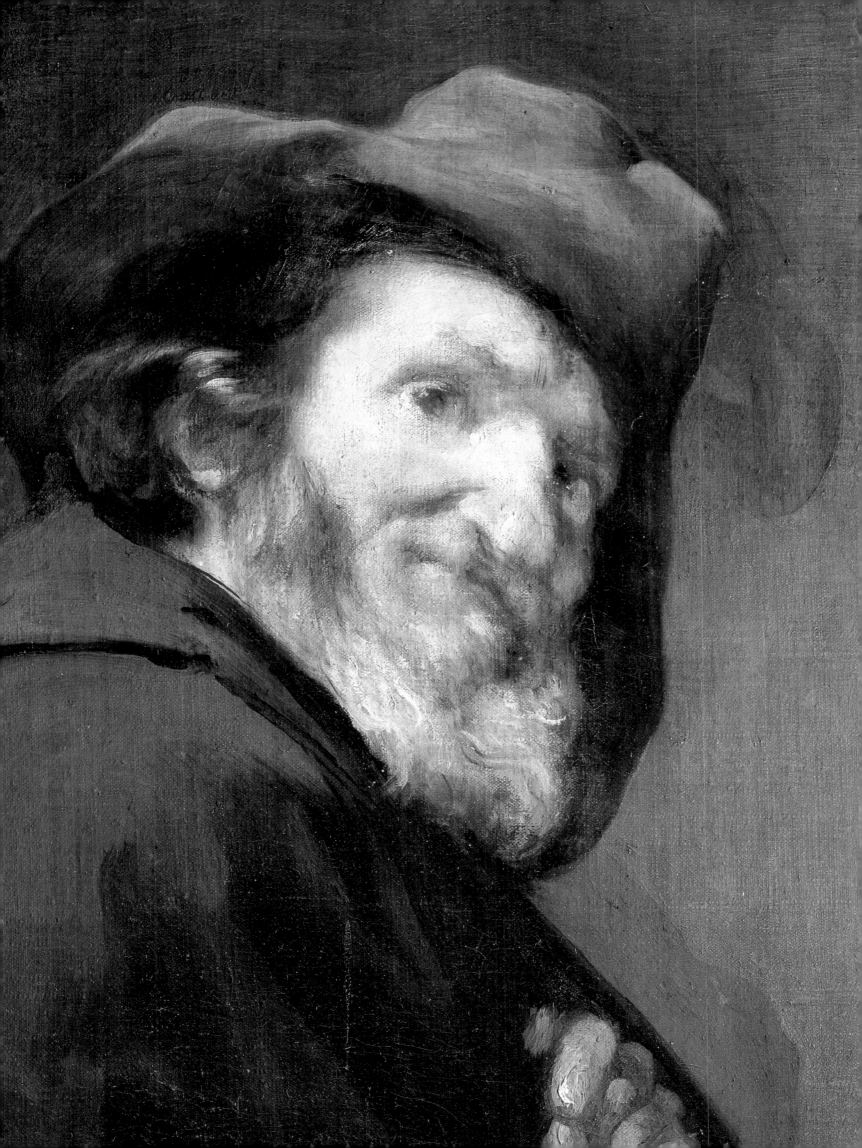

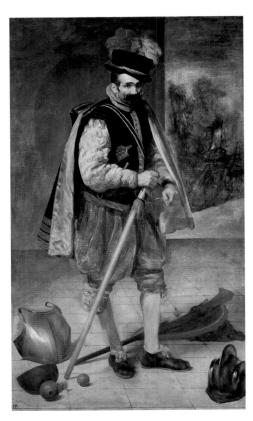

The Buffoon Don Juan de Austria
1632–1633
Cat. no. 65

In the late 1620s, Velázquez had painted a portrait depicting a laughing Democretes (cat. no. 40). This traditional subject, together with that of the weeping Heraclitus, had found space in Marino's *Galeria*.[127] Rubens painted both subjects for the Torre de la Parada.[128] Other painters had earlier represented men of antiquity as guiding thinkers. Ribera was doing so about the time that Velázquez was in Naples in 1630. Rembrandt – to cite the one seventeenth-century painter equal to Velázquez in the effortless use of pigment for sheer expressiveness – was still to paint pictures like the one in which he fashioned the classical bust of Homer into a three-quarter-length likeness of the blind poet, whose figure, monumental and richly hued, is pervaded by the rhythm he is beating out with his hands (The Hague, Mauritshuis, no. 584).[129]

Velázquez' *Aesop* does not seem to be concerned about the condition of the tattered brown robe he wears, while *Menippus,* his legs also in brown rags, is snugly wrapped in a cloak, grey and tattered like his hat. Each of them stands against a neutral background, shadows narrowing the space marked by the floor-line. Everything is subdued and fluidly painted but the wasted faces and gnarled hands, which are accented beyond the descriptive by vivid textures of rough impasto. Each is centred in the midst of the unemphatic symbols of his way of thought, intently looking outside, his bovine or sharp eyes and his ruminating or knowing expression stressing the carnality of his features and, with it, the purely human nature of his knowledge (cat. nos. 92 and 93).

Seen within the Master's *œuvre,* his pictures of *Mars, Aesop* and *Menippus* rank with his portraits of Court fools and jesters, in all of which the sitter's coarse carnality is vividly realised. Within the broader context of Velázquez' Spain *Aesop* and *Menippus* appear as pictorial counterfigures to the *picaro,* the literary type who lives by his wits and sinks beyond salvation, as age withers him into a wretch. As for *Mars,* it has been pointed out more than once that it was not unusual in Velázquez' day to regard mythology as a merry farce.[130] Nor was this derisive attitude peculiar to Spain. Catholic writers in other countries, such as Marino, freely indulged in it on occasion.[131]

Velázquez' depiction of mythological or classical subjects – based as it was on humanistic knowledge – corresponded to a climate of sentiment which in his day led to understanding the world of antiquity as having been formed from human nature and thought. Yet, there is no caricatural distortion in his pictures of subjects from antiquity, which are, on the contrary, endowed with the pulse of life. For instance, the caricatural traits, sharply defined in the engraving illustrating Porta's comparison of man's traits with the ox's, are composed into a human presence in Velázquez' painting of *Aesop* that is palpably alive.

Although Velázquez' humanistic knowledge is woven into his compositions, it ought not to be identified as their theme. What he appears always to be intent on is the life he is in – whose splendour, drollery, coarseness, delicacy, misery, truth and deceit are heightened, but not distorted, by an imagination, at ease and able to embrace both the divine and the human aspects of his religious belief.

Sheer depiction of human nature

Available documentary evidence, supported by stylistic considerations, leads to the conclusion that five of the six extant portraits of identified Court fools, dwarfs and other jesters by Velázquez were painted before his second Italian journey,[132] and there is no reason to suppose that any of the other Velázquez' extant portraits of similar subjects was painted later.

Four of the sitters, Juan Calabazas, Pablo de Valladolid and Francisco Lezcano, died before Velázquez' departure from Madrid in November 1648 or within the next eleven months, long before his return. Neither stylistic nor documentary evidence suggests that any of the four portraits was painted posthumously (cat. nos. **39**, **82**, **83** and **99**). As for the portrait of *Don Juan de Austria*, there is documentary evidence that it was painted in 1632 or soon afterwards, as is also suggested by the composition and execution of the painting (cat. no. **65**).

Dwarfs and jesters had been a feature of European courts and aristocratic mansions for a long time. Their portraits often decorated the palaces of their masters.[133] Velázquez' earliest portrait of any such court retainer is one of the buffoon Calabazas holding a small bust portrait of a woman in one hand and in the other a pinwheel. This children's toy, known in Spanish by a large variety of names, such as *rehilandera, rehilete, reguilete* or *molinillo de papel*, had long been regarded as an attribute of Folly.

A woodcut illustration to *Pazzia* (Madness) in Cesare Ripa's *Iconologia*, published in Padua in 1630, represents a man riding a cane with a children's pinwheel in his hand.[134] For a broader understanding of the subject, I should add that Mateo Alemán in his picaresque novel *Guzmán de Alfarache*, a seventeenth-century bestseller, first published in Madrid in 1599 and translated soon after into every major European language, had personified idle dreaming in the figure of a boy riding a cane and carrying a pinwheel in his hand.[135]

It is evident that Velázquez' *The Buffoon Juan Calabazas* does not correspond to Ripa's engraving of Madness, since the buffoon is not riding a cane. In addition to this, one should understand that the pinwheel was merely a child's toy in Velázquez' day, as has always been and still is the case. In fact, it is possible that Calabazas may well have used the pinwheel, with or without any suggestive intention, in some of his acts as a buffoon.

The nervous, somewhat tight modelling of Calabazas' face, highlighted on the nose and mouth, particularly at the corners of the lips, recalls the figure of Bacchus in the large composition of 1628–1629 (cat. nos. **39** and **41**). This encourages the belief that this portrait must also have been painted before Velázquez set out on his Italian journey in 1629.

As in the face of Bacchus, the smallness of Calabazas' eyes, vacuously looking at something outside the composition, is underscored by the light that broadens the sockets. The squint is emphasized by a highlight, pictorially balanced by another on the teeth. The distortion of the jester's features is also rendered by the shadows that harden the left side of the face and by the lights that dislocate the mouth to the same side. His empty smile quickens our eye to the contrast between his smallish head and torso and his gangling limbs completed with big hands and feet. As he stands, his figure is made restless not so much by his gesture as by the interplaying diagonals of the toy pinwheel, the folding stool, and the shadows on the floor. Despite all this, the likeness of the misshapen buffoon has the fullness of an individual presence.

The paintings that followed are the portraits of the buffoons *Don Juan de Austria* and *Pablo de Valladolid*, both of about the same size, and larger than the

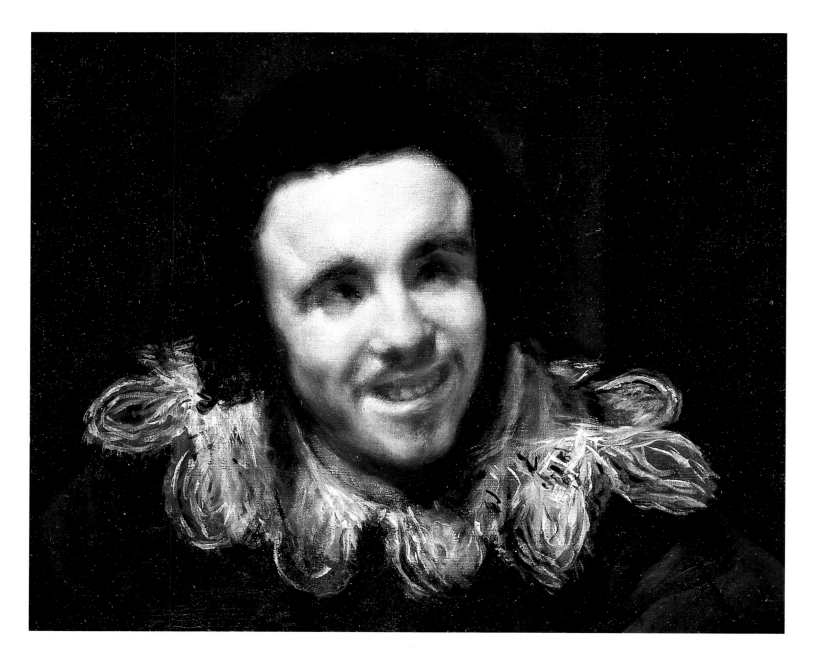

The Buffoon Juan Calabazas (Calabacillas)
(detail)
1637–1639
Cat. no. 83

earlier *Calabazas.* The dating of *Don Juan de Austria* to 1632 or soon afterwards is suggested by a clothier's bill submitted to the King's accounting office that year. This bill lists several pieces of different fabrics to be made into a costume complete with cape and cap for this jester, whose services at the Court from 1624 till 1654 were infrequent. The materials listed coincide, almost to the last detail – as to stuff, colour and quantity – with the velvet and silk attire, in black and pink that he wears in Velázquez' portrait (cat. no. **65**). Court jesters used to mimic famous personalities, and sometimes they had costumes especially made for such impersonations.

The name Don Juan de Austria, probably given to this jester by Philip III or some other royal person, was that of the hero of the naval battle of Lepanto (1571), Charles V's son, memories of whom were very much alive at the time of Philip IV, when the buffoon may have been encouraged, or commanded, to impersonate his illustrious namesake.

Velázquez has represented him in a martial pose, one hand rests on his sword and the other on a baton. The Master was doubtless aware that there was a life-size portrait of Philip III by Pedro Antonia Vidal at the Royal Palace. In this painting the late monarch was represented holding the baton in his right

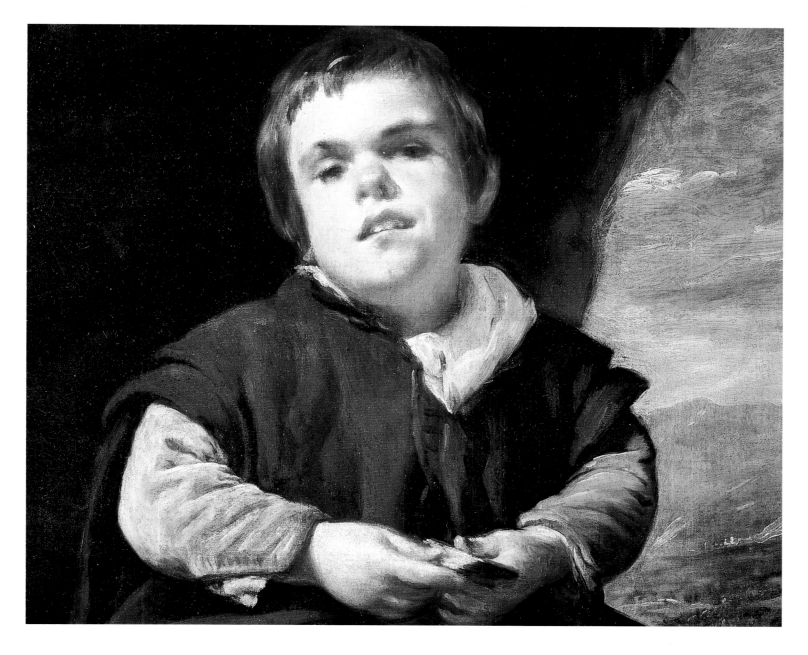

The Dwarf Francisco Lezcano (el Niño de
Vallecas) (detail)
c. 1643–1645
Cat. no. 99

hand and resting the left on the sword, while he stood between a terrestrial globe with his helmet and gauntlets neatly arranged on a black pillow on the floor (p. 101).[136] The comparison invited by Velázquez' *Don Juan de Austria* exaggerated the ridiculous appearance of the dressed-up jester. Although, as we have just seen, Velázquez' portrait illustrates a practice and a sentiment of the time, its full significance lies well beyond that.

The composition recalls the two large pictures painted by the Master at Rome in 1630. As in *Joseph's Bloody Coat Brought to Jacob* (cat. no. 43), the lines of the tiled floor emphasize the perspective that leads towards an open wall in the background. This device is found only in these two paintings in the whole of Velázquez' œuvre. In point of modelling, on the other hand, the face of Don Juan de Austria recalls that of Vulcan in the six-figure composition which was painted by Velázquez in 1630 (cat. no. 44). Another analogy between this mythological picture and the portrait of the jester is the marked diagonal arrangement of the objects on the floor that is intended to further the sense of spatial depth in each work. Velázquez turned *Don Juan de Austria*, as he would later do with *Mars* (cat. no. 94), into a military simpleton, whose spiritless bearing is emphasized by the contrasting splendour of his attire and the mock naval

battle seen in the background, just as the shape of his weary figure is stirred by the interplay of the diagonals indicated by the baton in his hand and the armour and weapons at his feet.

No such distinct interplay of diagonals occurs in the portrait of *Pablo de Valladolid*, of the mid-1630s (cat. no. **82**). Here, the jester's declamatory gesture and stance enliven the empty space, as his well-rounded figure merges into the all-surrounding air, and his countenance is made both pitiful and comic and, as such, quite human by the animated touch which highlights the top of the nose, the slack mouth and the smallish eyes. Velázquez brushed in black upon grey a full and yet surprisingly shapeless man, standing in a space devoid of everything else, depicted just by dint of hue and shade, without even a floorline.[137]

The Buffoon Pablo de Valladolid
c. 1636–1637
Cat. no. 82

These three portraits of buffoons offer, as a group, a view of the consistency and flow of Velázquez' art where his first Italian journey marks a turning point. The nervous, somewhat tight brushwork of *Calabazas* gives way to the rather sketchy strokes of *Don Juan de Austria*. In these two works, however, there is an architectural depiction of space, more fluidly achieved in *Don Juan de Austria* which is totally expunged in *Pablo de Valladolid*. This latter painting is a seemingly effortless masterpiece which was to remain unequalled even within the Master's *œuvre* – a painting, incidentally, that in later centuries won him such admirers as Goya and Manet.

It was probably in a similar vein that Velázquez conceived the portrait of *Don Cristóbal de Castañeda y Pernia* (cat. no. **84**). This jester is known to have been at the Court from 1633 till 1649. His claims to military ability had earned him the nickname of "Barbarroja", made famous in the preceding century by an Algerian pirate. He was also much celebrated for his clownish performances as a bull-fighter, and seems to have been regarded as a king among jesters.

The portrait, most likely begun in the late 1630s, was left unfinished by Velázquez and has remained so, even though another painter worked further on it, mainly on the grey mantle that is draped over the sitter's shoulder. The Master's brushwork is unmistakeable in the painting of the head and hands as well as in the spirited outline of the whole figure. Barbarroja is clad in a red Turkish costume of sorts, which includes a head-piece not unlike a fool's cap. His energetic gesture is at one with his fiery expression stressed by a bristling moustache that, like those of *Vulcan* (cat. no. **44**), *Mars* (cat. no. **94**), and *Don Juan de Austria* (cat. no. **63**), gives a farcical touch to his countenance without distorting it into a caricature. The jester's pose of defiance is pictorially underlined in a spirit akin to that of comedy by his hold on the empty sheath, even stronger than the one he has on the bare sword. Unfinished as the portrait is, it reveals Velázquez' mastery in making the sitter's likeness come alive.

Not long before Calabazas' death, which occured in October 1639, Velázquez portrayed him again (cat. no. **83**). This time the buffoon was represented sitting on a low bench, flanked by two different varieties of gourd – a visual pun upon his name since *calabazas* is Spanish for both simpleton and gourd. The sketchy delineation of space is very similar to that in the portraits of *Barbarroja* and *A Dwarf Sitting on the Floor* (cat. nos. **84** and **103**). The high floor-line underscores the dwarfish torso of the jester, whose gangling limbs and flowing green robes are piled in a heap that reaches the foreground. His head is a shadowy blob roughed out by thick lights and circled around by the striking brilliancy of a white lacy collar. His smallish eyes are sunk into the sockets, made broad by dense shadows and deep by a thick light which extends from across the nose to the cheekbones skirting the lower side.

Velázquez could not have painted the portrait of *Francisco Lezcano* from life later than 1645, for the sitter, also known as the *Boy of Vallecas*, was absent from

the Court from then until 1648, and died the following year while the painter was in Italy. Nor could a much earlier date be suggested for it on stylistic grounds, 1643–1645 being indeed a reasonable one (cat. no. **99**).

This is one of the portraits of clownish dwarfs by Velázquez which were at the Torre de la Parada, where it was described as a buffoon playing with a deck of cards. The moronic dwarf, clad in green, is in fact picking at the edges of the playing cards that he idly holds in his hands. He sits clumsily against an over-hanging cliff which lets in a mountainous view; this setting lends a sort of monu-mentality to his oafish figure, while the relatively enormous hat fills most of the foreground and cuts him down to his true size – the conflicting appearances coalescing in an image of human shapelessness and spiritlessness beyond the merely descriptive.

A Dwarf Holding a Tome on his Lap was also at the Torre de la Parada. It was recorded there for the first time in the inventory of 1701, together with the portrait of *Francisco Lezcano*. Neither this, nor any later royal inventory which included it, mentioned the name of the sitter, who was described as just a buf-foon, sometimes said to be "clad in black" and holding a book simulating the actions of "a philosopher, studying". It was only in 1872 that the portrait was said to depict Don Diego de Acedo, nicknamed *El Primo*, and known to have been painted by Velázquez at Fraga in June 1644. This is a date that is consis-tent with the nature of the composition and the execution of the painting; a conclusion that has contributed to the general acceptance of the identification of the sitter as Don Diego de Acedo (cat. no. **102**).

As I discuss fully in the corresponding catalogue entry (no. **103**), this identi-fication, which I had previously accepted, cannot be regarded as conclusive in the light of available evidence. Yet, whoever the sitter may have been, it is safe to assume on stylistic grounds that the portrait was painted in the mid-1640s, if not exactly in June 1644.

The well attired dwarf is depicted holding a folio on his lap and surrounded by other large volumes, perhaps a reference to his bookish disposition. These heavy tomes emphasize the sitter's dwarfish shape, which is at the same time given a sort of dubious monumentality as his heavy shoulders and big head, underlined by the slant of the stiff collar, stand out under the weighty shape of a rakish hat against a mountainous backdrop.

Needless to say, there is nothing casual about this composition. Indeed, as X-ray photographs show, Velázquez had initially depicted the sitter bareheaded and wearing a falling collar; the substantial changes that he made concerning both the hat and the collar helped to achieve the scaling up and down of the dwarfish figure, and to make it into a compelling pictorial reality (cat. no. **102**). This scaling up and down of the figure of the oafish sitter allies this portrait with that of *Francisco Lezcano* (cat. no. **99**).

A similar interplay of the monumental and the oafish is noticeable in the portrait of *A Dwarf Sitting on the Floor,* of which we know the original as well as a replica, also by Velázquez, with possibly some workshop assistance (cat. nos. **103** and **104**). The original has been substantially cut down, particularly on the right; it comes from the Madrid Royal Alcázar. The replica, *A Dwarf Sitting on the Floor by a Pitcher,* shows the sitter off centre, as was Velázquez' habit. In the seventeenth-century it was in the Marquis of Carpio collection.[138]

The inventory entries concerning the replica in the Carpio collection iden-tified the sitter as *El Primo*, that is, Don Diego de Acedo. A portrait of *El Primo* and another of the dwarf *Sebastián de Morra*, both by Velázquez, had been included in inventories at the Madrid Alcázar from 1666 till 1700. Only one of them was included, without the sitter's name, in the list of paintings rescued

Edouard Manet
The Fifer
1866
Paris, Musée d'Orsay

from the fire that gutted the Alcázar in 1734 . Hence, the only documentary indication which we have about the sitter's identity is provided by the inventory entries referring to the Carpio replica.

Velázquez represented the bearded dwarf sitting on the floor, wearing a green dress and gold-braided red overgarment. His petulant temper is caught by the play of thick light upon shadow, which adds to the distortion of his features. His foreshortened legs, with the upturned soles of the shoes on his little feet, and the low floorline make his torso look large. While the symmetrical pull of his shortish arms give to his chest the appearance of a monumental bust; an appearance that is undermined by the diminutive and richly braided overgarment which hangs from his shoulders hardly touching the floor where he sits (cat. no. 103). In the replica the space is wider, and probably it was somewhat deeper. It seems, indeed, that there was in the background, to the sitter's left, a sort of window opening which the original composition might also have included (cat. no. 104).

As in his pictures of pagan gods or men of antiquity, Velázquez used foreshortening, highlights, and impasto to stress the sensuous features and earthliness of bearing, the comical gestures, the physical disfigurement, and the passions, appetites, idiocy, and age of the dwarfs and jesters that he painted.

Velázquez' portraits of dwarfs and jesters, unlike Callot's works of similar subjects, show no elaboration of caricatural traits or the pervasive rhythm of farce. His mind's eye was not focused on the mode of life and feeling that made those court retainers fashionable. There is, in fact, neither irony nor melancholy in his likenesses of men whose role was to act out, for the pleasure of the king and his courtiers their feelings and proclivities, even their infirmities. He used light, shade and the pigment's texture to make them into enduring, individual images of cloddish men. Velázquez' approach to the clowning of dwarfs and jesters resulted indeed in a sheer – or stoic – depiction of human nature .

The Buffoon Don Cristóbal de Castañeda y
Pernia (Barbarroja)
1637–1640
Cat. no. 84

RIGHT PAGE:
Detail of no. 84

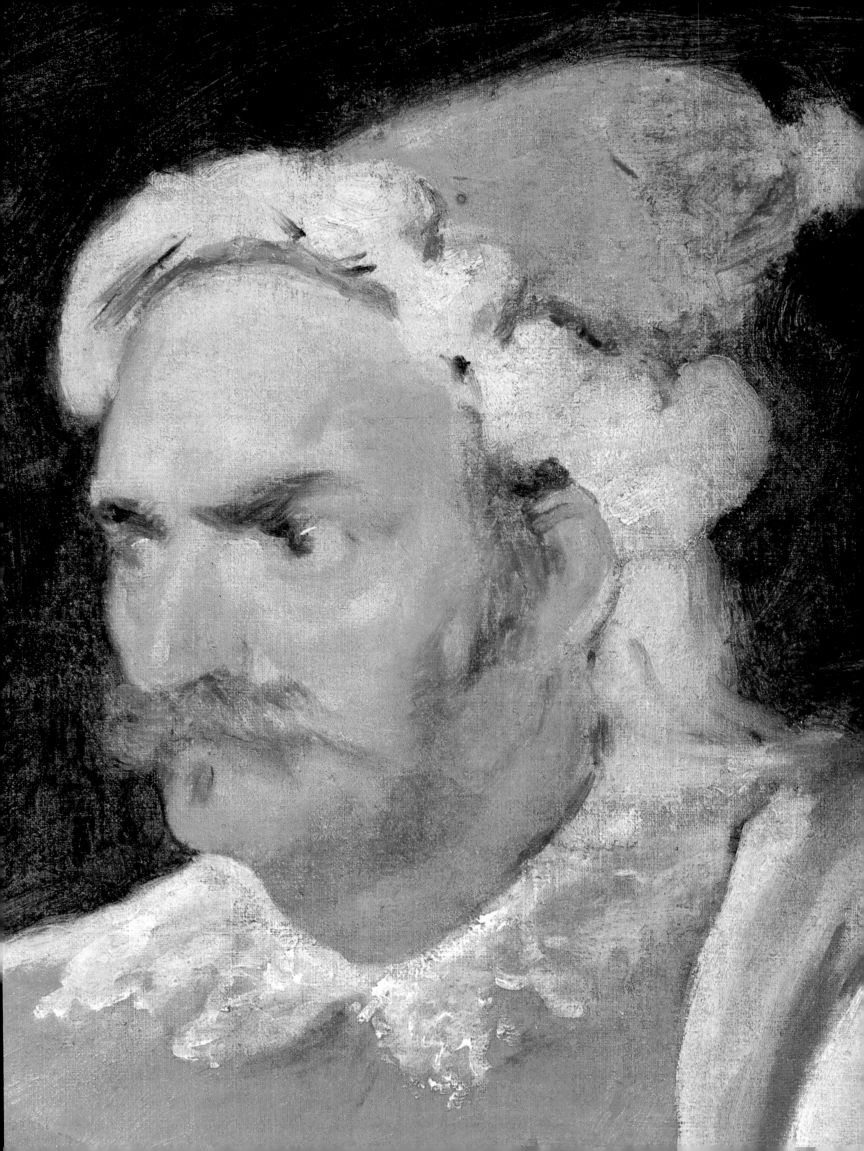

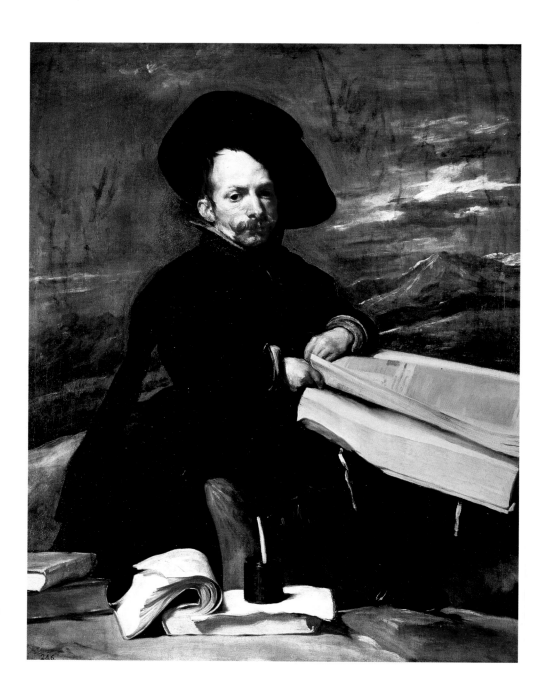

A Dwarf Holding a Tome on his Lap (Don Diego de Acedo, El Primo)
c. 1645
Cat. no. 102

The artist as creator

In 1635 Pietro Tacca was commissioned to make a monumental equestrian portrait of Philip IV. Since he was to execute it in Italy, he needed a likeness of the King to work from. The sculptor Juan Martinez Montañés, then sixty-seven years old, was called from Seville to Madrid to make a model of the King's head. He sculpted it from life in clay some time between June 1635 and January 1636, which was the length of his stay at the Court. His work was found to be sufficiently impressive for one of the leading Court poets, Don Gabriel de Bocángel, to write a sonnet on it, and this was subsequently included in a book of poems published in 1637. In the baroque manner then current, the sonnet played upon the human, that is perishable, connotation of clay to exalt the lasting life and shape achieved by the sculptor in the portrait of the King.[139]

Velázquez portrayed Martínez Montañés at work on that very portrait (cat. no. **76**). The sculptor, clad in black, is gazing into the distance, obviously at his royal sitter, holding the modelling tool pointed at the likeness sketched in clay that he supports from the back. The sculptor's head and hands are interrelated in a rhythm of readiness. Montañés' luminous head is modelled with a rich impasto which yet is brushed to a soft tissue in the cheeks and sockets, from whose fluid shadows the eyes, thinly painted, gaze out. This artistic ambivalence joins, in one shape, the lusty head and the serene countenance of the sculptor at work. Likewise Montañés' right hand, posed over the clay, is fully modelled. The depicted sensitivity of the fingers of this hand heightened by the visual qualities of a pigment that has been subtly worked from a rich impasto to

Detail of no. 102

just a film. As for the large-sized likeness of Philip, his main traits are sketched in directly on the grey priming of the canvas, and the sculptor's hand which props the shape of clay is just sketched out with a few strokes of heavy impasto.

These facts have led to suggestions that the picture is unfinished or that Velázquez completed it many years after Montañés' stay at Madrid. It has been argued that this would explain why he did not paint the sculpted head of the King in more detail, since, with the passing of years, he would not have remembered it.[140] Similar inferences have been made about other works, particularly portraits, by Velázquez. With a few exceptions they have been based on assumptions as to how Velázquez might, or ought to, have painted rather than on a realization of how he did paint.

Velázquez portrayed Martínez Montañés at work in an arrested and intent attitude, similar to the one in which he would portray himself at the easel some twenty years later in the so-called *Las Meninas* (cat. no. **124**). The painter's self-portrait in the latter work has been interpreted as an embodiment of the mannerists' views on the imitation of nature by art, in the light of the distinction between *disegno interno* and *disegno esterno* as formulated in *Cinquecento* treatises.[141] Yet, art treatises can throw as much, but no more, light on a painter's work as a book of rhetoric can on a literary creation – that is, rather little. They can inform us of the critical views, practical rules, or artistic aims current at the time, in narrow or wide circles to which the artist in question may have been exposed. It may also be of interest to ascertain just how far the artist conformed to, or departed from, such views, rules and aims. Learning, whether theoretical or practical, plays a role, which is perhaps impossible to isolate in the complex of an artist's creation. But it would, indeed, be a substanceless or misunderstood work whose full significance would just fit a point made in an art-treatise.

A meaningful analogy can be drawn between Velázquez' early *St. John at Patmos* and the *Martiñés at Work* of his mature years. Each of the central figures is represented at a moment of inner concentration on what he is shaping, whether in words or clay; his toiling hand in readiness for the conscious stroke. There is a difference too: the evangelist looks past the depiction of the vision that he is intent on describing towards an indeterminable point, outside the picture, while the sculptor looks out of the picture to a determinable though invisible point: his Royal sitter. The ineffable nature of the evangelist's experience is rendered by the mumbling of his lips and the far-off look in his eyes (cat. no. **12**). The piercing look in the sculptor's eyes suggests the presence of the invisible sitter as real and near.

Montañés' left hand is sketchy, though in a different manner from the head of clay that it cushions; roughed out with a heavy impasto that has also been used for the wrist cuff. It contrasts with the filmy lights and broad strokes which sketch the likeness of the King. Thus an ambivalent, but by no means confused, image is created as the shape roughed out by the sculptor is made into a painter's sketch. The monumental head of the King blends with the background, allowing the three-quarter figure of the sculptor to dominate the composition – which might not have been the case if Philip's features had been rendered in a more elaborate manner and on so large a scale.

Had Velázquez left this work unfinished, it would be necessary to conclude that he chose to do so at a point when he had strikingly expressed on the canvas the act of artistic creation. It appears, indeed, that Velázquez did not limit himself to superimposing, as it were, his own sketch of the likeness of the King on the representation of the head sculptured by Montañés. Actually he fashioned the portrait of the latter into a vivid image of the artist as a creator whose hand bends materials – whether clay or pigments – to his expressive purpose, height-

Detail of no. 78

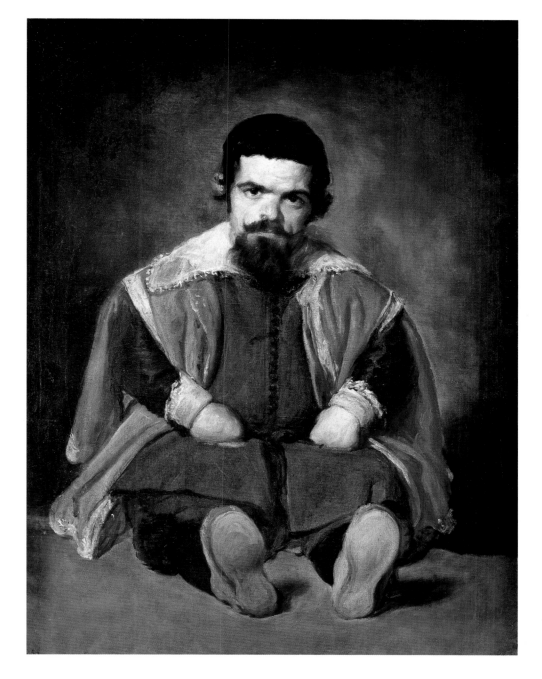

A Dwarf Sitting on the Floor (Don Sebastian de Morra?)
c. 1645
Cat. no. 103

Salvador Dalí
Velázquez Dying behind the Window on the Left Side out of which a Spoon Projects
1982
Figueras, Teatro-Museo Salvador Dalí

ening rather than disguising their earthly textures, and accentuating the superiority of the image achieved over the natural appearance that it portrays.

 The Needlewoman, datable to between the mid-1630s and the early 1640s is a fine example of what a clearly unfinished portrait by Velázquez looks like. The head, well modelled in light and shade, is the only finished part, as was noted at the time of the painter's death, and as any viewer will quickly realize. The arms and hands, sketched in, have their rhythm masterfully indicated, though they fall short of the full modelling of the face, and this results in a sort of distortion of space and of the limbs, particularly the left forearm. This painting, in its unfinished state, reveals Velázquez' felicity towards human gesture as well as the way he went about building a shape within a broadly brushed contour, plainly noticeable in the left hand and shoulders, and blending the figure with its ambient air, as seen in the head, whose contour has been thinned into an airy fluid of light and shade (cat. no. **81**).

The person of the King – and the redundancy of allegory

In January 1643 Philip IV removed the Count-Duke of Olivares from the office of chief minister and banished him from the Court. It was a decision that the Queen and the camarilla around her had been urging on him for a long time. Philip IV, in what proved to be one of his passing moods of self-assertion, then announced that he would now take the affairs of state into his own hands. Yet, within a few days the new chief minister, Don Luís de Haro, Marquis of Carpio – a nephew and political rival of Olivares – was running the government. The Count-Duke, who had at first been allowed to retire to his estate at Loeches, near Madrid, was sent into confinement at Toro, far away from the Court. He died there, a bitter man, two years later.

A couple of weeks before the downfall of Olivares, Velázquez had received the royal appointment of Gentleman of the Bedchamber. This was a post without duties but with corresponding perquisites. Less than five months after the new chief minister came into power, the painter was also made Assistant Superintendent of Works, and as such was placed in charge of such projects as the King might designate such as the refurbishing of the old Alcázar, made necessary by the transfer of many of the Court functions to the new Buen Retiro Palace.

Apparently, Velázquez never took part in the politics of the Court and always remained close to the King. Given Philip's character, it seems likely that he would have occasionally talked about political events to the man who had been at his side longer than any other. But Velázquez – whose exalted view of the person of the King is unmistakeable in his painting – never became embroiled in the strife of the camarillas.

The Marquis of Carpio remained in power till his death, which occurred in 1661, one year after Velázquez'. During his régime, the painter went on accumulating royal appointments, honours and privileges. The son of the chief minister, the Marquis of Eliche, collected a large number of paintings, including ten which were recorded at one time or another as by Velázquez, though not all of them were entirely by his hand. Some might well have come from Olivares' collection, but others were unquestionably painted after the Count-Duke's banishment.

During the twenty-odd years that Olivares was in power, many noblemen had avoided the Court. After his downfall they came back and grouped themselves round the King, hoping to have his authority reasserted. A military opportunity came their way when Philip IV decided to join his troops engaged in the rescue of the city of Lérida from the French occupation forces. In the spring of 1644, the King, accompanied by a large retinue, which included Velázquez, set out on a slow-moving journey to the distant battlefield. When he joined his troops he was wearing an army dress, as he also was when he formally entered Lérida after the French had been chased from the city. The fact that Philip IV had appeared in military dress before his troops was underscored in contemporary accounts of the campaign for then, as now, it was thought that a monarch could encourage, and even reward, his soldiers just by making an appearance before them. Thanks to the interest that the matter aroused, we have quite precise descriptions of two of the uniforms worn by the King during that campaign – in one of which Velázquez portrayed him early in June.[142]

It was during a halt at the city of Frage that Philip decided to have his portrait painted. In late May and early June, an easel was made for Velázquez, the

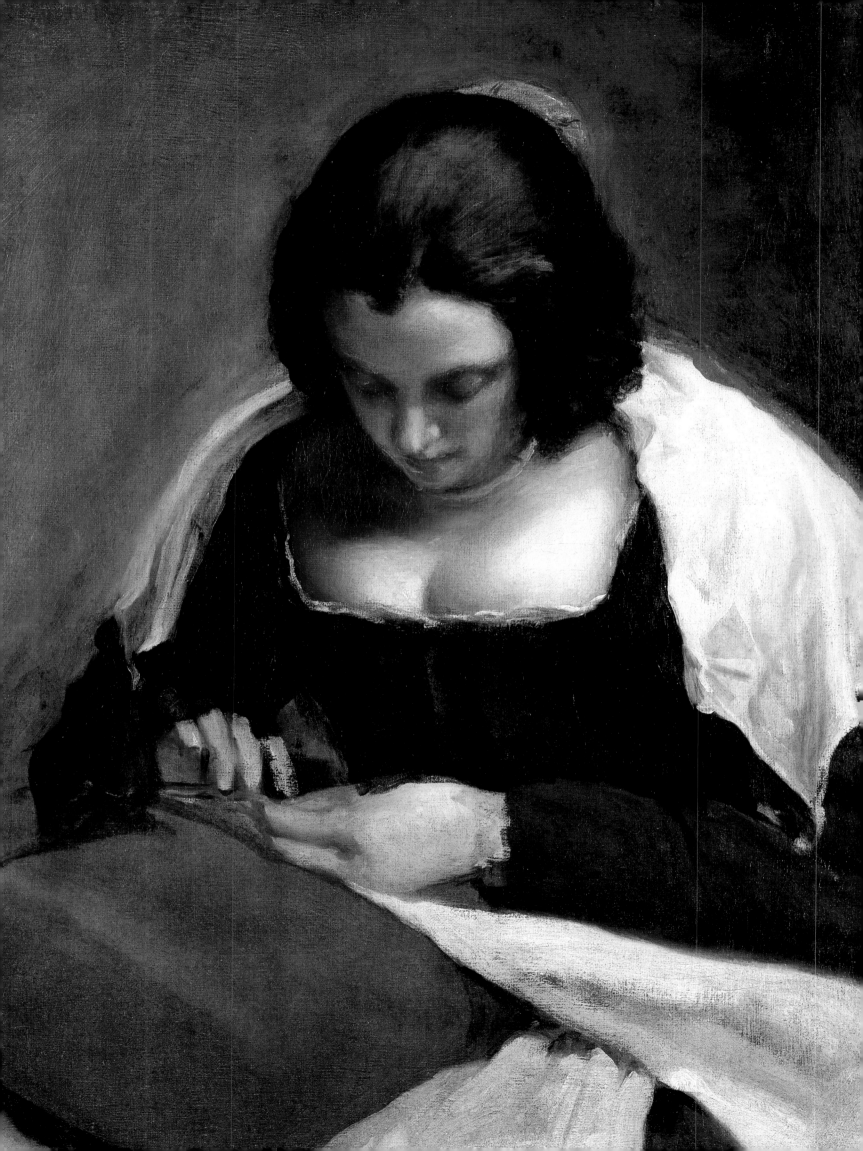

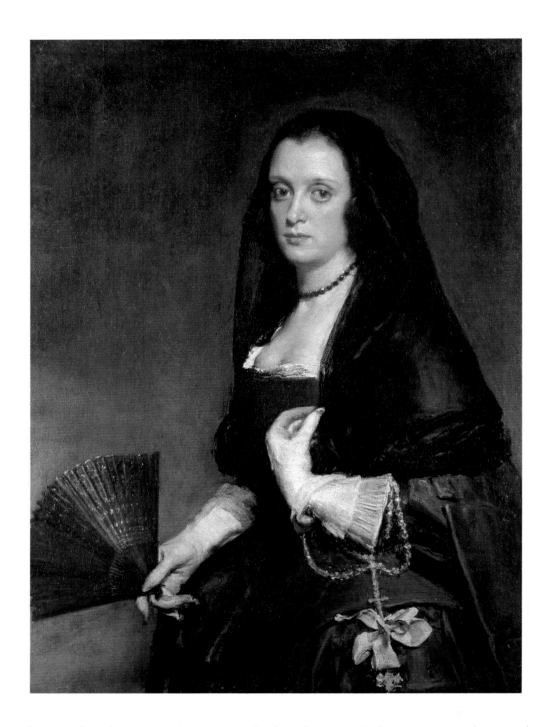

Lady with a Fan
c. 1635
Cat. no. 79

house where he was staying was repaired, and a new window was opened up so that he could "work and paint". At the same time the room, or rather alcove, described as just the "mantel of a chimney", where the King was to sit for the portrait, was renovated. It is not quite clear that the alcove was left without flooring, but it is known that a load of reeds was brought to cover the floor each day – three in all – that Philip sat for the portrait.

The documents referred to reveal a procedure which was probably usual for Velázquez as a portrait painter: to work from the model first, and then to finish the portrait in his workshop without the sitter. At least that was the way he went about it in the only other instance for which we have a reliable account – from an eye-witness in this case. Jusepe Martínez tells how Velázquez during one of his stays in Saragossa – that is, in either 1642, 1644, 1645, or 1646 – made the portrait of a young lady, now lost or unidentified. He painted just the head from life, and then, "in order not to tire" her, he brought the canvas to Martínez' house where he finished the rest of the figure. In this particular

instance, the sitter was disappointed, so much indeed that she refused to accept the portrait, mainly because Velázquez had not depicted the collar of very fine point lace from Flanders that she had worn at the sittings.[143]

As for the portrait for which Philip sat in that shored-up alcove illuminated from three windows, and which Velázquez completed in his makeshift workshop at Fraga, the royal sitter, truly pleased with it, sent it to the Queen in Madrid. Velázquez had represented him wearing the red and silver field dress, rather than the red and gold one which, according to the accounts of the time, he sometimes donned during that campaign.

The portrait shows Philip holding the baton in his right hand, and a black hat with red feathers in his left hand. His fair-hued face and red and silver costume is set off by the predominately brown background. Gliding touches build the King's features in aerial luminosity, without wrinkles or weighty shadows, and model the figure and its ambient air (cat. no. 100).

The portrait of the sovereign painted at Frage when he was leading his armies against the French might readily have suggested an allegorical composition to Velázquez if he had been allegorically-minded. He obviously was not. There is indeed no extant portrait of Philip IV with allegorical figures by Velázquez' hand. Nor is there documentary evidence that he ever painted any such portrait. It is true that when, in 1627, he painted a large canvas with the portrait of the previous monarch, *Philip III and the Expulsion of the "Moriscos" Decreed by Him*, he represented Spain as a matron in Roman armour carrying in her right hand a shield and arrows, and in her left, some ears of grain. That picture, now lost, was painted in competition with three other court painters at King Philip IV's command, and it is more than likely that the allegorical figure of Spain was specifically included in the subject that the four participants in the competition were required to depict.

As for portraits of Philip IV, Velázquez must generally have been given a free hand. Those which have come down to us show that he consistently made the presence of the King vivid by substituting an effortless gesture of innate power for what evidently was to him the redundancy of allegory. He did so even in the equestrian portrait painted for the Buen Retiro, that *amphiteatro* of the Spanish monarchy, in whose overall decoration, as well as in the painting praised above all others – Maino's (p. 110) – allegory was prominent.

Allegories were, of course, quite in vogue in literature and other arts, and allegorical portraits of Philip IV were painted in Velázquez' time. In fact, the likeness of Philip IV which he painted at Fraga was soon worked into an allegorical composition.

Velázquez' portrait of Philip IV in army dress was greatly admired in Madrid. The Catalans who resided there obtained permission to display it during their celebration of the recapture of Lérida at the church of Saint Martin, and many people came to see it. Within a few days, copies were being made of it, perhaps including the one now at Dulwich College.

As often happens in the case of unsurmountable national crisis, many of the noblemen who had returned to the Court after the King's banishment of Olivares harboured a wishful notion to bring back the glorious days of the past. Some such sentiment must have sparked the desire of the new chief minister's son, the Marquis of Eliche, to have a portrait of Philip IV which would spell out, in an allegorical manner, the glory and power of the Spanish monarchy now that the King had victoriously led his armies against the French. Such a portrait was indeed commissioned in the form of a copy after Rubens' allegorical portrait of Philip IV (now lost), painted a score of years earlier and, at that time, still at the Madrid Royal Palace. The commission apparently went to

Velázquez, who, as the 1651 inventory of the Eliche collection indicates, let one of his assistants copy Rubens' composition, limiting himself to painting the head of the King which, except that it has the hat on, is a close replica of that in the Fraga portrait (cat. no. 101).[144]

It is documented that Velázquez also painted a portrait of the dwarf Don Diego de Acedo at Fraga in June 1644. He probably worked on it at much the same time as on the portrait of the King. Acedo's portrait, however, was finished within the month of June, as a case was then built to ship it to Madrid, while the one of Philip IV may not have been completed till July, when the necessary case was made to send it to the Queen.[145]

As shown above, and contrary to earlier belief, there is no firm evidence to decide which of the extant Velázquez' portraits of dwarfs datable to the mid-1640s represents Don Diego de Acedo, *El Primo*. One of them has been satisfactorily identified as Francisco Lezcano, who incidentally was also in the retinue which Philip IV took with him for his military journey to Catalonia. Even if this identification were challenged, the obviously mentally feeble sitter could not be Don Diego de Acede, who performed some administrative functions at the Court, such as courier and assistant in the secretarial office where documents were stamped with the facsimile signature of the King. This leaves us with *A Dwarf Holding a Tome on his Lap* and *A Dwarf Sitting on the Floor*, which, owing to its replica, has some claim to be identified with the portrait of El Primo.

If we look at these portraits of the mid-1640s, we realize that in all of them Velázquez made use of rich impasto to model the dwarfs' faces. Thick light runs into shadow without dissolving it, accentuating the peculiarities and sensuality of the sitters' features. Every one of these portraits of dwarfs reveals in its execution a plain and meaningful contrast with the Fraga portrait of Philip IV, where Velázquez built with gliding touches the King's features in aerial luminosity, without wrinkles or any weighty shadows (cat. no. 100).

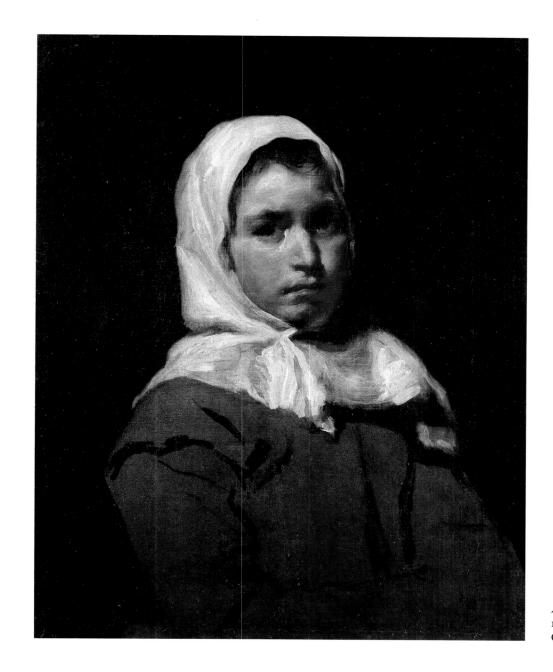

A Country Lass
1645–1650
Cat. no. III

Reality of painting

As indicated before, many of the extant portraits by Velázquez have often been described as unfinished. Underlying such a view, and frequently mentioned to support it, are one or more of the following facts. An unevenness of texture resulting from the use of both fluid and rough brushstrokes, as in *A Knight of Santiago*, of the late 1640s (cat. no. 110). The sketchy painting of the sitter's hands found in *A Young Lady*, of the mid-1630s (cat. no. 80) in *Juan Mateos*, of about 1632 (cat. no. 58), and in *A Young Man*, of 1630–1631 (cat. no. 50). The seemingly chance strokes left by Velázquez in the background of some portraits as if he had wiped his brush on the canvas – an example of which is the *Bearded Man*, close to 1640, where the flowing contour line adds to the unfinished aspect (cat. no. 91). Such "chance" strokes, which the painter could have easily erased or painted out, had he regarded them as a flaw, are also noticeable in works which can hardly be considered as unfinished, including *Don Pedro de Barberana*, of 1631–1633, and *Juan de Pareja*, of 1649–1650 (cat. nos. 57 and 112).

There are, however, pictures such as *The Needlewoman, Don Cristóbal de Castañeda* and *A Lass*, on which Velázquez obviously stopped working before completing what he had intended to paint (cat. nos. 81, 84 and 111). There is in these paintings, even in the portrait of *Castañeda* which another painter tried to finish, a lack of the pervading ambient air which Velázquez achieved in his finished works.

A Lass is a telling illustration of Velázquez' style – sharply criticized in his day – of brushing a figure on canvas from life, working out the composition as he went on painting (cat. no. 111). This work calls to mind Carducho's waspish rebuke addressed to "some" painters who, dispensing with preparatory drawings or sketches, would just use a piece of chalk to block out on the canvas "what they want to do, and go on painting it all at once, without erasing anything, painting or rather simply copying from life, and they may even perhaps complete half a figure without having determined how the other half should be".[146]

It seems likely that *A Lass* was cut down on the right after Velázquez' time for the purpose of "centring" the figure, as has been done with many of Velázquez' one-figure compositions. The girl's head appears nearly completed, in Velázquez' terms, down to her shoulders, including the kerchief. Strokes of white paint, unevenly thick and with a faintly pinkish tint, which highlight the face from the forehead to the chin, are distinctly unblended with the layers of skin colour. This, as well as the girl's chestnut hair, swiftly brushed in, brings this painting close in point of both execution and completion, to paintings by Velázquez from various periods, notably though not exclusively, *A Dwarf Holding a Tome on his Lap* (cat. no. 102), *Menippus* (cat. no. 93), *Pablo de Valladolid* (cat. no. 82), and *Juan de Pareja* (cat. no. 112). The girl's body though is merely blocked out with broad black strokes on a dark greenish-brown ground, the left arm and what is visible from the waist down scarcely indicated. It is an unfinished and yet strangely compelling painting, as telling as any work in progress can be.

Studies are, of course, a somewhat different matter since, however sketchy they may be, they are not likely to be impaired or made more challenging by want of further work. There are instances, though, in which it is difficult to decide whether a painting ought to be regarded as unfinished or just as a study. Such is the case with Velázquez' short bust of *Portrait of a Little Girl* (cat. no. 97). The sitter's head is well modelled in light and shade, while the neckline and sleeves of the grey-green dress are summarily indicated with bold strokes of brown paint. Yet, the light that pervades the figure and permeates the back-

The Coronation of the Virgin
c. 1645
Cat. no. 105

LEFT PAGE:
Detail of no. 105

Detail of no. 105

ground, painted in a grey-green hue darker than the dress, effects the kind of pictorial whole that studies often are.

Ultimately, the decision as to when a painting, whether sketchily or elaborately painted, is finished lies with the painter himself. Even so, works of art, whether finished or unfinished, are autonomous, and often only their very shape reveals whether they are completed. In any case, if outside terms of reference are to be looked for, they ought to be found within the artist's own *œuvre*.

Sketchy passages often appear in portraits by Velázquez that might otherwise seem quite finished; so often that one should pause before deciding that the Master did not regard those portraits as completed. Their comparatively large number would be of significance for the understanding of Velázquez' art, even if we were to conclude that he often simply put aside his portraits just as he was about to give them the final touches, leaving, for instance, no more than one hand to be finished or a few chance strokes to be laid down.

The sketchy passages noticeable in such portraits are, moreover, noticeable also in some of his religious, mythological or historical compositions which have always been regarded as finished. Hence it would seem that Velázquez sometimes used sketchy passages as one more means of expression.

Velázquez' sketchy passages are not distinctive of any particular period of his art, for he used them throughout most of his life, presumably whenever the reality of the sitter, or whatever subject he was depicting, encouraged him to do so; presumably, too, at the urge of the artistic reality that was taking shape on the canvas as his work went on.

Even if we were to assume that it was a matter of chance, it would be significant that the portrait of Martínez Montañés at work is the painting which shows the widest range from the "rough" to the "finished" within the Master's

El Greco
Coronation of the Virgin
1590
Madrid, Museo del Prado

œuvre (cat. no. **76**). Plainly Velázquez has brought into it the theme, as distinguished from the subject, of the artist's mastery of his medium for his expressive ends. He has not only portrayed Martínez Montañés in the process of shaping the King's likeness out of clay, but he has also achieved an image of the very act of artistic creation, encapsulating both the sculptor's and the painter's mastery of their media.

Baroque artists were intent on emphasizing the texture of their material – whether pigment, clay, marble or bronze – while making it bend docilely to their expressive ends. This – which is quite evident in the work of Bernini, the sculptor and architect – enhanced the superiority of the work of art over both the stuff it was made of and the natural appearances it might portray. This often resulted in a brilliant display of resourcefulness, sometimes bordering on virtuosity, noticeable in so many works of that time. In a broader sense, such brilliant resourcefulness appears akin to that exhibited by creative writers of the period in their use of neologisms, conceits, puns and other wordplay, by which they underscored the very structure of the words while building unique images with them.

Velázquez' sketchy passages in works which in every other respect appear to be finished – whether a shadowy or light-permeated blob, a sketched hand, a flowing contour, an unevenness between liquid paint and heavy impasto, or some strokes which smear the background without any representational function – have in common that they make us aware of both the painter's medium and the way he goes about putting his images on canvas. This is as true in *The Surrender of Breda* (cat. no. **73**) and in *Philip IV in Army Dress* (cat. no. **100**), as it is in *Lady with a Fan* (cat. no. **79**), *The Coronation of the Virgin* (cat. no. **105**), and *Mars* (cat. no. **94**).

Albrecht Dürer
St. Anthony Abbot and St. Paul Hermit
Engraving

Joachim Patinir
St. Jerome
1510–1515
Madrid, Museo del Prado

RIGHT PAGE:
St. Anthony Abbot and St. Paul the Hermit
1635–1638
Cat. no. 85

In 1865 Manet wrote from Madrid that Velázquez was *le peintre des peintres*[147] – a view that was shared by nearly all the Impressionists. These painters emphasized the texture of their nearly always light-hued pigments by the simultaneous use of liquid paint and heavy impasto. This acheived a contrast between the "finished" and the "roughed-out" areas of the same painting or even the same shape, as well as by leaving areas of the canvas entirely untouched. Their world, in which the mind and the senses played off each other, was of course, alien to Velázquez' firm grasp of the clear-cut polarity of the earthly and the divine. Indeed, quite contrary to that of the Impressionists, Velázquez' world was one in which the mind perceived and depicted the sensorial as dense. Yet the Impressionists could, and did, enjoy and admire Velázquez' art without oversimplifying or otherwise distorting its pictorial integrity. As often happens with felicitious statements, Manet's pithy remark soon became a catchword, thus losing its original meaning. Painters and scholars of a naturalistic or positivistic bent adopted it. To them, however, the art of Velázquez showed contradictions. In straightening such contradictions out, they devised a line of progressive development which has ever since been zig-zagging back and forth, often groundlessly and at times even contradicting available evidence, including that provided by the paintings themselves. Curiously, the efforts made to establish a line of progressive development in Velázquez' *œuvre* has resulted in considering the majority of his paintings as either having been retouched by himself endlessly throughout the years or as never having been finished.

There can be no question that Velázquez, like any other painter, left a number of works unfinished, some of which were so listed in the inventory of his possessions drawn up after his death. It is also known that he had a penchant for retouching his own works, which often show *pentimenti,* but there is not clear indication that such changes were not generally made in what he regarded as the course of execution – which was very likely a long one, given the overlapping of royal commissions for paintings, his other duties at the Court, and what seems to have been his own sense of leisure. It is well documented that he made a good many sketches, nearly all of which are lost. Sketches, of course, can be autonomous too, and they do not necessarily depend for understanding on the work to which they ultimately led and whose process of composition they help to grasp. Unlike paintings on which the painter stopped working before finishing the canvas, nothing is missing in a sketch.

The problem now at hand, however, is that of works in which Velázquez joined sketchy passages or non-representational strokes in a pictorial whole, such as *Martínez Montañés at Work* (cat. no. **76**), *A Knight of the Order of Santiago* (cat. no. **110**) or *Don Juan Mateos* (cat. no. **58**), to cite only a few outstanding portraits of the 1630s and 1640s. If we compare any of these portraits with *The Needlewoman* (cat. no. **81**), *A Country Lass* (cat. no. **111**), or, for that matter, with *Don Cristóbal de Castañeda* (cat. no. **84**) – we can see the difference between a painting on which the Master stopped working for whatever reason, before achieving a pictorial whole, and those pictorial signs embodying sketchy passages for expressive purposes, be it to accentuate a trait of the sitter, to reveal the painter's mastery of his medium, or to underscore the superiority of the painted image over the natural appearance that it portrays, or to do all things at one time.

The diaphanous world of Christianity

It was probably in the mid or late 1630s that Velázquez painted *St. Anthony Abbot and St. Paul the Hermit* for the Hermitage of St. Paul in the grounds of the Buen Retiro Palace, where this and other newly built hermitages, monumental statues, fountains, grottoes, ponds, gardens and groves offered a variety of extremely pleasant views. Very likely some of the landscapes with religious subjects that were painted by Claude Lorrain for Philip IV in those years, and which were contained within the Palace's inventory of 1701, were also originally intended for the new hermitages.[148]

Velázquez' *St. Anthony Abbot and St. Paul the Hermit* is the only extant large composition with small figures that is unquestionably by him. It is also one of his few compositions for which a colour sketch (cat. nos. **85** and **86**) is extant. The two saints are dynamically grouped at the centre, in the foreground, against an angular crag surrounded by the diaphanous view of a green valley and distant bluish mountains.

Attempts have been made at tracing this composition to various sources, such as the fresco of the same subject by Pinturicchio and his followers, at the Vatican. Two of Dürer's woodcuts – one of the same saints and the other of St. Joachim and the angel – have been suggested for the main scene, and Patinir's *St. Jerome* (Prado, no. 1614; p. 150) for the landscape. It has also been indicated that the background mountains are not unlike those of the Guadarrama near Madrid.[149]

Velázquez knew most, probably even every one, of the works just mentioned. Similarly he must have been familiar with the distant shape and hues of the Guadarrama mountains which were then, as they are today, visible from the Madrid Royal Palace. The Master, consequently, might have had in mind any of those works of art or nature. Yet the only similarities with them shown by his work are those to be expected, and hence of little consequence, because of either the iconography of the subject or the natural forms depicted.

Velázquez included in his composition several episodes from the visit of Abbot Anthony to the first hermit. He did so in an imaginative manner, making the narrative proceed unobtrusively from the background on the lively lines of perspectival depth which span the landscape. The various scenes are articulated to form a vivid rather than enumerative depiction. In the far distance, Anthony is seen asking the centaur the way to Paul's cave. Closer to his destination he meets the horned and goat-footed monster. The action then turns to the right where the holy man knocks at the door of the cave built in the crag. This scene forms a backdrop for the main one where the two saints, one making a gesture of prayer and the other one of wonder, are grouped together as the black raven, a small loaf of bread in its beak, flies down to them. To the left, in a barren area off the foreground, the concluding scene, second in point of scale, takes place as two lions dig the grave for St. Paul and as St. Anthony prays over his body (cat. no. **85**).

Everything is thinly painted, with impasto used only for highlights, particularly on the luminous faces and limbs of the saints. A silvery light permeates the whole composition, bringing out the richly hued green and blues of the landscape. The depiction of the hardships of the Thebaid, called for in the Golden Legend's narrative, is embodied in the rugged crag on top of which rises a palm, the tree on whose fruit St. Paul lived for about twenty years, and in the barren ground where the lions dig his grave. The surrounding landscape, verdant and flourishing, is not a departure from the narrative. Rather, it heightens the seclusion of the hermit from the luxuriant expanses of the earth – where temptation

LEFT PAGE:
St. Anthony Abbot
1635–1638
Cat. no. 86

Detail of no. 85

lurks. This contrast provides a vast and luminous setting for the miraculous event: the heaven-sent loaf of bread. Both are supported and impelled by the diaphanous colouring and the upward rhythm of the composition, stressed by the ivy-covered birch tree which rises from the thicket in the foreground, past the forbidding crag, and up into the sky.

The Coronation of the Virgin, of around 1644, is a lucid pictorial expression of the immaculate nature of the mother of Jesus, on which the belief in her coronation was postulated (cat. no. **105**). The Father and the Son, both clad in purplish tunics and red mantles, hold a crown of roses and green leaves over the Virgin, whose white kerchief leaves her chestnut hair uncovered, and whose blue mantle contrasts with her red gown. It is a masterful opposition of luminous reds and blues, made somewhat fiery by the juxtaposition of purple – in the tunics of the Father and Son.

The Virgin lightly holds a hand to her chaste breast which like her head, is bathed in light. A highlight across her luminous face and along her hair line enhances the unblemished symmetry of her features and blends with the most brilliant ray in the incandescent image of the Holy Ghost above. Her lids lowered, she looks down with an expression of modesty which, compositionally, accentuates the sense of distance from the earth as angels lift her to the Heavens.

The face of the Son is partly modelled by translucent shadows, similar to those that express His humanity and humility in the earlier *Supper at Emmaus* (cat. no. **42**). As for the Father, the most liquid and dynamic of shadows con-

tribute to the flame-like effulgence into which His face is built, and which is broadened by the radiant strokes across the folds of the blue mantle on His shoulders. As the Father and the Son hold the crown of roses over the ascending Virgin, her well-rounded head becomes the centre of the composition, and her shadowless unblemished features externalize her immaculate nature.

The luxuriant world of the fable

Beruete pointed out a number of stylistic analogies between *The Coronation of the Virgin*, *The Fable of Arachne* and *Venus at her Mirror* (cat. nos. **105**, **106** and **107**), and he concluded that they had all been painted by Velázquez "towards the end of his career" in the late 1650s.[150] This conclusion, accepted by most scholars at least for *The Fable of Arachne* and *Venus at her Mirror*, has been disproved by the discovery that the latter was held in a Madrid private collection and included in an inventory dated 1 June 1651, when Velázquez had not yet returned from his second Italian journey. Some writers, clinging to a residuum

Detail of no. 85

of the disproved conclusion, have suggested that Velázquez may have painted *Venus at her Mirror* in the course of his second Italian journey and dispatched it to Madrid, where it was included in the inventory before his return. It would be surprising if Palomino, who was remarkably well informed about the paintings executed by the Master during that journey, should have failed to mention so important a composition. In the present state of our knowledge, it appears that both *Venus at her Mirror* and *The Fable of Arachne* belong in a group, also including *The Coronation of the Virgin* (cat. no. 105) and *Arachne* (cat. no. 108), all of which are datable to the mid or late 1640s, and before November 1648, when Velázquez set out from Madrid for Italy.

The Coronation of the Virgin and *Venus at her Mirror* resemble each other in a "certain preponderance of purple tones", as Beruete saw it.[151] In the mythological composition, Velázquez has harmonized red and blue, the curtain and Cupid's sash, by means of lavender-pink hues, the ribbon looped over the mirror frame.

Until relatively recently, even though damaged by old tears, rubbing, spotty repaints and, in 1914, a suffragette's knife, *Venus at her Mirror* could be recognized at once as a masterpiece (cat. no. 106). One could readily grasp the masterful contrasts of smooth and rough impasto, essential to Velázquez' intent. The *pentimenti* reveal what was incidental to his way of painting: tentative shapes that he quickly painted over and which, with time, became noticeable to the naked eye, without, however, marring his pictorial achievement.

The painting was drastically cleaned and implausibly restored in 1965. As a result, some areas have been messily sketched while others are overworked.[152] As Velázquez had originally painted it, the flowing shape of Venus, her back turned to the viewer, weighed down a leaden grey drapery with only some bluish reflections.[153] Her face was softly reflected in the black-framed mirror held by Cupid. The blue of his sash, the red of the curtain and the lavender ribbons on the mirror frame acted as foils to her pale flesh tones. Velázquez centred the composition on the mirror, which, tilted away from the face of Venus, underscored the curtained space of the bed. Nothing like this space, exuberantly filled with textures and hues, could be found in any other painting of the same subject. Only in epithalamia of the time, such as Marino's, could one find a Venus-like image immersed in so sensuous an atmosphere.[154]

The reflection of the face of the chestnut-haired goddess in the tilted mirror corresponded quite closely with that of the Virgin in *The Coronation* (cat. nos. 105 and 106). Even today, both have the same oval shape and their features are identical point by point. The head of the Virgin, however, is spotlessly luminous and her tresses emphasize the impeccable balance of her features. Rather differently, Venus's face was, and to a considerable extent still remains, adumbrated in shadow which, together with the irregular frame provided by the untidy hair, alters the harmony of its oval shape and the symmetry of its features. Obviously, Velázquez worked in both cases, and, for that matter, in *The Fable of Arachne* and *Arachne* (cat. nos. 107 and 108), from the same model, the same sketch, or just the same idea of a beautiful young woman. Yet, he put on canvas two different images, one of divine and the other of earthly beauty.

Arachne (A Sibyl?)
c. 1644–1648
Cat. no. 108

Following pages:
Venus at her Mirror
c. 1644–1648
Cat. no. 106

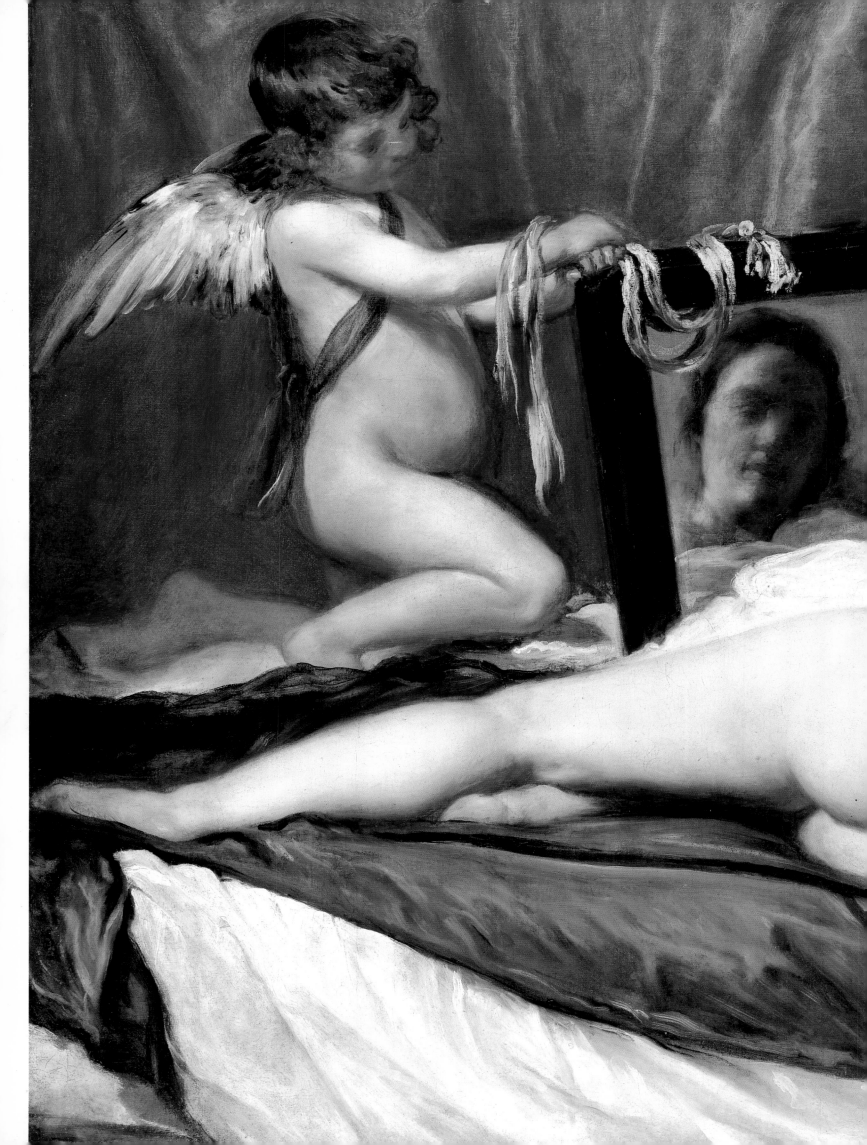

Michelangelo
Ignudi
1508–1512
Vatican, Sistine Chapel

The Fable of Arachne (Las Hilanderas)
c. 1644–1648
Cat. no. 107

Velázquez' naturalism

In discussing *The Fable of Arachne,* commonly known as *The Spinners,* one must begin by saying that its original composition was substantially enlarged by a hand other than Velázquez' after his death. The painting, which had for long been frayed and cracked, has recently also been allowed to deteriorate to an appalling condition. During the last two decades the pigment has been left to flake off in several areas, and its hues have undergone irreversible changes nearly everywhere (cat. no. 107).[155]

The painting, regarded for a long time as just a genre composition, is, as Angulo convincingly inferred and Caturla subsequently documented, Velázquez' rendition of *The Fable of Arachne.* It has also been documented, somewhat unnecessarily, that Velázquez was acquainted with the literary source of the subject. At the time of his death, his library included two copies of Ovid's *Metamorphoses* – one in Italian, the other in Spanish – where the contest between Pallas and Arachne is related.

The first known mention of Velázquez' *The Fable of Arachne* [156] is from 1664, some four years after his death. The painting was then in the collection of Don Pedro de Arce in Madrid, and Pedro de Villafranca, a painter and engraver familiar with Velázquez' paintings, described it as *The Fable of Arachne* by Velázquez and appraised it at five hundred ducats, considerably higher than any other painting in the collection; a collection that also included the names of other outstanding Spanish and Italian masters. The metric equivalent of the painting's recorded size was approximately 1.67 in height and "more than" 2.50 in width. The painting was then included in the 1772 inventory of the Madrid

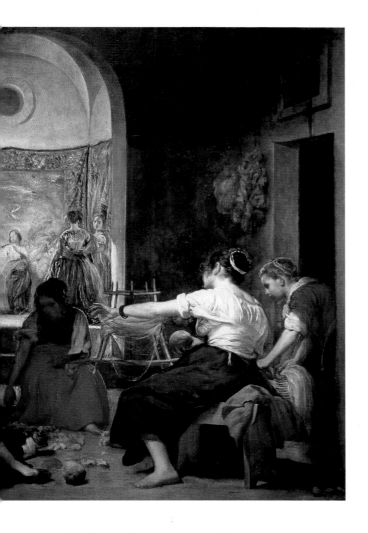

Peter Paul Rubens
Copy of Titian's *The Rape of Europa*
1628
Madrid, Museo del Prado

Royal Palace, where its true subject was not recognized. There it was described as just depicting a tapestry workshop. As for its size, it had already been enlarged to approximately the present one – 2.20 x 2.90 m. – by the additions of strips at the top, bottom and both sides, which are still plainly visible to the naked eye.

As explained before, most scholars have convincingly held to the idea that *The Fable of Arachne* and *Venus at her Mirror* are executed in a closely connected manner and that, consequently, both must come from the same period – which, in the present state of our knowledge means before the end of 1648, when Velázquez set out for Italy.[157]

Coming now to the subject, as told in Ovid's *Metamorphoses,* Arachne, a low-born weaver, had achieved so great a reputation that Lydian women came from far away to admire her work. She became so proud of her success that she boasted of having a skill superior to that of Pallas Athena, the goddess of the arts and crafts. On hearing of this, Pallas came, disguised as an old woman, to admonish her not to defy the gods. Arachne, however, repeated her daring words, whereupon Pallas discarded her disguise, showing herself in armour and helmet, and took up the challenge. A contest was arranged and Pallas wove a set of six tapestries depicting the fate of mortals who had dared to challenge the power of the gods, beginning with Europa and Zeus metamorphosed into the Bull. Pallas won, and punished Arachne by transforming her into a spider.

So much for Ovid's narrative. As for Velázquez' work, ignoring the extraneous additions, it depicts the richly hued interior of a tapestry workshop, where sunlight, coming from somewhere above as the cast shadows suggest, plays upon everything – the weavers, their tools, and the skeins, balls and tufts of

wool scattered here and there. In the background, there is an alcove, dazzlingly lit-up also from above.[158] To the right of the workshop, a girl in a white blouse and greenish-blue skirt is winding yarn as another young woman brings a basket to her side. To the left, a weaver in a white kerchief and brown costume works at a spinning wheel. Although she stoops like an old woman, the youthfulness of her figure is revealed by her shapely leg. Obviously she is Pallas, engaged in her contest with Arachne, the girl in the white blouse. Velázquez did not deviate from the subject which he had chosen, whilst also allowing his imagination to toy with Ovid's story.

Set slightly behind the two rivals, there is a woman carding tufts of wool that she picks up from the floor. Her figure, a deep-shadowed blob of white, brown and red, underlines the luminosity of the alcove behind, two steps above the workshop. Another moment of the contest is depicted in the lit-up space of this alcove, whose rear wall is covered with a tapestry of *The Rape of Europa*. Three ladies clad in seventeenth-century costumes – one in pink, another in blue, and the third in yellow – stand there. The one in pink looks into the workshop, while the others look at Pallas, in armour and helmet, and Arachne, who wears a red sash around her white blouse and olive green skirt.

A diagonal shaft of light fuses the space of the alcove with the composition woven into the tapestry hanging on the rear wall: Titian's *The Rape of Europa*. To Velázquez, Titian was the greatest of Italian painters. The Venetian master's *The Rape of Europa*[159], now at the Gardner Museum, Boston, was at the Madrid Royal Palace in Velázquez' day (p. 161). Rubens copied it there in 1628–1629 (Prado, no. 1693), as other painters had done before or were to do later. Mazo, Velázquez' son-in-law, was one of them. Velázquez must certainly have expected so well-known a composition to be readily identified by his contemporaries when he included it in *The Fable of Arachne*.

In spite of the painting's present condition, it is possible to see that light was the dominant element in the composition of this masterpiece, where not even shadows bear darkness. Perceptive critics have spoken of it as Velázquez' "chief essay in the rendering of light",[160] and noted that the "shadowed left half acts as a foil" to the "lively right half which contains the heroic figure of the spinning girl".[161] Indeed, as Beruete saw it, *The Fable of Arachne* is "the most brightly coloured, and the most animated of all the works of Velázquez".[162]

The rediscovery of the subject of this Velázquez work has led to various iconographical interpretations.[163] It seems clear that the girl winding the skein is Arachne, depicted also in the background scene, and that Pallas is represented twice too, disguised as an old woman in the workshop and wearing helmet and armour in the alcove. As for the three ladies in seventeenth-century dresses, it has been suggested that they stand for the Lydian admirers of Arachne. Another interpretation, based on sixteenth-century allegories of Pallas as the goddess of the Arts, holds that the lady in yellow to the left, near what it is said to be a viola da gamba, personifies Music, while Arachne herself stands for Painting, and the other two ladies for Architecture and Sculpture. The viola da gamba has also been understood to symbolize Music as the antidote to the spider's poison, or Harmony, the latter interpretation being based on Ripa's *Iconologia* – which was also in Velázquez' library.

It is not possible, at least in the present state of our knowledge, to conclude whether the three ladies in the alcove stand for the Lydian women or, together with Arachne, for the four Arts. Neither is it feasible to determine whether the viola da gamba, if it really is a viola da gamba, is meant as a symbol of Music, the attribute of Harmony and the antidote of the spider's poison. It is evident, though, that Arachne is the dominant figure in both the foreground and the

LEFT PAGE:
Detail of no. 107

background scenes, and that her two representations are integrated into a rhythm of light. The two scenes, dramatically linked by the gesture of the lady looking into the workshop, are, moreover, joined together by live diagonals and contrasts of shadow and light and of tints.

The interpretation of the background scene as showing Pallas Athena surrounded by the personifications of the four fine Arts has led to a consideration of the contrast between the workshop, where there is an interplay of light and shade, and the more luminous alcove, as a pictorial paraphrase of the mannerist belief, expressed in sixteenth-century treatises, on the superiority of the Fine Arts over craftsmanship. Charles de Tolnay's argument that the painting contains "in a nutshell" the art theory that Velázquez did not put in writing, and that the myth of Arachne was "so to speak, inserted *a posteriori* into the fundamental theme" of the composition.[164]

Were we to search for clues to the meaning of Velázquez' painting in his library, our choice of possible interpretations might be considerably broadened, even more so if we made the assumption that his mind docilely adhered to whatever he read. It is possible that the Spanish translation of the *Metamorphoses* that he owned was Sánchez de Viana's, regarded as the most authoritative at the time. In the commentaries with which Viana accompanied his translation, it was explained that the fable of Arachne signified the bitterness which fills an artist when he sees his work unjustly criticized.[165] Pérez de Moya, in his *Filosofía secreta*, of which Velázquez also had a copy in his library, interpreted the fable of Arachne in a similar manner.[166] It is quite within the realm of reasonable conjecture that Velázquez, who might have read Viana's text even if he did not own the book but was certainly acquainted with Pérez de Moya's, had had some disappointing experience which reminded him of their interpretation of the Ovid passage, and that this played some part in his choice of subject for a work which, from all we know, was not painted for the King. Even if it turned out that so flimsy an hypothesis corresponded to fact, the interpretation of the painting would have to be based on the composition itself.

Some of the pictorial facts in *The Fable of Arachne* have been a puzzle to scholars. Are the figures of Pallas and Arachne in the alcove woven into the background tapestry or standing before it? The answer has been provided by the observation that Arachne casts a faint shadow on the floor, and that consequently neither her figure nor that of Pallas can be regarded as woven into the tapestry. Even so Velázquez does not make the spatial relations among the tapestry, the figures of Pallas and Arachne, and those of the three ladies very explicit.[167] The shaft of light that comes in obliquely from the left blends the space of the alcove with that of the tapestry and sweeps the view of the floor out of perspectival certainty. The contrast of this light-hued scene with the richly-hued play of light and shade in the workshop must have been even more vivid in Velázquez' original composition, before it was altered by another hand intent on making the rendition of space more plausible in architectural terms – which resulted in the trivial addition of the cross vault and the *oculus*.

Tolnay correctly pointed out that Velázquez did not share the "conceptions of the Italian masters" for whom mythology was "a transcendent and heroic world" since for him it was rather "immanent in everyday reality", and in fact, he did away with "the limits between reality and myth".[168] Certainly, it was Velázquez' wont to do away with iconographical trivia.

There are in *The Fable of Arachne*, as in many Velázquez compositions, several layers of significance. The depiction of the contest between Pallas and Arachne with the goddess still in disguise is certainly a departure from Ovid's text. The figure of the ordinary woman, into whom Pallas has dissembled her-

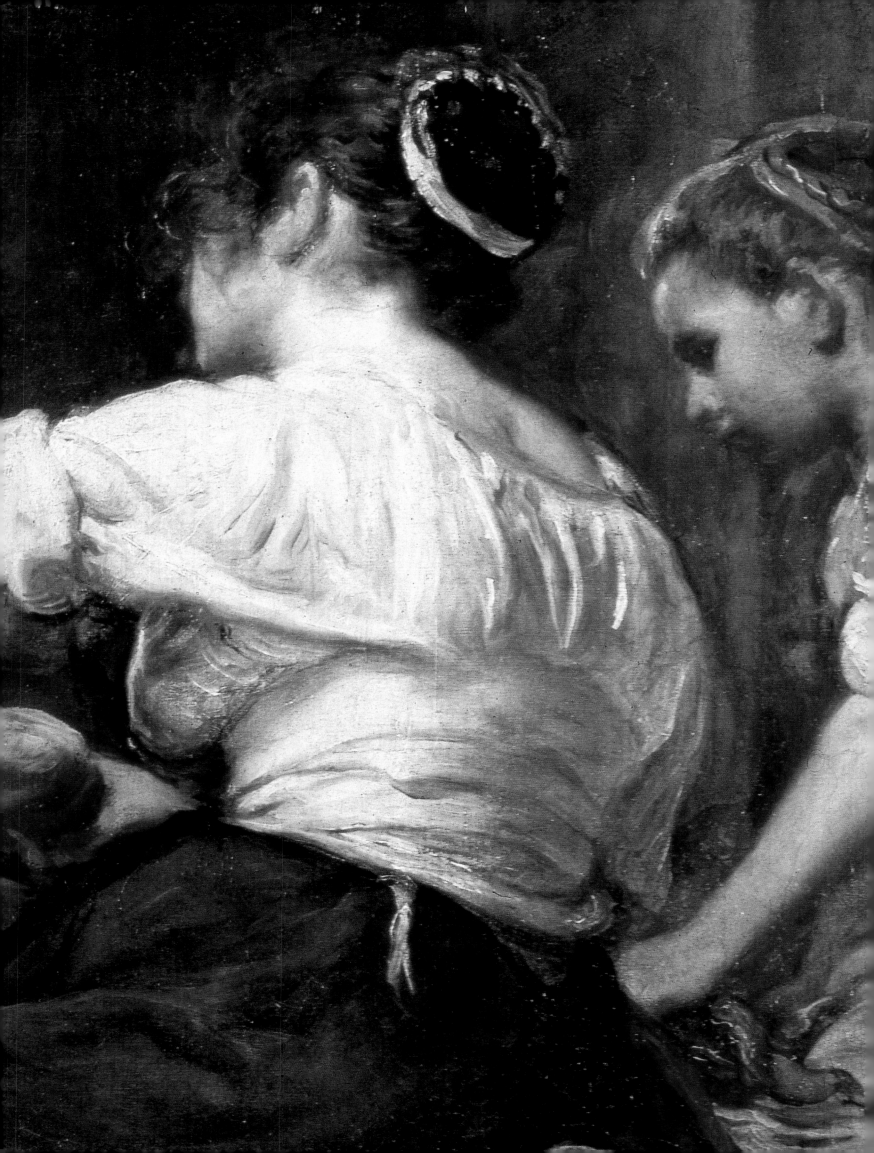

self, and the three workshop helpers, all have their character traits accentuated, and their figures modelled in shadows. Not so Arachne, whose face is not visible and whose torso is lit up from somewhere on the left. Her opulent figure breaks free from the shadows of the workshop, luminously out-balancing that of Pallas and falling within the rhythm of light marked by the shaft that hits the jambs of the alcove.

Contrasts of light and shadow and hue also heighten the foreground scene, where the goddess and the daring weaver are seen plying the wool with deft fingers. Indeed, the shadowed figure of Pallas, set off by the radiance of the whirring spinning wheel, is in turn a foil to the light-bathed figure of Arachne.

Velázquez, well read as he was in Ovid and his commentators, gave a new twist to the fable of Arachne. In neither of the scenes that he depicted did he represent her punishment as other painters and engravers had done. Instead he depicted the weaver, in the background scene, challenging Pallas, not only with her own work but with Titian's as well. The strength of this confrontation is underlined by the demonstrative gesture of the weaver's right hand, that stands in contrast with the more threatening hand of the goddess. He made the sky of Titian's composition considerably higher, freed the cupids of their bows and arrows, and stressed by strokes of light and shadow the course of their flight which appears to pass over the figure of Arachne. Light blends the space of the tapestry, readily identifiable as a work of art, with that of the alcove, fancied as a reality, while the rich hues depicting the shadows of the workshop frame the whole background scene as a painting within the painting, and the foreground figure of the dishevelled Arachne starts distinctly from the shadows. Velázquez thus created a work which exalts the flow and might of his own naturalism, as well as that of Arachne and Titian.

Velázquez and iconographical dicta

Velázquez was conversant with other artists' reworkings of mythological subjects, as well as with Ovid's *Metamorphoses* and with Ripa's *Iconologia*, but he did not feel bound by either traditional imagery or iconographical dicta when his subject was either mythological or religious. His vivid imagination brought the mythical characters within the compass of human nature, endowing them with the feeling of life, as he dispensed with rigid iconographical attributes. This often makes it somewhat difficult to ascertain conclusively the determining subject of some of his paintings. Such is the case with the half-length figure of a girl handling what looks like a canvas onto which she projects large shadows (cat. no. 108). Mayer, who was the first to point out that this work and *The Fable of Arachne* are "closely connected in style", remarked that "one of the models" for the latter "seems to have been used" in the half-length composition "for another version of the 'Sybil' motive".[169]

The stylistic analogy is in fact evident in the free interplay of light and shadow which pervades the two very different works and which heightens the depth and dynamism of both compositions. It is evident too in the execution of the figure, or rather the bust, of Arachne winding yarn, quite similar to that of the girl's half-length figure. Both women incidentally are black-haired, wear a white blouse and have a somewhat dishevelled appearance. Their shapes are built by dint of rough and smooth strokes, which a vivid light puts into sharp contrast. This light is centred on the girl's right shoulder and on Arachne's left. But the light is also not without variation in strength; here and there it is interrupted or even cut off by richly coloured shadows.[170]

LEFT PAGE:
Detail of no. 107

Infanta María Teresa
1648
Cat. no. 109

The iconographic significance of the half-length figure is rather elusive. One of the difficulties is that Velázquez has not made clear what it is that she is holding. It looks like a canvas, but the roundish appearance of its right border would suggest that it is not nailed on a stretcher, and that it may perhaps be a piece of fabric on an embroidery frame. The canvas and the dishevelled black hair are, according to Ripa, among the attributes of Painting, but the girl in this picture lacks any other such attribute, such as a brush. In earlier works, Velázquez had depicted St. John the Evangelist and the sculptor Martínez Montañés holding the instruments of their craft – pen or modelling tool – and later he portrayed himself at work holding the brush (cat. nos. **12**, **76** and **124**).

The shadows on the canvas, if that is what they are, recall the ancient legend, much alive in the seventeenth century, according to which the art of Painting began with the tracing of a shadow on a lit-up surface. The girl's forefinger and the shadows which she projects on the blank surface might, indeed, allude to this legend. If so the allusion is far less literal than Murillo's rendition of *The Origin of Painting*, the so-called *Picture of the Shadows (Cuadro de las sombras)*, executed around 1660.[171]

As some scholars have convincingly proposed, Arachne stood for Painting in Velázquez' mythological composition, where she is seen working with her bare hands in the foreground.[172] The resemblance between this figure of Arachne at work and the half-length figure of a girl holding a painter's canvas or a piece of fabric suggests that Velázquez had in mind the image of one while he was painting the other (cat. nos. **107** and **108**).

Velázquez represented the girl, set off centre, looking towards the canvas, or whatever it may be, on which she presses or lets run her forefinger, which projects a large shadow as does the left side of her body. The shadows contrast with the light on the same surface, which is enlivened to a further extent by contrasts of texture and hue. This vivid surface is indeed an essential part of the composition. Whether meant as a painter's canvas or as a piece of weaver's material, it would fit, in Velázquez' terms, the image of Arachne – possibly once more as Painting, possibly too embodying an allusion to the ancient legend of its origin.

Two measures of Velázquez' stature at the Court

By the end of 1646, one and a half years after Velázquez had portrayed Philip IV in army dress at Fraga, both Queen Isabel, who had persuaded the King to lead his armies, and Baltasar Carlos, the heir to the throne in whom many had put their hopes for the Spanish monarchy, were dead. Philip IV's sister, the Infanta María, wife of the Emperor Ferdinand III, had also died in the spring of 1646 at Linz. Velázquez' portraits of all three, as well as of Philip's younger brothers, Fernando and Carlos, also both dead, were in the royal collection.

For some time, Velázquez appears to have painted little for the King. From the mid-1640s till 1648, he had time on his hands for executing a number of paintings for private individuals, including such large compositions as *The Fable of Arachne* and *Venus at her Mirror* (cat. nos. 106 and 107).

Philip IV, having dismissed Olivares as chief minister, still went on dispensing honours and preferments to Velázquez, who continued to encounter a certain amount of ill-will on the part of the office from which his salary and fees for paintings were to be drawn. In earlier years he had also had to petition time and again, negotiate, and finally compromise, so that he might arrive at a settlement of back salaries and fees that were due to him. As contemporary documents show, tardiness in paying royal servants was then more of a custom than an irregularity.

This time, however, the situation was somewhat different. Even former officials who drew pensions, as well as the recipients of "alms" – a form of regular royal assistance – were being paid, while Velázquez was advised to wait until money would be available. He felt discriminated against, and said so in the petition which, on 17 May 1647, he addressed to the King, and which led to a clear-cut decision in his favour.

At the time that he wrote that petition, his position at the Court had been considerably strengthened. Early in the year, he had been appointed supervisor and accountant for the building of the Octagonal Room in the Alcázar. By taking this highly important responsibility away from the Superintendent, Don Bartolomé de Legasca, and entrusting it to Velázquez, who was the Assistant Superintendent, the King enhanced the latter's prestige in the royal offices, where, as in similar precincts then and now, red tape provided the only measure of power.

The new chief minister, the Marquis of Carpio, influenced the form – preferments and favourable decisions on litigious matters – which the King's regard for the Master took. Velázquez' prestige must have also been helped by the admiration that the Marquis of Eliche, the son of the chief minister, showed for his art. Indeed, by 1651, Eliche's remarkable collection included four Velázquez paintings, *Venus at her Mirror* being one of them.

Soon after overcoming the hostility of the bureaucrats, Velázquez found an opportunity to suggest that the King should again send him to Italy. As recounted by Jusepe Martínez, a friend of the Master, the sovereign, by whose command the Madrid Royal Palace was being refurbished, asked Velázquez to look for painters from among whom the best would be chosen to paint pictures for a new royal gallery. Velázquez answered that Philip IV should not be satisfied to have paintings which were within the reach of everyone, and requested leave to go to Venice and Rome where he would secure for the King the best available works by Titian, Paolo Veronese, Bassano, Raphael as well as antique statues, or moulds of them to be cast in Spain, which would be needed to decorate the rooms on the ground floor.[173] Philip IV agreed, and in November 1648 the administrative machinery was set in motion for Velázquez' second Italian

Velázquez' workshop
Maria Teresa of Spain
Philadelphia, Museum of Art

journey. On the 22nd a dispatch was sent to the Spanish Ambassador in Venice instructing him to assist the Court painter in the task of finding suitable paintings for the King.

Changes were then being anticipated at the Court. The marriage of Philip IV, then forty-three, to his thirteen-year-old niece Mariana of Austria had been decided on. Only a few years earlier she had been destined to marry the now dead Baltasar Carlos, but now the Duke of Nájera was about to leave, at the head of other royal envoys, for Trent, where they were to meet the King's bride and escort her to Spain. Philip IV granted two thousand ducats to Velázquez for his travelling expenses. Philip, furthermore, ordered that he should journey with the Duke and his suite to Italy, and be given the carriage, to which he was entitled by reason of his office, as well as "a mule to carry several paintings". It is not known what these paintings were, who they were by, or for whom they were intended. It is doubtful, but not wholly improbable, that they were to be presented to the future Queen, since Velázquez, although he was travelling with Nájera, was not part of his suite, nor did he go to Trent.

Not long before leaving for Italy, probably some time in 1648, Velázquez painted the earliest extant portrait of the Infanta María Teresa, then about ten years old (cat. no. **109**). The thought occurs that this portrait might have been intended to acquaint the future Queen with the likeness of Philip's only surviving child.

Even if that was not the case, it is more than probable that word of Velázquez' fame reached Mariana before she set foot on Spanish soil. On 21 December 1647, shortly after her betrothal to Philip IV, a masked ball was held at the Royal Palace in Madrid to celebrate her thirteenth birthday. According to a rhymed account of this fête written by the courtier Gabriel de Bocángel, the nine-year-old Infanta María Teresa opened the dance at the head of seventeen ladies and *meninas* or maids of honour. The ladies and *meninas,* singly, in pairs or in quadrilles, performed other dances before the King, the grandees and the Court dignitaries.

Since Bocángel's poem, published in 1648, was dedicated to Mariana, one may confidently assume that a copy of it was sent to her at Vienna. The name of Velázquez shines in one of the stanzas, where two ladies are depicted as so beautiful, graceful and statuesque that they appear to be "now miracles by Velázquez, then reliefs by Phidias":

Milagros ya de Velázquez,
Y ya relieves de Fidias.[174]

On 15 November 1649, when Mariana made her official entry in Madrid, she passed the church of San Salvador on her route from the Buen Retiro Palace to the Alcázar. This church's façade had been decorated with the likenesses of members of the House of Austria, embroidered after Velázquez' portraits, and this "attracted much attention".[175] Some time later, most likely early in 1650, the new Queen sat for a portrait by Mazo. It was doubtless explained to her that the great Velázquez, whose masterpieces, including several portraits of Philip IV, decorated the royal chambers, was in Italy.

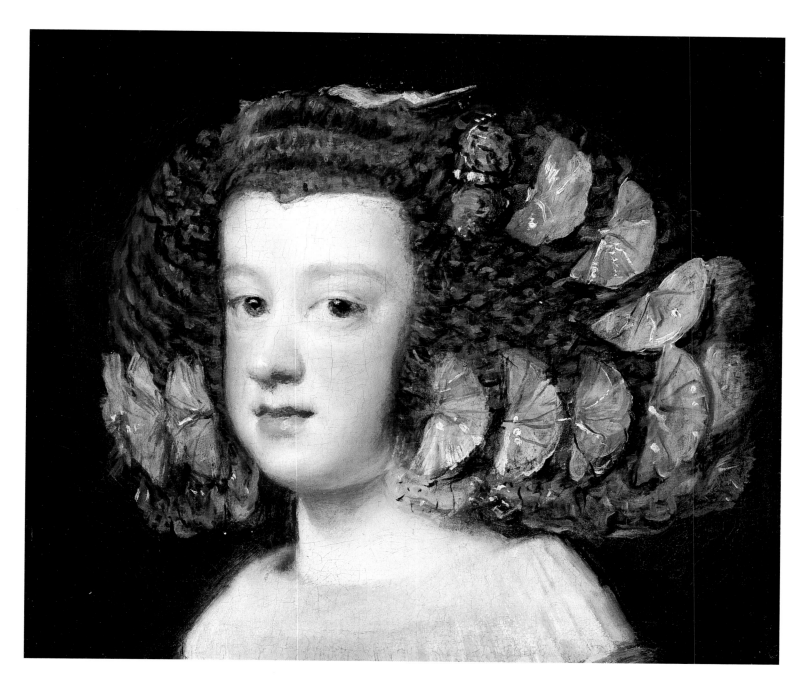

Infanta Maria Teresa
1651–1652
Cat. no. 118

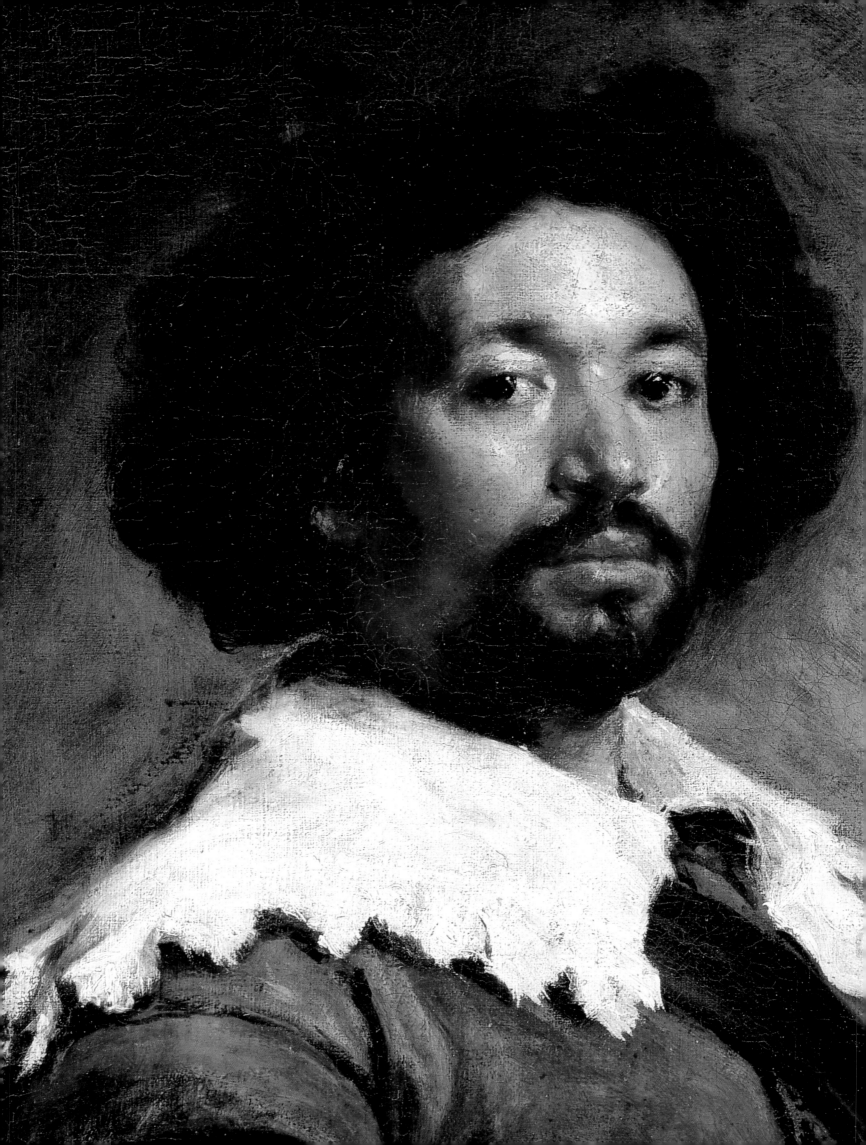

Italy again: the Master's success

Returning to Velázquez' departure for Italy, some members of the royal mission with whom he was to make the journey started from Madrid on 16 November 1648. The Duke of Nájera left two days later, but still a week before the King commanded Velázquez to accompany him. On 24 November, Velázquez was still in Madrid, where he signed an authorization for his wife, Juana Pacheco, to administer all his affairs, since he was about to leave Spain on King's business. The royal order that Velázquez should use the coach and mule for his journey was published the next day. It may also be that Velázquez set out from Madrid for Málaga, his port of embarkation, by himself, taking with him Juan de Pareja, his assistant, who was to be his travelling companion.

The Duke arrived at Málaga on 7 December. It still took six weeks – then not too long a wait – to make ready the ships, load the cargo, and gather together all who were to sail with the assembled fleet. On 21 January 1649 they finally set sail and, after a good many stops at ports along the Spanish coast, reached Genoa on 21 January 1649. It was here that Velázquez parted company with the Duke and started on his way to Venice.

He arrived on 21 April, and the Spanish Ambassador, the Marquis de la Fuente, explained that the painter was staying at his own house and seeing as many paintings as he reasonably could. According to Palomino, Velázquez bought Veronese's *Venus and Adonis* and several works by Tintoretto, including a group of scenes from the Old Testament that formed a ceiling decoration, and a sketch for *The Paradise*, all of them now at the Prado Museum (nos. 386, 388, 389, 393–6, 398 and 492).[176] However, it appears that it was in 1651, when he was back in Venice, that Velázquez acquired *"el model del Tintoreto"* for *The Paradise*, as Mario Boschini recalled in a poem published in 1660.[177]

Velázquez' stay in Venice in 1649 was possibly very short. Three days after his arrival the Spanish Ambassador described how he wished to set out for Modena where he had been advised he could find "something very much to his purpose". The reference probably was to Correggio's *Night,* then in the collection of the Duke of Modena, which Velázquez was determined to buy for Philip IV.

It was another work by Correggio that persuaded him to go first to Parma where, Palomino states, he went to see a cupola fresco decoration by him. This may have been the *Assumption of the Virgin* in the Cathedral rather than the not so widely known *Christ in Glory* in the Church of San Giovanni Evangelista. Whichever painting it was that made him take to the road, he must have seen both once he was there .

After this, and provided with letters of introduction from the Spanish Ambassador in Venice, he arrived in Modena. The Duke, Francesco d'Este, had been in Madrid in the autumn of 1638, and whilst there he had sat for Velázquez who was still at work on the portrait in March 1639, according to a dispatch from Count Fulvio Testi, the Duke's Minister in Madrid. This dispatch contains what was probably the contemporary critical evaluation of Velázquez as a painter. Like other "famous men", he hardly ever got around to finishing a work, and never told the truth as to when that would be. Although expensive, he was, as a portrait painter, comparable to any of the most renowned among either the "ancients or the moderns". Velázquez' procrastinating habit was well known by then. On 26 May 1639 the Cardinal Infante Don Fernando referred rather leniently to his dilatory ways in a letter to Philip IV written at Brussels. Only a few months later, in November, Sir Arthur Hopton, the British Ambassador in Madrid, wrote about Velázquez' "laziness".[178]

Juan de Pareja
Baptism of Christ
1667
Huesca, Museo de Bellas Artes

Juan de Pareja
Vocation of St Matthew (detail)
1661
Madrid, Museo del Prado

It is not known whether the portrait of Francesco d'Este, to which Count Fulvio Testi referred, was ever finished. It must have been, or been intended to be, larger than the bust portrait now at the Modena Gallery, in which the Duke is seen wearing the Golden Fleece, awarded to him by Philip IV in October 1638. Although this portrait looks like a fragment of a larger composition, it has been suggested that it may be a study from life (cat. no. **89**).

The Duke had another Velázquez work, a miniature, now lost. Soon after his visit to the Spanish Court, Philip IV had sent him a jewel in the shape of an imperial eagle, on the reverse of which there was, in the words of Count Fulvio Testi, "a little portrait of the King done by Velázquez, and so like and so beautiful that it is an astonishing thing".

Velázquez left Modena for Bologna and, after a probable stop at Florence, arrived at Rome by the end of May 1649. He stayed here for a short while before proceeding to Naples. He carried a letter from the King to the Spanish Viceroy there, the Count of Oñate, instructing him to give the artist eight thousand *reales* – the balance, roughly one-third, of the two thousand ducats granted to him for travelling expenses.

The precise date of Velázquez' arrival in Naples is unknown, and so is that of his departure. He seems to have been busy, as he later was in Rome, commissioning moulds from antique sculptures to be sent to Madrid, where they were to be cast in plaster or bronze. Some of the latter were used for the decoration of the Octagonal Room at the Royal Palace, the refurbishment of which had, as we know, been entrusted to Velázquez.

Back in Rome around 10 July, he went on selecting antique sculptures, shipped some of the moulds to Spain, and commissioned Giuliano Fanelli and Alessandro Algardi to do the casting of others. Contrary to what Palomino wrote Velázquez was not in Rome as Ambassador Extraordinary to the Pope, for no mention of such a mission was made by any of the witnesses who, six or seven years later, endeavoured to recall every honour bestowed on him or high position in which he had served in order to facilitate his admittance into the Order of Santiago. Indeed, Cardinal Alonso de la Cueva (1572-1655), an old diplomatic hand, whose work at the Sacred College left him time to help the Spanish Ambassador to the Pope, was convinced that Velázquez had no legitimate business in Rome. In letters to his brother, the Marquis of Bedmar, the

old Spanish Cardinal, who had held important appointments under both Philip III and Philip IV, referred to the Master as "a certain Velázquez, Usher of the King's Chamber", who claimed to have been commissioned by the King to look for works of art in Italy, and whose activities were nothing but a "swindle", a sour remark that reveals some sort of resentment against Velázquez .[179]

Much as it may have displeased Cardinal de la Cueva, great deference was shown to Velázquez at the Papal Court, where Prince Ludovisi, and the Cardinals Pamphili and Francesco Barberini [180] as well as others, honoured him with their courtesies. Pietro da Cortona was one of the artists whom he visited. Philip IV wanted him to come to Spain to undertake some fresco decorations, and there is documentary evidence that at one time, early in 1650, the monarch understood that Cortona would be sailing with Velázquez on the latter's return to Spain; this, however, did not happen. Palomino also mentioned Bernini, Poussin and Mattia Preti, among the artists with whom Velázquez was in contact in Rome. He must also have come to know Salvatore Rosa, if the discussion between the two that was reported by Boschini, to which I shall presently refer, reflects an actual thrashing out of their divergent views on painting.

There are, however, certain aspects of Velázquez' travels in Italy on which Palomino is not reliable. It has, for instance, been shown that when he enumerated the works of art that Velázquez wanted to see back in Bologna, he just followed Vincencio Carducho's description, which was already out of date when it was published. This accounts for such errors as the anomaly of depicting Velázquez as hoping to see the statue of Julius II which had gone into the making of a cannon in 1511.[181]

Juan de Pareja (?)
Agustín Moreto
Madrid, Museo Lázaro Galdiano

Sometimes Palomino filled-in his narrative with stock stories – when giving general descriptions of cities, for example, or when praising the true-to-life likeness of a good portrait that is almost invariably said to have been mistaken for the person of the sitter in flesh and blood. Yet Palomino's account of the works that Velázquez painted in Rome has a ring of authenticity, and many of its essential points have been confirmed by documentary evidence. He himself acknowledged that he had had at hand "some notes on Velázquez' life" gathered by the Master's pupil, Juan de Alfaro.

Alfaro was born in 1643 in Cordoba, where he was apprenticed for a very short time, seemingly a matter of days, to Antonio del Castillo, and then sent by his parents to Madrid, where he entered Velázquez' workshop. After attaining a measure of distinction, he returned to his native city when he was not yet twenty.[182] He must have been at least ten years old when he was apprenticed to Castillo, and consequently he could not have entered Velázquez' workshop before 1653. The information that he gathered together concerning the Master and which he later passed on to Palomino (1655–1726), is particularly detailed when it comes to the portraits executed during the journey from which Velázquez had returned in 1651. In fact, Palomino gives the names of most of the sitters. Of the portraits thus identified, Alfaro, as well as Palomino, could have seen only the replica of that of Innocent X which Velázquez brought with him to Spain. The rest remained in Italy, and there is no indication that any of them, not even the one of Pareja, was ever taken to Spain.

Palomino's statement that Velázquez painted all those portraits "with long-handled brushes, and in Titian's vigorous manner" sounds like an echo of workshop talk that Alfaro had most likely heard from Pareja, if not from Velázquez himself. It has the ring of a painter's emphatic account of a feat in which craftsmanship and artistic achievement elucidate each other.

In Palomino's account, Titian becomes the touchstone for Velázquez' art. According to Martínez, Titian's was the first name on Velázquez' lips when he

suggested to the King that he should be sent to Italy to buy paintings. Neither Martínez nor Palomino was quoting Velázquez verbatim. Yet, since Martínez and Alfaro – Palomino's acknowledged source – were enthusiasts of Velázquez and had been close to him, their admiration for the Venetian master would have been at least coloured by that expressed by Velázquez himself. I have shown how, in *The Fable of Arachne*, Velázquez had depicted Titian as the very embodiment of Painting.

During his stay in Rome – from early in July 1649 till the end of November of the following year, at the most – Velázquez painted many portraits, particularly that of his Holiness Innocent X. Other members of the Pope's household, from his domineering sister-in-law, Olimpia Maldachini, to his barber (cat. no. 113), also sat for him, as well as a woman painter by the name of Flaminia Triunfi, of whom nothing is known today. Neither this portrait nor that of Olimpia Maldachini has come down to us.

It is not known how it was arranged that the Pontiff should sit for Velázquez. For the painter of Philip IV, it must have been a challenge to portray Innocent X, who was rather unsightly in appearance, but was also a true connoisseur, as his patronage of Bernini proves. It is, however, known that, when it was decided that he should portray the Pontiff, Velázquez, who had been for some time out of practice, felt the need to prepare himself by painting "a head from life", and asked his assistant to sit for it (cat. no. 114).

Andrie Smidt, a Flemish painter then in Rome, who went to live in Madrid after Velázquez' death, recalled that the portrait of Pareja was exhibited at the Pantheon on St. Joseph's day, 19 March 1650, where it was unreservedly admired by all painters, whatever their nationality. He also thought that it was on account of this that Velázquez was made *"Académico romano"* in that year.[183] Velázquez' admission into the Academy of St. Luke was actually recorded in January 1650, and he was admitted into the "Congregazione dei Virtuosi al Pantheon", a religious brotherhood of painters, just a few weeks later, on 13 February. For all we know, the portrait of Pareja may have been painted at any time between early July 1649, when Velázquez returned to Rome, and 19 March the following year, when it was exhibited by the "Virtuosi al Pantheon" on the day of their patron saint. Consequently, it may well have determined the admission of Velázquez to either, or both, associations of painters before it was shown.

As for the portrait of the Pope, it made an even greater impact on the Roman painters, and many copies, some with variations, most of only the bust, were made after it. Pietro Martire Neri (1591–1661), who apparently was then in Velázquez' circle at Rome, copied it at least twice. He also executed a portrait of *Cristoforo Segni*, major-domo to the Pope, presumably after a sketch by the Master that has not been preserved.

Velázquez must have been pleased with his portrait of the Pope and took a copy of it back to Spain (cat. no. 115). The Pontiff expressed his pleasure by presenting him with a gold medal showing the portrait in relief. These two facts, reported by Palomino, are corroborated by the inventory of the Master's possessions drawn up at the time of his death. Listed there was "a portrait of the Pope Innocent X" and two gold medals with the likeness of the Pontiff – one with a Roman obelisk, which must have been Bernini's at Piazza Navona, and the other with a cross and two angels on the reverse. Innocent X also encouraged Velázquez' desire to be admitted into one of the three Spanish military orders.

While he was painting portrait after portrait, and doubtless enjoying it, for he was free not to have to undertake them, Philip IV was putting pressure on him to return to the Court. The King urged his Ambassador in Rome to make sure that Velázquez proceeded with the task of acquiring works of art and

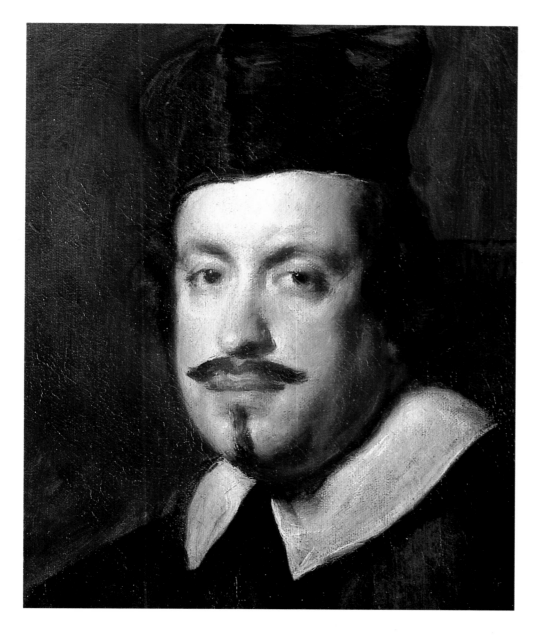

Camillo Massimi (detail)
1650
Cat. no. 116

warned against the painter's dilatory disposition, which might lead him to stay in Rome longer than was necessary. Philip wrote on 17 February 1650 that he expected Velázquez to be back in Madrid no later than May or early in June. To secure this, Philip instructed the Count of Oñate, his Viceroy in Naples, to provide Velázquez with the money necessary for his passage. Velázquez was at Naples sometime in February 1650, but by 8 March he had left for Rome, where he again busied himself with the acquisition of moulds from antique sculptures for Philip IV.[184]

There was then a new change in his plans. According to a royal communication to the Count of Oñate, dated at Madrid of 25 June 1650,[185] Velázquez had had his own way and was going to Venice again. Once more the Count was asked to urge Velázquez to return to Madrid as soon as possible.

On 12 December 1650, Velázquez was in Modena, apparently to keep the promise he had made to Francesco d'Este to visit him again. As it happened, the Duke was absent. Much as his secretary, Gemignano Poggi, a timorous character, wanted to oblige the renowned visitor, he was reluctant to let him into the ducal gallery for fear that he might carry off some of the paintings. So, he lodged him in the Commenda, and took him on a tour of the nearby Palazzo Sassuolo, decorated with frescoes which could not be so easily removed. While

Cardinal Astalli (Pamphili) (detail)
1650–1651
Cat. no. 117

looking at the frescoes, Velázquez mentioned to Poggi that Agostino Mitelli and Michele Colonna, two of the artists who had worked on them, were to sail with him from Genoa within a few days. For his part, Philip IV in a letter to his ambassador in Rome, the Duke of Infantado, dated on 2 January 1651, wrote that he hoped to have Velázquez back in Madrid very soon.[186] It was not till about half a year later that Velázquez did return to Madrid.

Boschini, in the poem already mentioned, provides the only information we have concerning Velázquez' whereabouts from mid-December 1650, when he was in Modena, until he sailed from Genoa to Barcelona, where he landed the following June. According to Boschini, Velázquez was in Venice in 1651, probably shortly after his stay at Modena, and was acclaimed as the painter of the portrait of Innocent X, painted in Rome, but "with the true Venetian stroke", a replica of which, presumably the one that he later took to Madrid, was shown and admired in Venice. During the time that he spent there looking for old masters' works for his King, Velázquez was full of praise for the great Venetian painters, and above all Titian and Tintoretto. To him, the latter's *Paradise* at the Sala del Gran Consiglio was in itself enough to make a painter immortal.

Paintings by old masters were hard to find, and Velázquez "only bought five": two by Titian, another two by Veronese, and the "model" for Tintoretto's *Paradise*. He then returned to Rome to take care of matters pertaining also to the service of the King. As Boschini has it, it was there, after his return from Venice, that Velázquez, in answer to a challenging question from Salvatore Rosa, said, with a ceremonious bow, that, to tell the truth freely and candidly, Raphael did not please him at all, and that when it came to good and beautiful painting, Venice was first and Titian her standard bearer – or, as Boschini put it in his rhymed account of Velázquez' reply:

> *... Rafael (a dirue el vero;*
> *Piasendome esser libero, e sinciero)*
> *Stago per dir, che nol me piase niente.*
>
> *A Venetia se troua el bon, e'l belo:*
> *Mi dago el primo liogo a quel penelo:*
> *Tician xé quel, che porta la bandiera.*

On his way back to Spain, Velázquez stayed in Genoa for some days before sailing for Barcelona, where he arrived in June 1651.[187] He hastened to Madrid bringing with him "many paintings by the best masters", as well as the portrait of Innocent X with which Philip IV was particularly pleased, as Giulio Rospigliosi, the Nuncio at Madrid, reported on 8 July. He also brought with him the hope of being made a knight of one of the military orders, an ambition that the Nuncio, on the Pontiff's instructions, undertook to support at the Spanish Court.

The Roman portraits

According to Palomino, Velázquez, while in Rome, was busy selecting and commissioning moulds and casts from antique sculptures and acquiring original pieces for Philip IV. "Without neglecting" this business, however, he completed ten portraits and left several others just sketched in "though not lacking in likeness to their sitters". Palomino, whose detailed account includes the names of the sitters for each of the ten completed portraits, does not mention paintings of any other subject painted by Velázquez during his second Italian journey, in Rome or elsewhere.

Velázquez could not have spent more than seventeen or eighteen months at Rome during the various times that he was there from May 1649 till the spring of 1651. Ten portraits finished in eighteen months or less, at times when he was busy with other pressing matters, is no small accomplishment for a painter reported to have had slow working habits. The thought occurs, indeed, that perhaps the Master allowed his reputation for slowness to grow in order to protect himself from unwelcome commissions.

Of the completed portraits, five, and a replica of one of them, *Innocent X*, are extant. The only exact date we have bearing on any of them is that of 19 March 1650, when the portrait of Pareja was exhibited at the Pantheon. Since the Master portrayed his assistant as an "exercise" – to use Palomino's word – to prepare himself for the portrait of the Pope, it is safe to assume that Pareja's portrait was the first he painted. As indicated above, it could have been executed any time between July 1649 and the date just mentioned.

Velázquez placed Pareja off centre, turned three-quarters to the right, his head, raised and boldly highlighted, set off by the whiteness of the wide – and broadly painted – scalloped collar (cat. no. **112**).[188] The copperish flesh tones of the face are framed by bushy black hair, beard and moustache, and accentuated by the reddish stroke which models the lobe of the ear. The vivid head stands out against a harmony of greys, that spreads into the right-hand background, as well as by a subtle greenish tinge in the sitter's doublet, sleeves, shoulder belt and cape. The dark shoulder belt runs across the chest in a rhythm opposing the black-haired head, heightening the roundness of the figure and the vivid tranquility of the composition, as does the hand which holds the folds of the cape hanging from his left shoulder.

Sketchy strokes around the figure carry the fluidity of the contour deep into space. Hence – as, for instance, in *Philip IV at Fraga* (cat. no. **100**) – atmospheric space and the nature of its rendition are both simultaneously enhanced as Pareja's copperish flesh tones and the blackness of his hair stands out against a grey background whose lighter area is made somewhat warmer by that slight greenish tinge.

His hand thus practised, Velázquez undertook the portrait of *Innocent X* (cat. no. **114**). He achieved an astounding masterpiece. He, indeed, brushed on the canvas both a striking human likeness and an absolute harmony of reds, yellows and whites. Innocent X, wearing a white alb and red biretta and mozzetta, broadly highlighted into scarlet, sits in an armchair. The chair's golden galloons and finials create a striking contrast with the red that curtains the whole background. His robust posture is accentuated by the searching look in his blue-grey eyes and the bold highlights on the purplish face. There is a most tenuous shade of green in the varying greys of his hair, moustache and beard, as well as in the yellow of the armchair's galloon to his left. The collar, painted in a slightly greyish white with the edges and wrinkles highlighted in sheer white, lets through a pale glow from the red underneath, while bluish-grey tints enliven the white

So-called Barber to the Pope (detail)
1650
Cat. no. 113

of the alb and of the paper in the Pope's hand. The hands are modelled with yellowish lights and purplish touches – the latter being somewhat more vivid in the right hand, where the stone in the pastoral ring gives off a blackish gleam.

The sense of depth is mainly achieved by a variety of red hues which flow into each other. From the lit-up folds of the red backdrop and the red chair to the deeper red of the shadow of the Pope's head on the back of the chair and the flashing scarlet stroke in the red mozzetta that outlines the sitter's right shoulder. The outlines are quite fluid everywhere, and the pigments are laid on thinly, particularly in the face, apart for the heavy impasto used to brush in the highlights.

Though the sitter's features have been made vivid, his ugliness has not been stressed. It is, indeed, a marvellous likeness in which papal splendour appears, as it were, knit into Innocent X's character traits and vigorous bearing. In the painting Velázquez embodied the sense of earthly power, as he had done in his portraits of Olivares and as he never did when portraying the person of his King.

For subtlety in the depiction of human nature, the portrait supposed to be of *Monsignor Michelangelo*, barber to the Pope, is one of Velázquez' outstanding works (cat. no. **113**). As in the portrait of Pareja, the background is grey with a

greenish tinge. The head, like the background, is thinly painted, with impasto highlights on the face, as well as on the black hair and the edges of the transparent white collar on the black costume. The outlines are broad, and that of the right shoulder is made the more fluid by a stroke of white which, vivid and thick about the neck, thins to a tenuous glimmer as it slopes down. Strong highlights on the forehead, nose, upper lip and neck accentuate the glints and flecks of impasto which give vivacity to his features. It is not surprising that, before the identification of the rascally-looking sitter was suggested, he was assumed to be a buffoon, even though he is not clowning, or dwarfish, or otherwise misshapen. Indeed, whatever was the relationship of the barber to the Pope, Velázquez achieved in this portrait, presumed to be of him, the very image of corporeal existence – and he did so by just the use of paint and brush.

Camillo Astalli was created a Cardinal on 19 September 1650. Consequently, Velázquez must have portrayed him wearing the red mozzetta and biretta either within the next ten or twelve weeks, before the painter started on his way to Modena, or in the early part of 1651, when he returned from Venice to Rome. Velázquez' portrait of *Cardinal Astalli* is thinly painted apart from the impasto highlighting the sitter's roseate flesh tints, which harmonize with the light red of the mozzetta and the biretta smartly worn at an angle (cat. no. 117). Broad strokes around the top and right side of the biretta and along the sitter's left shoulder are obviously *pentimenti* since they have been brushed over the original outline, that has remained visible through the brushwork of the grey background. They, as well as the quick strokes of the white collar which let through the red of the mozzetta, contribute to the rendition of atmospheric depth and to the accentuation of the pictorial reality of the portrait – which, in execution, is much the same as the other portraits painted by Velázquez in Rome.

The highlights on Astalli's rosy face and black hair animate his features. Yet somewhat differently from the portrait of *Monsignore Michelangelo*, where the light leaves the side of the face and the underchin in shadow, smooths the flecks of pigment used for the flesh tones into as even a surface as that of the creaseless mozzetta. Long before the sitter was properly identified, Beruete spoke of him as having a "good carriage and a touch of levity".[189] What we know today of Cardinal Astalli would tend to substantiate that view – which is to the credit of both the painter and the critic.

The other portrait painted by Velázquez in Rome that has come down to us is *Monsignor Camillo Massimi*, and is badly in need of careful cleaning (cat. no. 116). Though Velázquez' hand can be recognized in the quality of the brushwork in spite of the dirt which covers the painting, no meaningful description of its original colour scheme – apparently keyed to a harmony of blue hues – can be attempted.

We are acquainted through written sources with the character of Innocent X, know something about Cardinal Astalli's, hardly anything about either Pareja's or Monsignor Massimi, and nothing about the so-called barber to the Pope. Yet, neither our understanding nor our enjoyment of any of these portraits hinges on any knowledge that we may have, or lack, about its sitter. The character traits of each of them are expressive in themselves. Whether identifiable or not, their likenesses have been brought to life in the world of Velázquez' naturalism.

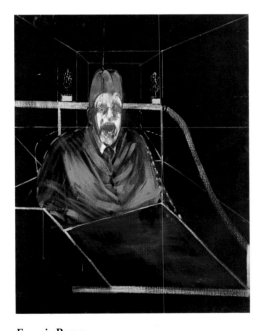

Francis Bacon
No. VII of Eight Studies for a Portrait
1953
New York, The Museum of Modern Art

LEFT PAGE:
Innocent X (detail)
1650
Cat. no. 114

The return to the Court: Chamberlain and painter

Philip's probable wish to have a portrait of his new Queen, Mariana, by Velázquez, plus the need he felt to refurbish the old Alcázar, may have been responsible for his urging the quick return of the Master to the Court. Yet Velázquez managed to delay for a full year, and it was probably not for some time after his arrival in Madrid in June 1651 that he could portray the Queen, who was then about to give birth to her first child.

The royal baby, the Infanta Margarita, was born on 12 July, and Mariana was ill for several months afterwards. Velázquez consequently could hardly have portrayed her before 1652. From then on, he and his assistants painted a large number of portraits of the Queen, the marriageable Infanta María Teresa, and the little Infanta Margarita – quite a few of which, as well as others of the King, were sent to foreign Courts.

Velázquez was all the busier after having been granted the office of Chamberlain of the Royal Palace. There had been six applicants upon whose qualifications a six-member board passed. Though none of the board members recommended Velázquez in the first place, it was he whom Philip appointed to the coveted position on 16 February 1652.

He was sworn in to the position three weeks later on 8 March. His new office brought him a handsome salary and the right to a large apartment in the Treasury House, which was connected by a passageway with the Royal Palace where he had had his workshop for years. As to his new duties, they included looking after the decoration and furnishings of the royal residences, each of which had to be readied, in succession, as the Court moved throughout the year from Madrid to Aranjuez, and then to the Escorial, and from there to the Prado, and back to Madrid. In addition Velázquez had to make arrangements for the King and his suite whenever he journeyed. All of this entailed frequent and extended absences from Madrid. He had likewise to supervise the arrangements and decoration required for state affairs or for other, less solemn, festivities. However, he had assistants who took care of the routine chores, thereby leaving him time free to paint.

For a long time he was busy with refurbishing several chambers in the Madrid Royal Palace, for which he had acquired moulds from antique sculptures in Italy, and on whose casting he had also to keep an eye. He painted, moreover, four large mythological compositions for one of the new chambers, the Hall of Mirrors. It was a time when, though the Spanish monarchy and treasury were steadily sinking, a tasteful effort was being made to give new splendour to the forlorn Court. The new young Queen made it possible to hope again for a male heir to the throne, and the marriageable age of the young Infanta allowed thought of some advantageous alliance.

In neither of the two palace interiors that he painted in those years (cat. nos. **124** and **129**), did Velázquez depict the kind of splendid décor which, as Chamberlain of the Palace, he was bringing to the royal chambers. Both interiors are rather plain and dark, except for the illuminated area where the royal sitter stands. Well read and skilled in architecture though he was, Velázquez never depended on architectural motifs for grandeur of pictorial composition. Nor did he ever emphasize wall décor or other room ornaments in his portraits. The only work which might be regarded as something of an exception in this regard is the portrait of the Infanta Margarita painted in 1659 (cat. no. **128**). In this painting – which cannot really be considered an "interior" since there is no depiction of architectural space strictly speaking – there is, in the background, a huge clock on the face of which could originally be seen, according to an

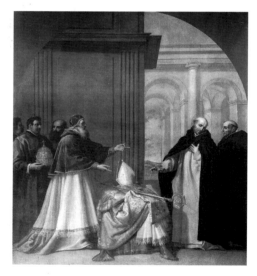

Pietro Martire Neri
Innocent X with a Prelate
1650–1655
El Escorial, Patrimonio Nacional, Monasterio de San Lorenzo

Vincencio Carducho
St. Bruno Declining the Archbishop's Mitre
1626–1630
Madrid, Museo del Prado

eighteenth-century account, the chariot of the Sun circling round the numerals of the hours.

Even in earlier years, however, Velázquez' assistants had occasionally let ornament play an important compositional function and brought a depiction of architectural décor into royal portraits entrusted to them at the workshop. Such is the case with the portraits of Philip IV, Prince Baltasar Carlos, or Queen Isabel, executed at various dates from the 1630s on (p. 186). A sharper departure from the Master's sense of composition is to be found in Mazo's portrait of *Queen Mariana*, painted in 1666, long after Velázquez' death (p. 185). Not much later, towards the end of the 1660s and again in the early 1670s, Carreño de Miranda would portray Queen Mariana, as well as Charles II – her and Philip IV's sickly son and the last monarch of his dynasty – in that famous Hall of Mirrors, in paintings where the vivid depiction of the ornaments and mirror reflections are one with the portrayal of the sitter's majesty (Prado, nos. 642 and 644, and Staatliche Museen, Berlin, no. 407). By comparison with Velázquez, Carreño appears to have shifted the emphasis from the figure of the King to the grandeur of his surroundings – which was current in the European painting of the seventeenth century (p. 100).

The old Royal Palace, or Alcázar, at Madrid, was gutted by fire in the following century, and over five hundred paintings, including quite a few by Velázquez, were lost. Only one of the four he had painted for the Hall of Mirrors was saved. Luckily, however, most of his royal portraits of the 1650s, including his most extraordinary work, *Velázquez and the Royal Family*, could be rescued or were safe elsewhere.

Pietro Martire Neri
Cristoforo Segni
c. 1652
Switzerland, private collection

Velázquez' workshop

So little is known of the make-up of Velázquez' workshop either at Seville or at Madrid that one must presume that the names of most of his pupils and assistants are buried in the dust of archives, and perhaps not undeservedly. As for those names which have come down to us, except for a few, there is little of substance that can be added to them.

It is recorded that in 1620 Velázquez signed up Diego de Melgar, then thirteen or fourteen years old, as an apprentice for a period of six years. The Master left Seville for Madrid three years later, and there is no indication as to whether or not he took Melgar with him.

No old copy of any of the religious paintings executed by Velázquez in Seville is extant or has ever been mentioned. There are, however, enough copies or replicas of his *bodegones* to conclude that he had followers or imitators, some of whom may have been his pupils, perhaps even before he left Seville for Madrid, where his Sevillian *bodegones* were admired and imitated. In the extant copies or replicas of his early works one misses the fluid handling of light, shade and colour by which Velázquez achieved his rendition of both texture and aerial space. Instead, one finds a sharp contrast of light and shade which is more Caravaggesque than Velázquez-like, and as such is more in keeping with the "modernism" that Velázquez had left behind even as a young man, but which remained ingrained in other painters of his day, including some of his followers. Occurrences of this sort are not unusual at times which may be described as plateaux of modernism.

Diego de Melgar and the nameless followers of young Velázquez naturally awake our curiosity. As for their works, the task of trying to characterize them would require the discovery of new data in order to arrive at conclusive results,

Juan Bautista Martínez del Mazo
Queen Mariana
1666
London, The National Gallery

Juan Bautista Martínez del Mazo
View of Saragossa
1646–1647
Madrid, Museo del Prado

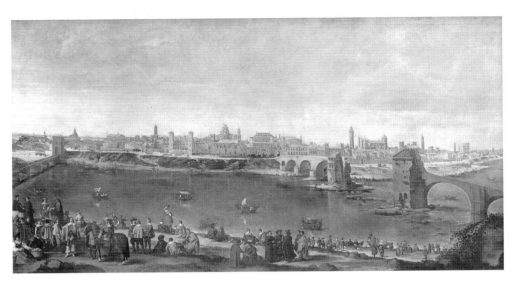

Velázquez' workshop
Philip IV Wearing Armour, with a Lion at his Feet
c. 1652–1654
Madrid, Museo del Prado

Juan Bautista Martínez del Mazo
Portrait of Philip IV in *The Family of the Artist*
c. 1660–1661

and these would, most likely, be of slight historical relevance and remain peripheral to the study of Velázquez' art.

Soon after his appointment as painter to the King, the Master was given the use of a workshop in one of the buildings within the compound of the Royal Palace, as well as an apartment in one of the houses that the King owned in the city.[190] As we shall see, he was later allowed to use some rooms of the apartment that Prince Baltasar Carlos had occupied in the Royal Palace until his death in 1646, as a workshop. As for his place of residence, he moved it to the rooms which the King assigned to him in the *Casa del Tesoro*, another building within the royal compound.

Most of the Master's pupils in Madrid were of gentle birth, like Don Diego de Lucena, who probably entered the workshop in the mid-1620s, dying in middle age in the 1650s. He was admired for his portraits, none of which are known today. Francisco de Burgos Mantilla, born around 1609, was nine years old when he moved from his native Burgos to Madrid, where he was a pupil first of Pedro de las Cuevas (d. 1644), and then of Velázquez. He was active and successful in Madrid as a portrait painter in 1648, according to Lázaro Díaz del Valle, to whom we also owe the information that he endeavoured to imitate Velázquez' manner in his works.[191] The only extant work by his hand is a still-life, signed and dated in 1631, in which blackish and grey hues prevail over a variety of ochres.[192] Don Nicolás de Villacis (1616–1694) studied with Velázquez in the years 1632–1636. He then went to Italy, and returned to his native Murcia in 1650. A few extant works have been attributed to him, though actually we know little, if anything, about his style.

Francisco de Palacios, who reportedly died at the age of thirty-six in 1676, was among those pupils of Velázquez who distinguished themselves mainly as portrait painters. If the dates we have concerning him are right, he could not have been a pupil of Velázquez before 1651, when the Master returned from Italy. Nor could he be the Francisco Palacios who in 1648 signed two still-lifes, a type of composition that, incidentally, Velázquez is not known to have painted at any time (Schloß Rohrau, Austria, Harrach collection).

Most of the information that we have about Lucena, Villacis and Palacios was gathered by Antonio Palomino, a painter and writer on art who, as we know, had been closely associated with Juan de Alfaro, another pupil of Velázquez.[193] According to Palomino, Alfaro was allowed, because of his status as Velázquez' pupil, to make copies of great masters' works, such as those of Titian and Rubens, at the Royal Palace. He excelled particularly in copying Van

Velázquez' workshop
Queen Isabel
1639
UK, Hampton Court

Dyck, whose manner soon had a greater impact than Velázquez' on his works. Alfaro, however, remained an enthusiastic admirer of Velázquez, at whose death, in 1660, he composed, with the help of his brother, Dr. Enrique Vaca de Alfaro, a Latin epitaph which Palomino printed in his biography of Velázquez.

Juan de Pareja was Velázquez' assistant but not his pupil in any meaningful sense of the word.[194] He was born, apparently of Moorish descent, around 1610 in Seville, where, as he stated in 1630, he was a professional painter, even though he was then planning to go to Madrid for four months of further study with his brother, Jusepe, also a painter. There is no indication of when he became assistant to Velázquez, whom he accompanied in that capacity on his Italian journey of 1648–1651. His extant dated works, none of which shows true affinity to Velázquez' style, were executed between 1658 and 1669, the year before his death. Awkwardly composed and somewhat rudimentary in execution, they reveal no more than a competent knowledge of the painter's craft (p. 174). Probably, Velázquez entrusted him mainly with menial tasks, such as grinding and mixing pigments, preparing varnishes, fixing canvases on stretchers and priming them.

Velázquez' workshop, where Philip IV often came to watch him painting, or perhaps just for a chat, was by no means a professional painters' precinct. Great and lesser writers who praised his art – such as Quevedo, Gracián, García de Salcedo Coronel, Gabriel de Bocángel, Manuel de Gallegos, Saavedra Fajardo, and Manuel de Faria y Sousa – most of whom were also courtiers, are likely to have been there at one time or another. There must also have been among the occasional or frequent visitors at least a sprinkling of courtiers who, in the fashion of the time – not too different from our own in this respect – amused themselves by practising the art of painting. Two such individuals were the Count of Siruela, a renowned diplomat who died in 1651, and Don Tomás de Aguiar, a gentleman who by 1657 had achieved some reputation for the portraits that he painted from life.[195] The portraits of both, Aguiar and Siruela, presumably by Velázquez, were in his workshop when he died. They are at present lost or unidentified.

One of Velázquez' duties was to make sure that his assistants or other painters, such as Mazo, kept up with the demand for replicas or copies of his portraits of members of the royal family, or for that matter of the Count-Duke of Olivares, whose painter he also was. Copies of other portraits were commissioned by the sitters, their families or the institutions with which they were associated. All of this explains, for instance, the large number of copies that we

Roman Bust (Domitia Lucilla?)
Mid-second century
Madrid, Museo del Prado

Pedro de Villafranca
Philip IV
Engraving
1655

have of the portrait of *Cardinal Borja*, the original of which has not been convincingly identified.[196] The copyists, of course, were not necessarily Velázquez' assistants or protégés, not even in the case of royal portraits, which were much in demand, particularly those of the King.

In the bust-length replica of his *Innocent X*, Velázquez painted little more than the sitter's head. The rest is plainly by another hand (cat. no. **115**). Assistants sometimes completed a portrait begun by the Master. An example of this is the three-quarter length of *Queen Isabel*, sent to Vienna in 1632, in which the head is by Velázquez, while the lesser work of assistants is noticeable nearly everywhere else in the painting (cat. no. **62**). Likewise, in the portrait of *Prince Baltasar Carlos*, of around 1639, now also at the Vienna Museum, only the head appears to be by the Master's hand, though he may have sketched-in the whole composition (cat. no. **90**).

Some assistants were obviously given a free hand to devise new compositions, which, mediocrity being what it has always been, might be readily achieved by borrowing compositional elements from other works by the Master. For example, the full-length portrait of *Queen Isabel* sent to England late in 1639 reproduces the head of the portrait sent to Vienna in 1632, mentioned in the preceding paragraph, and includes particulars, such as the barking dog and the somewhat disarranged rug, taken from *Joseph's Bloody Coat Brought to Jacob*, from where also the device of the background seems to derive (p. 187).[197]

Juan Bautista Martínez del Mazo
Philip IV
c. 1655
London, The National Gallery

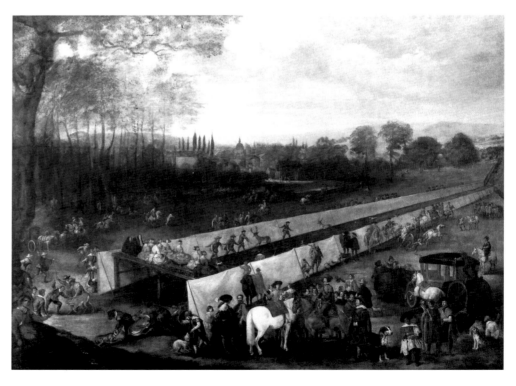

Juan Bautista Martínez del Mazo
The Stag Hunt at Aranjuez
c. 1630
Madrid, Museo del Prado

Velázquez' imitators

When Velázquez was a young man, his imitators were mainly attracted by his *bodegones*. From the mid-1620s, and particularly after his return from Italy in 1631, his impact on other painters of the time, including some that were his seniors, was chiefly noticeable in the field of portrait-painting.

Except for *Bacchus, Democritus* and *Supper at Emmaus*, all painted by Velázquez at Madrid before his departure for Italy in 1629, and *Christ on the Cross* which he most likely painted around 1632, after his return to Spain, none of his religious, mythological or historical compositions appears to have been copied during his lifetime. At least no copy is extant that may be regarded as of the period, and none has ever been recorded as executed by any of his contemporaries, not even by those of his pupils or followers such as Alfaro or Mazo, whose practice it was to copy paintings by other masters in the royal collections.

However, Velázquez' *The Forge of Vulcan* had an impact on Carducho, who sometimes introduced a change of atmospheric naturalism in his linearly built compositions. He was particularly successful in *Saint Bruno Declining the Archbishop's Mitre Offered by Pope Urban II*, dated 1632 (p. 184). In this painting, one of Carducho's best, a diffuse light creates a sort of atmospheric environment for the secondary figures at the left and for the archbishop's vestments placed at the centre, while the main figures are set directly against the background. The male profile to the left, modelled in light and shade, certainly recalls that of Apollo in *The Forge of Vulcan*, which had been in Madrid since 1631 (cat. no. 44).[198]

Velázquez made a good many drawings from Michelangelo's and Raphael's frescoes at the Vatican in 1629–1630. Yet, no deep or lasting impact of either Raphael's or Michelangelo's art is discernible in his works. As we know from his words and works, Titian was the painter whom he admired above all others. However, this admiration did not lead to imitation. There is, indeed, not any

Pedro de Villafranca
Philip IV
Engraving
1657

Luis Fernández Noseret
Count-Duke of Olivares
Engraving after a drawing by J. Maea,
19th century
Madrid, Calcografiá Nacional

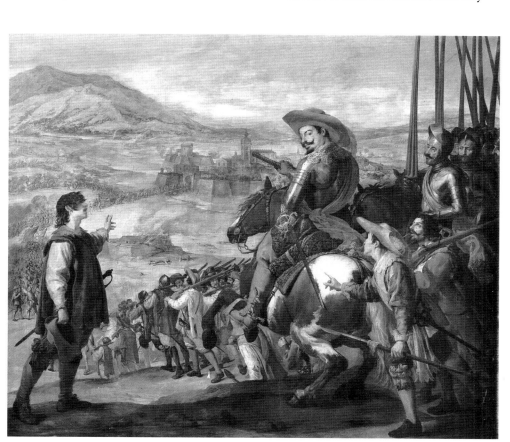

Jusepe Leonardo
The Taking of Brisach
1635
Madrid, Museo del Prado

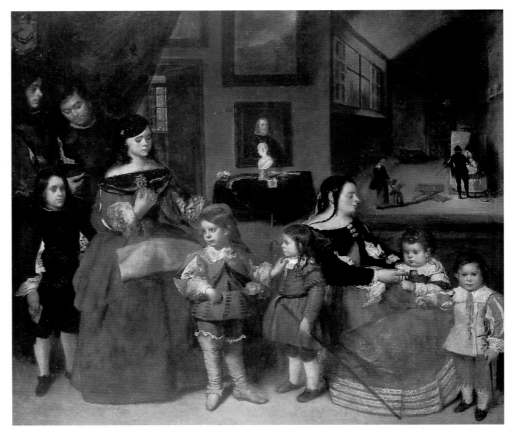

Juan Bautista Martínez del Mazo
Study for the young boy in *The Family of the Artist*
c. 1660–1661
London, Dulwich Picture Gallery

Juan Bautista Martínez del Mazo
The Family of the Artist
c. 1660–1665
Vienna, Kunsthistorisches Museum

evidence that Velázquez ever copied any of the Venetian master's works, except for *The Rape of Europa*, then at the Royal Palace in Madrid, which he sketched with purposeful changes, though meaning it to be recognized as Titian's composition, in *The Fable of Arachne*, datable to 1644–1648 (p. 161 and cat. no. **107**).

Perhaps Velázquez had come to realize during his first Italian journey that, contrary to Pacheco's views, copying was not really a way to empathize with another artist's work, much less to arrive at a personal creation, and in consequence he discouraged others from copying his works except, of course, for his royal portraits, copies of which with or without variations were made in his workshop. It might also be that from the 1630s Velázquez' large compositions would have appeared to be too overpowering to be imitated.

There is a painting by Velázquez, a life-size *White Horse*, which some of his followers appropriated in their works; excited, as they were, by the lively reality that was expressed in the original painting by Velázquez (cat. no. **67**). It is probably one of the three paintings of riderless horses, each of a different colour – the other two being grey or chestnut – that were in Velázquez' workshop at his death. The painting has suffered from cleaning and restoration, but the design that masterfully builds the shape of the horse in space remains alive.

One unspirited copy of this *White Horse* is known today (Madrid, private collection). It is likely that others were made in the Master's time and afterwards. At least, it is recorded that, as late as 1760, a promising young painter – who, as it happened, did not fulfil his promise – won a reward from the Spanish Royal Academy of Fine Arts for having copied "the horse of Velázquez" and other paintings which were then at the recently founded Academy.[199]

Apart from the colour, Velázquez' *White Horse* is quite close in shape, pose and lively design to the chestnut mount in his equestrian portrait of the *Count-Duke of Olivares,* painted around 1634–1635 (cat. no. **66**). In the small replica that Mazo painted of this portrait, probably in the mid-1630s, there are two

obvious changes, both showing familiarity with, and dependence on, other works by the Master (plate 41). The horse is white like the painting where Velázquez represented it without a rider, and the precipice over which the horse prances in the original has been replaced by a slope somewhat similar to that in Velázquez' equestrian portrait of *Philip IV* (cat. no. 71). Mazo also included Velázquez' white horse, riderless, in *The Stag Hunt at Aranjuez*, in the Prado (p. 188). It appears again, dappled in brown and white, as the mount of the Duke of Feria in *The Taking of Brisach*, painted around 1634–1635 by Jusepe Leonardo for the Great Hall of the Buen Retiro Palace (p. 189).

As we know, the impact of Velázquez' portrait of *Innocent X* on Italian and Spanish painters of the time was huge. No fewer than thirteen copies, executed either after the original three-quarter length or else after the Master's own bust-length replica, have come down to us. Some of them are, of course, copies of copies. Such appears to be the case with the short bust at the National Gallery of Art, Washington, in which, to mention only one telling difference, the eyes of Innocent X are brown with a little touch of grey rather than blue-grey as Velázquez painted them.

Pietro Martire Neri, who, as indicated above, appears to have been close to Velázquez in 1650 at Rome, signed two copies of the Master's likeness of Innocent X. In one of them, he enlarged the composition to a full-length double portrait of *Innocent X with a Prelate* (p. 184). Curiously, he copied the figure of the Pope from Velázquez' original without, however, attempting to imitate the Master's modelling of the face, while he endeavoured to achieve a Velázquez-like modelling in the head of the standing prelate.

From the mid-1620s until shortly after Velázquez' death, Spanish portrait-painting was to a very large extent under his spell. It was as if he had cast afresh for the benefit of his fellow painters the reality of the individual. As for the sitters, social affectation probably played some large part in their desire or willingness to appear on canvas with a Velázquez-like dignity of carriage.

By comparison with Velázquez' originals, the extant portraits from his workshop or by his followers often seem garish, and almost invariably make the sitter look relatively small in a space which is either pictorially jejune or too contrived. Naturally, most of them are mediocre. A few, however, are executed with a sense of emulation, making use of brilliant accents which add weight to the naturalism of the pictorial image.

The Master must have been aware of the gap between his work and that of his gifted assistants or followers, especially evident in their replicas of his portraits of the King. He probably was also aware that, as in similar cases, the imitation and emulation of his works were the small coin of the admiration paid to him.

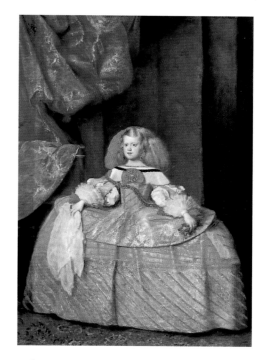

Infanta Margarita
Unfinished work, completed by Juan Bautista Martínez del Mazo
c. 1660
Madrid, Museo del Prado

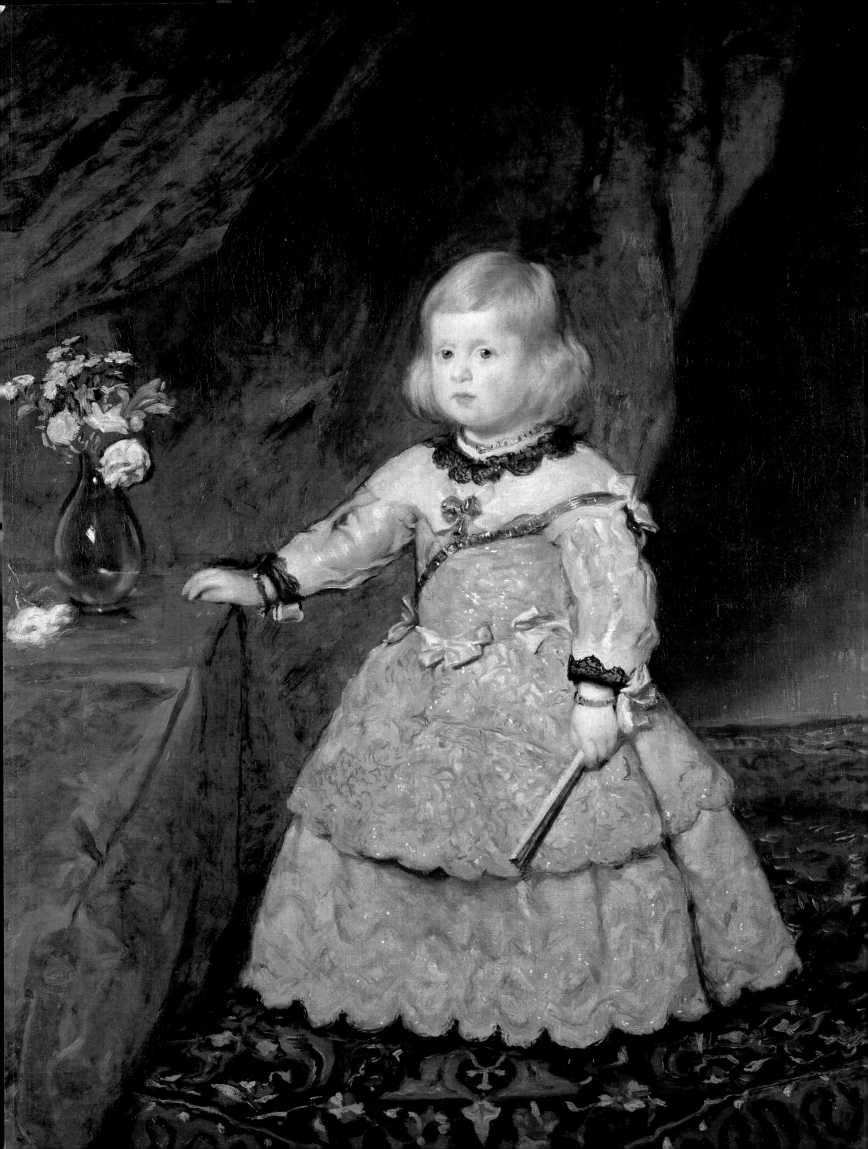

Life, fashion and painting

It was probably soon after his return to Madrid that Velázquez painted a new likeness of the Infanta María Teresa, whom he had portrayed some three years earlier (cat. no. 109). Only the head of this portrait has come down to us (cat. no. 118). Her lower lip is considerably more developed in the manner characteristic of her Habsburg family. Her left eye is more sharply almond-shaped, while the underlid of the right one still bulges out, and the outswelling of her temple is somewhat more marked.

María Teresa was about ten years old when Velázquez painted her earliest extant portrait (cat. no. 109) and just a few months over fourteen when he painted the latest of those which have come down to us. The teenager's features were obviously taking on new shapes under the eyes of her portraitist who, between the sitting for one portrait and that for another, saw a somewhat different presence which he fashioned into a new pictorial likeness.

The case was similar with the portraits of the Queen, who was just four years older than her blood cousin, María Teresa. Velázquez had what might have been a harder, but certainly turned out to be a more rewarding task with the Infanta Margarita – whom he portrayed from the time when she was a couple of years old up to when she was eight. If, whilst in Rome, the Master had enjoyed painting the Pope and members of the Papal Court, back in Madrid he obviously continued to delight in his work as the Queen and the Infantas came to have their portraits painted by him.

A portrait of the Infanta María Teresa by Velázquez, along with a workshop replica, left Madrid on 22 February 1653 as presents from the Spanish King, one for the Emperor Ferdinand III, in Vienna, and the other for the Duke Leopold Wilhelm, in Brussels. The original, now at the Vienna Museum, must consequently have been painted late in 1652 or early in 1653; unfortunately, it has been cut down, most notably at the bottom (cat. no. 119).

It is likely that Velázquez portrayed the Infanta María Teresa at least once more, at the time when her marriage to Louis XIV of France, which took place on 9 June 1660, was being arranged. However, the Vienna portrait, of 1652 or early 1653, is the latest we have of her by the Master's hand. In it, Velázquez fashioned the likeness of the Infanta into the subtlest harmony of white, silver and pink against a greenish-blue background. The voluminous and richly decorated headdress, the pleated tulle yoke, the bodice tight over the stiff corsage, and the ample farthingale on which ribbons and watches rest, is all keyed to the make-believe rouge and pearly tones on the Infanta's face. Such make-up and such a costume were a Spanish fashion which French ladies of the time found hideous. In more recent times, Velázquez has been pitied for having to portray faces which looked so lifeless and cumbersome costumes which made the sitter's figure and pose quite unnatural. However, if the paintings themselves may be taken as evidence, it would rather seem that the Master enjoyed painting these kinds of portraits.

In the portrait of María Teresa (cat. no. 119), a contrast is built-up between the artificial tones of her make-up and the lively pink and ivory hues of her broadly painted hands. Yet it is the face, rouged and pearly, that keys up the whole composition. The yoke-like collar of pink tulle, the light chestnut headdress decorated with a white plume and silver and rose ribbons, the strands of pearls which cast brownish shadows on the silver-tinselled grey-white costume, the rose ribbons which lie on the farthingale or those which adorn the Infanta's wrists. Lit up by a silvery light, she stands against the greenish-blue of a cloth-covered table and the background curtain, made into a vivid pictorial presence

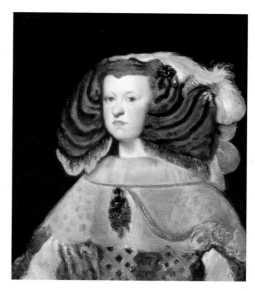

Queen Mariana
c. 1656–1657
Cat. no. 126

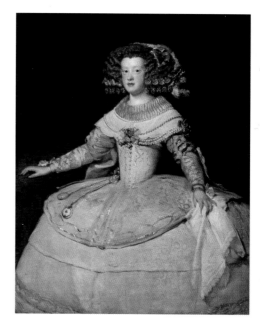

Infanta María Teresa
1652–1653
Cat. no. 119

LEFT PAGE:
Infanta Margarita
1653
Cat. no. 122

without putting the emphasis on the particulars of fashion in a manner that Velázquez' imitators generally failed to achieve.

The Infanta Margarita does not look more than two years old in what is the earliest surviving Velázquez portrait of her, and that is consequently datable to some time in 1653 (cat. no. 122). As he had done more than twenty years earlier in the portrait of the sixteen-month-old Prince Baltasar Carlos (cat. no. 51), Velázquez represented the sitter standing on a dais covered by a rug that is here patterned in blue, red and light ochre. At the right of the Infanta there is what looks like a table covered with a blue cloth, whose ample folds come in to the foreground and blend, at the other end, with those of the greenish-blue drapery which opens into the background shadows. This background opening marks a fluid diagonal which runs across the composition to the foreground, where it sets off the figure of the Infanta. Her roundish face, rosy and ivory, is framed by her flaxen hair. She is dressed in a pink and silver costume decorated with black lace and gold jewellery, and stands against the greenish-blue curtain and black-ish and ochre shadows. Her right hand rests on the blue tablecloth, on which lies a white rose next to a crystal glass containing a pink rose, a blue iris, and other flowers of yellow or light-blue hues – all of which keys up the whole colour scheme of the composition.

In this portrait, Margarita's neck is short and her chin roundish, which probably corresponded to her true appearance. However, in Velázquez' later portraits of her, shadows and lights elongate the neck and make the jaw look somewhat pointed, though in none has the chin quite the same shape as in the others nor, for that matter, have the eyes. Some of Velázquez' assistants continued to produce portraits where the Infanta's jaw is roundish and her neck short. The Master's concern to hide Margarita's round chin in shadow and to elongate her neck recalls similar changes in the likenesses that he painted of Philip IV after 1624.

Late in 1652 or early in 1653 Velázquez completed his first portrait of the nineteen-year-old Queen Mariana (cat. no. 121). She is seen full-length, in almost the same pose as the Infanta, wearing a silver-braided black costume decorated with red ribbons and gold chains and bracelets, completed with a large gold brooch pinned to the stiff bodice. Her pose is almost identical with that of María Teresa: her right hand rests on the back of a chair, reddish purple like the overhanging curtain and the cloth-covered table in the background, which brings about a pervasive harmony of reds and black. The sense of depth is stressed by the shadow of the farthingale on the foreground. Moreover the golden yellows of a clock shine in the background as do the similar colours of the jewels on the Queen's costume and headdress, making the depiction of aerial space that much more vivid.

This likeness of Mariana, with her rouged face made smallish under a heavy headdress, her bust encased in a tight bodice, and the rest of her figure, including the feet, lost to the eye in the stiff fullness of the farthingale, has led to suggestions that the fashion of his time resulted in some sort of handicap for Velázquez who, nevertheless, did his best to do justice to the splendid attire of his royal sitter.[200] Rather, is would seem that the Master took pleasure in under-scoring the pictorial nature of his work by keying the likeness of the sitter to the make-believe appearance of her face.

If a parallel between Velázquez' painting and the literature of his day were permissible, without implying that such a parallel is either necessary or conclu-sive, one could suggest that his vivid depiction of his sitters' artificial flesh tones, and the image of both human likeness and sheer pictorial presence that he pro-jects to the beholder, bring to mind the play-within-the-play which, on the

Queen Mariana
1652–1653
Cat. no. 121

RIGHT PAGE:
Detail of no. 121

FOLLOWING PAGES:
Detail of no. 121

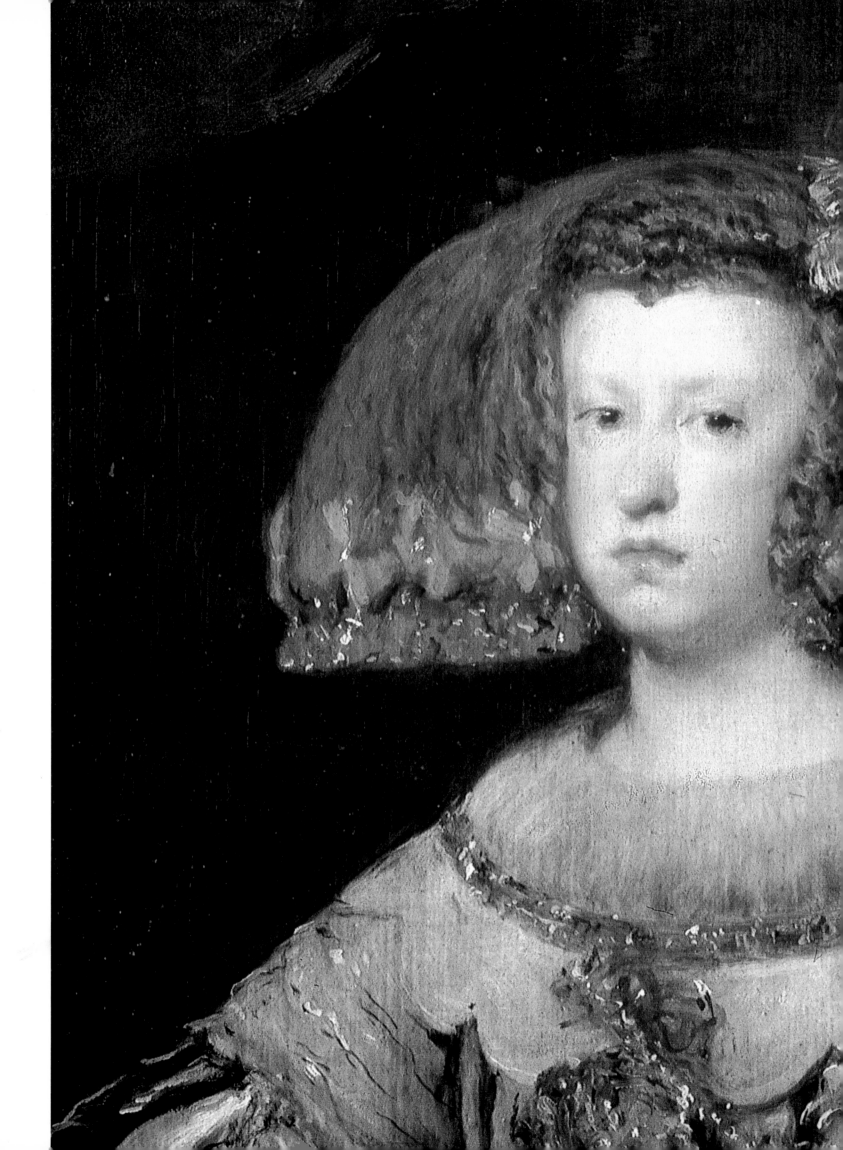

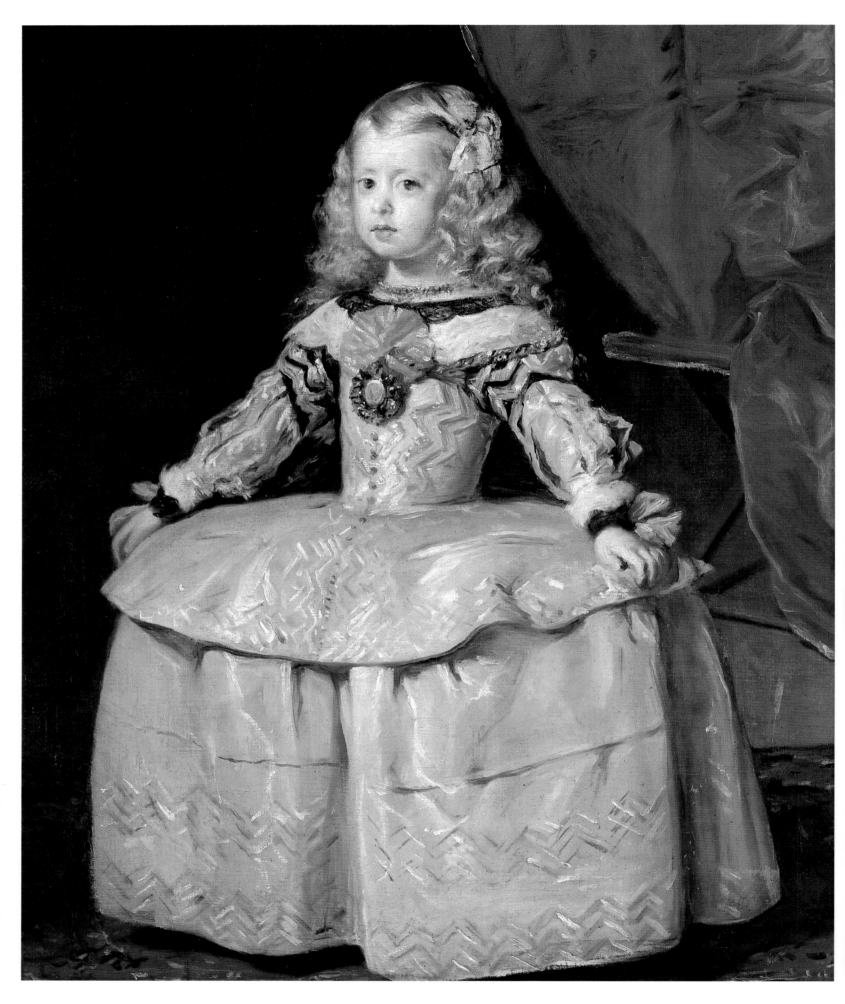

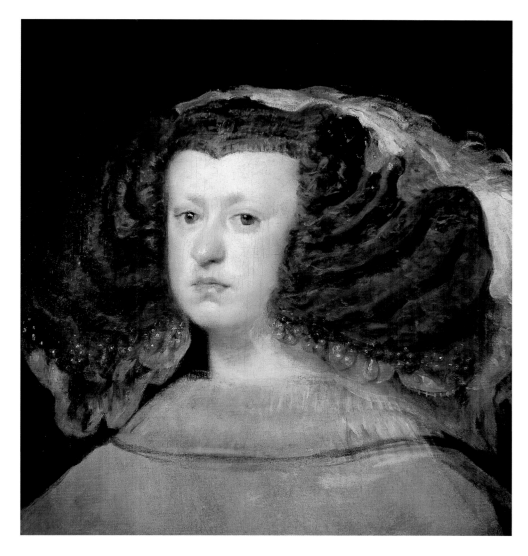

Queen Mariana
c. 1655–1656
Cat. no. 125

stage of the time, intensified, again simultaneously, both the true-to-life and the
theatrical nature of the action being played. It cannot be over emphasized that
such parallels between literature and other arts, helpful as they are for setting
our understanding of an artist, or just one work, within the flow of the time,
ought not to be understood as proving, or even suggesting, influence of one art
on the other. Nor are they to be taken as evidence of the existence of a pre-
ordained plan to which artists of the same period worked. They are no more
than coincidences helpful for describing, rather than circumscribing, the current
of creative life at a given point of historical time.

LEFT PAGE:
Infanta Margarita
c. 1656
Cat. no. 123

Last portrait of the King

Despite the new royal marriage, Philip IV still had no son and, as a result, the days of his dynasty in Spain seemed to be drawing to a close. Other European courts eyed the immediate future of the Spanish throne with as much restless anxiety and impatience as hope. Many requests were made for portraits of the now infirm King Philip, Mary, his young Queen, his marriageable daughter, and the little Infanta who had disappointed the Spaniards' hopes for a male heir to the throne. Hence the sizable number of portraits of the sovereigns and the two Infantas which have come down to us.

Yet, after 1644 when Philip IV sat for him in Fraga, Velázquez apparently portrayed the King from life only once more, in a bust portrait datable to 1652–1655 (cat. no. 120). This is the latest of the extant likenesses of Philip IV that are undoubtedly by Velázquez, except for the image of the King that in 1656 he sketched, together with that of the Queen, as a mirror reflection in the background of the group portrait commonly known as *Las Meninas* (cat. no. 124). Also extant are three workshop bust portraits of the King with notable variations from the Master's, and at least five that differ more markedly from it. In addition to these fine versions, there are others of mediocre quality, executed by Velázquez' less gifted assistants or by some of the jobbing painters then active at Madrid. Some were, it would seem, painted after the Master's death, in the last five years of Philip IV's life, and a few are obviously the work of later copyists or imitators.

As Chamberlain, Velázquez had probably to lend a hand in the elaborate plans which were made for the solemn reburial, in the new Pantheon at the Escorial, of Philip IV's ancestors and his first wife, Isabel. At the conclusion of the long ceremony, on 18 March 1654, Philip IV, having viewed the remains of his forefathers – the Emperor Charles V one of them – and of his first wife, was a sorrowful man, fearful of death, and tormented by the uncertainty of eternal salvation.[201]

Though, as indicated above, Philip IV was by then rather infirm in appearance, Velázquez represented him in the bust portrait of 1652–1655 as unmarked by age or illness (cat. no. 120). The light, as in earlier portraits by the Master's hand, bathes the face of the King and elongates his well-turned neck, with only the thinnest of shadows being used for the modelling of the whole. The costume, a black doublet and cloak, is just roughed in by bold strokes and subtle highlights which impart a statuary fullness to the bust.

An *antequem* date for this portrait of *Philip IV* is provided by an engraving based on it, made by Pedro de Villafranca in 1655 (p. 188). There are, however, a few differences between Velázquez' painting and Villafranca's engraving. For one thing, in the latter the King is clad in armour rather than in a doublet, though the white collar, which protrudes beyond his hair, is identical with that in the painting. Secondly, contrary to the painting, the curls at the right of Philip IV's head are arranged in regular waves. These are, of course, slight variations. Of far greater significance is the fact that Villafranca has hinted at a double chin in place of the elongated and well-rounded neck depicted by Velázquez. The other extant bust portraits of Philip IV from the mid-1650s or later also differ in this from Velázquez' original, as well as in lesser details. Every one of them represents Philip IV with a double chin, often quite flabby, which makes his neck shortish and contributes to his ageing appearance.

Doubtless the likeness of Philip as an aged man corresponded to the truth of his physique more closely than the one painted by Velázquez. The large number of such portraits which have come down to us indicates that the

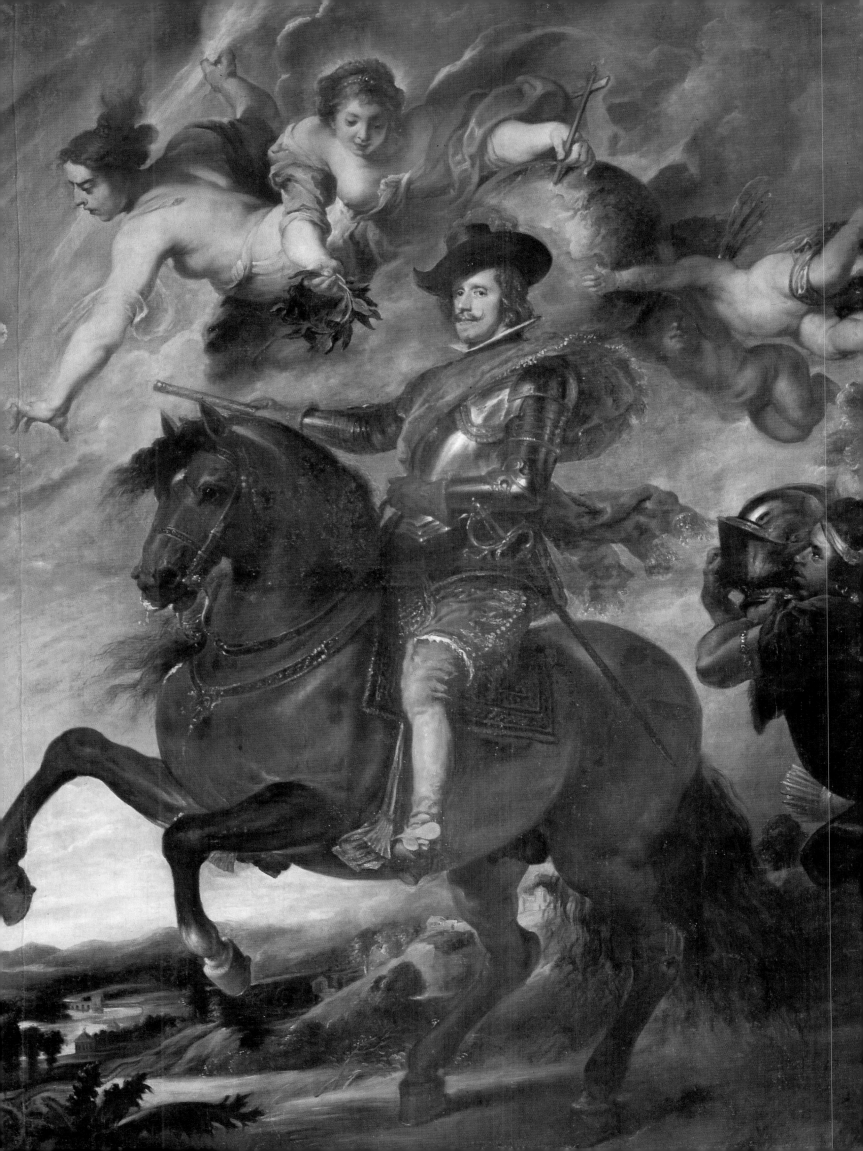

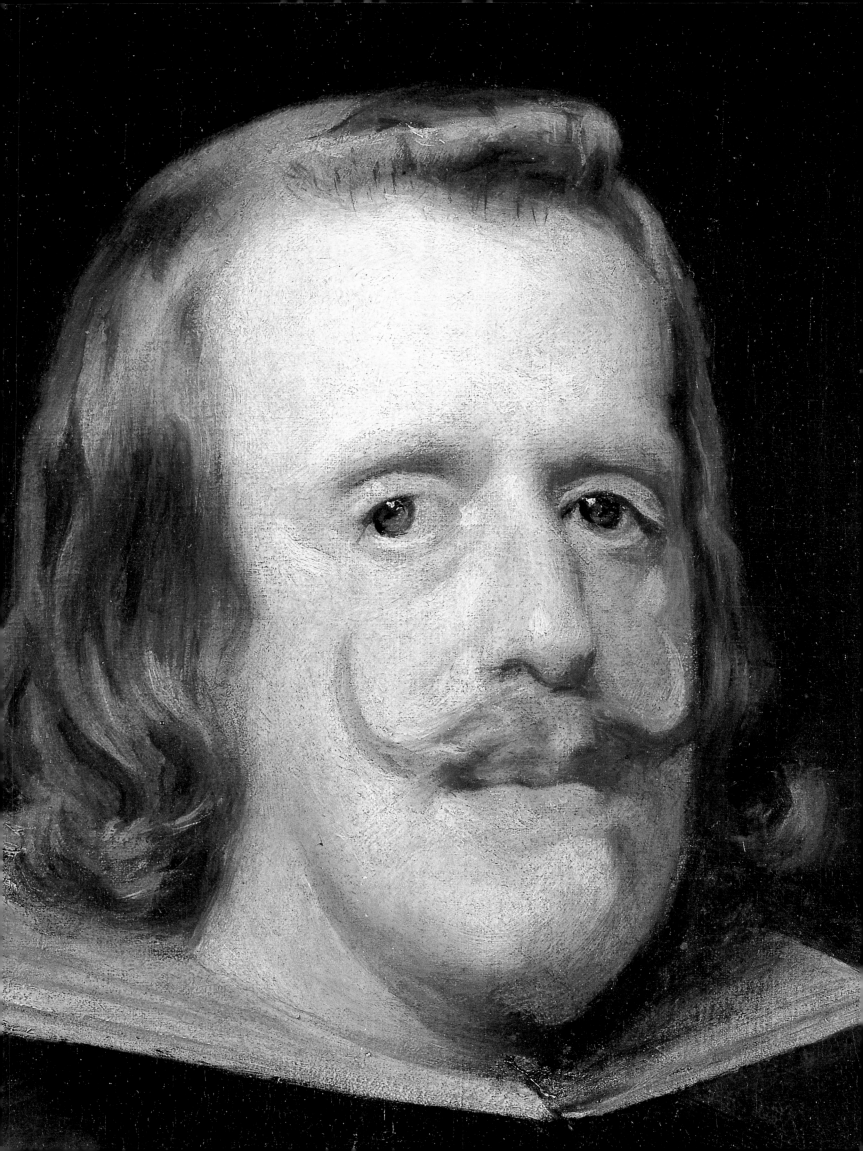

likeness they embodied was the one preferred by those familiar with his appearance. It might even be that Philip IV himself, who was by then well aware of his shortcomings as a King and of his many other weaknesses, favoured the portraits in which the flaws of his human nature were depicted.

The bust portrait at the Prado Museum is the only extant one of the King undisputedly painted by Velázquez after his return from Italy in 1651. From then on, and for whatever reasons, he let other painters in his circle, including his assistants, paint likeness after likeness of the ageing Philip which seemingly conformed to the taste of nearly everybody, though not to his own.

Velázquez' name has been claimed at one time or another, though always with reservations, for a few of the bust portraits of the ageing King. Two of them, one in Vienna and the other in London are rather fine, particularly the latter (p. 188). Today it is only the London picture which is still regarded by some as being, at least in part, by the Master, who would have painted the head, while the dress and the golden chain would have been painted by an assistant. It should be noted that the shoulder braid in Philip's doublet and the chain with the Golden Fleece appear in this and in almost every one of the derivative portraits of Philip IV, though not in Velázquez' original. In the latter, the highlights which fully model the bust make it questionable that a gold chain was to be painted on, with all the changes, particularly as to highlights, that this would have entailed. In some of the derivative pictures the chain is seen without the Golden Fleece hanging from it, most likely as a result of the canvas having been cut down.

Even Beruete, who included the London portrait among the Master's works, pointed out that, though it is "a picture of admirable effect" its execution does not entirely agree with that of Velázquez' last works. The colouring, particularly that of the hair, is lifeless. A sort of indistinctness in the filmy texture of the pigments contributes, moreover, to the lack of the in-the-round quality in the bust of the King. The lack of spatial depth is, indeed, the most telling difference between this and Velázquez' work. The portrait of Philip IV, of which the London picture is the finest extant version, was also reproduced in an engraving executed in 1657 by Pedro de Villafranca (p. 189). This suggests that the likeness of the King with a double chin, first engraved by Villafranca in 1655, had gained currency two years later.

Velázquez himself might have arrived at the point of turning the self-reproachful and shaken Philip IV into an elderly figure. However, there is no painting unquestionably by Velázquez' hand nor other evidence which can give substance to such a surmise. All indicates that it was rather one of the painters in the Master's circle who turned his portrayal of the august monarch into the likeness of an ageing man.

LEFT PAGE:
Philip IV (detail)
1652–1655
Cat. no. 120

The Master and the follower

There is reason to infer that Mazo was the painter in Velázquez' circle who, in the 1650s, originated the version of the bust portrait of Philip IV in which, contrary to the Master's original, the sitter's natural characteristics are accentuated. A bust portrait of the ageing King hangs prominently on the wall of *The Family of the Artist*, at the Vienna Museum (pp. 188 and 190). In this group portrait, a painter is seen working, though not from life, on a portrait of the Infanta Margarita. This painting resembles, even to the green colour of the dress, a copy, now in the Budapest Museum, of the likeness that Velázquez painted of her in 1659.

According to a convincing and generally accepted view, *The Family of the Artist* was painted by Mazo. It portrays his family, and he is the painter seen at work in the background. That the family depicted is Mazo's appears to be supported by the fact that the coat of arms in the upper left corner displays a mallet (*mazo*) held by a hand in armour. It has been suggested that the room represented is the same as that which is depicted in *The Fable of Arachne* but seen from another viewpoint. It should be added that the bust of a woman seen below the portrait of the King seems to have been taken from a marble bust of the second century A.D. that was then in the collection at the Royal Palace. Mazo had his workshop there after Velázquez' death (pp. 190 and 187). Still more important is that, in composition and execution, the painting coincides with Mazo's works, and so does the extant colour sketch for the figure of one of the boys, at the centre (p. 190).[202]

The portrait of the King in the background of *The Family of the Artist* corresponds quite closely in appearance, proportions and modelling to the likeness of the ageing King in the London National Gallery (pp. 186 and 188).[203] Hence, it would seem that it was Mazo who originated the variant of Velázquez' portrait of *Philip IV*, of which the London picture is the finest though not necessarily the earliest example, that gained acceptance in the mid-1650s. If so, it may be that his success prompted him to display that likeness of the King in the picture of his own workshop, probably after Velázquez' death, when he became Court painter. In that capacity, he went on painting portraits of the King and of the Infanta Margarita till the mid-1660s, when both he and Philip IV died.

Even if this picture of Mazo's workshop had been painted by another artist, the prominence given in it to the bust portrait of Philip IV as an ageing man would lead to the inference that Mazo was regarded as the originator, or at least as the outstanding painter of this true-to-life image of the King.

The earliest known document concerning Mazo is the entry in the registry of the church of Santiago in Madrid which tells of his marriage in 1633 to Francisca Velázquez. The date of his mother's birth, 26 June 1596, together with that of his marriage, suggests that he was born in the early part of the mid-1610s. *j* It is documented that Velázquez furthered his son-in-law's career with a steady hand and secured palace appointments for him and his children.[204] In the early 1640s, Mazo became master of drawing and painting to Prince Baltasar Carlos, who in 1645 became godfather to his fifth child. Although the Prince died the following year at the age of sixteen, Philip IV decreed that the perquisites that Mazo had been receiving be continued, and continued to employ him as a painter.

Mazo is often referred to as Velázquez' son-in-law by contemporary writers on art, as well as in administrative documents of the time that include petitions to the King signed by Mazo himself. However, no firm evidence has been found stating that he held any position in Velázquez' workshop before or, indeed, after

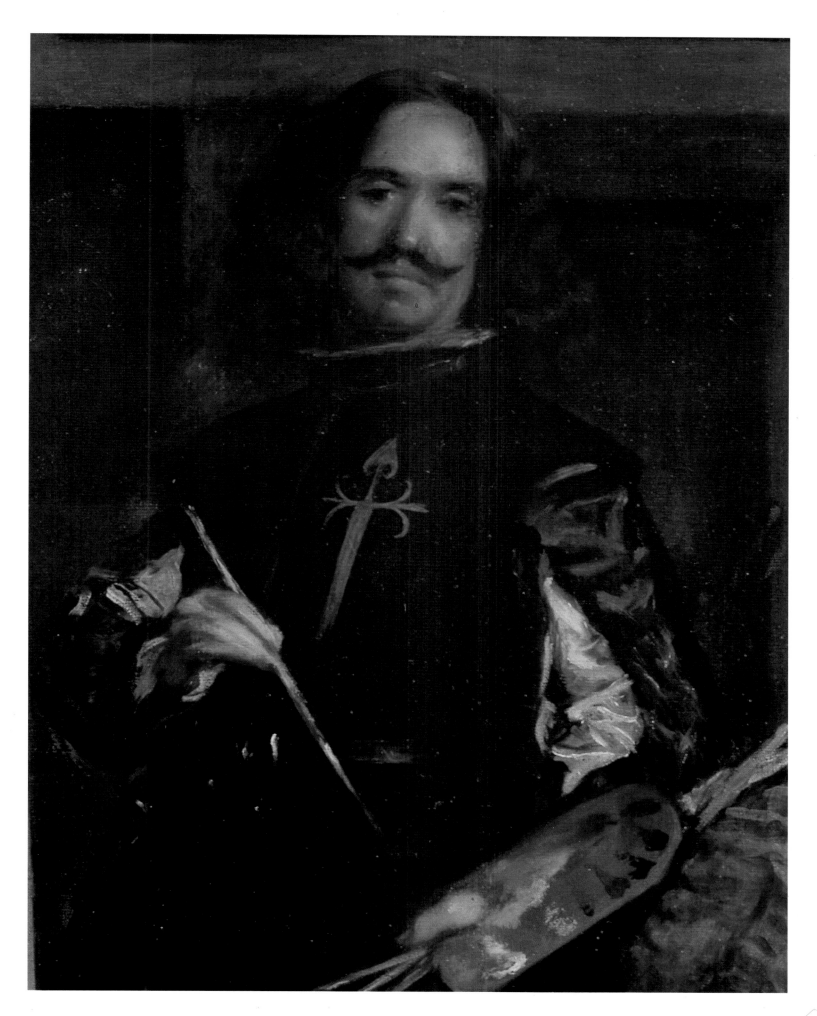

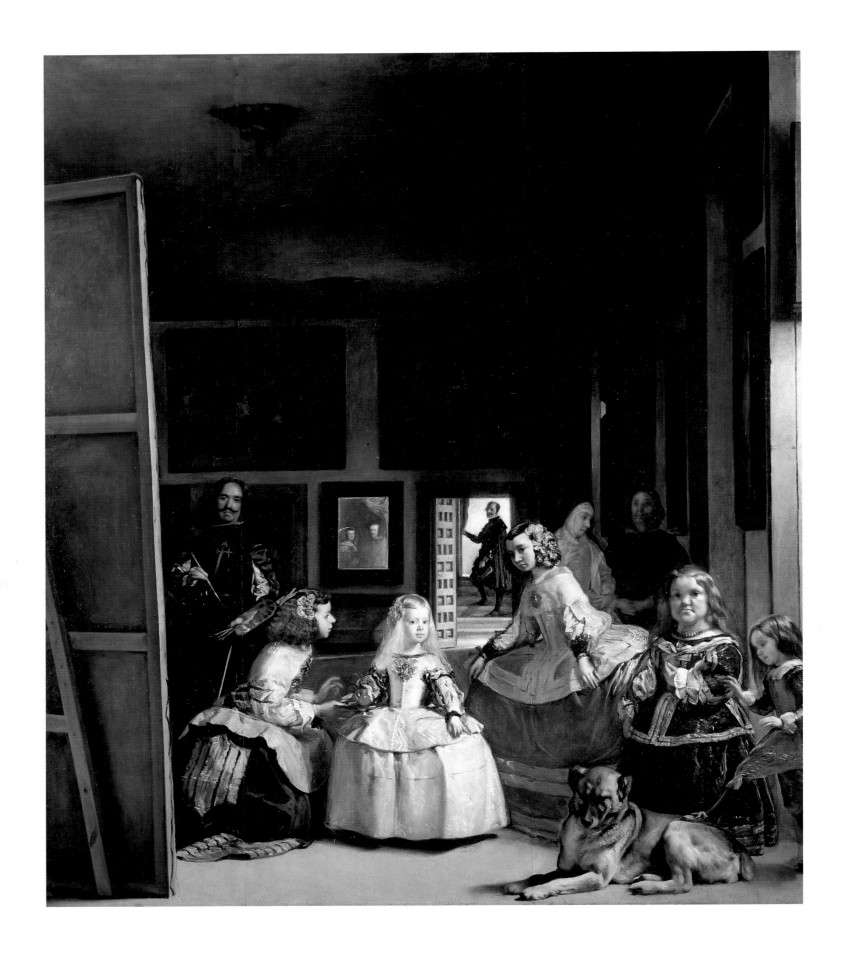

his marriage to Velázquez' daughter. At the same time, it is true that he came closer than any other painter to Velázquez' style, though not so close as the mis-attributions of works of one to the other has led some to believe. As his contemporaries noted and his signed or fully documented works plainly show, Mazo had a personality of his own, however much he might have owed to Velázquez' style. Jusepe Martínez (1601–1682), a friend of Velázquez, praised Mazo for his mastery in painting small figures,[205] certainly a cardinal compositional element in both his hunting pictures and his city views, such as that of *Saragossa* (p. 186), which Martínez, a native and resident of the city, most likely saw in 1646 when Mazo was at work on it.

In 1657, Lázaro Díaz del Valle, an enthusiastic admirer of Velázquez, wrote that Mazo painted hunting subjects and views of cities with great success. Of the city views he cited those of Pamplona and Saragossa, both of which had been executed at Philip IV's command. Díaz del Valle also praised Mazo for his portraits of Philip IV and Queen Mariana, emphasizing one of the latter which was displayed at one of the gates of Madrid on Corpus Christi day, presumably in 1650.[206] Since Velázquez was then in Italy and did not return to Madrid till June 1651, Mazo's portrait of Queen Mariana must have been very much his own work. According to Díaz del Valle this portrait exhibited a startling naturalism and marvellous execution and was also one of the first portraits of the new Queen to be seen at Madrid.

Mazo was also praised by Martínez for his copies after Titian, and it is known that he copied many works by Rubens, Jordaens, and other Flemish or Italian masters, especially for Prince Baltasar Carlos. Such copies must have considerably cut down the time available for his original work. So did the production of replicas after Velázquez' royal portraits that he painted. Nevertheless he still felt free to follow his own bent for brilliancy of execution and true-to-life naturalism.

Mazo's palette is rather like Velázquez', except for a penchant that he often shows for stressing blue or bluish tins. Of greater significance in his departure from the Master's style is Mazo's way of shaping men and things by highlights which flash the pictorial image toward the surface of the painting, even from the background. As a counterbalance, an explicit, even emphatic, perspective design marks out the spatial confines of the composition, making it look quite squarish. A further departure from Velázquez is Mazo's luxuriant depiction of detail or incident, which he achieves with brilliant, depthless strokes, whether on the figure of a sitter, a curtain, a wall, a floor, the surface of a river, or plain grounds. These stylistic traits ought not to be understood merely in a negative sense, as failures to be Velázquez-like. They actually reveal Mazo's own personality. Such traits are, indeed, as manifest in *The View of Saragossa*, begun in 1646 and completed in 1647 (Prado, no. **42**), as in the portrait of *Queen Mariana*, of 1666 (London, National Gallery, no. **31**), to cite his earliest and latest extant dated works. They are manifest, too, in the portrait of the *Infanta Margarita* (Prado, no. **51**), most likely painted around 1664–1665, where the background curtains build the space behind the glimmering figure of the Infanta as if they were stage flats – which is quite unlike Velázquez, as a comparison with his portrait of *Queen Mariana*, of about 1552–1553, also at the Prado, makes evident (cat. no. **121**).[207]

Jan Van Eyck
Jan Arnolfini and his Wife, Jeanne Cenami
1434
London, The National Gallery

LEFT PAGE:
Velázquez and the Royal Family (Las Meninas)
1656–1657
Cat. no. 124

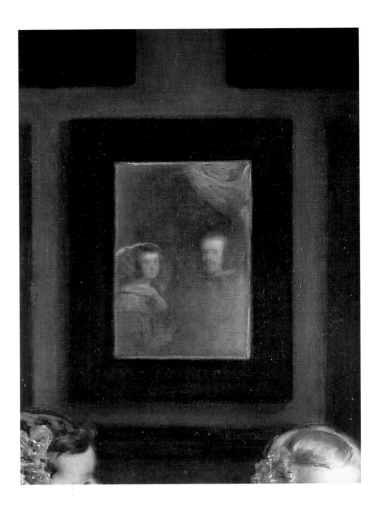

Detail of no. 124

Velázquez at work in his world

In the inventory of the Madrid Royal Alcázar begun by Mazo in 1666, at the death of Philip IV and six years after that of Velázquez, he described a large painting "portraying" the Infanta Margarita with "her ladies-in-waiting and a female dwarf, by the hand of Velázquez". Nothing else is known from any other of Velázquez' contemporaries concerning either the original title of this painting, or its subject or significance. The inventories of the Alcázar of 1686 and 1700 noted that in this work Velázquez had "portrayed himself painting". Later it was described as *The Family of Philip IV,* and from 1843 on it has commonly been known as *Las Meninas,* and occasionally as *The Royal Family.*[208] I should now like to suggest *Velázquez and the Royal Family* as a somewhat more matter-of-fact title (cat. no. **124**).

According to Palomino, this masterpiece "was finished" in 1656, and, while Velázquez was painting it, the King, the Queen, and the Infantas María Teresa and Margarita often came to watch him at work. Some forty years later, in the 1690s, a new Court painter, Luca Giordana, paused before the old masterpiece long enough to proclaim that it held "the theology of Painting".[209]

Palomino's account of this work is quite detailed, and the truth of it has been verified by documentary evidence in most respects. He identified by name and occupation nearly every person, and even the room, represented in the large group-portrait. The location is the main chamber of the apartment which Prince Baltasar Carlos had occupied in the Royal Palace till his death, in 1646. Some time later, Velázquez was allowed to use the apartment. In 1660, when he died, he had his workshop there and an office for his activities as Chamberlain of the Palace, which involved a great deal of paper work.[210]

Detail of no. 124

Unfortunately the unmitigated exposure to pollution has dulled the rich texture and colours of this painting. The vivid contrasts between the various grades of blues and whites, used in the costumes of the *meninas* to relieve the area surrounding the Infanta, have today almost disappeared.

Mazo, painter to the late Baltasar Carlos, had painted the forty paintings which decorated the main chamber of the Prince's apartment. Thirty-five of them were copies after Rubens or other Flemish painters, and only five – small canvases representing a wild boar and some dogs – were original. The forty paintings were catalogued there again, in exactly the same order, in 1686 and 1700.

In the painting, Velázquez is seen at the easel. A mirror in a black frame hanging on the rear wall, reflects the half-length figures of Philip IV and Queen Mariana under a red curtain. The Infanta Margarita is in the centre, attended by two *meninas,* or maids of honour, Doña Isabel de Velasco and Doña María Sarmiento, who curtsey as the latter offers her mistress a drink of water in a *búcaro* – a reddish earthen vessel – from a tray. In the right foreground stand a female dwarf, Mari-Bárbola, and a midget, Nicolás de Pertusato, who playfully puts his food on the back of the mastiff resting on the floor. Linked to this large group there is another formed by Doña Marcela de Ulloa, *guardamujer de las damas de la Reina* – attendant to the ladies-in-waiting – and an unidentified *guardadamas,* or escort to the same ladies. In the background, the *aposentador,* or Palace marshal, to the Queen, Don José Nieto Velázquez, stands on the steps that lead into the room from the lit-up doorway.

Philip IV's children by his first wife, Queen Isabel, were all dead, except for the eighteen-year-old Infanta María Teresa, whose likeness does not appear in this painting. Philip IV had married the new Queen in 1649, and the Infanta

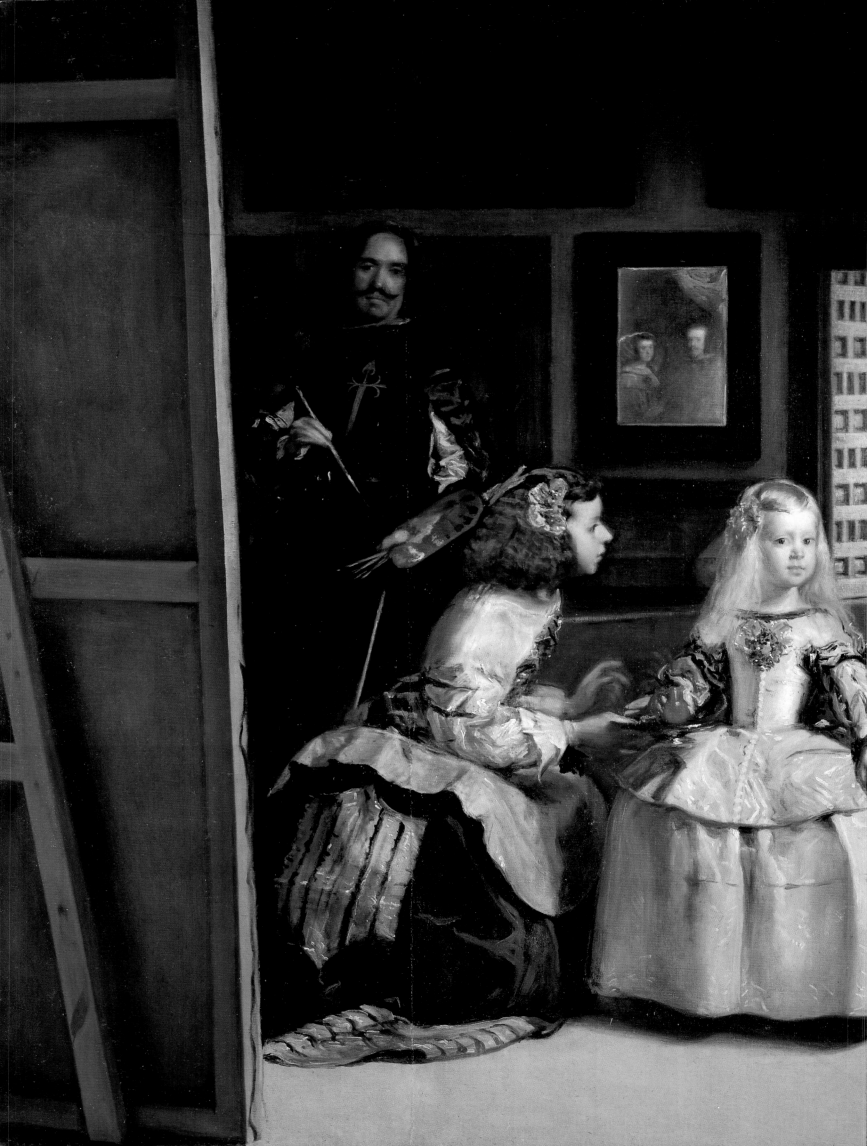

Margarita, born on 12 July 1651, was then their only child. Her apparent age in the painting confirms that this could not have been executed substantially earlier or later than 1656, as reported by Palomino.

There is another portrait of the *Infanta Margarita* by Velázquez that was most probably also painted in 1656 (cat. no. **123**). She is wearing a white costume decorated with red rosettes and black lace, standing on a rug, patterned in reds, ochres, blue and black, against a reddish ochre background, all enlivened by a red curtain. This is the only portrait in which Velázquez emphasized the curls of Margarita's hair. Fashion, of course, would suffice to explain such a change, as well as the fact that her hair is parted on the right rather than on the left. What matters, however, is that the two likenesses of Margarita painted by Velázquez about 1656 are different pictorially. In the group-portrait, the face of the Infanta appears elongated by thin shadows and by the luminous strokes which make her hair weightless and shape her figure into a translucent image the like of which he was never to paint again. Palomino pointed out that in "the large picture" of the Infanta Margarita "as a child", Velázquez had represented himself "painting", and explained that the red cross of the Order of Santiago on his doublet had been added, by command of Philip IV, after the painter's death. It is, of course, a known fact that Velázquez did not become a knight of Santiago till 28 November 1659, less than one year before he died. Velázquez was fifty-seven years old when he painted this work. Yet, he represented himself without a wrinkle on his pensive face, his dark chestnut hair flowing down to his shoulders.

Palomino called attention to the pictures decorating the walls of the room in Velázquez' composition – the "gallery" in Prince Baltasar Carlos' apartment – and said that one could see, if only dimly, that they were subjects from Ovid's *Metamorphoses* painted by Rubens. He obviously had in mind the two pictures hanging high on the rear wall, over the mirror, the only ones whose subjects, *Pallas and Arachne* and *Apollo and Pan*, are recognizable. Mazo's copies of Rubens' *Pallas and Arachne* and of Jordaens' *Apollo and Pan*, after a Rubens' sketch, hung side by side on one of the walls of the chamber represented by Velázquez, as recorded in the royal inventories of 1686 and 1700. –

There is no indication that there was a mirror on that wall. However, according to an inventory of objects belonging to the King which were at the apartment used by Velázquez till his death, there was "a mirror's black frame, without plate glass" in a small hall, near the main chamber, where the painter kept wooden planks, stretchers and ordinary frames.

In 1855, Stirling wrote in praise of *Las Meninas*: "Velázquez seems to have anticipated the discovery of Daguerre and, taking a real room and real people grouped together by chance, to have fixed them, as it were, by magic, for all time, on canvas". A quarter of a century later, Justi further explained that Velázquez' grouping of the figures of the Infanta and her attendants "would be inexplicable" as the painter's own "invention" and that it must consequently have been brought about "by chance", at the sight of an actual event.[211] Beruete thought that "Velázquez, a realist by temperament and education, surpassed himself in this work, to such a degree" that the viewer "may believe himself to be actively present at the scene" he had depicted.[212]

Lately, there has been a tendency to consider Velázquez' composition as mainly allegorical. Diverse readings of the painting have been suggested, based on one or another of the various allegorical or emblematic interpretations to which either the portraits or the objects included in the composition lend themselves. This is notably the case with the two mythological pictures dimly depicted in the background, both of which, as we know, did actually hang side

Pablo Picasso
Las Meninas (after Velázquez, detail)
1957
Barcelona, Museu Picasso

LEFT PAGE:
Detail of no. 124

FOLLOWING PAGES:
Detail of no. 124

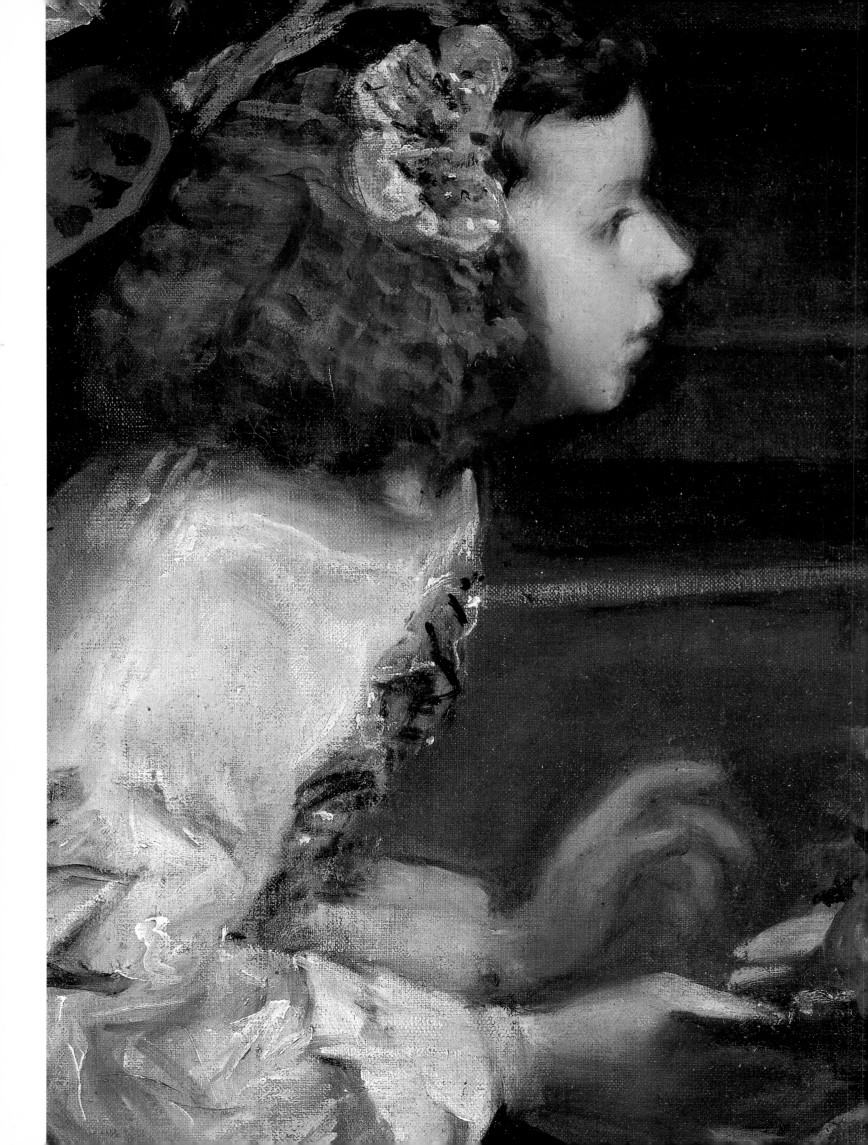

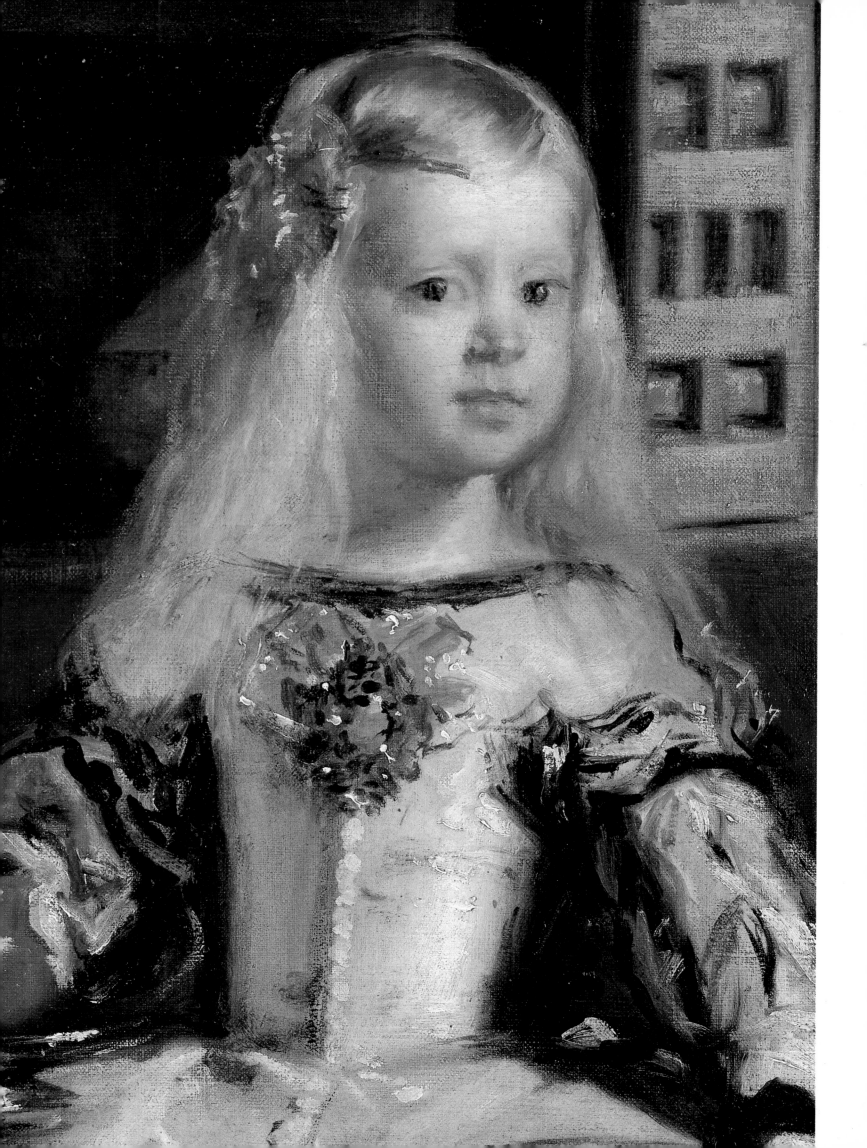

by side on a wall of the chamber that Velázquez represented in the painting.[213] With great subtlety of understanding, Michel Foucault suggested that the portrait of Velázquez himself, whose "dark form and lit-up face represent the visible and the invisible", depicts "the working painter in all his objective realism". Furthermore, he described the way in which the mirror in the background "lights up the figures observed by the painter who is standing next to his work," and who is "seen from the back".[214] Few will, I believe, nowadays regard the painter of this masterpiece as a precursor of Daguerre. Nor, to my mind, can he be cast in the implausible role of a learned critic.

This is not to imply that Velázquez, who had painted *The Fable of Arachne*, was unaware of, or indifferent to, the various allegorical meanings of the two pictures over the mirror on whose surface he chose to portray the King and the Queen as reflected images. He was doubtless as aware of the current interpretations of the two mythological subjects as he was also of the concept that the painter's true-to-life achievements emulated the images reflected in a mirror.[215] Yet, it would be inconsequential to reduce the significance of this masterpiece to an illustration of those ideas.

Van Eyck's portrait of *Arnolfini and his Wife*, of 1434, where the images of persons not otherwise included in the composition are reflected in a background mirror, was in the Spanish royal collection in Velázquez' time (p. 207). There can be no doubt that Velázquez knew it, and he might have had it in mind at one time or another during the composition of this group-portrait. However, the composition which he achieved is essentially different from Van Eyck's, where the convex mirror on the rear wall reflects not only the two men coming in through a door at the opposite end of the room, but also, and equally distinctly, the other three walls and the back view of the two sitters, none of whom is related by action or gesture to the space lying out of the picture frame (cat. no. **124**). Grouped together, indeed, they centre about themselves the space of the interior, which the reflection in the mirror makes the more definite. This has little in common with Velázquez' composition, the closest and most meaningful antecedent to which is to be found within his own *œuvre* in *Christ in the House of Martha and Mary*, painted almost forty years earlier, in Seville, before he could have seen the Arnolfini portrait in Madrid (cat. no. 7).

X-ray photographs that were made in 1960 show that Velázquez introduced several changes in the process of composition which, as we know, was often the same as that of execution. He made slight changes in most of the figures, and altered his own pose. He had sketched himself at first with his head bent to his right rather than to his left as he appears in the painting. There is no indication, however, that he depicted himself at any time looking at the Infanta or at any other of the figures in the group behind which he stands. As for the figures in this group – the Infanta, the two *meninas* and the two dwarfs – no major change is noticeable in any of them. A highlighted shape revealed by the X-rays between the figure of the painter and the edge of the canvas he is painting on could be the head of a woman wearing a wimple, perhaps that of Doña Marcela de Ulloa, who stands at the opposite side in the finished painting, forming a group with a man, who like herself is an attendant to the ladies-in-waiting.[216]

Returning to the painting, the composition that Velázquez represented himself putting on canvas is not shown. It has sometimes been suggested that he represented himself portraying the Infanta Margarita, who is being offered a drink of water. Or given the large size of the canvas on which he is seen working, he might be painting the very composition which he put before the viewer's eyes, including the portraits of the royal persons and their attendants, and his own likeness.[217] The main objection to both these theories is that, in Velázquez'

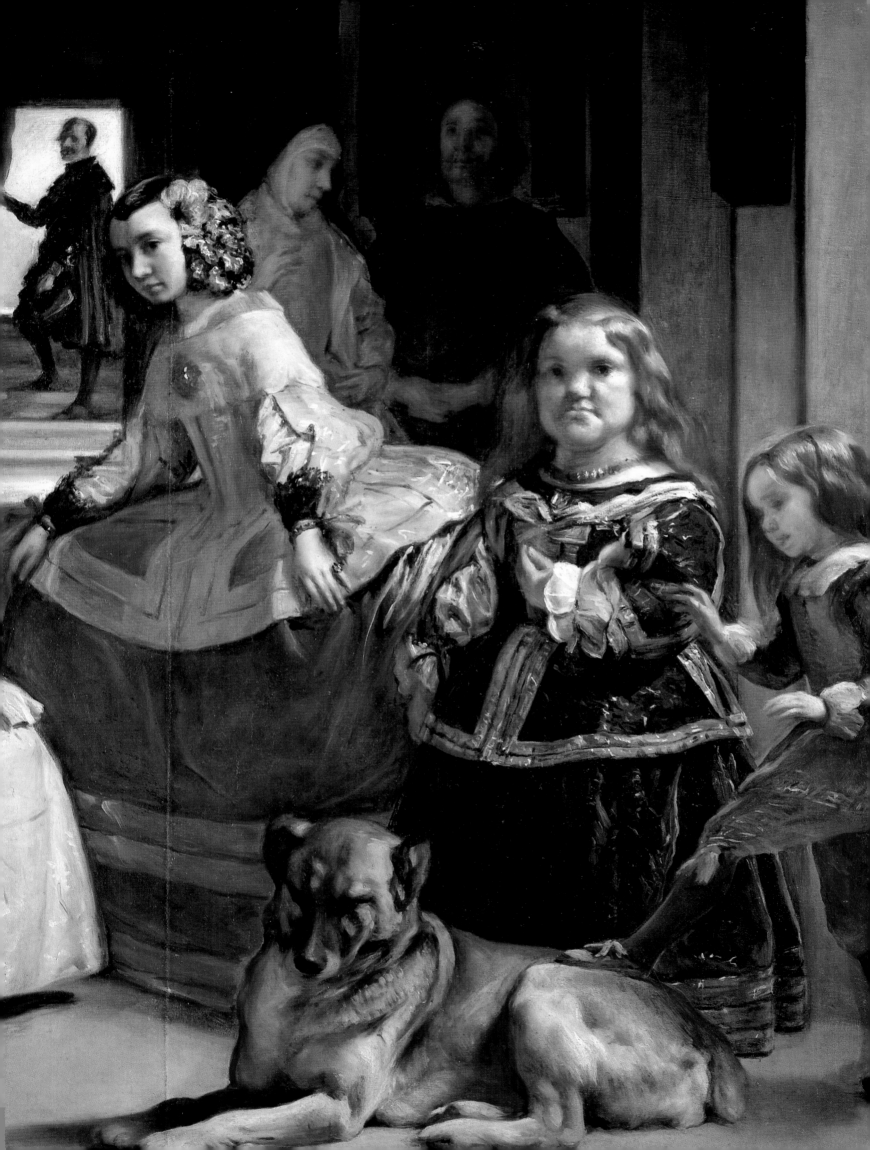

composition, he is standing behind the Infanta and the *menina* bearing a drink of water, and looks at neither of them. Moreover, his back is turned to the wall which is shown face-on in the picture.

Somewhat more plausible, though hardly conclusive, is the prevailing belief that Velázquez represented himself in the act of portraying Philip IV and Queen Mariana, whose half-length figures are reflected in the rear mirror. Yet, there is validity to the objection that the canvas is too large even for a double portrait, and that, moreover, there is no record that Velázquez ever painted a double portrait of the King and the Queen, except, of course, the one which appears in this composition as a reflection in a mirror.[218]

Whatever particular subject, if any, Velázquez had in mind for the painting that he portrayed himself working on, the decisive fact is that he chose not to show it. Since the composition does not seem to provide any firm indication, it is idle to try to identify the subject which Velázquez chose neither to show nor even to outline.

The lit-up mirror on the rear wall is in full view, and the images of the King and the Queen reflected in it are undisturbed by the reflection of anything else. These reflected images unequivocally suggest the presence of the King and the Queen in the depicted chamber, if, however, in the space lying out of the picture frame. The Infanta, one of her *meninas,* the girl dwarf, the courtier in the rear doorway, and Velázquez himself are looking, each from a different point, into this outlying space, obviously at the sovereigns. The viewer's attention is thus simultaneously directed to the very edge of the luminous foreground and to the lit-up half-length images of the King and the Queen reflected in the background – again a painting, fancied as a reality, within the painting. Thus, an interplay of variable distances to and from an outer focal point is established which spans, and hence underlies, the chasm between the realm of painting and the realm of reality with an apparent measure of success.

It has been pointed out in various ways that there is no other canvas that Velázquez brushed in more broadly or accented with sharper strokes. It has also been noted that "the unusual disproportion" between the height of the canvas and the figures leaves a large space above their heads, which contributes both to the truthfulness and the airiness of the composition.[219] Certainly Velázquez has built a vast perspective setting in which contrasts of light and shadow, roughed-out shapes, and a strikingly animated touch heighten at one and the same time the world around him and his depiction of it. He has portrayed himself, his brush in his right hand, a palette and a mahlstick in the other,[220] and the key of his office of Chamberlain at his belt, at work on a canvas. His face and his hands are lit up as he stands in the area of shadow which fills most of the composition.

Depicted on the other side, as a foil to this self-contained figure, are the shadowed shapes of two Court attendants engaged in conversation. Although the painting that Velázquez is working on is not visible, the reverse side of the canvas is keenly depicted. The stark structure of the stretcher and the easel along with the coarse texture of the canvas, its uneven edge lit-up along the upright board, are also sharply rendered. As somewhat of a contrast, the painter's right hand is luminously modelled, the fingers tapering to the point where they hold the slender brush, unerringly shaped by strokes of light. The poise of the hand as he holds the brush in readiness between the palette – where the pigments' hues can be distinctly seen – and the canvas is coupled with the sensitive expression on his face.

In the finished painting, the group portrait has three foci. The figure of the Infanta Margarita is the most luminous; the likeness of the Master himself is

another; while the third is provided by the half-length images of the King and the Queen in the mirror on the rear wall.

In no other painting has Velázquez rendered space in so architectural a manner as in this, the only work in which he has depicted a ceiling. There are, of course, spatial uncertainties which enhance the sheer representational character of the work. The composition is anchored by the two strong diagonals that intersect at about the spot where the Infanta stands, and encompass at one end the background shining mirror and lit-up doorway and, at the other, the expanse of light which fans out into the foreground to the very edge of the picture frame. The interlocking of these luminous areas is the more compelling as the middle distance is cut off by the shadows which spread across the floor. Yet, the depth of the chamber is underlined by the alternation of window jambs and picture frames on the right-hand wall, the stretcher of the large canvas on the left foreground, and the perspectival sequence constructed around the empty lamp hooks, which mark the central spot on the rear wall where the King and the Queen are seen to be reflected in the mirror.

There is also no other composition that Velázquez keyed so dynamically – or scenically – to areas which are out of the viewer's sight: the face of the canvas where the viewer is compelled to imagine Velázquez' work taking shape, and the space lying out of the composition frame where the viewer is compelled to imagine the presence of the sovereigns.

The vast ceiling, without decoration but for the two empty lamp hooks, underlines the bareness of the chamber, unfurnished and unadorned except for the pictures and the mirror on the walls – a state which could hardly have been that of the actual room. This bareness, further emphasized by the stark view of the back of the canvas on which Velázquez is at work, contrasts with the radiant and richly textured group of the Infanta and her entourage, and makes the whole composition into a world of painting. Ancient myths of the arts are dimly seen in the distance and living images, more vivid than reflections in a mirror, people not only the visible space but presumably also the surface of the canvas hidden from sight, on which the painter is at work.

There is in this masterpiece a starry interplay of ambivalences: one side spans the gulf between the realm of painting and the realm of reality, another underlines both the Infanta's regal bearing and her childish charm, a third offers the luminous images of the King and Queen and a view of their forlorn Court,

Felix Castello
La Torre de la Parada
1637
Madrid, Museo Municipal

and yet another makes vivid, at one and the same time, the compass of Velázquez' world – his circumstance – and the might of his brushstroke.

Velázquez knighted

The hope of being knighted must have entered Velázquez' mind rather early, and not later than his first Italian journey. In 1632, Pacheco punctually noted that he had learned from his son-in-law that the King of France, aware of Giuseppe d'Arpino's dissatisfaction with the none-too-prominent order of which he was a knight, had appointed him to a more prestigious one, sending him his new robes, a gold chain and a sword. Pacheco rounded off the paragraph which contains this piece of information – the last bit in chapter VII of *Arte de la Pintura* – with the statement that the Pope had bestowed the mantle of the Order of Christ on the Spaniard José Ribera. Pacheco, moreover, chose to open the following chapter, concerned mainly with an account of Velázquez' life, with a short narrative of the successes of Diego de Romulo Cincinato – a now obscure Spanish painter – knighted in 1625 by the Pope, and Peter Paul Rubens, who though already a knight, was knighted again by King Charles I of England.[221] Pacheco never did live long enough to see his son-in-law knighted. Back in Rome in 1650, Velázquez, after his success with the portrait of Innocent X, had secured the Pope's support for his desire to be made a knight of one of the Spanish military orders.

For the Master, the 1650s were marked by events of sorrow and joy which underscored his last years. On 5 November 1652, his seventh and last grandchild was born. Not much later, its mother, Velázquez' only remaining child, died. On 3 November 1654, Inés de Silva Velázquez, his granddaughter, had married Dr. Onofrio de Lefranchi, who had then received an appointment as magistrate to the Court of Justice of his native Naples, a position that had been granted by Philip IV expressly as a dowry for the Master's granddaughter. Lefranchi died in 1657 in Naples, and Velázquez had to send Mazo there, apparently to expedite the recovery of Inés' dowry. The King helped with the expenses of Mazo's journey out of the royal "secret funds", appointed him assistant to the Chamberlain of the Royal Palace, that is, to Velázquez, and authorized him to pass on to his son Gaspar the position of Usher of the Chamber which twenty-four years earlier Velázquez had passed to his son-in-law as dowry for his daughter, Gaspar's mother. Velázquez' patriarchal contentment must have been broken when his two-and-a-half-year-old great-grandson, Jerónimo Lefranchi, who was living under his roof, died on 27 March 1658. Within three months of this sad event, Philip IV appointed Velázquez to the Order of Santiago, decreeing that the inquiry required for the investiture should be promptly opened.

Two great masters, Velázquez' friends since his youth, were then in Madrid. Alonso Cano (1601–1667), for a while Velázquez' fellow apprentice at Pacheco's workshop, had been at the Court for some time, engaged in litigation with the canons of the Cathedral of Granada, who had deprived him of the prebendary which he had held for several years. Thanks to the King's support, a decision had recently been rendered in his favour. Francisco de Zurbarán (1598–1665) had just arrived in Madrid, where, as it turned out, he was to stay until his death. At Seville his reputation, as well as his income, had been declining for some time. This was only to be expected, given that he had let his towering personality be devalued by the steady and mediocre output of his workshop, which he ran with little concern for true values. In Madrid he was at last to display again a sense of artistic integrity, although this was too late for him to win back his old prestige.

As it happened, the rising star of Sevillian painting, Bartolomé Esteban Murillo (1617–1682) had also arrived in Madrid for a visit a few months earlier, and he was probably still there when Velázquez' appointment to the Order of

Santiago, a milestone in the Spanish painters' struggle for social status, became known.

In compliance with the rules of the Order, an inquiry was opened in Tuy, Vérin, Vigo and other Spanish towns near Portugal, as well as in Seville and Madrid, to determine whether Velázquez' ancestry was free from any Jewish or Moorish strain, and whether he descended from the nobility on both his paternal and his maternal side. One hundred and forty-odd witnesses came forward in order to testify in the affirmative. Several of them were aristocrats, such as the Marquis of Malpica who, putting aside old rivalries, described himself as Velázquez' colleague in the royal service. Among the fellow artists were Zurbarán, Cano, Nardi, and Burgos Mantilla, as well as Juan Carreño de Miranda (1619–1671) and Sebastían de Herrera Barnuevo (1614–1685) from the younger generation.

It also had to be proved was that Velázquez had never had a shop of any sort or practised any menial craft or occupation. Luckily, the rules of the Order, as revised in 1653, stated that only those painters who practised their art as a trade should be regarded as being engaged in a menial occupation.[222] Velázquez' friends took full advantage of this loophole. Reading their testimonies in the light of what we know of his life, it is obvious that many of them, including Cano (who some months earlier had been ordained as a priest) were so bent on securing the knighthood for Velázquez that, although they were under oath, they felt free to stretch the truth. They affirmed, for instance, that the Master had not studied his art under another painter, or had ever had a workshop in the professional sense, not even in Seville, nor had he ever sold any of his paintings, and that in fact, he had always painted either for his own pleasure or for that of the King.

The stumbling block was the nobility of Velázquez' ancestors, which could not be properly substantiated, particularly on his mother's side. Early in April 1659, the outcome of the inquiry was still undecided. At that point the King cut through the maze of red tape and instructed his ambassador at Rome to request from the Pontiff, Alexander VII, the issuance of a brief exempting Velázquez from the proof of nobility. The Pope complied promptly with this royal request, and on 28 November 1659, Philip invested his favourite painter with the Order of Santiago, thus fulfilling the Master's high hope.

Earlier, in 1657, Baltasar Gracián, a writer widely admired for his subtlety, had depicted the heroes of his allegorical novel, *El criticón*, setting out for the Isle of Immortality in a sloop of everlasting cedar, whose golden oars were like feathers and whose sails looked like canvases painted by either the ancient Timanthes or "the modern Velázquez".[223]

The Hall of Mirrors

The weariness which had pervaded the aging Spanish monarchy for a number of years had become more and more evident throughout the 1650s with Philip IV's own increasing penury and lack of purpose. However, the splendid refurbishment of the Madrid Royal Alcázar, in which Velázquez took a more active part from 1643, continued with no trimming of expenses.[224] Velázquez spent much of his time in Italy in 1649–1651 securing casts from the antique, and employing other artists for the refurbishment and decoration of the old Alcázar. One of his achievements at the Alcázar was the rebuilding of an old tower into a magnificently decorated "octagonal hall", a glimpse of which has been preserved in Mazo's portrait of *Queen Mariana*, dated 1666 (p. 185).

Velázquez' architectural activity was not limited to the Alcázar. He took charge of similar work in other royal palaces, including El Escorial. In 1656 and again in 1659 Lázaro Díaz del Valle referred to Velázquez as a "renowned architect and painter", [225] though the truth is that his architectural work never did command, nor deserve, more than a fraction of the admiration that his painting won for him.

On 22 October 1659, the Duke of Gramont, who had come to the Spanish Court as an ambassador, requesting the hand of the Infanta María Teresa for Louis XIV, admired the paintings hanging in the chamber where he was received by Philip IV, and expressed a wish to see the rest of the royal collection. Velázquez took him on a tour of the Palace where the new Hall of Mirrors had just been completed.[226] Velázquez had both designed and supervised the refurbishment of this hall, which derived its new name from the Venetian mirrors that were prominent in the overall decorative scheme. The subject of the whole fresco ceiling decoration was divided into five sections and showed the fable of Pandora. The painting of the various scenes had been entrusted to

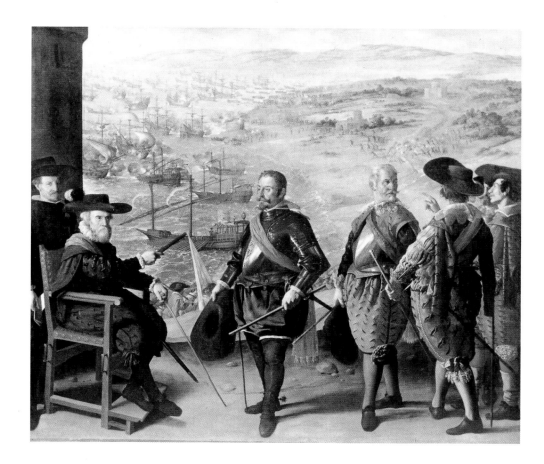

Francisco de Zurbarán
Cadiz Defended against the English
1634
Madrid, Museo del Prado

Agostino Mitelli and Michele Colonna, whom Velázquez had engaged to come to Spain some years earlier, as well as to the younger Spaniards, Juan Carreño de Miranda and Francisco Rizi de Guevara (1608–1685), who were engaged as Mitelli and Colonna's assistants. On the walls hung oil paintings, all in black frames, by Titian, Tintoretto, Veronese, Rubens, José de Ribera, and Velázquez. Most of these paintings were mythological compositions, though there were several biblical subjects too. Four focal points were provided by large portraits of the monarchs from the reigning Spanish dynasty: Titian's *Charles V at the Battle of Mühlberg* (p. 58) and *Philip II after the Battle of Lepanto* (Prado, no. 431), Velázquez' *Philip III and the Expulsion of the Moriscos from Spain*, and Rubens' *Philip IV Equestrian with the Allegorical Figures of Faith and Divine Justice*.

The mythological compositions painted by Velázquez for the Hall of Mirrors were *Apollo Flaying Marsyas*, *Mercury and Argus*, *Venus and Adonis*, and

Psyche and Cupid. Three of them, as well as the portraits of Philip III and Philip IV mentioned above, were destroyed in the fire that gutted the Palace in 1734. Rescuers, however, succeeded in cutting *Mercury and Argus* out of its frame. Like its lost companion piece, *Apollo Flaying Marsyas*, it hung in a narrow space above a large window and this explains the somewhat unusual proportions of the canvas, the height of which was originally one-third of its width. Sometime between 1746 and 1772, narrow strips were added to the bottom and the sides of the canvas, and a substantially larger one at the top, with the result that the height, originally about 0.835 m., was increased by half to its present 1.27 m. (cat. no. **127**).

For all the monumentality of the figures, giving depth to the composition, Velázquez has once more stressed the power of the fable in *Mercury and Argus*. The painting's dark tints make both Argus and Mercury virtually faceless, while the highlights on their bodies accentuate the murderous treachery of the action

Mercury and Argus
c. 1659
Cat. no. 127

depicted. Argus, in black and grey rags, is in a deep sleep in the shadow of the cave. Mercury, wearing a red and dull-yellow cloth, steals in on his knees, while the earthen reddish blob of Io, the heifer, outlines itself against both the shadows of the cave and the distant cloudy sky.

Charles Le Brun
Meeting of Philip IV and Louis XIV at the Isle of Pheasants
Wall hanging depicting the official ceremony attended by Velázquez, who is no doubt represented by one of the noblemen on the right
c. 1600
Madrid, French Embassy

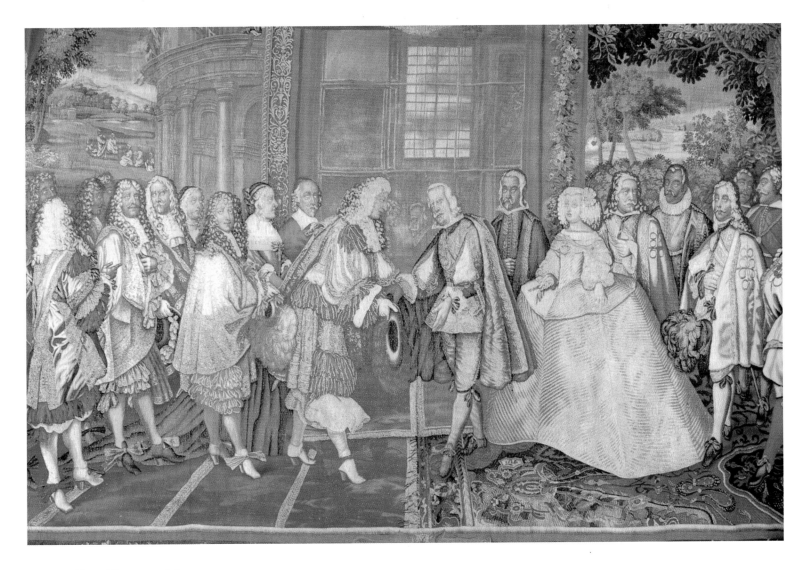

Last works

The last years of Velázquez' life were a time of melancholic anxiety for most Spaniards. Philip IV, after the solemn reburial of his ancestors in the Pantheon of the Escorial, had become even more painfully aware of his own inadequacies as a king, and watched more helplessly than ever the threatening march of world events. Military, diplomatic and commercial reverses were compounded by the self-righteous thoughts and actions with which these reverses were dealt with. For over two decades, the Spanish monarchy's options for their present stability and future were steadily narrowed.

The French proposal of marriage between Louis XIV and his cousin María Teresa had been looked upon with distrust by many Spaniards who feared that it might result in the political union of France and Spain under a French king. The Infanta, however, contemplated the union with cheerfulness. It was only after the birth of Prince Felipe Próspero, on 20 November 1657, that those fears were allayed, and the marriage of the French king and the Spanish Infanta was agreed upon. In the event, even this prudently delayed action proved to be premature. The heir to the throne, on whom the hopes for the continuity of the Spanish monarchy were pinned, was a sickly child from birth. Despite the great care that was taken to protect him against both infectious diseases and spiritual misfortune, he died before reaching his fourth birthday, little more than a year after the marriage of his half-sister and the King of France.

In 1659, Philip IV commanded Velázquez to paint the portraits of Felipe Próspero and his sister, the Infanta Margarita, as a present for Emperor Leopold I, whom she was to marry years later. These two paintings, still extant, and a lost miniature portrait of Queen Mariana, were, as far as it is known, the last works to be painted by Velázquez. Margarita was then eight years old, and Felipe Próspero about two, somewhat younger than Velázquez' great-grandson had been on his death the year before. The portrait of the *Infanta Margarita* was altered into an oval shape in the eighteenth century (cat. no. 128). Although the painting has now been skilfully restored, it lacks the sense of depth that it must have had originally. The chariot of the Sun would have been seen distinctly, circling around the numerals of the hours on the face of the huge clock in the background. Even so, its present condition, the blue-clad Infanta appears to be encompassed by the ochre hues of both the clock and the sideboard on which it stands as well as those of the fur muff that she holds in her hand. For pervasive harmony of colour, this portrait must have been – and to a considerable extent still is – an outstanding work. Everything is keyed to the Infanta's blue eyes and her faintly rouged pearly face, framed by the pale gold of her hair and necklace. This corresponds to the gold and faded red of the hanging on the wall, the golden yellow of the *passementerie* gimp across her bust and of the gilt-bronze lions on the sideboard, the silver trimmings on the blue velvet costume, and the greenish touches which lighten this blue, harmonizing it with the tint that suffuses her white collar, undersleeves, and wrist cuffs.

Velázquez represented *Prince Felipe Próspero* (cat. no. 129) wearing a silverbanded rose dress under a transparent white pinafore. Conspicuously placed are a pomander ball, to prevent infection, and several amulets to ward off the evil eye. He does not appear to be quite two years old and looks scarcely older than the sixteen months that Baltasar Carlos was when, twenty-eight years earlier, the Master portrayed him, at a time when the Monarchy appeared to be still a living idea and a boundless reality to all sensitive Spaniards.

In the earlier portrait of *Baltasar Carlos* (cat. no. 51), Velázquez included the figure of a dwarf, whose shape and gesture are a foil to the majestic bearing and

pose of the Prince, who towers over his surroundings. In the painting of Felipe Próspero, a playful little dog – one which, according to Palomino, was very dear to Velázquez[227] – brings a note of warmth into the composition in which the frail figure of the Prince is seen against a looming space. The purplish hues dominant in both portraits are about all that the two works have in common.

The Prince stands in the rectangle that has been marked-out by a red and brown rug. At his back is a full-sized stool, set at an angle to which is the short-legged armchair at his side. He rests a hand on the gold-braided armchair, on which the dog is curled-up and his silver and rose cap lies casually on the silver-tasselled cushion which builds up the height of the stool – a compositional scheme which emphasizes the stature of the Prince child without dwarfing him. The lively diagonal rhythm is enhanced by the perspectival relationship between the illuminated purplish drapery hanging from above in the foreground and the one that is in shadow near the half-lit doorway at the rear.

The bloodless face of the blue-eyed Felipe Próspero is modelled with grey-ish tints which also tinge the top of the white pinafore, where the rose shoulder bow is set off by a vivid blue shadow. The Prince, in his white, silver and rose dress, looks all the paler as highlights pick out his straw-coloured hair. The sombre half-light coming from the distant doorway adumbrates a high floor line and accentuates the vertical lines of the door against whose bottom panels the head of the Prince is set. Thus, the vastness of the chamber is stressed, and the shadowy space looms over the Prince child, whose melancholy shape and comely bearing are enhanced by the brilliancy of his immediate surroundings. It is a somewhat dramatic portrait painted with a degree of warmth, whilst also being the first portrait in which Velázquez embodied a sentiment of sadness. As it happened, this was one of his very last works.

Last service to the King, and death

From October 1659 and until the following spring Velázquez, as Chamberlain of the Palace, was busy with the arrangements for the Spanish section of the building erected on the Isle of Pheasants, off Fuenterrabía, in the North of Spain. It was here that the peace between France and Spain was to be formalized and the Infanta María given in marriage to Louis XIV. After deciding on the decoration and choosing the tapestries for the Spanish rooms, Velázquez left Madrid on 8 April 1660, two weeks ahead of the King, so that he could attend to the preparation of the lodgings for the royal party along the route to Fuenterrabía. He was accorded the use of a travelling litter for the journey, and was accompanied by a crew of workers who rode on mules.

On 7 June Velázquez, wearing a gold chain from which hung the diamond-studded badge of the Order of Santiago, was one of the magnificently dressed courtiers present at the great hall when Philip IV led the Infanta from the Spanish section, that was decorated with a series of tapestries of the Apocalypse, over to the French side, that was decked with hangings from a narrative cycle of Scipio and Hannibal. The following day, he started on his way back to Madrid, this time with the royal party. He arrived home on the 26th, much to the relief of his family and friends, for rumours of his death had circulated at the Court. He felt "weary of travelling by night and working by day, but was in good health", as he wrote to Diego Valentín Díaz, a fellow painter whom he had just seen at Valladolid during a five-day stop on the return trip. In the same letter he also wrote that Queen Mariana and Prince Felipe Próspero, who had stayed at the Court, looked "very pretty".

Infanta Margarita
1659
Cat. no. 128

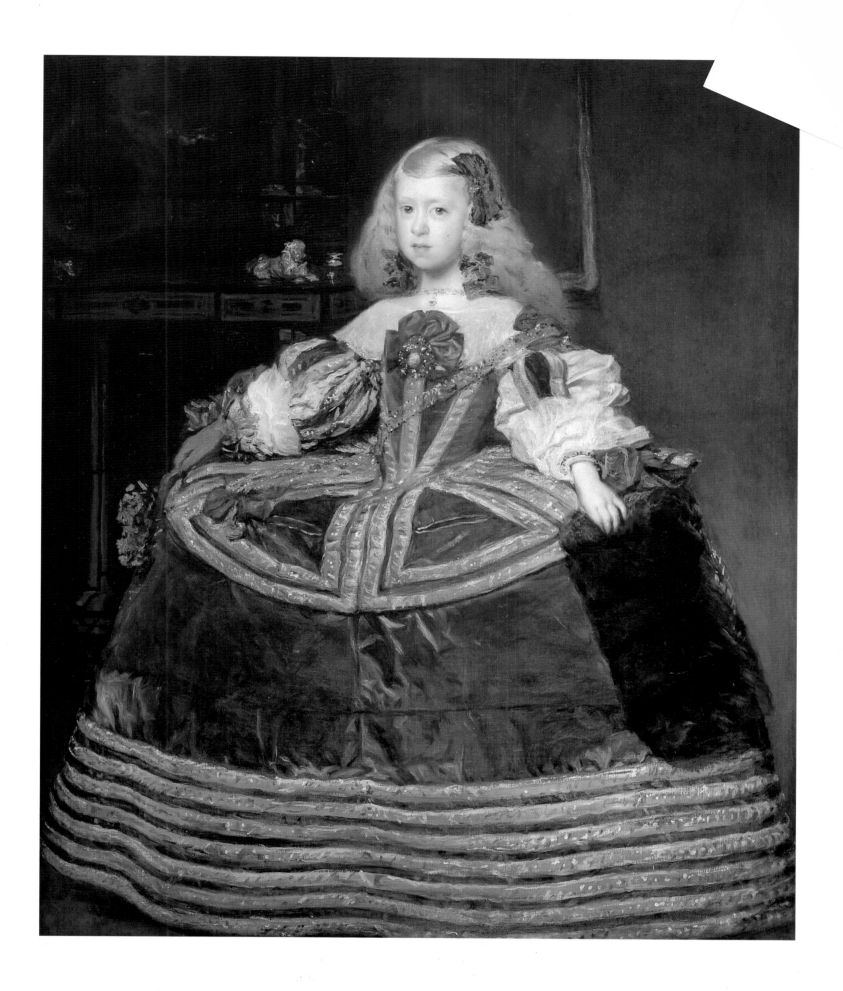

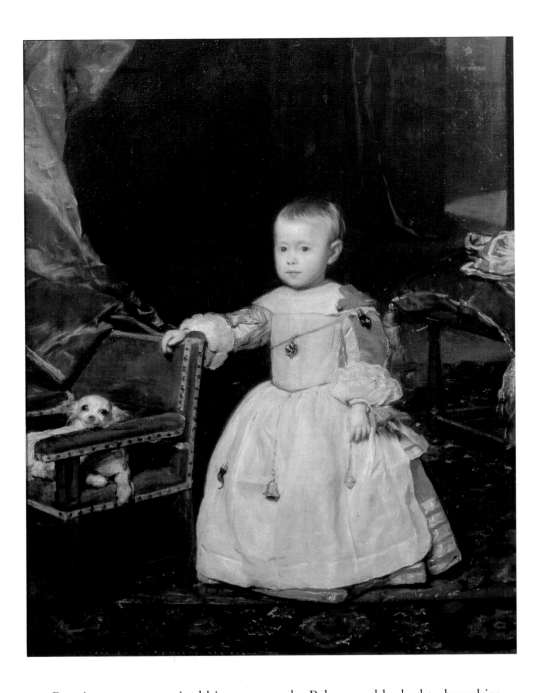

Prince Felipe Próspero
1659
Cat. no. 129

Routine matters awaited his return at the Palace, and he had to busy himself with making payments that were due to others for services rendered or for small purchases made in the course of the royal journey. On 1 July, he went to a bullfight. This turned out to be a rather simple affair, without horsemen, which made him and other courtiers think of the more elaborate one that they had watched with the King a few days earlier at Valladolid.

On 31 July he had been attending the King for the whole morning at the Palace when he felt fatigued and feverish, and retired to his apartments. Philip sent two of his doctors to care for him and, on hearing that there was little or no hope of recovery, he asked the Patriarch of the Indies, Archbishop Don Alfonso Pérez de Guzmán, to assist his dying painter.

Death came to Velázquez on Friday, 6 August 1660. His body, clothed in the robes of the Order of Santiago, lay in state in his bedroom, where an altar was erected. The following night he was buried in the church of San Juan Bautista at solemn services attended by titled aristocrats and royal servants. His wife, who survived him by only seven days, was also buried there. Nothing remains of either their tomb or the church of San Juan Bautista.

A few years later, Louis XIV had a series of tapestries made, under the direction of his favourite painter, Charles Le Brun (1619–1690), to commemorate his marriage to María Teresa. One of these represents the meeting of the French and the Spanish kings in the grand hall at the Isle of the Pheasants, each surrounded by his Court, and depicting the Spaniards and the French as quite different in costume and bearing (p. 224). Le Brun portrayed Philip IV in a graceful stance though he was by then aged and somewhat stoop-shouldered. He made the Infanta stand out rather ungracefully by the use of a perspective scheme which emphasizes the bulk and stiffness of her farthingale. To the student of Velázquez, Philip IV and the Infanta María Teresa appear miscast in Lebrun's somewhat anecdotal portrayal of courtly pomp, a world that was alien to that of an unconditional monarchical sentiment into which Velázquez had fashioned his royal sitters.

Like other truly great masters, Velázquez was more a creator than a recorder of his epoch, and whatever his subject – whether he was painting gods, kings or aristocrats, dwarfs or artists – his work has contined to live.

Notes

Additions in italics and footnote references in alphabetical order are updated corrections by José López-Rey.
Editor's notes are mentioned in parentheses (ed. note).

1.
I have discussed the relation between art-historical interpretation and connoisseurship in "On the matter of attributions", *Museologia 4*, Florence, Università Internazionale dell'Arte, 1976, pp. 51–4.

2.
Velázquez: A Catalogue Raisonné of his Œuvre, with an Introductory Study, London, 1963, and *Velázquez' Work and World*, London, 1968.

3.
A black chalk drawing on white paper, catalogued at the École des Beaux-Arts, Paris, as by an anonymous hand (M.315, 19.3 x 15.9 cm), has lately been published as a portrait of Olivares by Velázquez (Jonathan Brown, "A portrait drawing of Olivares by Velázquez", *Master Drawings*, spring 1976, pp. 46–50). It is a bust portrait, enclosed by an oval borderline, showing an entirely frontal view of the sitter's head, erect without the slightest tilt. As far as I know, no such pose occurs in any of the extant portraits by Velázquez. Nor, for that matter, in the Rubens' portrait of Olivares, to which, it is argued, the drawing in question would be related.
As I see it, this black chalk drawing hardly brings to mind Velázquez' hand, particularly the subtle interplay of light and shade which he used to build firmly the human figure while placing it in ambient air. Indeed, this frontal-view portrait seems to be the work of a diligent but somewhat dull hand; for instance, the bridge of the nose, broad and flat, sets the sitter's eyes apart, not quite at the same level. For the style of portraits drawn by Velázquez, see also the commentary to cat. No. 114.

4.
In a letter to Théodore Fantin-Latour, reproduced by E. Moreau-Nélaton, *Manet raconté par lui-même*, Paris, 1926, vol. I, pp. 71–2.

5.
For example, José Camón Aznar describes *Pablo de Valladolid* as "warmer" in hue than earlier Velázquez' works "since the background

is ochre"; he goes on to explain that this ochre background is one of the means by which Velázquez endows the figure of the sitter with "an impetuous plastic effect" – after which he perfunctorily quotes Manet's discerning words (*Velázquez*, Madrid, 1964, vol. I, pp. 477–9). Camón's views have been echoed by other authors. Julián Gallego sees in the background of *Pablo de Valladolid* "the luminous ochre of celestial visions" which Velázquez would have brushed in with some sort of blasphemous intention (*Zurbarán*, Barcelona, 1976, p. 38; the second part of this book is a catalogue of Zurbarán's works independently compiled by José Gudiol). It is not my purpose, of course, to chastise any of the writers whose understanding of Velázquez' style has been warped by inadvertent exposure to seriously impaired paintings that have lost some of their essential qualities. See also Ortega y Gasset, 1950, p. 33.

6.
My exclusion of two paintings till now included, one for over half a century and the other for almost a century, in every Velázquez catalogue, deserves some explanation. *The Temptation of St. Thomas Aquinas* (Orihuela, *Diocesan Museum*, cat. no. 130), was included as by Velázquez in Allende-Salazar's catalogue of this master's works, published in 1925 (pp. 47 and 276), and in every other one published since then (Mayer, 1936, no. 44; Lafuente, 1943, no. 42, and 1944, no. 44; López-Rey, 1963, no. 54, and Gudiol, 1973, no. 57). After examining this remarkable painting anew, I reversed my opinion. In 1979–81 I concluded indeed that, though it certainly has similarities with some Velázquez' works of the late 1620s – notably the brushwork which builds the future in the background and the objects in the foreground – there are other features which suggest a hand other than Velázquez'. The shapes of the three main figures are imbued with a malleable quality, which contrasts with the markedly linear definition of space; both of these con-trasting traits are rather alien to Velázquez' style. The discovery of the payment for transport of *The Temptation of St. Thomas Aquinas* and in particular laboratory analyses carried out on the occasion of the 1990 exhib-ition allow this canvas to be attributed to the Master.
The half-length portrait of the *Count of Benavente* (Prado Museum) was purchased sometime before 1746 from an unknown source by Queen Isabel Farnese (1692–1766), wife of Philip V of Spain, as Titian's portrait of an unidentified prince. Pedro de Madrazo attributed it to Velázquez (*Catálogo descriptivo e histórico de los cuadros del Museo del Prado de Madrid*, Madrid, 1872, p. 624, no. 1090), an attribution which has found acceptance in every Velázquez catalogue published since then (Curtis, 1883, no. 182; Cruzada Villaamil, 1885, no. 132; Allende-Salazar, 1925, pp. 124 and 281; Mayer, 1936, no. 333; Lafuente, 1943, no. 88, and 1944, no. 99; López-Rey, 1963, no. 487; and

Gudiol, 1973, no. 126). Beruete, who held that Velázquez had painted this portrait in 1635–38, remarked that there "is nothing in the whole of Velázquez' painting which approaches nearer to the style of El Greco", and that the armour worn by the sitter "recalls, by its colour and reflected lights, that worn by the principal fig-ure in the *Burial of the Count of Orgaz*" (*Velázquez*, London, 1906, pp. 47–8). On the other hand, as Pedro Beroqui pointed out, Benavente's armour is rather like that worn by Philip II in the full-length portrait painted by Titian in 1550–51 (Prado, no. **411**) – a suit of armour which has been preserved at the Madrid Real Armería (*Tiziano en el Museo del Prado*, Madrid, 1946, p. 116). As I now see it, there is in the Benavente portrait a prodigality of reflected lights which emphasize the awkward shape of the sitter and of the helmet on which he rests his right hand; the rendition of space appears also rather maladroit, though this could partly be explained as a result of the fact that the painting has evidently been cut down, probably on all sides. Even taking this into consideration, the muddled character of the com-position leads to the conclusion that it is not by Velázquez.
(ed. note) All the technical data resulting from the analysis of the half-portrait of Juan Francisco Pimentel, Count of Benavente, *correspond with the data obtained from a study of Velázquez' work dating from around 1630. Professor López-Rey, who died in 1991, could not have been famil-iar with the conclusions from this analysis pub-lished by Carmen Garnido Pérez (1992, pp. 180–9).*

7.
Velázquez' actual date of birth was published for the first time by Juan Augustín Ceán Bermúdez (*Diccionario histórico de los más ilus-tres profesores de las Bellas Artes en España*, Madrid, 1800, vol. V, p. 155). Up till then, he was thought to have been born in 1594, the date indicated in 1660, when he died, by his pupil Juan de Alfaro (See Palomino, *El Museo Pictórico*, Madrid, 1947, p. 935; the first edition of this work dates from 1724).

8.
Francisco Pacheco, *Arte de la Pintura*, ed. F.J. Sánchez Cantón, Madrid, 1956, vol. I, pp. 155, 162, 166; vol. II, pp. 146, 154. Pacheco com-pleted the manuscript on 24 January 1638, but it was not published till 1649, at Seville. All my references are to Sánchez Cantón's edition of the original manuscript.

9.
We owe, in fact, this information to three of the witnesses who in 1658, when Velázquez' ancestry was being scrutinized to decide whether he could be admitted into the Order of Santiago, testified that he was descended from the nobility and had always behaved accord-ingly. For a fuller discussion of the matter, see José López-Rey "Nombres y nombradía de Velázquez", Goya, Madrid, July-October, 1960, pp. 4–5.

10.
See F.J. Sánchez Cantón, "La librería de Velázquez", *Homenaje a Don Ramón Menéndez Pidal,* vol. III, Madrid, 1925, pp. 379–406.

11.
Antonio Palomino Velasco, *El Museo Pictórico,* Madrid, 1947, pt. III, p. 892 (1st ed., Madrid, 1724).

12.
For this and all other quotations from Pacheco's narrative of Velázquez' life see *Arte de la Pintura,* vol. I, pp. 155–62. Whenever the references to Velázquez are from other sections of this work, the corresponding page number has been indicated.

13.
For the document, see Celestino López, *Desde Jerónimo Hernández hasta Martinez Montañés,* Seville, 1929, pp. 127–8.

14.
Pacheco, *Arte de la Pintura,* vol. I, p. 370; vol. II, pp. 8, 165.

15.
Arte de la Pintura, vol. I, pp. 366–71, and passim. A critical edition of *Arte de la Pintura,* which has not yet been undertaken, would help to clarify Pacheco's views on the matter. *(ed. note)* Professor López-Rey would have had no knowledge of the critical edition by Bonaventura Bassegoda i Hugas, published in Madrid in 1990.

16.
Op. cit., vol. I, p. 478.

17.
Ibidem, vol. I, pp. 370 and 456; vol. II, p. 79.

18.
Pacheco, *Arte de la Pintura;* vol. II, p. 146. The verb *Cohechar* (to bribe) with which Pacheco refers to the agreement between Velázquez and the peasant-boy apprentice connotes an idea of mischief which can only be understood if Velázquez, too, was still an apprentice.

19.
Considerazioni sulla Pittura, ed. by Adriana Marucchi, Rome, 1936, vol. I, p.223.

20.
For data on works by Caravaggio, or copies after them, in Spain early in the seventeenth century, see J. Ainaud, "Ribalta y Caravaggio", in *Anales y Boletín de los Museos de Arte de Barcelona,* July–December 1947, pp. 345–413.

21.
Arte de la Pintura, vol. II, p.13.

22.
Op. cit., vol. I, pp. 108–9. Mancini points out the unnatural character of Caravaggesque chiaroscuro: "It is peculiar to this school to light up [the composition] with an even light, coming from above, without reflections, as if through a window into a room with the walls painted black, for by so doing, by making the lights very light and the shades very dark, they succeed in giving relief to the painting, even though in an unnatural manner."

23.
I expressed this view in *Velázquez ...,* London, 1963, p. 26. Yet, as Richard E. Spear has written

"the Caravaggio mystique still persists" and "Velázquez' *bodegones* and earliest religious paintings are repeatedly explained in terms of Caravaggio's art, despite the visual contradictions that this thesis rises" (*Caravaggio and his followers,* Cleveland, 1971, p. 19).

24.
Cf. Theodor Hetzer, *Tizian, Geschichte seiner Farbe,* Frankfurt a/M., 1948, pp. 232 ff.

25.
Arte de la Pintura, vol. I, pp. 155 and 160; vol. II, p. 154.

26.
Pacheco, *Arte de la Pintura,* vol. I, p. 165. The Spanish word *limpieza* may be translated as integrity, but in Pacheco's context it rather means "purity of blood", that is, an ancestry free of any Jewish, Moorish or heretic – i.e., non-Catholic – strain.

27.
Baltasar de Cepeda, a guest at the wedding banquet, wrote a poem describing it (William L. Fichter, "Una poesía contemporánea inédita sobre las bodas de Velázquez", *Varia velazqueña,* vol. I, pp. 636–9).

28.
For Velázquez' extant signed or dated paintings, see cat. nos. **6, 7, 19, 20, 21, 51, 52, 56, 77** and **114.** For paintings with the folded-out piece of blank paper, see cat. nos. **66, 71** and **73,**

29.
F.J. Sánchez Cantón, "Sobre la vida y las obras de Juan Pantoja de la Cruz", *Archivo Español de Arte,* Madrid, 1947, pp. 95–120.

30.
For a historical account of the early origins and later development of still-life painting in Europe, see Charles Sterling, *La Nature morte de l'Antiquité à nos jours,* Paris, 1952. On Dutch and Spanish still-life, see; Ingvar Bergström, *Dutch still-life painting in the seventeenth century,* London, 1956, and *Maestros españoles de bodegones y floreros del siglo XVII,* Madrid, 1970. Julio Cavestany's catalogue *Floreros y bodegones en la pintura española* (Madrid, 1940) remains a most valuable source on the subject. Professor Pérez Sánchez's book *La Nature Morte du XVIIe siècle à Goya,* Paris, 1987, is currently considered to be the reference work. The catalogue of the recent exhibition in London of Spanish still-life from Velázquez to Goya, by Peter Cherry and William B. Jordan (London, 1995) should also be consulted *(ed. note).*

31.
Max J. Friedländer, one of the first to hold that still-life had emerged in the wake of the Dutch struggles for freedom, made the more valid suggestion that still-life may be regarded as a form of art for art's sake (*Landscape, Portrait, Still-life,* London, 1949, p. 279).

32.
I first expressed these views on *bodegón* and still-life painting in the foreword to the catalogue of the exhibition *The Golden Age of Spanish Still-life Painting,* organized by the

Newark Museum, Newark, New Jersey, December 1964–January 1965.

33.
For this and the preceding references to Pacheco's understanding of *bodegones,* see *Arte de la Pintura,* vol. II, pp. 135–9. Antonio Palomino, writing in the first quarter of the eighteenth century, defined the term *bodegón* somewhat more broadly as a "type of painting in which victuals are depicted" (see *Indice de los términos privativos del Arte de la Pintura* appended to the second volume of his *El Museo Pictórico,* first published in Madrid in 1724). About a century later, Juan Agustín Ceán Bermúdez, after describing several *bodegones* is the same as painting food and kitchenware" (*Diálogo sobre el Arte de la Pintura,* Seville, 1819, pp. 26–8). Vicente Poleró gave a similar defini-tion of the term in his *Tratado de la Pintura en general,* Madrid, 1886, p. 267.

34.
Cf. August L. Mayer, "Velázquez und die niederländischen Küchenstücke", *Kunstchronik und Kunstmarkt,* 3 January 1919, pp. 236–7, and *Velázquez,* Berlin, 1924, p. 57; Kurt Gerstenberg, *Diego Velázquez,* Munich and Berlin, 1957, pp. 22 ff.; Halldor Soehner, "Die Herkunft der Bodegones de Velázquez" *[sic],* *Varia velazqueña,* vol. I, pp. 233–44, and J. López-Rey, *Velázquez ...,* 1963, p. 32.

35.
This suggestion was renewed by Emilio Orozco Díaz ("Un aspecto del barroquismo de Velázquez", *Varia velazqueña,* vol. I, pp. 184–99) and the present writer (*Velázquez ...,* 1963, pp. 32–3). To some, however, the background scene is seen through an opening into another room. Others hold it to be a picture hanging on the wall. If either were the case, Velázquez would have represented Jesus gesturing with His left hand and with the right one motionless, and Mary holding her mantle close to the chin with her high-lighted left hand, while the right, hardly noticeable, rests on her lap. Had Velázquez so represented both Christ and Mary, an awkward emphasis would have crept into the composition, of which he could not have been unaware since left-handed people were then, and later, regarded in Spain and elsewhere as mischievous or even devilish. This does not, of course, imply that he, or for that matter any other painter of his, earlier or later times, would have excluded altogether left-hand gestures from his representations of the divine persons or of the saints. Yet, we are concerned here with a particular work which can only be understood within the context of its time in terms of its own composition. Hence it cannot be reasonably assumed that since in Velázquez' *The Supper at Emmaus* the background scene is seen through an open hatch, the door of which is plainly visible, the same must be the case in *Christ at the House of Martha and Mary,* where no hatch door is visible. Neither does the significance of the

painting hinge on whether the background scene is regarded as a picture on the wall, a reflection in a mirror, or a view through an opening into another room. See cat. nos. 7 and 17.

36.
For Pacheco's description of this picture, see *Arte de la Pintura*, vol. II, pp. 327–8. Cf. Priscilla E. Muller, "Francisco Pacheco as a painter", *Marsyas*, New York, 1960–61, vol. X, p. 40.

37.
Alfonso Sobrino, *Tratado de la Immaculada Concepción*, Seville, 1615, and Alvaro Piçaño de Palacios, *Discurso primero en confirmación de la purísima concepción de la Virgen María*, Seville, 1615. The latter was followed by a *Discurso segundo, etc.*, published by the same author in 1616, also in Seville.

38.
See Ramon Menéndez Pidal, "Onomástica inspirada en el culto mariánico", *Cuadernos del idioma*, Buenos Aires, 1965, vol. I, pp. 9–16.

39.
Apacible conversación entre un tomista y un congregado acerca del misterio de la purísima concepción de Nuestra Señora, Seville, 1620 (reprinted in José Maria Asensio's *Francisco Pacheco: Sus obras artisticas y literarias*, Seville, 1886, pp. LVII–LXVIII).

40.
Vol. II, pp. 208–12, and 317–9.

41.
See José López-Rey, "Pincelada e imagen en Velázquez", *Varia velazqueña*, vol. I, pp. 200–6.

42.
According to Pacheco, Velázquez left Seville for Madrid "sometime in April of the year 1622". On the 14th, Velázquez was still in Seville and signed a document empowering Pacheco to collect on his behalf any and all moneys or goods due to him.

43.
Duque de Berwick y de Alba, *Discursos leídos ante la Real Academia de San Fernando en la recepción pública del ...]*, Madrid, 1924, pp. 23–4.

44.
For the date of Vincencio Carducho's birth, 1570, see A. Gambacorta, "Arte in Puglia. Vincenzo Carducci", *Tempi nostri*, 1967, No. 11, and A. Rodriguez G. de Ceballos, "La fecha de nacimiento de Vicente Carducho", *Archivo Español de Arte*, 1975, pp. 263–4.

45.
For Borgianni's years in Spain, see Alfonso Pérez Sánchez, *Borgianni, Cavarozzi y Nardi en España*, Madrid, 1964, pp. 10 ff.

46.
I am indebted to Mr. Volker Schierk who some ten years ago gave me the date of Lanchares' death, 14 March 1630, which he had found in the course of his research on this painter. Jusepe Martínez, who in 1634 was at Madrid where he mixed with many of his fellow painters, wrote that Lanchares, an outstanding pupil of Eugenio Caxés, had spent a long time in Rome, and had died prematurely (*Discursos*

practicables del nobilísimo arte de la pintura, ed. Valentín Carderera, Madrid, 1866, p. 115).

47.
See J. Ainaud, "Ribalta y Caravaggio", *Anales y Boletín de los Museos de Barcelona,* July–December 1947, pp. 345–413.

48.
In 1653 it was still at Valladolid, inventoried as Caravaggio's "original" in the collection of the 10th Count of Benavente, grandson of its first owner. Its valuation, 1500 ducats, was the highest in the inventory, almost four times as much as a *St. Jerome* by Jusepe Ribera appraised at 400 ducats, (see Esteban García Chico, *Documentos para el estudio del Arte en Castilla*, Valládolid, 1946, vol. I, pp. 392–4). Emmerich and Christa Back-Vega published *Crucifixion of St. Andrew* which they claimed was Caravaggio's original ("A lost masterpiece by Caravaggio", *The Art Bulletin*, March 1958, pp. 65–6); as I have pointed out elsewhere, there is no validity to this claim (*Velázquez' Work and World*, London, 1968, p. 37). There are other versions of the same composition. One of them (2.54 x 1.52 m.) was included under no. 4 in the exhibition *Caravaggio y el naturalismo español* held at Seville in 1973. A.E. Pérez Sánchez, author of the catalogue, described it as "Caravaggesque" and as surely not representing the *Crucifixion of St. Andrew*, for the representation of which, he mistakenly believed, the transverse cross would have been absolutely "indispensable". The painting was acquired as Caravaggio's original *Crucifixion of St. Andrew* by the Cleveland Museum of Art in 1976; it is said to be "in acceptable, but not the best condition". See Ann Tzeutschler Lurie, "Caravaggio's Crucifixion of St. Andrew from Valladolid", *The Bulletin of the Cleveland Museum of Art*, January 1977, pp. 3–24, and *La Chronique des Arts*, Paris, July–August 1977, p. 8. I know the painting only from a photograph.

49.
Diálogos de la Pintura, Madrid, 1633 [actually published in 1634] fols. 89 r. and ff.

50.
Ibidem fol. 39 r.

51.
In *Diálogos de la Pintura* several important Madrilenian art collections are described. One of them, outstanding on account of the number and quality of the pieces it contained, was at a house – whose owner exceptionally is not named – where works of art by old and living masters were traded, and there artists, intellectuals and highborn people gathered to discuss art matters (folios 147 v. and 148 r.). María Luisa Caturla has pointed out that several works of art described as in the unnamed collector's house were included in the inventory of Carducho's possessions drawn up at the time of his death ("Documentos en torno a Vicencio Carducho", *Arte Español*, Madrid, 1968–69, pp. 145–221). In this article María Luisa Caturla published most of the documents concerning Carducho's estate preserved at the Archivo de

Protocolos, Madrid. One of those documents, not mentioned by Caturla, is a list of paintings which Carducho had shipped on 22 April 1631 to the Spanish Dominions in America (*"las Yndias"*) to be sold at prices ranging from 66 to 880 *reales* (fol. 443). The subjects of the paintings are described but no painter's name is mentioned. The lowest price corresponded to each of the five full-length portraits of Philip IV, his Queen, brothers and sister. Obviously such low-priced works could not be by the hand of Carducho, who, moreover, is not known to have ever portrayed any of the mentioned royal persons. Doña Carmen Caamaño Diaz' transcription of the documents concerning Carducho's estate has been made available to me by Dr. William B. Jordan.

52.
For data on Maino see Fray Antonio García Figar, O.P., "Fray Juan Bautista Maino, pintor español", *Goya*, Madrid, July–August 1958, pp. 6–12. Jusepe Martínez wrote that Maino "had been a pupil and friend of Annibal Carracci, and a great crony of our great Guido Reni" (*op. cit.*, pp. 120–1).

53.
Hernani Collection, Madrid; The Fine Arts Gallery of San Diego, California, and Museo Provincial de Bellas Artes, Granada.

54.
See Enriqueta Harris, "Cassiano dal Pozzo on Diego Velázquez", *The Burlington Magazine*, June 1970, pp. 364–73. Both Velázquez' and Van der Hamen's portraits of Cardinal Francesco Barberini are lost or unidentified.

55.
José López-Rey, foreword to the catalogue of the exhibition, *The Golden Age of Spanish Still-life Painting*, The Newark Museum of Art, Newark, N.J., 1964, p. 4. See also William B. Jordan, "Juan Van der Hamen y León: A Madrilenian Still-life Painter", *Marsyas*, New York 1964–5 [actually printed in 1966], pp. 52–69.

56.
Villandrando was a pupil of Pantoja de la Cruz (1553–1608). He took the oath as "Usher of the Chamber without perquisites" on 6 July 1621, and died in December 1622. The inventory of the Madrid Royal Alcázar compiled in 1636 described in some detail six portraits by him; the sitters were Philip III, Queen Margarita, Prince Philip (later Philip IV), Princess Isabel, the Infanta Doña María and the Infante Don Fernando. The description of Princess Isabel's dress ends with the statement that it is the one she wore on the occasion of Philip III's entrance into Lisbon (on 29 June 1619). That royal journey ended with the return of the King to Madrid on 4 December 1619. A few weeks later, on 31 December, Bartolomé González was paid 400 *reales* on account for a life-size portrait of Philip III in the stately robes which he wore when he made his formal appearance at the Portuguese *Cortes*. Consequently, Villandrando's portraits of

Princess Isabel and Philip IV as a Prince with the dwarf Soplillo, none of which is dated though both are signed, were most likely painted around 1620, certainly before 31 March 1621, when Philip III died and Philip IV became King (José López-Rey, "Muerte de Villandrando y fortuna de Velázquez", *Arte Español*, Madrid, 1968–69, pp. 1–4.

57.
See preceding note.

58.
José López-Rey, "Idea de la imitación barroca", *Hispanic Review*, July 1943, pp. 253–7.

59.
Juan Agustín Ceán Bermúdez stated as a matter of fact that Pacheco accompanied Velázquez in his second trip to Madrid (*Diccionario histórico de los más ilustres profesores de las Bellas Artes en España*, Madrid, 1800, vol. V, p. 159). The statement has since been repeated by all writers on the subject, including the present one. There is, however, no evidence that Pacheco went with Velázquez to Madrid in 1623.

60.
Pacheco's report about the portrait of Philip IV finished by Velázquez on 30 August 1623 closes with the statement: *"Hizo también de camino un bosquexo del Príncipe de Gales, que le dió cien escudos"*. The expression *de camino* in this context cannot be taken to mean that Velázquez made a sketch of the Prince of Wales "at the time of the trip" to the Escorial, or anywhere else, nor to indicate that Velázquez portrayed the Prince "in travelling dress", as some writers have held in what can be regarded only as an assertion of freedom from knowledge of the Spanish language. What Pacheco says is that Velázquez made a colour sketch of the Prince of Wales at roughly the same time, or immediately after, he painted the portrait of Philip IV. According to Enriqueta Harris, an entry of 8 September 1623 in an account book for the Prince of Wales' Spanish journey mentions a payment to an unnamed painter "for drawing the Prince's picture". See "Velázquez and Charles I', *Journal of the Warburg and Courtauld Institutes*, London, 1967 [published in 1968], pp. 414–20. The unnamed painter might have been Velázquez, but the picture must certainly have been drawn in Madrid since it was paid for on 8 September and the Prince did not leave there till the following day (See *Account of the departure which the most serene Prince of Wales made from this city of Madrid*, written at the time by Andrés de Almansa y Mendoza, published by the Hispanic Society of America, New York, 1902, p. 5).

61.
In the summer of 1847 a portrait of Charles I was exhibited at London as the missing colour sketch by Velázquez. Its owner, John Snare, a bookseller at Reading, subsequently published a book giving his reasons for the attribution of the picture to Velázquez: *The history and pedigree of the portrait of Prince Charles, (afterwards Charles the First) painted at Madrid in 1623 by*

Velázquez, Reading, 1847. The attribution was rejected on rather plain grounds by Sir Edmund Head and William Stirling, then the leading British connoisseurs of Spanish painting. Snare replied to both with hollow arguments in a second publication: *Proofs of the authenticity of the portrait of Prince Charles (afterwards Charles the First) painted at Madrid in 1623 by Velázquez contained in observations on the remarks of Sir Edmund Head, Bart. and William Stirling, Esq. M.A.*, Reading, 1848. The painting has since been lost sight of.

62.
See Francisco de Quevedo y Villegas, "Grandes anales de quince días (1621)", *Obras completas, Obras en prosa*, ed. Luis Astrana Marín, Madrid, 1932, p. 476.

63.
The document is not at the archive of the ducal house of Granada de Ega-Zaráuz as stated in *Varia velazqueña*, vol. II, p. 224, but at The Metropolitan Museum of Art, New York. See cat. nos. **29** and **30**.

64.
The similarity of mien and countenance between *Philip IV in Parade Armour* and the portrait of the same young King in half armour included in Maino's *The Recapture of Bahia* of 1635 (Prado) is accented by the brisk and lively rhythm which pervades both portraits. It is likely that *Philip IV in Parade Armour*, or another version of it, was sent to Flanders. Gaspar de Crayer (1584–1669), a Fleming who never was in Spain nor saw Philip IV in person, made a dull copy of the figure of the King in an awkward composition, showing Philip IV, without leg armour, standing on a platform with a dwarf carrying the royal helmet, and a page holding a horse down below; the perspective setting of the latter group is particularly maladroit (Madrid, Palacio de Viana).
In 1639, Crayer painted a portrait of the Cardinal Infante Don Fernando, Governor of Flanders, who sent it to his brother Philip IV, at Madrid, without mentioning the name of the painter in either of the letters in which he referred to the completion of the portrait and to its shipment (the rather finical portrait, signed and dated, is at the Prado, no. 1472). The following year, after Rubens' death, Don Fernando had to concern himself with several paintings commissioned by Philip IV which the deceased master had left unfinished; he wrote to the King that at the moment there were available only two painters capable of finishing them, even though both were "very inferior to Rubens". One was the latter's "first assistant", who, Don Fernando pointed out, might possibly not perform as well on his own as he had done under Rubens' direction. The other was Crayer, who was held in "great esteem", particularly as a painter of "large figures"; he was the one who painted "the portrait of myself which I sent to Your Majesty last year", stated Don Fernando, adding that

he did not know whether there were in Spain other works by Crayer. For the full text of Don Fernando's references to Crayer, see Justi, *Diego Velázquez ...*, vol. II, Berlin, 1923, pp. 421–24.
The belief has been expressed that Crayer was the painter of *Philip IV in Parade Armour* at the Metropolitan Museum. Leaving aside plain stylistic considerations, it seems rather preposterous, literally speaking, to suggest that Maino, who had been close to Philip IV for sixteen years, would have used for his likeness in *The Recapture of Bahia* a portrait done by a painter who had never seen the sitter. See José López-Rey, "Maino y Velázquez: Dos retratos de Felipe IV en el Metropolitan Museum of Art", *Colóquio*, Lisbon, October 1963, pp. 15–19; "A portrait of Philip IV by Juan Bautista Maino", *The Art Bulletin*, New York, December 1963, pp. 361–3, and "Sobre la atribución de un retrato de Felipe IV a Gaspar de Crayer", *Archivo Español de Arte*, Madrid, 1966, pp. 195–6. For the attribution of *Philip IV in Parade Armour* to Gaspar de Crayer, see Matías Díaz Padrón, "Gaspar de Crayer, un pintor de retratos de los Austria", *Archivo Español de Arte*, Madrid, 1965, pp. 229–44, and Hans Vlieghe, *Gaspar de Crayer, sa vie et ses œuvres*, Brussels, 1972, vol. I, pp. 258–9.

65.
Six portraits of Philip IV painted by Velázquez in the 1620s, including two visible only by means of X-rays, have come down to us:
(i) The full-length hidden under a later portrait, at the Prado. Most probably the one finished on 30 August 1623 (plate **99**).
(ii) The bust portrait in black, Meadows Museum, Dallas, Painted after August 1623, and most probably before December 1624 (plate **89**).
(iii) The full-length at the Metropolitan Museum. Finished by 4 December 1624 (plate **91**).
(iv) The bust in armour, hidden under a later portrait, at the Prado (plate **102**).
(v) The full-length painted over (i) in 1626–1628, Prado Museum (plate **100**).
(vi) The bust in armour painted over (iv) in 1626–1628, Prado Museum (plate **103**).

66.
Diego Saavedra Fajardo, *República literaria* (first published posthumously in 1655), ed. Vicente García de Diego, Madrid, 1942, pp. 18–19, 21. The date of the definitive manuscript of this work has not been established with certainty. Saavedra Fajardo perhaps saw Bernini's *Apollo and Daphne* in the mid 1620s, a period when he visited Rome several times, which is where this sculpture was finished, or on the point of being finished (see Rudolf Wittkower, *Gian Lorenzo Bernini*, New York, 1955, pp. 183–4). He may also have seen it in 1633 during a later stay in Rome. As for the portrait of Philip IV which he may have had in mind, Velázquez did not paint any prior to 1623.

In the short biography of Velázquez written by Lázaro Díaz del Valle in 1656, a short time after the publication of Saavedra Fajardo's *República literaria*, the author states that the work by Velázquez which "aroused the greatest admiration" in him was a portrait of Philip IV which he saw, at an unspecified date, when the painter "had just completed it" *("acababa de hacer")*. The resemblance to the King was so striking that it seemed as if he only lacked the power of speech, as it embodied "so much soul within a living body" *("mucha alma en carne viva")*, to the extent that Díaz del Valle was overcome with respect for it and was led to "venerate and revere it", as he says in a passage reminiscent of the imaginary account by Saavedro Fajardo.
For the biography of Velázquez written by Díaz del Valle in 1656, and a slightly longer version containing a summary of the master's life to 1658, see: Instituto Diego Velázquez, *Velázquez: Biografías de los siglos XVII y XVIII…*, Madrid, 1960, pp. 24–8.
Francisco de Quevedo drew a vivid parallel between the figure of Christ on the Earth and that of the King in *Política de Dios, Gobierno de Cristo*, the first part of which was published in 1626 *(Obras en prosa*, pp. 302–447). Father Francisco de los Santos referred to the Spanish Kings from the Habsburg dynasty as "Vicegods on earth" *("Vicedioses en la tierra")* in a context which indicates that the expression was current at the time *(Descripción breve del monasterio de S. Lorenzo el Real del Escorial*, Madrid, 1657, fol. 166 r.).

67.
José López Navío, "Velázquez tasa los cuadros de su protector D. Juan de Fonseca", *Archivo Español de Arte*, January–March, 1961, pp. 53–84.

68.
Cf. fols. 2 r. and 56 r. [misnumbered 52].

69.
Cf. *Diálogos de la Pintura*, fol. 160 v. and 161 r., and Antonio Palomino, *El Museo Pictórico y escala óptica*, Madrid, 1947, pp. 161 and 853. Palomino's first reference corresponds to vol. I, first published in Madrid in 1715; the second, to vol. III, first published in 1724, also in Madrid.

70.
George Kubler has given an iconographic interpretation of the eight allegories of Painting, pointing out what they owe to traditional sources and what they have of original ("Vicence Carducho's allegories of Painting", *The Art Bulletin*, December 1965, pp. 439–45). The engravings corresponding to dialogues 1, 3 and 4 are signed by Francisco Fernández, who also signed the engraved title page and the endpiece, both of which have also value as allegories of Painting. Francisco López signed the plates corresponding to dialogues 2, 5, 6, 7, and 8.
In the article mentioned, Kubler has suggested that Carducho made the preparatory drawings – none of which has come down to us – for the allegorical engravings corresponding to each of the eight dialogues. It should be noted that the style of Fernández is more linear than that of López.
At the time of his death, Carducho had in his house the plates of the ten engravings for *Diálogos de la Pintura*, but no drawing for any of them was mentioned in the inventory drawn up then.
Kubler has convincingly identified the Francisco Fernández who signed half of the ten plates as the painter of the same name who, according to Palomino, was born in 1604 or 1605, studied under Vincencio Carducho, and died in Madrid about 1646. I should add that on 14 November 1638, shortly before his death, Carducho drafted a codicil in which he left "to Francisco Fernández a colour sketch of a St. James" by Carducho's hand.
As for Francisco López, Kubler has supposed that he too was a pupil of Vincencio Carducho. He has given López' birthdate as 1552, and that of his death as 1629. Actually, the Francisco López to whom Kubler refers was born in 1554 at Colmenar de Oreja; in 1581, he was active as a painter in Madrid, where he died, in fact, in 1629 (Cf. José Martí y Monsó, *Estudios histórico-artísticos relativos principalmente a Valladolid*, Valladolid 1901, p. 280; Cristóbal Pérez Pastor, *Noticias y documentos relativos a la historia y literatura españolas*, Madrid, 1914, pp. 26 and 34, y Conde de la Viñaza, *Adiciones al Diccionario histórico de los más ilustres profesores de las Bellas Artes en España de D. Juan Agustín Ceán Bermúdez*, Madrid, 1894, vol. II, p. 245). Consequently, he could hardly have been a pupil of Vincencio Carducho, born in 1570, and who arrived in Spain, with his brother Bartolomé in 1585. It is also unlikely that five of the plates for the *Diálogos,* whose title page bears the date 1633, would have been completed by 1629.

71.
Diálogos de la Pintura, fols. 52 r. and v. and 110 v. – 112 r.

72.
It is documented that Francisco Pacheco was a "resident" of Madrid by 20 October 1624; he refers to his being there in 1625, and to "those two years which I lived in Madrid", where on 8 August 1626 he signed a power of attorney to be sent to Seville. However, it has been generally held that Pacheco made at least two trips to Madrid during 1624–6 since a document, as published, placed him at Seville on 27 December 1624 (Universidad de Sevilla, Facultad de Filosofia y Letras, *Documentos para la Historia del Arte en Andalucía*, vol. VIII, ed. Antonio Muro Orejón, Seville, 1935, p. 67). Mr. Myron Davy, of High Point Anchorage, Lorton, Virginia, let me know in 1969 that there seemed to be an error in the transcription of the date of the mentioned document, preserved in the Archivo de Protocolos Notariales, Seville. I am indebted to the staff of this archive for having confirmed, at my request, that the transcription of the date was in error, since the document is plainly dated 23 December 1626.

There is no reference to any later stay of Pacheco in Madrid. Consequently, the two years that he spent there can reasonably be placed within the period 1624–6. For Pacheco's mention of Vincencio Carducho as his "intimo amigo", see *Arte de la Pintura*, vol. I, p. 149.

73.
Carducho begins by acknowledging that expressing one's ideas in the form of dialogues is no longer fashionable. Though he expounds his ideas with remarkable consistency, he shows now and then a desire to come to terms with the new tendencies, which however he fails to grasp. According to Sousa Viterbo, the manuscript of the Diálogos de la Pintura was in the Library of the National Archive at Lisbon (*Noticia de alguns pintores portuguezes, et de outros que, sendo estrangeiros, exerceram a sus arte em Portugal*, Lisbon, 1902, pp. 40–1). I have been unable to verify this information. If the manuscript were found, it might throw light on the process of composition of the *Diálogos,* possibly including corrections, additions and deletions. For Carducho's views referred to above, see *Diálogos,* fols. 29 v., 30 r. and v., 74 r., 77 v., 84 v., 90r., 109 r., 154 v. and *passim*.

74.
The available data on Nardi have been summarized by A.E. Pérez Sánchez, *Borgianni, Cavarozzi y Nardi en España*, Madrid, 1964, pp. 25–30.

75.
The cited documents state that the twelve *reales* daily allowance is equal to that of the King's barbers. As Cruzada wrote, only by taking this fact out of its historical context could one read in it any disparagement of either Velázquez or the painter's profession (*Anales de la vida y de las obras de Diego de Silva Velázquez*, Madrid, 1885, p. 45). A like instance concerning an Italian artist is that of Andrea Sacchi, who from 1637 to 1640 "was placed in Cardinal Antonio Barberini's household among three slaves, a gardener, a dwarf and an old nurse" (Francis Haskell, *Patrons and Painters*, London, 1963, p. 7). Like all others, administrative documents ought to be read within the context of usage. For instance, in 1950, both chairwomen and university professors in the United States of America were granted Social Security benefits at the same time and by the same law. Surely it would be a distortion of fact to see in it a disparagement of either group.

76.
J.J. Martín González, "Sobre las relaciones entre Nardi, Carducho y Velázquez", *Archivo Español de Arte*, Madrid, 1958, pp. 59–66, and José López-Rey, "Muerte de Villandrando y fortuna de Velázquez", *Arte Español*, Madrid, 1968–9, pp. 1–4.

77.
Arte de Pintura, vol. I, pp. 152–5.

78.
"*Mórbido*", as well as "*morbidez*", meant in art terminology a certain softness or smoothness achieved in the depiction of human flesh. See

Carducho, *Diálogos de la Pintura*, fol. 134 r;
Juan Interián de Ayala, *El pintor christiano y
erudito*, Madrid, 1733, vol. I, p. 429; Palomino,
Museo Pictórico y escala óptica, Madrid, 1947,
p. 1157 (first. ed. 1724), and Real Academia
Española, *Diccionario de la lengua castellana*,
Madrid, 1734, vol. IV, p. 605 and *Vicente
Poleró*, 1886, p. 276.

The lines concerning Velázquez occur in one of
the two incomplete drafts of the poem *El
pincel*, published as independent pieces by
Quevedo's nephew, Don Pedro Aldrete Queve-
do y Villegas (*Las tres musas últimas castellanas.
Segunda cumbre del Parnaso español de Don
Francisco de Quevedo y Villegas ...*, Madrid,
1670, pp. 196 and 201). Luis Astrana Marín
held that the two versions were written in 1629,
and published them in the form of a single
poem (*Obras completas de Don Francisco de
Quevedo y Villegas, Obras en verso*, Madrid,
1932, pp. 496–9). José Manuel Blecua has
published another incomplete version of *El
pincel*, which does not include the lines about
Velázquez, quoting the date assigned to the
poem by Astrana Marín, and borrowing, as
the latter did, some lines from another of the
known versions for the sake of completeness
(*Francisco de Quevedo, Obras completas. I.
Poesía original*. Barcelona, 1963, pp. CXX-CXXI
and 249–53). The matter deserves further study
from both a literary and a biographical point
of view. It should be noted that the one draft in
which the lines on Velázquez occur contains
also a praise of Pacheco's drawings for the *Libro
de retratos*. One of the drawings for this work,
begun in 1599 or earlier, and left unfinished by
Pacheco, represents Quevedo with his spect-
acles on, a wreath of laurel on his head, and
the red cross of Santiago on both his doublet
and his cloak. If this portrait was drawn from
life, which there is no compelling reason to
believe it was, Pacheco must have executed it
no later than 1624–26, when he was in Madrid
for the last time. In those years, in 1625 to be
precise, Pacheco signed the portrait of *An
unknown knight of Santiago*, whom he also
represented wearing spectacles (Lawrence Art
Museum, Williamstown, Massachusetts). It
may be that Velázquez originated the portrait
of Quevedo with the glasses on – which would
explain why Palomino called attention to this
detail – if he actually portrayed him. The
Master could have painted the portrait referred
to by Palomino in 1622, when he was first in
Madrid, or between 1623 and 1629, when he
left for Italy, or perhaps between his return in
1631 and 1639, when Quevedo was imprisoned
by order of the King far from Madrid, to
which he never returned.

As I have stated elsewhere, contrary to the
opinion held by most scholars, it is not certain
that any of the extant oil portraits of Quevedo
wearing spectacles was executed after the one
that, according to Palomino, Velázquez painted
(*Velázquez: a catalogue Raisonné of his Oeuvre*,
nos. 530–4).

79.
According to Pacheco, Velázquez sailed from
Barcelona on the day of St. Lawrence, that is,
on 10 August. Data concerning Velázquez' first
journey to Italy other than that provided by
Pacheco or collected in *Varia velazqueña* can
be found in Palomino, *El Museo pictórico*,
pp. 900–3; Antonio Rodríguez Villa, *Ambrosio
Spínola, primer Marqués de los Balbases*, Madrid,
1904, pp. 547–8, and Johannes A.F. Orbaan,
"Notes on art in Italy", *Apollo*, July 1927,
pp. 28–9.
80.
Ellis Waterhouse, *Italian Baroque Painting*,
London, 1962, p. 115.
81.
In his testimony concerning Velázquez'
qualifications for admission in the Order of
Santiago.
82.
Beruete, *Velázquez*, 1906, p. 38; Moreno villa,
Velázquez, 1920, p. 33, and Gerstenberg, *Diego
Velázquez*, 1957, p. 68.
83.
Pedro Beroqui, *Ticiano en el Museo del Prado*,
2nd ed., Madrid, 1946, p. 139.
84.
Francisco de los Santos, *Descripción breve del
Monasterio de S. Lorenzo el Real de El Escorial*,
Madrid, 1657, fols. 80 r.–81 r.
85.
Gerstenberg, *Diego Velázquez*, pp. 217–19.
86.
F.J. Sánchez-Cantón, "La Librería de
Velázquez", *Homenaje a Don Ramón Menéndez
Pidal*, Madrid, 1925, vol. III, pp. 379–406.
87.
Aureliano de Beruete, *Velázquez*, London, n.d.
[1906], p. 35.
88.
José López-Rey, "Pincelada e imagen en
Velázquez", *Varia velazqueña*, Madrid, 1960,
vol. I, pp. 200–6.
89.
R.A.M. Stevenson, *Velázquez*, London, 1962,
pp. 110–11. The first edition of this lively and
perceptive book appeared in 1895. For my views
on it, see "A great Velázquez critic revived",
Apollo, London, September, 1962, pp. 558–60.
90.
Velázquez, p. 39.
91.
Velázquez is only known to have signed three
other paintings, in addition to the two men-
tioned portraits of Philip IV, after his appoint-
ment as Court painter; all those three are also
portraits, and two of them were of momentous
importance to him: the lost *Philip III and the
expulsion of the "Moriscos"*, painted in the
crucial competition of 1627, he signed in Latin,
and the portrait of *Innocent X*, painted in 1650,
carries a dedication in Italian, signed by the
artist as painter to His Catholic Majesty. The
other signature has come down to us in a
fragment of a picture: the hand of an eccle-
siastic holding a paper with the following

inscription: *Ill^{mo} Señor – Diego Velázquez*
(no. 56).
92.
On the Buen Retiro Palace, see Elías Tormo,
"Velázquez, el Salón de los Reinos del Buen
Retiro y el poeta del palacio y del pintor",
*Pintura, escultura y arquitectura en España,
Estudios dispersos*, Madrid, 1949, pp. 127–246;
María Luisa Caturla, *Pinturas, frondas y
fuentes del Buen Retiro*, Madrid, 1947; *Un pintor
gallego en la Corte de Felipe IV: Antonio Puga*,
Santiago de Compostela, 1952, pp. 10–13, and
"Cartas de pago de los doce cuadros de batallas
para el Salón de Reinos del Buen Retiro",
Archivo Español de Arte, 1960, pp. 333–55; and
Bottineau, "Felipe V y el Buen Retiro", *Archivo
Español de Arte*, 1958, pp. 117–23. No account
of the Palace's early decoration nor of corres-
ponding payments has been published.
93.
In the minutes of a meeting of the *Cortes del
Reino* held in Madrid on 9 September 1633, it is
stated that Velázquez, appearing as a petitioner,
is "*pintor de Cámara de Su Magestad y de el
Señor Conde Duque*".
94.
Pedro Beroqui, *El Museo del Prado*, Madrid,
n.d. (1933), vol. I, pp. 27–9.
95.
Loc. cit.
96.
Sorano listed twelve subjects, with no
indication of the painters who had painted
them. However, according to documents
published by María Luisa Caturla (*Archivo
Español de Arte*, vol. 33, 1960, pp. 333–55), the
number of battle-pieces executed for the Great
Hall was thirteen. Only eleven of them have
come down to us; their measurements vary
within the following limits: height, from 2.9 m.
to 3.09 m.; width, from 3.11 m. to 3.81 m. All
are now at the Prado Museum; their painters,
subjects, and inventory numbers are as follows:
Velázquez, *The Surrender of Breda* (no. 1172);
Maino, *The Recapture of Bahía* (no. 885);
Zurbarán, *The Relief of Cadiz* (no. 656); Pereda,
The Relief of Genoa (no. 1317a); Jusepe
Leonardo, *The Surrender of Julich* and *The
Taking of Brisach* (nos. 858 and 859); Caxés
(with help of Antonio Puga), *The Recapture of
San Juan de Puerto Rico* and finished by Luis
Fernández (no. 653); Félix Castelo *The Recap-
ture of the Island of Saint Christopher*, (no. 654);
Vincencio Carducho, *The Victory of Fleurs,
The Relief of Constanza*, and *The Storming of
Rheinfelden* (nos. 635, 636 and 637).
It is documented that Zurbarán received
payment for the extant picture of *The Relief of
Cadiz* and for another of the same subject
executed by him at the same time and for the
same destination, which has not come down to
us. M.L. Caturla holds that Zurbarán's lost
The relief of Cadiz was mistitled by Sorano,
who thought that it represented *The Dislodging
of the Dutch from the Island of Saint Martin by
the Marquess of Cardereyta* – an error that

would have arisen from the fact that Cardereyta had also played an important role in the naval action fought off Cadiz in 1625. A painting depicting the *Marquis of Cardereyta with the Spanish Armada*, with dimensions corresponding to those in this series, was listed, with no artist's name, at the Buen Retiro palace in 1701. It has since been lost. If indeed Zurbarán did paint two pictures of *The Relief of Cadiz*, it is probable that only one was hung in the *Salón*, where Sorano recorded it as one of the twelve battle scenes.

Another Spanish military victory, *The Rescue of Valenza del Pó in 1635* was painted by Juan de la Corte for another chamber in the Buen Retiro Palace some time later. According to the royal inventory of 1701, the head of the victorious general, Don Carlos Coloma, was painted by Velázquez. The picture disappeared from the Madrid Palace at the time of Napoleon's invasion of Spain (1808–14); its present whereabouts is unknown.

97.
Diego de Covarruvias i Leyva, *Elogios al Palacio Real de Buen Retiro escritos por algunos ingenios de España. Recogidos por ...*, Madrid, 1635, fol. D2. The sonnet about the portrait of Baltasar Carlos is by Don José Pellicer de Tovar, and the one on the portrait of Philip IV by Dr. Felipe Godínez; they read as follows:

Esse Mayor que todo el edificio
Magnifico Salon, Theatro grave
A donde aun el silencio apenas cave
Por ser siempre menor que su artificio
Esse que dá esculpido tanto indicio
De quanto Españo de su Reynos sabe,
Y sin que el ocio su materia acabe
Lisonja Real embuelta en beneficio
Esse exemplo eloquente, estudio mudo
Purpureo Baltasar, que os ha labrado
Varon Heroyco en nunca estilo rudo.

Esse pues, consultad, que alli enseñado
En vivas lenguas de uno y otro Escudo
Quedareis a mas glorias empeñado.

Felipe, El que con tantos atenciones
Tu nombre copia, o su grandeza imita,
No se si te dá gloria, o te la quita,
Tu mismo a ti parece que te opones.
A sido equivocar admiraciones
Que la pintura en la verdad compita,
La fè que erige templos, solicita
Cultos a la Deidad, no emulaciones.
Mas si inspirando tu, que se construya
A tu nombre esta fabrica; en presencia
De tanta Magestad luzio la suya.

Esse es tambien obsequio de la sciencia
Pues osó competir, porque era suya
La gloria de su misma competencia.

A new limited edition of this collection of poems was issued in Valencia in 1949.

98.
The titles of four of the poems mention both Maino's name and the subject of his painting.
99.
See, for instance, *Elogios al Palacio del Buen Retiro*, fols. A2, C2, E (poems by Luis Vélez de Guevara, "Arminda", and Juan de Paredes).
100.
The entry in the inventory reads: "*El Principe Nro. Sr. A cavallo, en bosquejo*". Pacheco makes it clear that *bosquejo*, or *metido de colores*, is always in paint; though he is aware that some painters use only black and white, or reddish and white pigments, his advice is to employ a full range of colours, especially for the heads and flesh of human figures sketched from life (*Arte de la Pintura*, vol. II, pp. 78, 127–8). There were also in Velázquez' studio three unfinished large canvases, representing respectively a white, a chestnut, and a grey horse, without any human figure; it is likely that they were by the artist himself, though it is possible that some of them were among the four canvases of similar subject and size inventoried at the Royal Palace as early as 1600.
101.
Pacheco, *Arte de la Pintura*, vol. I, p. 419; vol. II, p. 133.
102.
Velázquez, pp. 79–81.
103.
Pacheco, *Arte de la Pintura*, vol. I, p. 153.
104.
F. Saxl, "Velázquez and Philip IV", *Lectures*, vol. I, London, 1957, p. 314.
105.
Lettere, Paris, 1609, vol. V, fol. 53 v., and José López-Rey, "Idea de la imitación barroca", *Hispanic Review*, vol. XI, July 1943, pp. 253–7.
106.
Baltasar Gracián, *El político* (Madrid, 1961, pp. 39 and 55).
107.
Anales de la vida y de las obras de ... Velázquez, 1885, p. 118.
108.
For accounts of the surrender of Breda published before Velázquez painted this subject, see Saxl, "Velázquez and Philip IV", *Lectures*, vol. I, pp. 315–18, and Marqués de Lozoya, *La Rendición de Breda*, Barcelona, 1953, pp. 8, 14–19. Saxl stated that he had "not read in any account that Justinus delivered up the keys" (*op. cit.*, p. 317). Nor have I, not even in the passage, cited by Lozoya, in which Gonzalo de Céspedes y Meneses, after describing the surrender, mentions that Don Fernando de Guzmán was sent with the news to Madrid (*Historia de Don Felipe III, Rey de las Españas*, Barcelona, 1634, p. 226).
109.
G. Barry, *The Siege of Breda*, Louvain, 1627, p. 145, and Herman Hugo, *The Siege of Breda* (translated from the Latin), [Brussels?], 1627, pp. 140–2. The Latin edition, *Obsidio Bredana*, had been published in Antwerp in 1626. A Spanish translation, *Sitio de Breda* was also

published there in 1627. Father Hugo was Spinola's confessor. His account of the siege includes 14 illustrative engravings and is based on first-hand document information. For the terms of the capitulation, dated 2 June 1625, see pp. 129–38; for Philip IV's letter suggesting it would be better to end the siege, p. 142, and for Pope Urban VIII's letters of congratulation to the Infanta Isabel Clara Eugenia and to Spinola, see pp. 150–52.
110.
Angel González Palencia (ed), *Noticias de Madrid, 1621–27*. Madrid, 1942, p. 120.
111.
Shirley B. Whitaker has convincingly shown that Calderón's play was performed at Court for the first time in November 1625 ("The first performance of Calderón's *El sitio de Breda*", *Renaissance Quarterly*, winter 1978, pp. 515–531).
112.
Two of the outstanding elements in the composition of *The Surrender of Breda*, the lances and the group of Spínola and Nassau, have lured some writers into a search for works by other artists which might have influenced Velázquez'. José Ortega y Gasset crisply commented on the *naíveté* of a method which results in regarding any picture executed before April 1635 whose composition includes soldiers holding their lances up – or for that matter, a group of two men embracing or bending to each other – as a source for *The Surrender of Breda (Papeles sobre Velázquez y Goya*, Madrid, 1950, pp. 74–5). However, the number of works supposed to have influenced the composition of this masterpiece keeps growing at random and *ad nauseam*; those most frequently or most recently suggested are the following: Bernard Salomon's smallish woodcut representing *Melchizedek presenting Abraham with bread and wine*, which illustrates Claude Perrin's *Quadrines historiques de la Bible*, Lyon, 1553; an illustration to *Concordia* found in some editions of Alciati's *Emblemata* brought out by Christian Wechsel between 1534 and 1545; a drawing dated 1565 by Jan van der Straet (Stradanus) which is an allegory of Philip II's role as mediator of the treaty of Cateau-Cambrésis (Ashmolean Museum); Martin de Vos's illustration of *Melchizedek presenting Abraham with bread and wine* in the *Thesaurus sacrarum historiarum* of Gérard de Jode, Anvers, 1579; Antonio Tempesta's frontispiece for *Batavarum cum Romanis bellum* of Otho Vaenius, 1612; three paintings by Rubens *Melchizedek presenting Abraham with bread and wine, Reconciliation between Henry III and Henry of Navarre*, and *The Cardinal Don Fernando and the King of Hungary after the battle of Nördlingen*; El Greco's *Despoiling of Jesus* and *Martyrdom of St. Maurice*; Veronese's *Susanna and the Elders* and *Jesus and the centurion*; Dürer's *Large horse*, and Christopher Jobst's tapestry cartoon of 1615, *The Surrender of Hersfeldt* (Kassel, Archiv). It is rather unlikely that Velázquez was acquainted with some of the works supposed to have

influenced his compos-ition of *The Surrender of Breda*. For instance, both Rubens' *The Cardinal Infante Don Fernando and the King of Hungary after the battle of Nördlingen* and Velázquez' *The Surrender of Breda* were shown publicly for the first time in April 1635, one in Antwerp and the other in Madrid.

The same sort of catch-as-catch-can effort has, of course, been applied to other masterpieces, including Velázquez' *The Fable of Arachne (The Weavers)* and *Velázquez and the royal family (Las Meninas)*.

113.
Velázquez had certainly departed from the traditional ways of composition and execution still being taught in the 1630s. As Carducho explained it, the master ought to begin by making preparatory drawings, which he should then use for the final composition; this was to be squared and transferred to the canvas by either the master himself or an assistant. Either of them must then brush in the colour though only the master could give the final and decisive touches (*Diálogos de la Pintura*, fol. 133 r.).

114.
The original phrase in Latin "insigni canitie venerabilem" was translated as "venerable old gentleman" in the English edition of *Obsidio Bredana* (p. 141) and word for word in the Spanish edition as "venerable por sus canas" (venerable on account of his white hair) (p. 123). Both editions were published in 1627. (See page 174, no. 109).

115.
The Rijksmuseum has another portrait of a man with white hair and balding, by Jan Anthonisz Ravensteyn; the sitter is presumed to be Justin de Nassau, although this is not certain.

116.
As Saxl suggested ("Velázquez and Philip IV", *Lectures*, vol. I, p. 316), it is very likely that Velázquez knew the extraordinarily large en-graving (more than one metre high) depicting the siege and surrender of Breda which Jacques Callot made in 1628 by commission of the Infanta Isabel Clara Eugenia, Governor of the Netherlands. He doubtless had also seen the engravings, some with details of the siege, which illustrate Herman Hugo's *The Siege of Breda*, which had been available in Latin, Spanish, and other languages since 1626–27.

117.
See José López-Rey, "An unpublished Zurbarán: The Surrender of Seville", *Apollo*, London, July 1965, pp. 23–5.

118.
Discursos practicables, p. 115. For data on Jusepe Leonardo, see María A. Mazón de la Torre, "La partida de bautismo de Jusepe Leonardo" and "En torno a Jusepe Leonardo", *Archivo Español de Arte*, 1969, pp. 59–62, and 1975, pp. 266–70 and *Jusepe Leonardo y su tiempo*, Saragossa, 1977. In the light of Jusepe Leonardo's docu-mented paintings, including *The Taking of Breisach* mentioned in note 119 below, it is groundless to regard him as a "disciple" of

Velázquez, as was done by Martin S. Soria ("José Leonardo, Velázquez' best disciple", *The Art Quarterly*, 1950, pp. 267–80).

119.
In *The Taking of Breisach* (Prado No. 859), also painted for the Grand Salon of the Buen Retiro, he clumsily imitated the horse in the equestrian portrait of Olivares by Velázquez at the Prado Museum, and in *The Surrender of Jülich* he plainly imitated one of the horses in Rubens' *Riding school*, of 1608, now at the Berlin Museum (Olle Cederlof, "Kallorna till 'Las Lanzas'", *Konsthistorisk tidskrift*, vol. 26, 1957, pp. 43–62).

120.
What little is known on the rebuilding of the Torre de la Parada has been summarized by Pedro de Beroqui, *El Museo del Prado*, Madrid, 1933, vol. I, pp. 29–30, and by Svetlana Alpers, *The decoration of the Torre de la Parada* (part IX of *Corpus Rubenianum Ludwig Burchard*), London, 1971, pp. 25–9. The latter book fully discusses Rubens' commission for the Torre de la Parada; it also throws light on the overall decoration of the hunting lodge.

121.
It is said that there are extant, in private hands, some seventeenth-century pictures depicting the interior of the Torre de la Parada with paintings on the walls. Yet, as far as I know, such pictures, if they do exist, have never been exhibited or reproduced.

122.
José Ortega y Gasset, *Papeles sobre Velázquez y Goya*, Madrid, 1950, p. 262.

123.
Philip IV became soon proud of the Prince's prowess as a hunter, according to a letter written by the Cardinal Infante Don Fernando on 6 April 1638, published by Justi (*Velázquez*, 1923, vol. II, pp. 418–9).

124.
Erwin Walter Palm has suggested that Velázquez' *Aesop, Menippus* and *Mars* were, as part of the decoration of the Torre de la Parada, conceptually related to Rubens' *Democritus, Heraclitus* and *Vulcan* ("Diego Velázquez: *Aesop and Menipp*", in *Lebende Antike, Symposium für Rudolf Sühnel*, ed. by H. Meller and H.J. Zimmermann, Berlin, 1967, pp. 207–17). As Svetlana Alpers has pointed out the suggestion is somewhat implausible since the paintings by Rubens did not hang in the same room as those by Velázquez (*op. cit.*, pp. 134–5). Curiously though, after Rubens' *Democritus* and *Heraclitus* and Velázquez' *Aesop* and *Menippus* were moved to the Prado Palace, the four were placed in the same room, with other paintings – which suggests that some sort of relation, conceptual or otherwise, was then discerned among, or forced upon, them. See the Prado inventory of 1747, fols. 4 and 49.
The attribution of *The Wedding of Peleus and Thetis* to Jan Reyn, still maintained in the 1972 Prado catalogue, "has no foundation" as Alpers has explained (*op. cit.*, p. 249).

125.
An interesting contrast is afforded by *Vulcan forging rays for Jupiter*, executed by Rubens for the Torre de la Parada (Prado, no. 1676). In this picture, almost identical in size with Velázquez' *Mars*, a shield and pieces of armour are also placed at the feet of the god, but their function is to scale his figure up to heroic proportions.

126.
Gerstenberg, *Diego Velázquez*, pp. 221–4.

127.
La Galeria del Cavalier Marino distinta in pitture e sculpture, Venice 1620, pp. 173–5.

128.
Svetlana Alpers has explained the error as a result of which Rubens' *Heraclitus* and *Democritus* (Prado, nos. 1680 and 1682) have for long been mixed up with another picture representing Democritus and Heraclitus together, on the same canvas, known to have been painted by Rubens in 1603 (*op. cit.*, p. 270).

129.
See F. Saxl, "Rembrandt and Classical Anti-quity", *Lectures*, vol. I, pp. 298–310.

130.
Cf. Jacinto Octavio Picón, *Vida y obras de Don Diego Velázquez*, p. 54, and José Moreno Villa, *Velázquez*, Madrid, 1920, p. 62.

131.
La Galeria ..., passim.

132.
José Moreno Villa published many documents bearing on the matter (*Locos, enanos, negros y niños palaciegos*, Mexico, 1939).

133.
For a general discussion of the subject, see E. Tietze-Conrat, *Dwarfs and Jesters in Art*, New York, 1957. The following picaresque novels throw much light on the matter: Mateo Alemán, *Guzmán de Alfarache* (1959) and *La vida de Estebanillo González, hombre de buen humor*, written anonymously by a buffoon, who apparently had been on the service of the Cardinal Infante Don Fernando in Flanders in 1639–41 (first published in 1646).

134.
Henry S. Francis, "Velázquez: Portrait of the jester Calabazas", *The Bulletin of the Cleveland Museum of Art*, November, 1965, pp. 117–23.

135.
Samuel Gil y Gaya's edition, Madrid, 1965, II, p. 14. On the words *rehilandera, rehilete*, etc., see J. Corominas, *Diccionario crítico y etimológico de la lengua castellana*, Madrid, 1954, III, under *rehilar*.

136.
Of Pedro Antonio Vidal we know rather little. On 31 July 1616 Philip III designated him for a position of Court painter, left vacant by the death of Pedro Guzmán, but the king cancelled the appointment for reasons of economy. (J.J. Martín González, *Archivo Español de Arte*, Madrid, 1958, p. 130); he was still active in 1617, and his portrait of Philip III, now at the Prado

(no. 1950) was ascribed to him in the 1636 inventory of the Madrid Alcázar.

137.
The painting has substantially deteriorated during the last twenty years; the background, originally of luminous grey hues, has changed to a foul ochre. See cat. no. **82.**

138.
For a full discussion of the provenance and condition of these two paintings, see cat. nos. **103** and **104.**

139.
La Lira de las Musas, in Obras de Don Gabriel Bocángel y Unzueta, ed. by Rafael Benítez Claros, Madrid, 1946, vol. I, pp. 251–2.

140.
Cf. Justi, Diego Velázquez (third ed.), II, pp. 82–3; Beruete, Velázquez, pp. 73–4, and Trapier, Velázquez, pp. 224–7.

141.
Charles de Tolnay, "Velázquez' 'Las Hilanderas' and 'Las Meninas'", Gazette des Beaux-Arts, vol. 35, January 1949, pp. 21–38.

142.
For the documents concerning this portrait of Philip IV, see Aureliano de Beruete, El Velázquez de Parma, Madrid, 1911.

143.
Jusepe Martínez, Discursos practicables del Arte de la Pintura, p. 132.

144.
José López-Rey, "A Head of Philip IV by Velázquez in a Rubens Allegorical Composition", Gazette des Beaux-Arts, vol. 53, January 1959, pp. 35–44.

145.
Beruete, El Velázquez de Parma, Madrid, 1911.

146.
Diálogos de la Pintura, fol. 58 r. and v.

147.
In a letter to Fantin-Latour (see E. Moreau-Nélaton, Manet raconté par lui-même, Paris, 1926, vol. I, pp. 71–72). Manet's expression, "le peintre des peintres", can be translated as either "the painter of painters" – meaning the first among them – or the "painters' painter" – meaning the one to be truly appreciated by painters. Manet may have meant both connotations; yet, if one reads his full sentence in the light of what immediately precedes it, the meaning "first among painters" seems to be stressed: "Que je vous regrette ici, et quelle joie c'eût été pour vous de voir Velázquez, qui, à lui tout seul, vaut le voyage. Les peintres de toutes les écoles, qui l'entourent au Musée de Madrid et qui y sont très bien représentés, semblent tous des chiqueurs. C'est le peintre des peintres".

148.
These paintings are now at the Prado Museum, most of them kept in storage. As Marcel Röthlisberger has noted, several points concerning them are in need of further research (Claude Lorrain, New Haven, 1961, I, p. 155).

149.
See José Moreno Villa, Velázquez, Madrid, 1920, pp. 65–6; Diego Angulo Iñiguez,

Velázquez: Cómo compuso sus principales cuadros, Madrid, 1947, pp. 63–75; Trapier, Velázquez, pp. 241–5.

150.
Velázquez, pp. 108–12.

151.
Ibid.

152.
See cat. no. **107.**

153.
It is perhaps not irrelevant to mention that a seventeenth-century Spanish actress created a scandal when it became known that she used black taffeta sheets on her bed. (Felipe Picatoste, Estudios sobre la grandeza y decadencia de España, vol. III, El siglo XVII, Madrid, 1887, p. 121).

154.
See Giambattista Marino, Epitalami, Venice, 1646.

155.
See cat. no. **108.**

156.
Diego Angulo Iñiguez, "Las Hilanderas", Archivo Español de Arte, Madrid, 1948, pp. 1–19, and María Luisa Caturla, "El coleccionista madrileño don Pedro de Arce que poseyó 'Las Hilanderas' de Velázquez", Archivo Español de Arte, 1948, pp. 292–304.

157.
Venus at her mirror was in the Marquis of Carpio collection at Madrid by 1 June 1651 before Velázquez' return from Italy. In her cited article, written before the just mentioned fact became known, María Luisa Caturla held that since The Fable of Arachne was not included in an inventory of the Arce collection compiled in 1657, Velázquez must have painted it after this date, which would confirm the view of those who believed it to be the Master's "latest work". Caturla's argument does not hold for there is no indication that Velázquez painted The Fable of Arachne for Arce nor that the latter acquired it either from Velázquez or in Velázquez' lifetime. We only know that he acquired it sometime between 1657 and 1664, a period during which he also acquired other works by painters who were deceased such as Borgianni (1578–1616) and Jusepe de Ribera (1591–1652), according to data published by M. L. Caturla in her mentioned article.

158.
Velázquez made changes, of course, in the process of execution, and so did the unknown painter who enlarged the composition. A few of those changes have always been noticeable to the naked eye; others have recently been revealed by the use of X-rays or infra-red light. For instance, the Master painted out the full face of a woman which he had originally placed in the space between the sitting Arachne and the girl at her back. This discovery is due to Gonzalo Menéndez Pidal, co-author with Diego Angulo Iñiguez of 'Las Hilanderas' de Velázquez – Radiografías y fotografías en infrarrojo", Archivo Español de Arte, Madrid, 1965, pp. 1–12.

159.
This identification was first suggested by C. Lewis Hind, Days with Velázquez, London, 1906, pp. 139–140.

160.
Ibid., p. 140.

161.
R.A.M. Stevenson, Velázquez, London, 1962, p. 128 (first ed., 1895, p. 85).

162.
Velázquez, p. 114.

163.
Angulo Iñiguez, art. cit. and "Las Hilanderas: Sobre la iconografía de Aracne", Archivo Español de Arte, 1952, pp. 67–84; Charles de Tolnay, "Velázquez" "Las Hilanderas" and "Las Meninas", Gazette des Beaux-Arts, January, 1949, pp. 21–38; Gerstenberg, Diego Velázquez, pp. 232–239. Both the iconography and the composition of this masterpiece have understandably challenged the ingenuity of other writers of various persuasions, whose suggestions it would be pointless to record here.

164.
Tolnay, art. cit., p. 32.

165.
Pedro Sánchez de Viana, Anotaciones sobre los quinze libros de las Transformaciones de Ouidio. Con la Mithologia de las fabulas y otras cosas,, Valladolid, 1589, fol. 128v. The title page for the translation reads: Las Transformaciones de Ouidio: Traduzidas del verso Latino, en tercetos, y octauas rimas, Por el Licèciado Viana. En Lègua vulgar Castellana, Valladolid, 1589. The illustration corresponding to the fable of Arachne depicts the weaver turning from her work, which is being admired by two women, to speak with Pallas, disguised as a sort of hag; a spider's web is partly visible in the upper left, above Arachne's workshop (fol. 92 r.).

166.
Juan Pérez de Moya's book was first published in Madrid in 1585; several other editions were printed in the following decades. My reference is to Filosofía secreta, donde debaxo de historias fabulosas, se contiene mucha doctrina prouechosa a todos estudios, Alcalá de Henares, 1611, p. 502.

167.
Cf. Trapier, Velázquez, p. 350 and Karl M. Birkmeyer, "Realism and Realities in the Paintings of Velázquez". Gazette des Beaux-Arts, vol. 52. July–August 1958, pp. 63–80.

168.
Tolnay, 1949 art. cit.

169.
See August L. Mayer, "Ein unbekanntes Spätwerlk des Velázquez" Zeitschrift für bildende Kunst, vol. XXIV, 1912, pp. 40–41; Velázquez, Berlin, 1924, p. 176, and Velázquez: A Catalogue Raisonné of the Pictures and Drawings, London, 1936, no. 570. Velázquez' earlier "version of the 'Sibyl' motive" to which Mayer referred is no. 49 in the catalogue.

170.
William B. Jordan has titled the painting Sibyl with tabula rasa, borrowing the last two words,

translatable as blank tablet, from a Latin inscription in the end-piece to Carducho's *Diálogos de la Pintura*. He believes that Velázquez' painting represents a prophetess pointing to a blank tablet and uttering some truth as a result of inspiration – which he finds in harmony with the artistic philosophy expounded by Vincencio Carducho (*The Meadows Museum: A Visitor's Guide to the Collection*, Dallas, 1974, pp. 20–1 and 106, no. 21; figs. 5 and 6, and frontispiece). Carducho's end-piece is an allegorical engraving; it represents a brush, held by no one, which touches a blank tablet where it projects its shadow, the whole encircled by a laurel wreath. The engraving includes the mentioned Latin inscription and a quatrain in Spanish which epitomize Carducho's tenet that only the brush possessed of "sovereign science", that is, the painter both theoretic and practical, can bring potentially creative talent to the act of achievement.

171.
The legend goes back to Pliny the Elder. Vasari referred to it (*Le Vite ...*, ed. G. Milanesi, Florence, 1878, vol. I, p. 218), and so did Marino (*Dicerie sacre*, Milan, 1618, fol. 5 v.); Carducho (*Diálogos*, fol. 27 r.), Saavedra Fajardo (*República literaria*, 1942 ed., p. 19), and Pacheco (*Arte de la Pintura*, I, p. 31). For further references to the legend and to Murillo's depiction of it, see Al. Busuioceanu, "A re-discovered painting by Murillo: *El cuadro de las sombras*", *The Burlington Magazine*, 1940, pp. 55–9, and Robert Rosenblum, "The origin of Painting: A problem in iconography of Romantic classicism", *The Art Bulletin*, 1957, pp. 279–90.

172.
Angulo Iñiguez, 1965; Tolnay, 1949.

173.
Jusepe Martínez, *Diálogos practicables del Arte de la Pintura*, ed 1866 pp. 118–9.

174.
Gabriel Bocángel y Unzueta, *Piedra cándida con que en real y festiva máscara numera los felicíssimos años de la Serenissima, y Augustissima Señora Archiduquesa María Ana de Austria, Reina de las Españas, el Rey N.S. Don Felipe III*, Madrid, 1648, fol. 10 r. (Included in *Obras de Don Gabriel Bocángel y Unzueta*, ed. by R. Benítez Claros, Madrid, 1946, vol. II, p. 122).

175.
J.E. Varey, "Notas velazqueñas", *Archivo Español de Arte*, 1972, pp. 58–60.

176.
The power of attorney mentioned above by which Velázquez gave his wife the authority to deal with his affairs was published by Mercedes Agulló Cobo (*Noticias sobre pintores madrileños de los siglos XVI and XVII*, Granada, 1978, pp. 176–7). For this and the following references to Palomino's account of Velázquez' second Italian journey, see *El Museo Pictórico*, pp. 910–7.

177.
La carta del navegar pitoresco, Venice, 1660, pp. 56–8. According to a letter to Philip IV's chief Minister, Don Luis Méndez de Haro, written from Venice on 12 July 1653 by the Marquis de la Fuente, Velázquez had left with him at an unspecified date some notes about paintings which were available in Venice, one of them being "a *Glory* by Tintoretto" which Velázquez had seen at an unnamed dealer's "en Casa del formento". The Marquis had now learned that a dealer named Muti, who lived at "el Rio de San Casan" had a *Glory* by Tintoretto; he had been unable to see it, and wondered whether it could be the one mentioned in Velázquez' notes. The picture to which the Marquis referred as being in Venice in 1653 was between 2.92 and 3.34 m. in height, and about 5 m. in width (*"6 baras de largo y tres y media o cuatro de alto"*). Obviously, it could be neither the one at the Prado (no. 398, height 1.68 m.; width 5.44 m.) nor the one at the Louvre (no. 1496, height 1.43 m.; width 3.62 m.). It may be that Velázquez, after leaving his notes with the Marquis de la Fuente, bought in 1651, as Boschini says, *The Paradise*, or *Glory*, by Tintoretto now at the Prado. Surely, nothing said in the Marquis de la Fuente's letter warrants the conclusion that the *Glory* by Tintoretto seen years earlier by Velázquez at Venice was still there in 1653. Since not even the catalogue of the Prado Museum has mentioned it, I should point out that *The Paradise* by Tintoretto now there was inventoried in 1700 at the Madrid Royal Palace, under no. 553, as "damaged".

178.
The dispatch of Count Fulvio Testi is reproduced in *Varia velazqueña* (II, p. 246) though with many misprints. It was first published by Gustavo Frizzoni, who reproduced it in full ("Intorno al secondo viaggio del Velázquez in Italia", *Rassegna d'Arte*, vol. XVII, pp. 106–16). For Sir Arthur Hopton's views on Velázquez, "a man of great judgement" on artistic matters, see Enriqueta Harris, "Velázquez and Charles I", *Journal of the Warburg and Courtauld Institutes*, vol. XXX, 1967 (actually published in 1968), pp. 414–20. For the text of the Cardinal Infante's remark, see Justi, *Diego Velázquez ...*, vol. II, Berlin, 1923, p. 421.

179.
Cardinal Alonso de la Cueva had been for many years in Flanders on the service of Philip III and Philip IV, first at the elbow of Archduke Arbert and, after his death, as a sort of untitled chief minister to the Archduchess, the Infanta Isabel Clara Eugenia. After the surrender of Breda, he said there the first mass of thanksgiving for the victory in the presence of the Infanta and her Court. The Cardinal, who aroused hatred wherever he exercised political power, had finally to be removed from Flanders by Philip IV.
The thought occurs that Velázquez' depiction of *The Surrender of Breda* – a painting which the Cardinal very likely had seen at Madrid – might have hurt the latter's feelings about the actual event, and led to his acid remarks about "a certain Velázquez, Usher of the King's Chamber", who is not even referred to as a painter.

180.
Palomino mentions Antonio instead of Francesco Barberini. However, according to Francis Haskell, Antonio Barberini "did not return from France until 1653, long after the departure of Velázquez, and Palomino must be confusing Antonio with Francesco" (*Patrons and Painters*, London, 1963, p. 60, n. 5). In the same footnote, Haskell misquotes Palomino as saying that "when in Rome Velázquez painted a portrait of Cardinal Antonio Barberini". Palomino simply says that Cardinal Antonio Barberini was among those who honoured the painter with their courtesies, and makes no allusion to any portrait in that context (*Museo pictórico*, p. 912). Velázquez had painted a portrait of Cardinal Francesco Barberini at Madrid in 1626; it is now lost or unidentified. See note 54 above.

181.
Trapier, *Velázquez, 1948*, p. 298.

182.
Palomino, *El Museo Pictórico*, pp. 999–1002. Juan de Alfaro was born on 16 March 1643 at Cordoba, and died on 7 December 1680 at Madrid. I owe this information to Don José Valverde Madrid, who has discovered several documents bearing on Alfaro, some of which he has summarized in an article published in the newspaper *Informaciones*, Cordoba, 4 November 1965.

183.
Palomino, *El Museo Pictórico*, p. 913.

184.
See: Domingo Martínez de la Peña y González, "El segundo viaje de Velázquez a Italia: Dos cartas inéditas, en los archivos del Vaticano" *Archivo Español de Arte*, 1971, pp. 1–7. The two letters, transcribed in extenso, are from the Count of Oñate to Cardinal Giovanni Giacomo Panzirolo, at Rome.

185.
The date of this letter is 25 rather than 21 June 1650 as published by Enriqueta Harris in her valuable article "La misión de Velázquez en Italia", *Archivo Español de Arte*, 1960, pp. 129–36, and as reproduced in *Varia velazqueña*, vol. II, p. 270. I owe the rectification to Doña Carmen Caamaño, of the Archivo Histórico Nacional, Madrid.

186.
Archivo Histórico Nacional, Madrid (Osuna, Legajo 1883–1920). I am indebted to Doña Carmen Caamaño for the knowledge of this letter, not included in either the cited article by Harris nor in *Varia velazqueña*.

187.
Letter of 27 June 1651 from the Secretary of State, Don Fernando Ruiz de Contreras, to the Duke of Infantado, Spanish Ambassador in Rome (Archivo Histórico Nacional, Madrid, Osuna, Legajo 1883–20 tri.). Not included in the above cited article by Harris nor in *Varia*

velazqueña. I owe the knowledge of this letter to Doña Carmen Caamaño.

188.
The portrait was cleaned and restored in 1971; a resin varnish altering the original colour scheme was then removed. See cat. no. 112.

189.
Velázquez, p. 70.

190.
Francisco Iñiguez Almech, "La Casa del Tesoro, Velázquez y las obras reales", *Varia velazqueña*, I, pp. 649–82.

191.
Díaz del Valle's text is included in F.J. Sánchez Cantón, *Fuentes literarias para la historia del arte español*, Madrid, 1933, II, p. 372. For other data on Burgos Mantilla, see his testimony concerning Velázquez' qualifications for admission in the Order of Santiago, given on 24 December 1658.

192.
Oil on canvas; height 0.295 m. width 0.585 m. Acquired in 1972 by the Museum of Yale University.

193.
El Museo Pictórico, pp. 867–88, 984, 999–1004, and 1046–7. See also José Crisanto López Jiménez, "Don Nicolás de Villacis Arias, dicípulo de Velázquez", *Boletín del Seminario de estudios de Arte y arqueología*, Valladolid, 1964, pp. 195–210.

194.
On Pareja, see Palomino, *op. cit.*, and Juan Antonio Gaya Nuño, "Revisiones sexcentistas: Juan de Pareja", *Archivo Español de Arte*, 1957, pp. 217–85.

195.
As recorded by Lázaro Díez del Valle (see Sánchez Cantón, *op. cit.*, II, pp. 334 and 339).

196.
See cat. no. 98.

197.
This is most probably the portrait of Queen Isabel which, together with one of Philip IV and another of Prince Baltasar Carlos, was sent sometime between November and December 1639 to the Queen of England (Enriqueta Harris, "Velázquez and Charles I", *Journal of the Warburg and Courtauld Institutes*, London, 1967, pp. 414–20). None of the three portraits now at Hampton Court is by Velázquez, but from his workshop.

198.
However, in the profile painted by Carducho, the eye, linearly defined, is not Velázquez-like. The head of the bearded old man in Carducho's work is also sharply drawn, but otherwise it recalls two paintings attributed to Velázquez, datable to 1619–20: the half-length *Saint Paul*, at the Museo de Arte de Cataluña, Barcelona, and a similar head, unfortunately rubbed and darkened, in the Countess of Saltes' collection, Madrid, nos. 14 and 15.

199.
Distribución de los premios concedidos por el Rey N.S. a los discípulos de las tres nobles artes hecha por la Real Academia de S. Fernando en la junta general de 28 de Agosto de 1760, Madrid, p. 18. The young painter's name was Ginés de Aguirre (1727–1800); among his extant works there is a copy of Velázquez' painting, entitled *Count-Duke of Olivares, Equestrian* at the City Hall of Yecla (on loan from the Prado Museum).

200.
Justi, *Diego Velázquez*, 1923, II, p. 279; Beruete, *Velázquez*, p. 103, and Trapier, *Velázquez*, p. 324.

201.
See Francisco de los Santos, *Descripción breve del Monasterio de S. Lorenzo el Real del Escorial*, Madrid, 1657, fols. 155 ff. For Philip's sentiments, see his letters of 25 March and 20 April 1654 (*Cartas de la venerable Madre Sor María de Agreda y del Señor Rey Don Felipe IV*, ed. by Francisco Silvela, Madrid, 1888, vol. II, pp. 289–90, and 293–4).

202.
Francisco Iñiguez Almech, "La Casa del Tesoro, Velázquez y las obras reales", *Varia velazqueña*, I, pp. 649–82. It is now at the Prado Museum, catalogued as "Domitia Lucilla (?)"; its height is 0.62 m. See A. Blanco, *Museo del Prado, Catálogo de la escultura*, Madrid, 1957, p. 80, no. 114–E.

203.
Dr. Vladimir Kemenov has attempted to show, contrary to the unanimous opinion of other specialists, that a bust portrait of Philip IV listed in the Hermitage Museum catalogue as originating from Velázquez' workshop (L–R, 1963, no. 274), is a copy, executed at least partly by Velázquez himself after the London bust portrait, which was the master's original (*Velázquez in Soviet Museums*, Leningrad, 1977, pp. 106–127). To back up this theory, he finds similarities in the execution of both London and Hermitage portraits, which contrary to his intentions, would seem to confirm that neither is by Velázquez' hand. He also incorrectly quotes a biographical note dedicated to Velázquez written by his friend and admirer Lázaro Díaz del Valle for inclusion in an anthology of the lives of eminent painters which he compiled from 1656 to 1659.
According to Kemenov, Díaz del Valle wrote in 1656 that Velázquez was "just finishing" a portrait of Philip IV "so lifelike that it only lacked the power of speech". Kemenov concludes that this firstly supports "the idea that the London bust portrait was actually painted by Velázquez, and that it was painted in 1656, thus refuting my opinion that the bust portrait in the Prado is "the only existing portrait of the king undeniably painted by Velázquez after he returned from Italy in 1651" to state my own words precisely. Kemenov's statement is based on an incorrect interpretation of Díaz del Valle's text. The latter in fact refers to a portrait of Philip IV which he had seen, at an unspecified date, when Velázquez "had just finished it". It should be explained that Díaz del Valle finished his biography of Velázquez in the same way as he did those of other painters of his time, by stating that the artist whose biography he is compiling was alive at the time of writing, in this particular case, in 1656 (*"Vive este presente año de 1656"*) – a statement which even the most vivid imagination could not interpret as being applicable to any and all of Velázquez' works. For Díaz's text, see note 66 above.
Dr. Kemenov also claims that if Velázquez had not painted any other portrait of the King "in the five years following" the execution of the bust portrait in the Prado, it is unlikely that Philip IV *"would have tolerated such negligence on the part of his Court painter"* (italicised by Kemenov). This assumption supposes, without foundation, that Philip IV had a tyrannical or irascible character, and does not take account of the fact that he understood Velázquez' procrastinations perfectly. In fact, during his second stay in Italy, Velázquez delayed over a year in obeying the King's orders, which were repeated various times in 1650–1651, and entreated him to return promptly to Spain. However, a short time after this late return, Philip IV gave him the coveted position of chamberlain to the royal palace.

204.
Mazo died 9 February 1667. See the personal file of *Mazo, Juan Bautista* at the Archive of the Madrid Royal Palace. Most, though not all, the documents in this file, as well as others pertaining to Mazo, have been included in the documentary section of *Varia velazqueña*, Madrid, 1960, II, pp. 235–410. Many of them have been extracted or quoted in Juan Antonio Gaya Nuño's article, "Juan Bautista del Mazo, el gran discípulo de Velázquez", published in vol. I of the same publication (pp. 471–81), and in other articles written as a sequel to the third centenary of Velázquez' death.

205.
Discursos practicables del nobilísimo arte de la pintura, ed. Valentin Carderera, Madrid, 1866, p. 119.

206.
The text is included in F.J. Sánchez Cantón, *Fuentes literarias para la historia del arte español*, Madrid, 1933, II, p. 374.

207.
The Prado portrait, in which the Infanta Margarita, born in 1650, appears to be between fourteen and sixteen years old, could not have been painted before 1664, at least four years after Velázquez' death. In it, the features of the Infanta are markedly different from those in the portrait painted by Velázquez some time in 1659 (plates 51, 229). She, indeed, looks much the same as in another portrait, at the Vienna Museum, in which she is wearing a brooch with the imperial double eagle, the gift of her bridegroom, the Emperor Leopold, to whom she was betrothed in 1664 and whom she married two years later. This portrait is painted in a manner close to Mazo's, and I once

suggested that it was "most likely" that he had executed it (*Velázquez: A Catalogue Raisonné*, no. 410). However, a recent re-examination of its brushwork has convinced me that it was executed after Mazo's original by a less dexterous hand.

The Prado *Infanta* Margarita has for years been attributed to Velázquez in the Museum's catalogues, formerly with the contention that the sitter was really the older Infanta María Teresa, now "with the qualification that the Master left it unfinished and that, after his death, Mazo completed it, painting the "face, neck and hands", to quote from the 1972 edition (p. 738, no. 1192). The suggestion that Velázquez started the portrait by painting the background curtains and the sitter's dress is incredible. Surely, he was no itinerant portrait-painter.

Dr. Vladimir Kemenov has recently claimed, with the support of new but unconvincing arguments, that the full length portrait of the Infanta Margarita was executed by Velázquez, with the exception of the face, painted later by Mazo (*Velázquez in Soviet Museums*, Leningrad, 1977, pp. 129–72). His point of departure is a bust portrait of the Infanta Margarita in the Museum of Western and Oriental Art in Kiev, which he attributes to Velázquez (0.80 x 0.625 m.; L–R, 1963, no. 411). He considers that this was originally a three-quarters portrait, and rightly notes that it depicts the Infanta "in the same position and wearing the same costume as the full length portrait in the Prado". He also finds similarities in the execution of these portraits, although the "description of the head and face of the Infanta" are "incomparably superior" to the portrait in Kiev. He concludes that this portrait was certainly painted from life by Velázquez, around 1658, the time when he painted the full length portrait in the Prado. Kemenov therefore assumes that in 1659 Velázquez must have stopped work on the portrait in the Prado because he received an "urgent order" – for which no documentary information exists – "to paint another portrait of the Infanta, of very different conception, for the Viennese court", in which she wears a blue dress (no. 128). Kemenov goes on to state that when Velázquez stopped work on the full length portrait now in the Prado he had already effectively painted the Infanta's dress, handkerchief, bouquet of flowers, "the objects surrounding her", and also the accessories, including her "hair", but not her face.

According to him, the face, which Velázquez intended to transfer from the three-quarters portrait of the Infanta which he had painted "from life" (now in Kiev) "was either never drawn at all or had scarcely been started" when Velázquez stopped work on the Prado portrait in 1659. It remained unfinished at his death. Later, in 1662–1664, according to Kemenov, Mazo finished the portrait "completing the head and face" after the portrait now in Kiev. He may also have painted the background

curtains "in his own style".

In June 1965, the director of the Kiev Museum was good enough to take the portrait of the Infanta Margarita down from the wall, and allowed me to examine it in a good light. It was abraded in various places, and had obviously been restored, yet without revealing the "individual manner" of execution of Velázquez evidenced by Dr. Kemenov. (ed. note). Professor López-Rey could not have known the results of the laboratory analysis of this portrait of the Infanta Margarita of Austria in the Prado, considered by the majority of authors as Velázquez' last work, finished by Mazo. The study of the preparation and pigments used, especially in the dress and jewellery of the young princess, shows great similarity with the later works of Velázquez. Other areas, mainly the background, curtain and carpet, which are weaker, may suggest Mazo. The painting was enlarged at a later date. This is definitely the master's own work, finished in his workshop after his death (*Garrido Pérez*, 1992, pp. 602–11).

208.
See cat. no. **125.**

209.
Palomino, *El Museo Pictórico*, pp. 920–2.

210.
Cf. F.J. Sánchez Cantón, *Las meninas y sus personajes*, Barcelona, 1952, and Yves Bottineau, "L'Alcázar de Madrid et l'inventaire de 1686", *Bulletin Hispanique*, October–December, 1958, pp. 450–83. See also *Certificación de las alhajas que se hallan en el cuarto del Principe Tocantes a S.M. por muerte de Diego Velázquez …*, drawn up on 10 August 1660, and *Relación de las Pinturas que ay en el Obrador del Pintor de Cámara de Palacio oy 10 de Agosto de 1694"*, both in the Archive of the Madrid Royal Palace (the first is included in *Varia velazqueña*, II, pp. 388–9).

In his cited article, Bottineau has shown that Palomino's identification of the room depicted, by Velázquez as one in the *"cuarto del Príncipe"* is right, contrary to the views held by Francisco Iñiguez Almech in *Casas reales y jardines de Felipe II*, Madrid, 1952, pp. 97–8. The number and apparent dimensions of the pictures above and between the windows on the side wall of Velázquez' composition correspond with the data provided by the 1686 inventory about the paintings that decorated a like wall of the main chamber of the *"cuarto del Príncipe"*. As for the large paintings on the rear wall, *Pallas and Arachne* and *Apollo and Pan*, they also correspond in apparent size with the paintings of the same subjects which, according to the cited inventory, hung side by side in the same chamber. Both were by Mazo, the first after Rubens; the second, as we now know, copied after Jordaens' version of a work by Rubens. Justi, and others after him, held that the latter represented *Apollo and Marsyas* (*Velázquez*, II, p. 337). J.A. Emmens properly rectified this identification ("Les Menines de Vélasquez, miroir des princes pour Philip IV", *Nederlands*

Kunsthistorisch Jaarboek, vol. 12, 1961, pp. 51–79).

211.
William Stirling, *Velázquez and his works*, London, 1855, p. 173. Justi, *Diego Velázquez* (third ed.). Vol. II, p. 333. Justi suggested that Philip IV, as he and the Queen were sitting to Velázquez for a portrait, noticed the artistic quality of the lively chance group, and said "That is a painting!", whereupon Velázquez got busy to put on canvas the "instantaneous" scene. (ed. note).

212.
Velázquez, p. 117.

213.
Charles de Tolnay, who, following Justi, believed that one of the paintings represented *Apollo and Marsyas* rather than *Apollo and Pan*, concluded that the two mythological pictures placed in the background signified "that the talent of artistic creation is an expression of divine principle", and that they were meant as commentaries on the painting's main subject, "the dignity of the artist as creator" ("Velázquez' Las Hilanderas and Las Meninas", *Gazette des Beaux-Arts*, January 1949, pp. 21–8). George Kubler rather thinks that Velázquez may have intended "to suggest the equal rank of painting (Pallas and Arachne) with music (Apollo and Pan), in his contribution to the contemporary campaign to secure recognition of painting as a liberal art under Spanish taxation law" ("Three remarks on the Meninas", *The Art Bulletin*, June 1966, pp. 212–14). J.A. Emmens holds that the two mythological paintings signify the triumph of wisdom over pride, and that the mirror on the same wall is meant as the attribute of prudence with particular reference to the King; he sees other allegorical or emblematic meanings in the drink of water offered to the Infanta, in the dwarfs, the *meninas* and the courtiers – all of which Velázquez would have had in mind for the composition of this painting, conceived as an allegory of the *Mirror of Princes*, intended though for the Infanta Margarita and, exceptionally too, for both the King and the Queen (art. cit. in note 210 above). Other authors have written along lines similar to those just mentioned.

214.
Michel Foucault, *Les mots et les choses*, Paris, 1966, pp. 19–31.

215.
Cf. Pacheco, *Arte de la Pintura*, II, p. 207, and Benedetto Varchi, *Lezzione dalla maggioranza delle Arti* (1547) in *Trattati d'Arte del cinquecento*, ed. Paola Barocchi, Bari, 1960, vol. I, pp. 41–2. Varchi, arguing in favour of the superiority of Sculpture over Painting, says that in the latter the figures are only "apparent" like the images reflected in a mirror. Pacheco, who praises Painting by referring to the similarity of her images to those reflected in a mirror, does not mention Varchi's views on the matter, even though he repeatedly cites the latter's *Lezzione* elsewhere in *Arte de la Pintura*.

216.
Felix da Costa, a Portuguese painter (1639–1712), stated in his *Antiguidade da Pintura*, written before 1696, that Velázquez had painted "a picture which adorns a room of the palace at Madrid" in which he portrayed himself "in a cape bearing the cross of Santiago" with "his glance upon" the Infanta Margarita, whom the *meninas* are entertaining. The only painting of this subject listed in any of the Spanish royal inventories compiled in the seventeenth century or later is the one now at the Prado, in which Velázquez wears no cape and is not glancing at the Infanta. Nor do the X-rays indicate that any change concerning either point was made prior to the completion of the painting. In his above cited article (pp. 213–4), Kubler has suggested that Costa "must have been looking at a lost drawing or canvas prior to the state we now see", and "was describing a picture in progress". Actually, Costa discussed "Velázquez' painting as one more example of the high honours conferred by Kings on painters, and his description of the picture – the only one by Velázquez that he mentions in the whole book – begins with a long reference to the cross of Santiago, which he believed was painted by Velázquez himself (Felix da Costa, *The Antiquity of the Art of Painting*, ed. G. Kubler, New Haven, 1967, pp. 258 and 458). As we know, the cross of Santiago is a later addition, made several years at least after the painting was finished. In addition, since there is no evidence that Costa was ever in Spain, it rather seems that his inaccurate idea of Velázquez' composition, sprang from his recollection of an oral description, which might have been provided, among others, by his brother and fellow painter, Bras d'Almeida (1649–1707), who had been in Spain before 1677.
In his 1966 article mentioned above, Kubler misinterprets Costa's text, thinking that he describes the *meninas* doing the Infanta's hair. However, in the English translation of all of Costa's account, published shortly after by Kubler (see above), this passage was rendered more correctly, describing the *meninas* as "entertaining" the Infanta.

217.
Cf. Gerstenberg, *Diego Velázquez*, Munich, 1957, p. 191, Trapier; *Velázquez*, New York, 1948, p. 341, and José Camón Aznar, *Velázquez*, Madrid, 1964, II, p. 834.

218.
Cf. Palomino, *op. cit.*, p. 921; Tolnay, *art. cit.*; Emmens, *art. cit.*; and Kubler, *art. cit.* recently, Bartolomé Mestre Fiol suggested that the mirror does not reflect directly the persons of the sovereigns but rather their likenesses on the canvas which Velázquez is seen painting, and that it was only after painting the mirrored images that Velázquez introduced his self-portrait in the composition since otherwise it would have obstructed the space between the royal sitters' portrait and the mirror ("El

'espejo referencial' en la pintura de Velázquez", *Traza y Baza,* Barcelona, 1973, no. **2**, pp. 15–36, and no. **3**, pp. 75–100). It is an ingenious though not convincing suggestion; the difficulties to accept it are indeed too evident.

219.
Beruete, *Velázquez*, p. 117.

220.
Some scholars have remarked that the palette in Velázquez' hand is too small; it is not smaller than the one in the *Self-portrait* by Pedro de Moya (1610–74), at the Museum of Bordeaux. Obviously, so small a palette was not unusual in the seventeenth century.

221.
Pacheco, *Arte de la Pintura*, vol. I, pp. 149–54.

222.
Regla, y establecimientos, de la Orden y Cavalleria del glorioso Apostol Santiago, Patrón de las Españas, con la historia del origen y principio de ella, Madrid, 1655, fol. 57 v.

223.
Third part, last chapter (or *crisi*).

224.
On Velázquez' activity as superintendent of works, cf. Antonio Bonet Correa, "Velázquez, arquitecto y decorador", *Archivo Español de Arte*, 1960, pp. 215–50; Enriqueta Harris, "La misión de Velázquez en Italia", *Archivo Español de Arte*, 1960, pp. 109–36, and José María Azcárate, "Noticias sobre Velázquez en la Corte", *Archivo Español de Arte*, 1960, pp. 357–86.

225.
For Diáz del Valle's texts, see *Velázquez: Homenaje en el tercer centenario de su muerte*, Madrid, 1960, pp. 24–9 and 334–5.

226.
Palomino, *El Museo Pictórico*, p. 929. Juan Carreño de Miranda (1614–85) gives a partial view of the Hall of Mirrors in his portraits of *Charles II of Spain*, signed and dated 1673 (East Berlin, Staatliche Museen), and *Queen Mariana* (Prado , no. 644). Several versions of varying quality of each of these portraits are known.

227.
El Museo Pictórico, p. 929.

a.
The inventory of the collection of Luis de Medina Orozco, drawn up in Seville on 11th September 1655, listed "three *Bodegones* by Diego Velázquez". This owner was a *veinticuatro* in Seville (town councillor) and his father was a knight of the Order of Santiago (see Kinkead, 1979, p. 185). Kinkead recalls that one of Murillo's sons also owned a still life by Velázquez, listed in 1709 and valued at 30 *reales* (Sebastian Montoto, "Nuevos Documentos de Bartolomé Esteban Murillo", *Archivo Hispalense*, 1945, V, p. 353).

b.
Francisco Pacheco generally prefers to make studies for his painted portraits using the light of morning. "The face can be sketched and drawn between nine o'clock and midday, and if it is not finished, the final touches can be added

another day at the same time". (Pacheco, II, p. 149).

c.
A document dated 31 October 1623 – not included in the texts collected in *Varia velazqueña,* 1960, II, but published in the exhibition catalogue *Velázquez y lo velazqueño*, Madrid, 1960, (p. 163, no. **277**, facsimile reproduction pl. CXXVII and CXXVIII) – establishes the status as "painter to the King" and Velázquez' salary. Philip IV signed this document, which starts: "On the basis of the good reports I have heard of the skill and ability of Diego Velázquez, painter, he has been appointed ….".

d.
For the document confirming this sale in return for life annuity, see Harris, 1981, pp. 95–6.

e.
In 1624 the Milanese painter Luca Riva (c. 1591–1624), illiterate, deaf and dumb, showed the notary who drew up his will – dictated by gestures and drawings because of his infirmity – a portrait of Philip IV, Duke of Milan, by his hand (Exhibition catalogue *La Ca' Granda,* Milan Palazzo Reale, May–August 1981, nos. 142–143).

f.
In 1626 Velázquez received a pension from the Pope in the form of an ecclesiastical benefice (Harris, 1981, pp. 95–6).

g.
Completely burnt by a lunatic on 13 June 1985. We thank Dr. Christian Klemm, Curator of the Kunsthaus in Zurich for confirmation of this deplorable loss (é 11 December 1995). (ed. note).

h.
Jennifer Montagu discovered the illegitimate birth of one of Velázquez' sons, called Antonio, born in Rome probably in 1652. (Montagu, 1983, pp. 684–5).

i.
Recent studies have proved that Francisco de Palacios, born between 1622 and 1625, died on 27 January 1652 (J.L. Barrio Moya "El pintor Francisco de Palacios: algunas noticias sobre su vida y su obra", *Boletín del Seminario de Estudios de arte y arqueología*, 1987, LII, pp. 425–435).

j.
He died on 9 February 1667. There is no scientific study of this artist. New biographical information was added in 1990 by P. Cherry (see Supplementary bibliography ed. note).

k.
Unfortunately the richness of the palette and the tones of the painting have faded considerably recently, notably due to an excessively long exhibition without protection from pollution. The striking effect of the different blue and white tones which Velázquez used in the costumes of the *meninas* and which illuminated the space around the small infanta is currently lost.

(ed. note) Recent restoration of the paintings, for the 1990 exhibition in particular, may modify Professor López-Rey's comments on the state of Velázquez' works. These are indicated in the catalogue.

Bibliography

The following list includes only the publications mentioned in the preceding pages. References to page numbers, whether in books or periodicals, have been omitted; they are given in the corresponding notes to the text.

Agulló Cobo Mercedes, *Noticias sobre pintores madrileños de los siglos xvi y xvii*, Grenada, 1978.
Ainaud Juan, "a Pinturas de procedencia sevillana", *Archivo Español de Arte*, 1946.
Ainaud Juan, "Ribalta y Caravaggio", *Anales y Boletín de los Museos de Arte de Barcelona*, July–December 1947.
Ainaud Juan, "Francisco Ribalta : Notas y comentarios", *Goya*, Madrid, September–October 1957.
Ainaud Juan, "Caravaggio y Velázquez", Academia dei Lincei, CCCLXX, 1974, no. 205. (Colloquium *Caravaggio e i Carravageschi*, Rome, 12–14 February 1973).
Alba, see **Berwick**.
Alemán Mateo, *Guzmán de Alfarache* (first edition, Madrid, 1599) ed. Samuel Gil y Gaya, Madrid 1965.
Allende-Salazar Juan and **Sánchez Cantón** Francisco Javier, *Retratos del Museo del Prado*, Madrid, 1919.
Allende-Salazar Juan (ed.), *Velázquez. Des Meisters Gemälde*, vol. VI, *Klassiker der Kunst*, 4th ed., Berlin and Leipzig, 1925.
Alpers Svetlana, *The decoration of the Torre de la Parada*, vol. IX, *Corpus Rubenianum Ludwig Burchard*, London, 1971.
Andrés Gregorio de, "Los cinco retratos reales de la Biblioteca de El Escorial", *Archivo Español de Arte*, 1967.
Andrés Gregorio de, "En centenario de Ribera. Ribera y *Las Meninas*", *Archivo Español de Arte*, 1952.
Angulo Iñiguez Diego, *Velázquez : Cómo compuso sus principales cuadros*, Madrid, 1947.
Angulo Iñiguez Diego, "Las Hilanderas", *Archivo Español de Arte*, 1948.
Angulo Iñiguez Diego, "Las Hilanderas : Sobre la iconografia de Aracne", *Archivo Español de Arte*, 1952.
Angula Iñiguez Diego, "*La imposición de la casulla a San Ildefonso* de Velázquez", *Archivo Español de Arte*, 1960.
Angulo Iñiguez Diego, "La cuerna de venado, cuadro de Velázquez", *Reales Sitios*, 1967.
Angulo Iñiguez Diego, *Pintura del siglo 17* vol. SV, *Ars Hispaniae*, Madrid, 1971.
Angulo Iñiguez Diego, "Velázquez : Retrato del Conde-Duque de Olivares. La túnica de José", *Archivo Españole de Arte*, 1978 (published in May 1979).
Angulo Iñiguez Diego, see also **Menéndez Pidal**.
Anonymous, *La vida de Estebanillo González, hombre de buen humor, compuesta por él mismo* (first edition, Brussels, 1646) ed. Juan Millé y Giménez, Madrid, 1956.

Aretino Pietro, *Lettere*, Paris, 1609.
Arts Council of Great Britain, The, *An Exhibition of Spanish Painting*, London, 1947.
Asensio José Maria, *Francisco Pacheco : sus obras artísticas y literarias*, Seville, 1866.
Astrana Marín Luis, see **Quevedo y Villegas**.
Azcárate José María, "Noticias sobre Velázquez en la Corte", *Archivo Español de Arte*, 1960.

Barcia Angel M. de, *Catálogo de la colección de dibujos originales de la Biblioteca Nacional*, Madrid, 1906.
Bardi P.M., *Tout l'œuvre peint de Velázquez*, Introduction de Yves **Bottineau**. Paris, 1969, Italian ed., Milan, 1969; Spanish ed., Barcelona, 1970 and 1982.
Barocchi Paola, see **Varchi**.
Barry G., *The Siege of Breda*, Louvain, 1627.
Baxandal David, "A dated Velázquez bodegón", *The Burlington Magazine*, vol. 99, 1957.
Benítez Claros, see **Bocángel y Unzueta**.
Bergström Ingvar, *Dutch still-life painting in the seventeenth century*, London, 1956.
Bergström Ingvar, *Maestros españoles de bodegones y floreros del siglo xvii*, Madrid, 1970.
Beroqui Pedro, *Adiciones y correcciones al catálogo del Museo del Prado, Parte segunda, Escuelas españolas*. Valladolid, 1915.
Beroqui Pedro, *El Museo del Prado*, Madrid, n.d. (1933).
Beroqui Pedro, *Ticiano en el Museo del Prado*, 2nd ed., Madrid, 1946.
Beruete Aureliano de, *Velázquez*, Paris, 1898; English ed., revised by the author, London, n.d. (1906); German ed., revised by the author, Berlin, 1909. Although this title was originally written in Spanish, no edition has ever been published in that language. Unless otherwise indicated, all references are to the English edition. *A Spanish edition does exist currently, Madrid, 1987 (ed. note).*
Beruete Aureliano de, *El Velázquez de Parma*, Madrid, 1911.
Beruete y Moret Aureliano, *The School of Madrid*, London, 1911.
Beruete y Moret Aureliano, *Conferencias de Arte*, Madrid, 1924.
Berwick y de Alba Duque de, *Discursos leídos ante le Real Academia de San Fernando en la recepción pública del…*, Madrid, 1924.
Birkmeyer Karl, "Realism and realities in the painting of Velázquez", *Gazette des Beaux-Arts*, July–August 1958.
Blanco A., *Museo del Prado, Catálogo de la escultura*, Madrid, 1957.
Blegua José Manuel, see **Quevedo y Villegas**.
Bocángel y Unzueta Gabriel de, *La lira de las Musas*, Madrid, n.d. (1637).
Bocángel y Unzueta Gabriel de, *Piedra cándida, etc.*, Madrid, 1648. Both works are included in *Obras completas de Don Gabriel de Bocángel y Unzueta*, ed. Rafael Benítez Claros, Madrid, 1946.
Bonet Correa Antonio, "Velázquez, arquitecto y decorador". *Archivo Español de Arte*, 1960.

Borelius Aron, *Études sur Velázquez*, Linköping, 1949.
Boschini Mario, *La carta del navegar pitoresco* (first edition, Venise, 1660), ed. Anna Palluchini, Venise, n.d. (1966).
Bottari G., *Raccolta di lettere sulla Pittura, Scultura ed Architettura*, vol. VI, Milan, 1820.
Bottineau Yves, "L'Alcazar de Madrid et l'inventaire de 1686", *Bulletin Hispanique*, Bordeaux, October–December 1958.
Bottineau Yves, "Felipe V y el Buen Retiro", *Archivo Español de Arte*, 1958.
Bottineau Yves, *L'art de cour dans l'Espagne de Philippe V, 1700–1746*, Bordeaux, n.d. (1962).
Braham A., see **National Gallery**.
Brown Jonathan, "A portrait drawing by Velázquez", *Master Drawings*, New York, 1976.
Brown Jonathan, and **Elliott** J.H., *A Palace for a King : The Buen Retiro and the Court of Philip IV*, New Haven, 1980; Spanish ed., Madrid, 1981 and 1985. *Bulletin du Laboratoire du Musée du Louvre*, 1964. "Notes sur les radiographies de deux tableaux appartenant aux Musées de Pau et de Rouen."
Bürger W., see **Stirling**.
Busuioceanu Al., "A rediscovered painting by Murillo : *El cuadro de las sombras*", *The Burlington Magazine*, 1940.

Camón Aznar José, *Velázquez*, Madrid, 1964.
Carderera y Solano Valentín, see **Martínez**.
Carducho Vincencio, *Diálogos de la pintura*, Madrid, 1633 (published in 1634).
Carriazo J.M. de, "Correspondencia de don Antonio Ponz con el Conde del Águila", *Archivo Español de Arte y Arqueologia*, 1929.
Carturla María Luisa, *Pinturas, frondas y fuentes del Buen Retiro*, Madrid, 1947.
Carturla María Luisa, "El coleccionista madrileño don Pedro de Arce, que poseyó "Las Hilanderas" de Velázquez", *Archivo Español de Arte*, 1948.
Carturla María Luisa, *Un pintor gallego en la corte de Felipe IV : Antonio Puga*, Santiago de Compostela, 1952.
Carturla María Luisa, *La boda de Doña Ynés, nieta de Velázquez*, Madrid, 1955.
Carturla María Luisa, "Cartas de pago de los doce cuadros de batallas para el Salón de Reinos del Buen Retiro", *Archivo Español de Arte*, 1960.
Carturla María Luisa, "Devanaderas", *Arte Español*, Madrid, 1962 (published in 1968).
Carturla María Luisa, "Documentos en torno a Vincencio Carducho", *Arte Español*, 1968–1969.
Cavestany Julio, *Floreros y bodegones en la pintura española*, Madrid, 1940.
Ceán Bermúdez Juan Agustín, *Diccionario histórico de los mas ilustres profesores de las Bellas Artes en España*, Madrid, 1800; 2nd ed., Madrid, 1965; re-ed in facsimile form, Madrid, 1965.
Ceán Bermúdez Juan Agustín, *Diálogo sobre el Arte de la Pintura*, Seville, 1819.
Ceán Bermúdez Juan Agustín, *Catálogo de las pinturas y esculturas que se conservan en la Real Academia de San Fernando*, Madrid, 1824 (the

title page does not mention the author's name).

Cederlof Olle, "Kallorna till 'Las Lanzas'", *Konsthistorisk tidskrift*, vol. 26, Stockholm, 1957.

Céspedes y Meneses Gonzalo de, *Historia de Felipe III, Rey de las Españas*, Barcelona, 1634.

Colección litográfica de los cuadros del Rey, N.S., vol. II, Madrid, 1826.

Cook Walter W.S., "Spanish Paintings in the National Gallery of Art", *Gazette des Beaux-Arts*, August 1945.

Corominas J., *Diccionario crítico y etimológico de la lengua castellana*, Madrid, 1954.

Correa Calderón E., see **Gracián**.

Costa Felix da, *The Antiquity of the Art of Painting*, ed. George Kubler, New Haven and London, 1967.

Cotarelo y Mori Emilio, *Ensayo sobre la vida y obras de D. Pedro Calderón de la Barca*, Madrid, 1924.

Covarruvias i Leyva Diego de, *Elogios al Palacio Real de Buen Retiro escritos por algunos ingenios de España…*, Madrid, 1634; limited edition, Valencia, 1949.

Crombie Theodore, "Isabella of Bourbon by Velázquez, A recorded portrait in the Spanish Royal Collections", *The Connoisseur*, June 1958.

Crombie Theodore, "La Reina Isabel de Borbón, por Velázquez", *Archivo Español de Arte*, 1961.

Cruzada Villaamil Gregorio, *Anales de la vida y de las obras de Diego de Silva Velázquez*, Madrid, 1885.

Curtis Charles B., *Velázquez and Murillo*, London and New York, 1883.

Díaz Padrón Matías, "Gaspar de Crayer, un pintor de retratos de los Austria", *Archivo Español de Arte*, 1965.

Diego Velázquez : Cinquante planches d'après ses œuvres les plus célèbres, Paris 1906.

Diéz del Corral Luis, *Velázquez, la Monarquía e Italia*, Madrid, 1979.

Difiniciones de la Orden y Cavallería de Alcántara con la historia y origen de ella, Madrid, 1662.

"Documentos para la historia del Museo de la Academia de San Carlos : Legado de don Francisco Martínez Blanch", *Archivo de Arte Valenciano*, 1920.

Dolce Lodovico, *L'Aretino*, Venice, 1557.

Elliott John H., see **Brown**.

Emmens J.A., "Les Ménines de Velasquez, miroir des princes pour Philip IV", *Nederlands Kunsthistorisch Jaarboek*, 1961.

Fernández Bayton Gloria (ed.), *Museo del Prado, Inventarios Reales, I, Testamentaría del Rey Carlos II, 1701–1703*. Madrid, 1974.

Fichter William L., "Una poesía contemporánea inédita sobre las bodas de Velázquez", *Varia velazqueña*, vol. I, Madrid, 1960.

Foucault M., *Les mots et les choses*, Paris, 1966.

Francis Henry S., "Velázquez : Portrait of the jester Calabazas", *The Bulletin of the Cleveland Museum of Art*, 1965.

Frick Collection, The, *An illustrated catalogue*, vol. I, Pittsburgh, 1949.

Friedländer Max J., *Landscape, Portrait, Still-life*, London, 1949.

Frizzoni Gustavo, "intorno al secondo viaggio del Velázquez in Italia", *Rassegna d'Arte*, vol. XVII, 1917.

Gállego Julián et **Gudiol** José, *Zurbarán*, Barcelona, 1976.

Gallegos Manuel, "Silva topográfica", in *Obras varias al Real Palacio del Buen Retiro*, Madrid, 1637.

García de Diego, see **Saavadra Fajardo**.

García Fígar Fray Antonio, "Fray Juan Bautista Maino, pintor español", *Goya*, Madrid, July–August, 1958.

Gaya Nuño Juan Antonio, "Revisiones sexcentistas: Juan de Pareja", *Archivo Español de Arte*, 1957.

Gaya Nuño Juan Antonio, "Juan Bautista del Mazo, el gran discípulo de Velázquez", *Varia velazqueña*, vol. I, Madrid, 1960.

Gemäldegalerie, Staatliche Museen Preussischer Kulturbesitz, *Katalog der ausgestellten Gemälde des 13.–18. Jahrhunderts*, Berlin, 1975.

Gerstenberg Kurt, *Diego Velázquez*, Munich and Berlin, 1975.

Gesteso y Péréz J., *Catálogo de la exposición de retratos antiguos celebrada en Sevilla en Abril de mcmx*, Madrid, 1910.

Gibbs-Smith Charles H., and **Percival** H.V.T., *Apsley House : A guide to the Wellington Museum*, London, 1957.

Gil y Gaya, see **Alemán**.

Gómez Moreno Manuel, "El Cristo de San Plácido", *Boletin de la Sociedad Española de Excursiones*, Madrid, 1916.

Gómez Moreno Manuel, "Un Vélazquez en el Museo de Orléans", *Archivo Español de Arte y Arqueología*, 1925.

Gómez Moreno Manuel, "*Los borrachos* y otras notas velazqueñas", *Varia velazqueña*, vol. I, Madrid, 1960.

González Palencia, Angel (ed.), *Noticias de Madrid, 1621–1627*, Madrid, 1942.

Gracián Baltasar, *El político Don Fernando el Católico* (first edition, 1640), ed. E. Correa Calderón, preface by E. Tierno Galván, Madrid, 1961.

Gracián Baltasar, *El criticón, III*, Madrid, 1657 (critical edition by M. Romera Navarro, Philadelphia, 1938–1940).

Gudiol José, "Algunas réplicas en la obra de Velázquez", *Varia velazqueña*, vol. I, Madrid, 1960.

Gudiol José, *Velázquez*, Barcelona, 1973.

Haraszti-Takács Marianne, catalogue for the exhibition *Spanyol Mesterek* held at the Museum of Fine Arts, Budapest, 1965.

Haraszti-Takács Marianne, *Budapest Museum of Fine Arts : Spanish Masters*, Budapest, 1966.

Haraszti-Takács Marianne, "Quelques problèmes des *bodegones* de Velasquez", *Bulletin du Musée hongrois des Beaux-Arts*, no. 41, Budapest, 1973.

Harris Enriqueta, "Velázquez en Roma", *Archivo Español de Arte*, 1958.

Harris Enriqueta, "Velázquez's portrait of Camillo Massimi", *The Burlington Magazine*, August 1958.

Harris Enriqueta, "La misión de Velázquez en Italia", *Archivo Español de Arte*, 1960.

Harris Enriqueta, "Velázquez and Charles I", *Journal of the Warburg and Courtauld Institutes*, 1967 (published in 1968).

Harris Enriqueta, "Cassiano del Pozo on Diego Velázquez", *The Burlington Magazine*, June 1970.

Harris Enriqueta, "The cleaning of Velázquez's Lady with a fan", *The Burlington Magazine*, May 1975.

Harris Enriqueta, "Velázquez's portrait of Prince Baltasar Carlos in the Riding School", *The Burlington Magazine*, May 1976.

Harris Enriqueta, "Velázquez's Apsley Portrait: An identification", *The Burlington Magazine*, May 1978.

Harris Enriqueta, and **Elliot** John, "Velázquez and the Queen of Hungary", *The Burlington Magazine*, January 1976.

Haskell Francis, *Patrons and painters*, London, 1963; 2nd ed. New-Haven, London, 1980; Spanish ed., Madrid, 1984.

Herrero García Miguel, *Ideas de los españoles del siglo xvii*, 2nd ed., Madrid, 1966.

Hetzer Theodor, *Tizian : Geschichte seines Farbe*, Frankfurt, 1948.

Hind C. Lewis, *Days with Velázquez*, London, 1906.

Horsely Carter B., "Metropolitan reattributes 300 paintings", *The New York Times*, January 1973.

Horsely Carter B., "Who really painted it?", *Artnews*, March 1973.

Hugo Herman, *The Siege of Breda*, [Brussels?], 1627. Originally published in Latin (*Obsidio Bredana*, Antwerp, 1626); a Spanish translation in Spanish, *Sitio de Breda rendida a las armas del Rey Don Phelipe IV, a la virtud de la Infanta Doña Isabel, al valor del Marqués Ambr. Spínola*, was published in Antwerp, 1627.

Ilustración Española y Americana, La, 15 April 1912.

Instituto Diego Velázquez, *Velázquez : Biografías de los siglos xvii y xviii. Comentarios a él dedicados en los siglos xvii y xviii. Su biografía a través de cartas y documentos contemporáneos. Autógrafos. Facsimiles de documentos e impresos — Homenaje en el tercer centenario de su muerte*, Madrid, 1960.

Interían de Ayala Juan, *El pintor christiano y erudito*, Madrid, 1782.

Iñiguez Almech Francisco, *Casas reales y jardines de Felipe II*, Madrid, 1952.

Iñiguez Almech Francisco, "La Casa del Tesoro, Velázquez y las obras reales", *Varia velazqueña*, vol. I, Madrid 1960.

Jordan William B., "Juan van der Hamen y León, a Madrilenien still-life painter", *Marsyas*, New York, 1964–1965 (published in 1966).
Jordan William B., *The Meadows Museum: A visitor's guide to the collection*, Dallas, 1974.
Justi Carl, *Diego Velázquez und sein Jahrhundert*, 3rd ed., 2 vols., Bonn, 1922 and 1923 (the first edition was published in 1888, also in Bonn).

Kemenov Vladimir, *Velázquez in Soviet Museums*, Leningrad, 1977.
Kubler George, "Vincente Carducho's allegories of Painting", *The Art Bulletin*, December 1965.
Kubler George, "Three remarks on The Meninas", *The Art Bulletin*, June 1966.
Kubler George see **Costa**.

Lafuente Ferrari Enrique, *Velázquez*, London, 1943.
Lafuente Ferrari Enrique, *Velázquez*, Barcelona, 1944.
Lafuente Ferrari Enrique, "Velázquez y Felipe IV", *Mundo Hispánico*, Madrid, February 1961.
Leon Pinelo Antonio, *Anales de Madrid*, Madrid, 1971.
Levina Irène, "Novoe o Velaskese (New data about Velázquez)", *Iskusstvo*, Moscow, 1975.
Levy Michael, *Painting at Court*, New York, 1971.
Ligo Larry L., "Two seventeenth-century poems which link Rubens' equestrian portrait of Philip IV to Titian's equestrian portrait of Charles V", *Gazette des Beaux-Arts*, May–June 1970.
Loga Valerian von, "Zur Zeitbestimmung einiger Werke des Velázquez", *Jahrbuch der Preuszischen Kunstsammlungen*, 1913.
Loga Valerian von, *Die Malerei in Spanien*, Berlin, 1913.
Longhi Roberto, "Un San Tomaso del Velázquez e le congiunture italo-spagnole tra il '500' e il '600'", *Vita Artistica*, 1927.
López Jiménez José Crisanto, "Don Nicolás de Villacis Arias, discípulo de Velázquez", *Boletin del Seminario de Arte y Arqueologia*, Valladolid, 1964.
López Martínez Celestino, *Desde Jerónimo Hernández hasta Martínez Montañes*, Seville, 1929.
López Navío José, "Velázquez tasa los cuadros de su protector D. Juan de Fonseca", *Archivo Español de Arte*, 1961.
López-Rey José, "Idea de la imitación barroca", *Hispanic Review*, Philadelphia, July 1943.
López-Rey José, "On Velázquez's portrait of Cardinal Borja", *The Art Bulletin*, December 1946.
López-Rey José, "A head of Philip IV by Velázquez in a Rubens allegorical composition", *Gazette des Beaux-Arts*, January 1959.
"Nombres y nombradia de Velázquez", *Goya*, Madrid, July–October 1960.
López-Rey José, "Nombres y nombradia de Velásquez", *Goya*, Madrid, July–October 1960.

López-Rey José, "Pincelada e imagen en Velázquez", *Varia velázqueña*, vol. I, Madrid, 1960.
López-Rey José, "Velázquez : Clues from Madrid", *Artnews*, February 1961.
López-Rey José, "A great Velázquez critic revived", *Appolo*, September 1962.
López-Rey José, *Velázquez : A catalogue raisonné of his œuvre*, London, 1963.
López-Rey José, "Maino y Velázquez : Dos retratos de Felipe IV en el Metropolitan Museum of Art de Nueva York", *Colóquio*, Lisbon, October 1963.
López-Rey José, "A portrait of Philip IV by Juan Bautista Maino", *The Art Bulletin*, December 1963.
López-Rey José, Foreword to the catalogue of the exhibition *The Golden Age of Spanish Still-life Painting*, Neward, N.J., 1964.
López-Rey José, "An unpublished Zurbarán : The surrender of Seville", *Apollo*, July 1965.
López-Rey José, "Sobre la atribución de un retrato de Felipe IV a Gaspar de Grayer", *Archivo Español de Arte*, April–September 1966.
López-Rey José, "Velázquez's *Calabazas with a portrait and a pinwheel*", *Gazette des Beaux-Arts*, October 1967.
López-Rey José, "Velázquez *Philip IV*", *Artnews*, summer 1968.
López-Rey José, *Velázquez' Work and World*, London, 1968.
López-Rey José, "Muerte de Villandrando y fortuna de Velázquez", *Arte Español*, 1968–1969.
López-Rey José, "An unpublished Velázquez : A knight of Calatrava", *Gazette des Beaux-Arts*, July–August 1972.
López-Rey José, "The reattributed Velázquez : faulty connoisseurship", *Artnews*, March 1973.
López-Rey José, Review of José Gudiol's *Velázquez*, *La Chronique des Arts*, January 1974.
López-Rey José, "Perils of the Prado", *Artnews*, summer 1974.
López-Rey José, "On the matter of attributions", *Museologia 4*, Florence, Universitá Internazionale dell'Arte, 1976.
López-Rey José, "New data on Velázquez", *La Chronique des Arts*, September 1976.
Lozoya Marqués de, *La rendición de Breda*, Barcelona, 1953.
Lozoya Marqués de, "El caballo blanco de Velázquez", *Varia velázqueña*, vol. I, Madrid, 1960.
Lurie Ann Tzeutschler, "Caravaggio's Crucifixion of St. Andrew from Valladolid", *The Bulletin of the Cleveland Museum of Art*, January 1977.

McKim-Smith Gridley, "The problem of Velázquez' drawings", *Master drawings*, New York, 1980, no. 1, pp. 3–24.
Mac Laren Neil, see **National Gallery**.
Madrazo Pedro de, *Catálogo descriptivo e histórico de los cuadros del Museo del Prado*, Madrid, 1872.
Mancini Giulio, *Considerazioni sulla Pittura*, ed. Adriana Marucchi, Rome, 1956.

Marino Giovanbattista, *Dicerie sacre*, Milan, 1618 (included in *Dicerie sacre e La strage de gl'innocenti*, ed. Giovanni Pozzi, Turin, 1960).
Marino Giovanbattista, *La Galeria del Cavalier Marino distinta in pitture e sculture*, Venice, 1620.
Marino Giovanbattista, *Epitalami*, Venice, 1646.
Martí y Monsó José, *Estudios histórico-artísticos relativos principalmente a Valladolid*, Valladolid, 1901.
Martín González Juan José, "Sobre las relaciones entre Nardi, Carducho y Velázquez", *Archivo Español de Arte*, 1958.
Martín González Juan José, "Arte y artistas del siglo xvii en la Corte", *Archivo Español de Arte*, 1958.
Martín González Juan José, "Algunas sugerencias acerca de los bufones de Velázquez", *Varia velázqueña*, vol. I, Madrid, 1960.
Martínez Jusepe, *Discursos practicables del nobílisimo arte de la pintura*, ed. Valentin Carderera y Solano, Madrid, 1866 (published for the first time by Mariano Nouguès Secall, Saragossa, 1853).
Martínez de la Peña y González Domingo, "Importante colección de cuadros del Vaticano, sacados en la invasión francesca y trasladados a Madrid", *Arte Español*, 1963–1967.
Martínez de la Peña y González Domingo, "El segundo viaje de Velázquez a Italia : Dos cartas inéditas, en los archivos del Vaticano", *Archivo Español de Arte*, 1971.
Marucchi A., see **Mancini**.
Matute y Gaviria Justino, "Adiciones y correcciones de D... al tomo IX del *Viage de España* por D. Antonio Ponz anotadas nuevamente por D. Gestoso y Pérez", *Archivo Hispalense*, 1886, I and II, 1887, III, 1888, IV.
Mayer August L., "Ein unbekanntes Spätwerk des Velázquez", *Zeitschrift für bildende Kunst*, 1912.
Mayer August L., *Kleine Velázquez-Studien*, Munich, 1913.
Mayer August L., *Handzeichnungen Spanischer Meister*, Leipzig, 1915.
Mayer August L., "Velázquez und die niederländischen Küchenstücke", *Kunstchronik und Kunstmarkt*, January 1919.
Mayer August L., "Einige unbekannte Arbeiten des Velázquez", *Zeitschrift für bildende Kunst*, 1921.
Mayer August L., *Diego Velázquez*, Berlin and Leipzig, 1924.
Mayer August L., "Three studies", *The Burlington Magazine*, June 1927.
Mayer August L., *A study by Velázquez for the Apollo in the Forge of Vulcan*, New York, n.d.
Mayer August L., *A portrait by Velázquez : Francisca Velázquez, daughter of the Master (The woman sewing)*, New York, n.d.
Mayer August L., *Velázquez : A catalogue raisonné of the pictures and drawings.* London, 1936.
Mayer August L., *Velázquez*, Paris, 1940.
Mazón de la Torre María A., "La partida de

bautismo de Jusepe Leonardo", *Archivo Español de Arte*, 1969.

Mazón de la Torre María A., "En torno a Jusepe Leonardo", *Archivo Español de Arte*, 1975.

Mélida José Ramón, *Los Velázquez de la Casa de Villahermosa* (reprint of *Revista de Archivos, Bibliotecas y Museos*), Madrid, 1905.

Mélida José Ramón, *Un recibo de Velázquez* (reprint of *Revista de Archivos, Bibliotecas y Museos*), Madrid, 1906.

Menéndez Pidal Gonzalo, and **Angulo Iñíguez** Diego, "*Las Hilanderas* de Velázquez — Radiografías y fotografías en infrarrojo", *Archivo Español de Arte*, January–March 1965.

Menéndez Pidal Ramón, "Onomástica inspirada en el culto mariánico", *Cuadernos del Idioma*, Buenos Aires, 1965.

Mengs Anthony Raphael, *The Works of*, London 1796.

Mestre Fiol Bartolomé, "El *espejo referencial* en la pintura de Velázquez", *Traza y Baza*, Barcelona, 1973.

Metropolitan Museum of Art The, *Handbook of the Benjamin Altmam Collection*, New York, 1915.

Milanesi G., see **Vasari**.

Millé y Giménez Juan, see **Anonymous**.

Ministerio de Educación Nacional, Dirección General de Bellas Artes, *Varia velázqueña*, vol. I, *Estudios sobre Velázquez y su obra*; vol. II, *Elogios poéticos — Textos y comentarios críticos — Documentos — Cronología*, Madrid, 1960.

Moreau-Nélaton E., *Manet raconté par lui-même*, Paris, 1926.

Moreno Villa José, *Velázquez*, Madrid, 1920 (2nd ed., Málaga, 1961).

Moreno Villa José, *Locos enanos, negros y niños palaciegos*, Mexico, 1939.

Muller Priscilla E., "Francisco Pacheco as a painter", *Marcyas*, New York, 1960–1961.

Muro Orejón Antonio (ed.), *Documentos para la historia del arte en Andalucía*, vol. VIII, Seville, 1935.

Museum of the Hermitage, Department of Western Art, *Catalogue des Peintures*, vol. I, Leningrad, 1958.

Museum of the Hermitage, *Peinture de l'Europe occidentale, Catalogue, I, Italie, France, Suisse*, Leningrad, 1976.

Museo del Prado, *Catálogo de las pinturas*, Madrid, 1972.

Museo del Prado, see **Madrazo**.

(Museo del Prado), *Noticia de los cuadros que se hallan colocados en la Galería del Museo del Rey, nuestro Señor, sito en el Prado de esta Córte*, Madrid, 1828.

National Gallery The, *An exhibition of cleaned pictures (1936–1947)*, London, 1947.

National Gallery The, *The Spanish School* (by Neil Maclaren), London 1952 (2nd ed. reviewed by Allan Braham, London, 1979 and 1988).

National Gallery The, *June 1962–December 1964*, London, 1965 (Director's report).

National Gallery The, *January 1965–December 1966*, London, 1967 (rapport du Directeur).

National Gallery Of Canada, *European Drawings from Canadian Collections*, (catalogue of M. C. Taylor exhibition), Ottawa, 1976.

National Museum, exhibition catalogue for *Christina, Queen of Sweden*, Stockholm, 1966.

Nicolle Marcel, "Portrait d'un Cardinal par Vélasquez", *Revue de l'Art*, 1994.

Nougués Segall, see **Martínez**.

Orbaan Johannes A.F., "Notes on art in Italy", *Apollo*, July 1927.

Orozco Díaz Emilio, "Un aspecto del barroquismo de Velázquez", *Varia velázqueña*, vol. I, Madrid, 1960.

Ortega y Gasset José, *Papeles sobre Velázquez y Goya*, Madrid, 1950; rééd. dans *Obras completas*, vol. 8, Madrid, 1962, pp. 457–87.

Pacheco Francisco, *El Arte de la Pintura*, ed. F.J. Sánchez Cantón, Madrid, 1956 (first edition, Seville, 1649). See also **Fallay d'Este** and **Bassegoda i Hugas** in the Supplementary Bibliography.

Pacheco Francisco, *Libro de descripción de verdaderos retratos…* (facsimile edition), Seville, n.d. (1886).

Palluchini Anna, see **Boschini**.

Palm Erwin Walter, "Diego Velázquez : Aesop und Menipp", *Lebende Antike, Symposium für Rudolf Sühnel*, Berlin, 1967.

Palomino Velasco Antonio, *El Museo pictórico*, Madrid, 1947 and 1988 (first edition, Madrid, 1724).

Pardo Canalis Enrique, "Una visita a la galería del Principe de la Paz", *Goya*, Madrid, January–June 1979 (published in December 1979).

Pariset François-Georges, "Y a-t-il affinité entre l'art espagnol et Georges de la Tour?", *Velázquez, son temps, son influence* (colloquium held at the Casa de Velázquez in Madrid), Paris, 1963.

Percival, see **Gibbs-Smith**.

Pérez de Moya Juan, *Filosofía secreta*, Alcalá de Herares, 1611.

Pérez Pastor Cristobal, *Noticias y documentos relativos a la historia y literatura españolas*, Madrid, 1964.

Pérez Sánchez Alfonso E., *Borgiani, Cavarozzi y Nardi en España*, Madrid, 1964.

Pérez Sánchez Alfonso E., "El paradero de la colección de cuadros del Vaticano trasladados a Madrid en 1798", *Arte Español*, 1968–1969.

Pérez Sánchez Alfonso E., exhibition catalogue for *Caravaggio y el naturalismo español*, Seville, 1973.

Piçaño de Palacios Alvaro, *Discurso primero en confirmación de la purissima concepción de la Virgen María*, Seville, 1615.

Piçaño de Palacios Alvaro, *Discurso segundo, etc.*, Seville, 1616.

Picatoste Felipe, *Estudios sobre la grandeza y decadencia de España*, vol. III, *El Siglo xvii*, Madrid, 1887.

Picón Jacinto Octavio, *Vida y obras de Don Diego Velázquez*, Madrid, 1899 (2nd ed. Madrid, 1925).

Pidal y Bernaldo de Quirós Roque, *El Cristo del Sacramento pintado por Velázquez*, Madrid, 1951.

Pita Andrade José Manuel, "Los cuadros de Velázquez y Mazo que poseyó el séptimo Marqués del Carpio", *Archivo Español de Arte*, 1952.

Pita Andrade José Manuel, "Noticias en torno a Velázquez en el Archivo de la Casa de Alba", *Varia velázqueña*, vol. I, Madrid, 1960.

Poleró Vicente, *Tratado de la pintura en general*, Madrid, 1886.

Ponz Antonio, *Viaje de España*, ed. Casto María del Rivero, Madrid, 1947 (the first edition appeared in 18 volumes in 1772–1794). Facsimile re-ed., Madrid, 1972.

Pozzi G., see **Marino**.

Preciado de la Vega Fransciso, see **Bottari**.

Pruvost-Auzats Jacqueline, "L'Apôtre Saint Thomas de Vélasquez au Musée des Beaux-Arts d'Orléans", *Varia velázqueña*, vol. I, Madrid, 1960.

"Queen Isabella de Bourbon, a 'lost' portrait by Velázquez located", *The Connoisseur*, August 1951.

Quevedo y Villegas Francisco de, *Obras completas*, ed. Luis Astrana Marín, Madrid, 1932.

Quevedo y Villegas Francisco de, *Obras completas*, ed. José Manuel Blecua, Barcelona, 1963.

Real Academia de San Fernando, *Distribución de los premios concedidos por el Rey N.S. a los discípulos de las tres nobles artes*, Madrid, 1760.

Real Academia de San Fernando, *Catálogo de los cuadros, estatuas y bustos que existen en la Real Academia de San Fernando*, Madrid, 1817.

Real Academia de San Fernando, *Catálogo de los cuadros, estatuas y bustos que existen en la Real Academia de San Fernando*, Madrid, 1819.

Real Academia de San Fernando, *Catálogo de los cuadros, estatuas y bustos que existen en la Academia Nacional de San Fernando*, Madrid, 1821.

Real Academia de San Fernando, *Catálogo de las pinturas y esculturas que se conservan en la Real Academia de San Fernando*, Madrid, 1824 (also listed above under **Céan**).

Real Academia Española, *Diccionario de la lengua castellana*, 6 vols., Madrid, 1726–1739.

Regla y establecimientos, de la Orden y Cavalleria del glorioso Apostol Santiago, Patrón de las Españas, con la historia del origen y principio de ella, Madrid, 1655.

Ripa Cesare, *Iconologia*, with an introduction by Erna Mandowsky, New York, 1970.

Rivero Casto María, see **Ponz**.

Rodríguez G. de Ceballos, "La fecha del nacimiento de Vicente Carducho", *Archivo Español de Arte*, 1975.

Rodríguez de Rivas M., "Autógrafos de artistas españoles", *Revista Española de Arte*, 1932.

Rodríguez Villa Antonio, *Ambrosio Spínola, primer Marqués de los Balbases*, Madrid, 1904.
Romera Navarro, see **Gracián**.
Rosenblum Robert, "The origin of Painting : A problem in iconography of Romantic classicism", *The Art Bulletin*, 1957.
Röthlisberger Marcel, *Claude Lorrain*, New Haven, 1961.
Royal Academy of Arts, exhibition catalogue of *Seventeenth-century Art in Europe*, London, 1938.
Royal Academy of Arts, exhibition catalogue *The Golden Age of Spanish Painting*, London, 1976.

Saavedra Fajardo Diego, *República literaria*, ed. Vicente García de Diego, Madrid, 1942. Posthumous first publication under the title *Juicio de artes y sciencas* attributed to a certain Claudio Antonio de Cabrera, in 1655.
Salamanca, *Catalogue des tableaux anciens... composant la galerie de M. le Mis de*, Paris, 1867.
Saltillo Marqués del, "Artistas madrileños", *Boletin de la Sociedad Española de Excursiones*, Madrid, 1953₁.
Saltillo Marqués del, "Identificación de un retrato de Velázquez", *Archivo Español de Arte*, 1953₂.
Salvadori Fabia Borroni, "Le esposizione d'arte a Firenze dal 1674 al 1767", *Mitteilungen des Kunsthistorischen Institutes in Florenze*, Dusseldorf, 1974.
Sampere y Guarinos Juan, *Historia del luxo y de las leyes suntuarias de España*, Madrid, 1788.
Sánchez Cantón F.J., *Los Pintores de Cámara de los reyes de España*, Madrid, 1916.
Sánchez Cantón F.J., "La librería de Velázquez" *Homenaje a Don Ramón Menéndez Pidal*, vol. III, Madrid, 1925.
Sánchez Cantón F.J., *Fuentes literarias para la historia del arte español*, vol. II, Madrid, 1933.
Sánchez Cantón F.J., *Dibujos españoles*, vol. III, Madrid, 1930 (published several years later).
Sánchez Cantón F.J., "Cómo vivía Velázquez", *Archivo Español de Arte*, 1942.
Sánchez Cantón F.J., "La espiritualidad de Velázquez", *Revista de la Universidad de Oviedo*, Oviedo, March–June 1943.
Sánchez Cantón F.J., Review of Enrique Lafuente's *Velázquez* (1944), *Archivo Español de Arte*, 1944.
Sánchez Cantón F.J., "New facts about Velázquez", *The Burlington Magazine*, December 1945.
Sánchez Cantón F.J., "Sobre la vida y las obras de Juan Pantoja de la Cruz", *Archivo Español de Arte*, 1947.
Sánchez Cantón F.J., *Retratos de los Reyes de España*, Barcelona, 1948.
Sánchez Cantón F.J., *Las meninas y sus personajes*, Barcelona, 1952.
Sánchez Cantón F.J., see also **Pachedo** and **Allende-Salazar**.
Sánchez de Viana Pedro, *Anotaciones sobre los quinze libros de las Trásformaciones de Ouido, etc.*, Valladolid, 1589.
Santos Francisco de los, *Descripción breve del monsterio de S. Lorenzo el Real del Escorial*, Madrid, 1657; 2nd edition : Madrid, 1967.
Saxl F., *Lectures*, London, 1657.
Silvela Francisco (éd.), *Cartas de la venerable Madre Sor María de Agreda y del Señor Rey Don Felipe IV*, Madrid, 1888.
Snare John, *The history and pedigree of the portrait of Prince Charles (afterwards Charles the First) painted at Madrid in 1623 by Velázquez*, Reading, 1847.
Snare John, *Proofs of the authenticity of the portrait of Prince Charles (afterwards Charles the First) painted at Madrid in 1623 by Velázquez contained in observations on the remarks of Sir Edmund Head, Bart. and William Stirling, Esq., M.A.*, Reading, 1848.
Sobrino Alfonso, *Tratado de la Immaculada Concepción*, Seville, 1615.
Soehner Halldor, "Un nuevo Velázquez", *Clavileño*, Madrid, 1951.
Soehner Halldor, "Die Herkunft der Bodegones des Velázquez", *Varia velazqueña*, vol. I, Madrid, 1960.
Sonnenberg Hubert, "The technique and conservation of the portrait", [Pareja's] *The Metropolitan Museum of Art Bulletin*, New York, June 1971.
Soria Martin S., "José Leonardo, Velázquez's best disciple", *The Art Quarterly*, vol. 13, 1950.
Sousa Viterbo, *Noticia de alguns pintore portuguezes, e de outros que, sendo estrangeiros, exerceram a sua arte em Portugal*, Lisbon, 1952.
Spear Richard E., *Caravaggio and his followers*, Cleveland, 1971.
Stepánek Pavel, "La pintura española en la Galeria Nacional de Praga", *Ibero-Americana Pragensis*, Prague, 1969.
Sterling Charles, *La Nature morte de l'Antiquité à nos Jours*, Paris, 1952; re-ed. 1959, 1985; English ed., New York, 1981.
Stevenson R.A.M., *Velázquez*, London, 1962, (first published under the title *The Art of Velázquez*, London, 1895).
Stirling William, *Velázquez and his works*, London, 1855. (French translation by W. Bürger, Paris, 1865).

Tapia y Robles Juan Antonio de, *Illustración del renombre de grande*, Madrid, 1638.
Tierno Galván E., see **Gracián**.
Tietze-Conrat E., *Dwarfs and jesters in art*, New York, 1957.
Tolnay Charles de, "Velázquez's *Las Hilanderas* et *Las Meninas* par Vélasquez", *Gazette des Beaux-Arts*, January 1949.
Tonci Salvatore, *Descrizione ragionata della Galleria Doria*, Rome, 1794.
Tormo Elías, "El busto en bronce de un Guzmán en el Museo del Prado", *Boletin de la Sociedad Española de Excursiones*, 1909.
Tormo Elías, *Pintura, escultura y arquitectura en España : Estudios dispersos*, Madrid, 1949.
Trapier Elisabeth du **Gué**, "Velázquez : New data on a group of portraits", *Notes Hispanic*, vol. IV, New York, 1944.
Trapier Elisabeth du **Gué**, *Velázquez*, New York, 1948.
Trapier Elisabeth du **Gué**, "The cleaning of Velázquez Count-Duke of Olivares", *Varia velazqueña*, vol. I, Madrid, 1960.
Trapier Elisabeth du **Gué**, *Treasures from Chatsworth*, n.p., 1979–1980 (catalogue of a loan exhibition from the Devonshire collection, circulated in the United States by the International Exhibitions Foundation).
Trésors de la peinture espagnole : Églises et Musées de France (exhibition catalogue), Paris, 1963.
Twiss Richard, *Travels in Portugal and Spain*, London, 1775.

Valverde Madrid José, article from the newspaper *Informaciones*, Cordoba, 4 Novembre 1965.
Varchi Benedetto, *Lezione dalla maggioranza delle arti* (first edition, Florence, 1549), in *Trattati d'arte del Cinquecento*, ed. Paola Barocchi, vol. I, Bari, 1960.
Varey J.E, "Notas velazqueñas", *Archivo Español de Arte*, 1972.
Vasari Giorgio, *Le vite de' più eccellenti pittori, scultori ed architettori*, ed. G. Milanesi, 9 vols., Florence, 1878–1885.
Velázquez y lo velazqueño (exhibition catalogue), Madrid, 1960. The second edition, published in 1961, is preferable since it contains fewer misprints and factual errors.
Venturi Adolfo, "Altro ritratto del Velázquez", *L'Arte*, vol. II, 1899.
Viñaza Conde de la, *Adiciones al Diccionario histórico de los más ilustres profesores de las Bellas Artes en España de D. Juan Agustin Cean Bermúdez*, Madrid, 1894.
Vlieghe Hans, *Gaspar de Crayer, sa vie et ses œuvres*, Brussels, 1972.
Vollard Ambroise, *En écoutant Cézanne, Degas, Renoir*, Paris, 1938.
Voss Hermann, "Zur Kritik des Velázquez Werkes", *Jahrbuch der Preussischen Kunstsammlungen*, 1932.
Vosters Simon A., *La rendición de Bredá en la literatura y el arte de España*, London, 1973.

Waterhouse Ellis, *Italian Baroque Painting*, London, 1962.
Wittkower Rudolp, *Gian Lorenzo Bernini*, New York, 1955.
Whitaker Shirley B., "The first performance of Calderón's *El sitio de Bredá*", *Renaissance Quartely*, winter 1978.

Ximénez Andrés, *Descripción del Real Monasterio de San Lorenzo del Escorial*, Madrid, 1764.

Zimmermann Heinrich, "Zur Iconographie des Hauses Habsburg", *Jahrbuch der Kunsthistorischen Sammlungen des Allerhöchsten Kaiserhauses*, Vienna, 1904.
Zimmermann Heinrich, "Die Bildnisse der Köningin Marianne", *Jahrbuch der Kunsthistorischen Sammlungen des Allerhöchsten Kaiserhauses*, Vienna, 1905.

Supplementary Bibliography (since 1980)

Aguerri Martínez Ascención and **Salas Vázquez** Eduardo, *Catálogo del Gabinete de Estampas del Museo Municipal de Madrid, I, Estampas Extrangeras* (about 1513–1820), i and ii, Madrid, 1989.

Agulló y Cobo Mercedes, Más noticias sobre pintores madrileños de los siglos 16 y 17, Madrid, 1981.

Agulló y Cobo Mercedes, *Documentos para la historia de la pintura española*, i, Madrid, Museo del Prado, 1994.

Alcolea Blanch Santiago, *Velázquez*, Barcelona, 1987.

Alcolea Blanch Santiago, *Prado's Masterpieces*, Barcelona, 1991.

Alpers Svetlana, " Interpretation without Representation, or the Viewing of Las Meninas", *Representation*, i, February 1983, pp. 31–42.

Andersen-Bergdoll Greta, see **McKim-Smith**, 1988.

Angulo Iñiguez Diego, review of *Velázquez* by Henriqueta Harris, *Archivo Español de Arte*, 1983₁, lvi, no. 223, pp. 303–04.

Angulo Iñiguez Diego and **Pérez Sánchez** Alfonso E., *A Corpus of Spanish Drawings: Madrid School 1600–1650*, Oxford, 1977, 1983₂.

Angulo Iñiguez Diego and **Pérez Sánchez** Alfonso E., *Historia de la Pintura Española. Escuela madrileña del segundo tercio del siglo 1 7*, Madrid, 1983₃.

Asemissen Hermann U., *Las Meninas von Diego Velázquez*, Kasseler Hefte für Kunstwissenschaft und Kunstpädagogik, II, Cassel, 1981.

Augé Jean-Louis, **Braun-Vega** Herman, **Capdevilla** Lauro, **Courdeau** Danièle, in: *De Velázquez à l'art contemporain*, Tours, 1995.

Ayala Mallory Nina, "La pintura de Velázquez, en Nueva York", *Goya*, 1990, no. 214, pp. 231–5.

Ayala Mallory Nina, *Del Greco a Murillo. La pintura española del Siglo de Oro 1556-1700*, Madrid, 1991.

Azcárate José María de, *Guía del museo de la Real Academia de Bellas Artes de San Fernando*, Madrid, 1988.

Barbiellini A., "L'iconografia pamphiliana. Notizie dei ritratti di papa Innocenzo X ", *Imago Peitatis 1650. I Pamphilj a San Martino al Cimino*, Rome, 1987.

Barcelona 1983, Palau Reial de Pedralbes, *L'Època del Barroc*, exhibition catalogue, 1983.

Barcelona 1992, Palacio Nacional de Montjuic, *Prefiguración del Museu Nacional d'Art de Catalunya*, July-November 1992 (exhibition catalogue 1993).

Barreno Sevillano María Luisa, "La restauración de pinturas de las colecciones reales durante el siglo 18", *Archivo Español de Arte*, 1980, liii, nos. 209–12, p. 489.

Barrio Moya José Luis, "El pintor Francisco de Palacios: algunas noticias sobre su vida y su obra", *Boletín del Seminario de Arte y Arqueología*, 1987, liii, pp. 425–35.

Barry Claire M., "Diego Velázquez. Portrait of Don Pedro de Barberana, c. 1631-33, Knight of the Order of Calatrava", *Kimbell Art Museum Calendar*, Fort Worth (Texas), September 1995 – January 1996, p. 19.

Bassegoda i Hugas Bonaventura, critical edition of *El Arte de la Pintura* de Francisco **Pacheco**, Madrid, 1990.

Baticle Jeannine, in: **Brejon de Lavergnée** Arnauld, **Thiébaut** Dominique, *Concise illustrated catalogue of the paintings of the Musée du Louvre. ii: Italy, Spain, Germany, Great Britain et al.,* Paris, 1981₁.

Baticle Jeannine, 'L'Âge baroque en Espagne. La peinture espagnole de la seconde moitié du 16e siècle à la fin du 17e siècle', in: *L'Âge baroque en Espagne et en Europe septentrionale*, Geneva, 1981₂.

Baticle Jeannine, **Marinas** Christine, *La Galerie espagnole de Louis-Philippe au Louvre, 1838–1848*, Paris, 1981₃.

Baticle Jeannine, "Velázquez ou le miracle de l'illusion optique", *Connaissance des Arts*, 1989₁, no. 452, pp. 98–109.

Baticle Jeannine, *Velázquez, peintre hidalgo*, Paris, 1989₂.

Baticle J., in: *Mille peintures des musées de France*, Paris, 1993, pp. 308–309, 312–313, 322–323.

Bazin Germain, review of *Velázquez. The Artist as a Maker de José López-Rey*, *La Chronique des Arts*, supplement to the Gazette des Beaux-Arts, 1980, no. 1335, pp. 32–3.

Bermejo Elisa, "Crónica Exposición Velázquez", *Archivo Español de Arte*, 1990, lxiii, no. 250, pp. 387–91.

Bermejo Vega Virgilio, exhibition catalogue, Frankfurt, 1991–1992.

Bernis Carmen, "El "Vestido Francés"en la España de Felipe IV", *Archivo Español de Arte*, 1982, lv, pp. 201–08.

Boone Danièle, *L'Âge d'or espagnol*, Neuchâtel, 1993.

Borobia Guerrero María del Mar, see **Pita Andrade**, 1992.

Bottineau Yves, *L'Art baroque*, Paris, 1986.

Bottineau Yves, "Velázquez: proposition pour un portrait", *Travaux d'histoire de l'art offerts à Marcel Durliat pour son 75e anniversaire*, Toulouse, 1992, pp. 541–55.

Bouza Fernando, *Locos, enanos y hombres de placer en la corte de los Austrias*, Madrid, 1991.

Braham Allan, exhibition cat., London, 1981.

Braun-Vega Herman, see **Augé** Jean-Louis.

Brejon de Lavergnée Arnauld, "Pittori stranieri in Italia", *La Pittura in Italia. Il Seicento*, 1st ed. Milan, 1988, 2nd ed. Milan, 1989, ii, pp. 531–58.

Brigstocke Hugh, *Italian and Spanish Painting in the National Gallery of Scotland*, Edinburgh, 1978; 2nd ed. 1992.

Brown Jonathan, *Images and Ideas in Seventeenth-Century Spanish Painting*, Princeton (New Jersey), 1978; Spanish ed., Madrid, 1980; French ed., Paris, 1993.

Brown Jonathan, "Un italiano en el taller de Velázquez", *Archivo Español de Arte*, 1980, liii, pp. 207–08.

Brown Jonathan, "Velázquez and the Evolution of High Baroque Painting in Madrid", *Record of The Art Museum*, Princeton University, 1982, xli, pp. 4–11.

Brown Jonathan, *Velázquez: Painter and Courtier*, New Haven and London, 1986; Spanish ed., Madrid, 1986; French ed., Paris, 1988.

Brown Jonathan, "Enemies of Flattery: Velázquez Portraits of Philip IV", *Journal of Interdisciplinary History*, 1987₁, 17, pp. 137–64.

Brown Jonathan, "Felipe IV, el rey de coleccionistas ", *Fragmentos*, 1987₂, pp. 4–20.

Brown Jonathan, *The Golden Age of Painting in Spain*, London, 1990; Spanish ed., Madrid, 1990, French ed., Paris, 1990.

Brown Jonathan, *Kings & Connoisseurs. Collecting Art in Seventeenth-Century Europe*, The A.W. Mellon *Lectures in the Fine Arts*, 1994, The National Gallery of Art, Washington, D.C., Princeton (New Jersey), 1995; Spanish ed. *El triunfo de la pintura. Sobre el coleccionismo cortesano en el siglo 17* , Madrid, 1995.

Brown Jonathan and **Elliot** J.H., "Further Observations on Velázquez' Portraits of Jesters at the Buen Retiro", *Gazette des Beaux-Arts*, 1981, xcvii, pp. 191–92.

Brown Jonathan and **Kagan** Richard L., "The Duke of Alcalá: His Collection and Its Evolution ", *The Art Bulletin*, 1987, pp. 231–55.

Brussels 1985, Palais des Beaux-Arts, *Splendeurs d'Espagne et les villes belges 1500-1700. Europalia 1985 España*, exhibition catalogue, September–December 1985, 2 vols.

Bull Duncan and **Harris** Enriqueta, "The Companion of Velázquez's *Rokeby Venus* and a Source for Goya's *Naked Maja*", *The Burlington Magazine*, 1986, cxxviii, no. 1002, pp. 643–54.

Burke Marcus B., *Private Collections of Italian Art in Seventeenth-Century Spain*, Ph.D., New York University, 1984.

Burke Marcus B., exhib. cat., New York, 1987.

Bustamente García Agustín, *El Siglo 17. Clasicismo y Barroco*, Madrid, 1993.

Caballero Bonald José Manuel, *Sevilla en tiempos de Cervantes*, Barcelona, 1991.

Cabrera José María, see **Garrido Pérez**, 1983.

Calvo Castellón Antonio, "Iconografía de Antiguo Testamento en la obra de grandes maestros de la pintura barroca andaluza", *Cuadernos de Arte e Iconografía*, Madrid, 1988, i, no. 1, pp. 135–58.

Calvo Serraller Francisco, *Teoría de la pintura del siglo de Oro*, Madrid, 1981.

Calvo Serraler F., *Velázquez*, Barcelona, 1991.

Campo y Francés Angel del, "La trama de 'Las Hilanderas'", *Boletín de Información. Colegio Oficial de Ingenieros de Caminos, Canales y Puertos*, April 1983, 67, pp. 22–31.

Cañedo-Arguelles Cristina, *La Contrarreforma y España*, Oviedo, 1982, "Ethos-Arte", no. 6.
Cantera Montenegro Jesús, "La presencia del teatro en las Meninas y en las Hilanderas", *Boletín del Museo e Instituto "Camón Aznar"*, 1989, xxxvi, pp. 107–23.
Capdeville Lauro, see **Augé** Jean-Louis.
Caracas 1981, Museo de Bellas Artes, *400 años de Pintura española*, exhibition catalogue, 1981.
Caturla María Luisa and **Delenda** Odile, *Zurbarán,* Paris, 1994.
Checa Fernando, see **Morán Turina** José Miguel, 1984 and 1985.
Cherry Peter, "Juan Bautista del Mazo, viudo de Francisca Velázquez (1653)", *Archivo Español de Arte*, 1990, lxiii, no. 249, pp. 511–27.
Cherry Peter, "New Documents for Velázquez in the 1620s", *The Burlington Magazine*, 1991, cxxxiii, no. 1055, pp. 108–15.
Cherry Peter, "Una sugerencia acerca del 'Marte' de Velázquez como 'burla de la Antigüedad'", *La Visión del mundo clásico en el arte español*, vi Jornadas de Arte, c.s.i.c, Madrid, 1993, pp. 223–35.
Cherry Peter, exh. catalogue, London, 1995.
Chevillot Catherine and **Foucart** Bruno, *La Collection du musée de Grenoble. Peintures, sculptures du 15e siècle*, Grenoble–Paris, 1995.
Chicago (Illinois) 1992, The Art Institute, *Master European Paintings from the National Gallery of Ireland: Mantegna to Goya*, exhibition catalogue, June–August 1992, see **San Francisco** (California) 1992.
Coe-Wixom Nancy, in *European Paintings of the 16th, 17th and 18th Centuries. The Cleveland Museum of Art*, Cleveland (Ohio), 1982.
Cohen Ted, see **Snyder**, 1980.
Colomer José Luis, ""Dar a Su Majestad algo bueno": Four letters from Velázquez to Virgilio Malvezzi", *The Burlington Magazine*, 1993, cxxxv, no. 1079, pp. 67–72.
Colomer José Luis and **Harris** Enriquetta, "Two letters from Camillo Massimi to Diego Velázquez", *The Burlington Magazine*, 1994, cxxxvi, no. 1097, pp. 545–8.
Constans Claire, *Musée National du château de Versailles. ii. Les Peintures*, Paris, 1995.
Courdeau Danièle, see **Augé** Jean-Louis.
Cuyás María Margarita, exhibition catalogue Barcelona, 1992.

Dávila María Teresa, see **Garrido Pérez**, 1986 and 1988.
Dávila Rocío, see **Garrido Pérez**, 1986 and 1988.
Delenda Odile, "L'Art au service du dogme. Contribution de l'école sévillane à l'iconographie de l'Immaculée Conception", *Gazette des Beaux-Arts*, 1988, cxi, pp. 239–48.
Delenda Odile, *Velázquez, peintre religieux*, Geneva–Paris, 1993.
Díaz Padrón Matías, "Influencia y legado del retrato flamenco del siglo 17 en la España de los Austria", *Archivo Español de Arte*, 1982, lv, pp. 129–42.
Díaz Padrón Matías, exhibition catalogue, Brussels, 1985.

Díaz Padrón Matías, "Gaspar de Crayer y Velázquez, bajo la sombra de los Austrias", *Gallería Antiquaria*, 1990, viii, no. 75, pp. 14–21.
Díez Borque José María, *La Vida española en el Siglo de Oro según los extranjeros*, "Viajes, Paises, Culturas", no. 6, Barcelona, 1990.
Díez del Corral Luis, *Velázquez, la monarquía e Italia*, Madrid, 1979.
Domínguez Ortiz Antonio, *La Sevilla del siglo 17*, Seville, 1983 ; 3rd ed., 1986.
Domínguez Ortíz Antonio, see **New York**, 1989–1990, Madrid, 1990.
Dorival Bernard, "À propos des Ménines", *L'Œil*, no. 462, pp. 36–41.

Edinburgh, 1996, National Gallery of Scotland, *Velázquez in Seville*, exh. catalogue, 8 August–20 October 1996.
Eisler Colin, *La Peinture au musée de l'Ermitage*, Paris, 1991.
Elliott John H., see **Brown**, 1981.
Elliott John H., *The Count-Duke of Olivares. The Statesman in an Age of Decline*, New Haven and London, 1986.
Elliott John H., under the direction of, *The Hispanic World*, London, 1991; French ed., Paris, 1991.
Elliott John H., *Olivares (1587–1645). L'Espagne de Philippe IV*, introduction, bibliographical guide and glossary by Bartolomé **Bennassar**, chronology by Pascal **Arnoux**, Paris, 1992.
Espagne 1994–1995, *Pintores del reinado de Felipe IV*, catalogue of travelling exhibition, September 1994–December 1995.

Fallay d'Este Laurianne, French ed. of selected texts taken from *L'Art de la Peinture* de Francisco **Pacheco**, Paris, 1986.
Fernández Álvarez Manuel, *La sociedad española en el Siglo de Oro*, Madrid, 1983.
Fernández Arenas José, *Renacimiento y Barroco en España* ("Fuentes y Documentos para la Historia del Arte", vi), Barcelona, 1982.
Fernández Bayton Gloria, *Inventarios reales: la Testamentaria de Carlos II*, Madrid, 3 vols., 1975–1985.
Florence 1986, Palazzo Vecchio, *Da El Greco a Goya*, exhibition catalogue, September–December 1986.
Fort Worth (Texas) 1985, Kimbell Art Museum, *Spanish Still Life in the Golden Age: 1600 to 1850*, exhibition catalogue, May–August 1985; see **Toledo** 1985.
Foucart Bruno, see **Chevillot**, 1995.
Frankfurt 1991–1992, Städtische Galerie im Städelschen Kunstinstitut, *Goya und Velázquez. Das Königliche Portrait*, exhibition catalogue, 10 July 1991–1 September 1992.
Fukuoka 1984, Fukuoka Art Museum, *Masterpieces of European Painting from the Museum of Fine Arts*, Boston, exhibition catalogue, January 1984, see **Kyoto** 1984.

Galerie der Starken Frauen (Die), Munich, 1995.
Gállego Julián, *Vision et symboles dans la*

peinture espagnole au Siècle d'or, Paris, 1968; Spanish ed., Madrid, 1972 and 1984.
Gállego Julián, *Diego Velázquez*, Barcelona, 1983.
Gállego Julián, *El cuadro dentro del cuadro*, Madrid, 1984 ; 3rd ed., Madrid, 1991.
Gállego Julián, exhibition catalogue Paris, 1987–1988.
Gállego Julián, exhibition catalogue New York, 1989, Madrid, 1990.
Gállego Julián, *Velázquez*, Madrid, 1994.
Gamonal Torres Miguel Angel, see **Moreno Garrido**, 1988.
Garrido Pérez Carmen, "Technique radiographique grand format applicable in situ sur les tableaux exposés actuellement au Musée du Prado", *ICOM*, Copenhagen, 1985.
Garrido Pérez Carmen, *Velázquez, técnica y evolución*, Madrid, Museo del Prado, 1992.
Garrido Pérez Carmen, **Cabrera** José María, **McKim-Smith** Gridley and **Newman** Richard, "La Fragua de Vulcano. Estudio técnico y algunas consideraciones sobre los materiales y métodos del siglo 17", *Boletín del Museo del Prado*, 1983, iv, no. 11.
Garrido Pérez Carmen, **Dávila** María Teresa and **Dávila** Rocío, "Las hilanderas: Estudio técnico y restauracíon", *Boletín del Museo del Prado*, Madrid, 1986, vii, no. 21.
Garrido Pérez Carmen, **Dávila** Rocío and **Dávila** María Teresa, *Las hilanderas. Proceso de Restauración*, Madrid, 1988.
Garrido Pérez Carmen and **Gómez Espinosa** María Teresa, "Estudio técnico comparativo de los dos retratos de la venerable madre Jerónima de la Fuente", *Boletín del Museo del Prado*, Madrid, 1988, ix, nos. 25–7.
Gassier Pierre, *Goya, témoin de son temps*, Freiburg, 1983.
Gassier Pierre, **Wilson** Juliet, **Lachendal** François, *Goya, Life and Work*, Freiburg, 1971 and Cologne, 1984.
Geneva 1989, musée d'Art et d'Histoire, *Du Greco à Goya: Chefs-d'œuvre du Prado et de collections espagnoles*, exhibition catalogue, June–September 1989.
Gérard Véronique, "Los sitios de devoción en el Alcázar de Madrid: capilla y oratorios", *Archivo Español de Arte*, 1983, lvi, pp. 275–84.
Gérard Véronique, *De castillo a palacio. El Alcázar de Madrid en el siglo 17*, Madrid, 1984.
Gérard Véronique, "Les Ménines de Velázquez", *Beaux-Arts Magazine*, September 1985, no. 27, pp. 64–7.
Girona 1987, Museu d'Història de la Ciutat, *L'època dels genis. Renaixement i Barroc*, exhibition catalogue, 1987.
Glendinning Nigel, "Nineteenth-Century British Envoys in Spain and the Taste for Spanish Art in England", *The Burlington Magazine*, 1989, cxxxi, no. 1031, pp. 117–26.
Goldberg Edward L., "Velázquez in Italy: Painters, Spies and Low Spaniards", *The Art Bulletin*, 1992, lxxiv, no. 3, pp. 453–6.
Gómez Espinosa María Teresa, see **Garrido Pérez**, 1988.

González de Zárate Jesús María, "Una nota sobre el tema de Marte", *Goya*, 1991, no. 221, pp. 296–8.

González de Zárate Jesús María, exhibition catalogue, Frankfurt, 1991–1992.

González Muñoz Carmen, "Datos para un estudio de Madrid en la primera mitad del siglo 17", *Anales del Instituto de Estudios Madrileños*, 1981, 18, pp. 149–91.

Haraszti-takács Marianna, *Spanish Genre Painting in the Seventeenth Century*, Budapest, 1983.

Harris Enriqueta, "G.B. Crescenzi, Velázquez and the "Italian"Landscapes for the Buen Retiro", *The Burlington Magazine*, 1980, cxxii, pp. 562–4.

Harris Enriqueta, "Velázquez and His Ecclesiastical Benefice", *The Burlington Magazine*, 1981₁, cxxiii, no. 935, pp. 95–6.

Harris Enriqueta, "Velázquez and the Villa Medici", *The Burlington Magazine*, 1981₂, cxxiii, no. 942, pp. 537–41.

Harris Enriqueta, "Review of José López-Rey, *Velázquez. The Artist as Maker*", *The Burlington Magazine*, 1981₃, cxxiii, no. 942, pp. 555–6.

Harris Enriqueta, *Velázquez*, Oxford, 1982 ; Spanish ed., Vitoria-Gasteiz, 1991.

Harris Enriqueta, see **Bull**, 1986.

Harris Enriqueta, "*Las Meninas* at Kingston Lacy", *The Burlington Magazine*, 1990, cxxxii, no. 1043, pp. 125–30.

Harris Enriqueta, see **Colomer**, 1994.

Harris Enriqueta and **Lank** Herbert, "The Cleaning of Velázquez's Portrait of Camillo Massimi", *The Burlington Magazine*, 1983, cxxv, no. 964, pp. 410–15.

Haskell Francis and **Penny** Nicholas, *Taste and the Antique. The Lure of Classical Sculpture, 1500-1900*, New Haven and London, 1981.

Hernández Guardiola Lorenzo, "La *tentación de Santo Tomás de Aquino* de Velázquez: estudio iconológico", *Boletín del Museo e Instituto "Camón Aznar"*, 1990, xl, pp. 95–100.

Herrera Javier, "El Joven Picasso en el Museo del Prado", *Boletín del Museo del Prado*, 1994, xv, no. 33, p. 61.

Hobhouse Janet, "Power and Flesh", *Artnews*, November 1989, pp. 112–15.

House John, exhibition catalogue, Melbourne, 1994, Sydney, 1995.

Hoving Thomas, *La Venus del Espejo*, Madrid, 1990.

Ingamells John, *The Wallace Collection. Catalogue of Pictures. i. British, German, Italian, Spanish*, London, 1985.

Izquierdo Rocío, **Muñoz** Valme, *Museo de Bellas Artes. Inventario de Pinturas*, Sevilla, 1990.

Jordan William B., "Velázquez's *Portrait of don Pedro de Barberana*", *Apollo*, 1981, cxiv, no. 238, pp. 378–9.

Jordan William B., exhibition catalogue, Fort Worth (Texas), Toledo (Ohio), 1985.

Jordan William B., exhibition catalogue, London, 1995.

Kagan Richard L., see **Brown**, 1987.

Kahr Madlyn M., "Velázquez's *Las Hilanderas*: A New Interpretation", *Art Bulletin*, 1980, lxii, pp. 376–85.

Karge Henrik, under the direction of, *Vision oder Wirklichkeit. Die Spanische Malerei der Neuzeit*, Munich, 1991.

Kauffmann C.M., *Catalogue of Painting in the Wellington Museum*, London, 1982.

Kinkead Duncan T., "Tres bodegones de Diego Velázquez en una colección sevillana del siglo 17", *Archivo Español de Arte*, 1979, lii, no. 205, p. 185.

Kinkead Duncan T., "The Picture of Don Nicolás Omazur", *The Burlington Magazine*, 1986, cxxviii, pp. 132–46.

Kitaura Yasunari "¿Qué aprendío Velázquez en su primer viaje por Italia?", *Archivo Español de Arte*, 1989, lxii, no. 248, pp. 435–54.

Kubler George, "The 'Mirror' in *Las Meninas*", *Art Bulletin*, 1985, lxvii, p. 316.

Kyoto 1984, Kyoto Municipal Museum of Art, exhibition catalogue, February–April 1984, see **Fukuoka** 1984.

Lachendal François, see **Gassier**, 1971 and 1984.

Laing Alastair, *In Trust for the Nation. Painting from National Trust Houses*. London, 1995.

Lank Herbert, see **Harris**, 1983.

Leningrad 1984, Museum of the Hermitage, *Murillo and the Andalusian painters of the 17th century in the collections of the Hermitage*, exhibition catalogue, 1984.

León Aurora, *Los Fondos de arquitectura en la pintura barroca sevillana*, Sevilla, 1984.

León Tello Francisco José and **Sanz** María Virginia, *Estética y teoría de la arquitectura en los tratados españoles del siglo 18*, Madrid, 1994.

Liedtke Walter A. and **Moffitt** John F., "Velázquez, Olivares, and the Baroque Equestrian Portrait", *The Burlington Magazine*, 1981, cxxiii, no. 942, pp. 529–37.

Lima 1985, Casa de Osambela, *El Siglo de Oro de la pintura sevillana*, exh. catalogue, 1985.

Lipschutz Ilse Hempel, *Spanish Painting and the French Romantics*, Harvard, 1972; Spanish ed., Madrid, 1988.

Lleó Cañal Vicente, "The Art Collection of the ninth Duke of Medinaceli", *The Burlington Magazine*, 1982, cxxxi, no. 1031, pp. 108–16.

London 1981, National Gallery, *El Greco to Goya. The Taste for Spanish Painting in Britain and Ireland*, exhibition catalogue, 1981.

London 1995, National Gallery, *Spanish Still Life from Velázquez to Goya*, exhibition catalogue, London, 22 February–21 May 1995; Spanish translation, Madrid, 1995.

López-Rey José, *Velázquez, The Artist as a Maker*, Lausanne-Paris, 1979; French edition, Lausanne-Paris, 1981.

López-Rey José, "On Velázquez's Portraits of Jesters at the Buen Retiro", *Gazette des Beaux-Arts*, 1981, xcvii, pp. 163–6.

López-Rey José, "Retrato atribuido a Velázquez", *Archivo Español de Arte*, 1982, lv, pp. 316–17.

López-Rey José, "Velázquez: A partial Portrait", *Apollo*, 1983, cxviii, no. 258, pp. 192–3.

López-Rey José, "Nombres y nombradía de Velázquez", *Gazette des Beaux-Arts*, 1990₁, cxvi, July–August, pp. 1–8.

López-Rey José, see *Velázquez y el arte de su tiempo*, 1990₂.

López-Rey José, *Velázquez, Painter of Painters* (I) et *Velázquez. Catalogue raisonné* (II), Cologne, 1996.

López Torrijos Rosa, *La Mitología en la pintura española del Siglo de Oro*, Madrid, 1985.

Los Paisajes del Prado, Various Authors, Madrid, Fundación Amigos del Prado, 1993.

Lugano 1985, Villa Favorita, Thyssen-Bornemisza Foundation, *Capolavori da Musei ungheresi*, exhibition catalogue, 15 June–15 October 1985.

Luna Juan J., "Velázquez, las pinturas que no están en el Prado", *El País*, 24 March 1990, *Artes*, p. 2.

Lynch John, *Spain Under the Habsburgs*, 2nd ed., Oxford, 1981, 2 vol.

McKim-Smith Gridley, "On Velázquez's Working Method", *Art Bulletin*, December 1979, pp. 589–603.

McKim-Smith Gridley, see **Newman**, 1982.

McKim-Smith Gridley, see **Garrido Pérez**, 1983.

McKim-Smith Gridley, **Andersen-Bergdoll** Greta and **Newman** Richard, technical photographs by A. **Davidharzy**, *Examining Velázquez*, New Haven and London, 1988.

McKim-Smith Gridley, Newman Richard, *Ciencia e historia del arte. Velázquez en el Prado*. Madrid, 1995.

Madrid 1981–1982₁, Palacio de Velázquez, *El Arte en la época de Calderón*, exhibition catalogue, December 1981–January 1982.

Madrid 1981–1982₂, Museo del Prado, *Pintura española de los siglos 16 al 18 en colecciones centroeuropeas*, exhibition catalogue, December 1981–January 1982.

Madrid 1982₁, Museo del Prado, *El Greco de Toledo*, exhibition catalogue, April-June 1982.

Madrid 1982₂, Museo del Prado, *Murillo (1617–1682)*, exhibition catalogue, October–December 1982.

Madrid 1983–1984, Palacio de Bibliotecas y Museos, *Pintura española de Bodegones y Floreros de 1600 a Goya*, exhibition catalogue, November 1983–January 1984.

Madrid 1986₁, Palacio de Villahermosa, *Carreño, Rizi, Herrera y la pintura madrileña de su tiempo (1650–1700)*, exhibition catalogue, January–March 1986.

Madrid 1986₂, Museo del Prado, *Monstruos, enanos y bufones en la Corte de los Austrias*, exhibition catalogue, 20 June–31 August 1986.

Madrid 1987, Real Academia de Bellas Artes de San Fernando, *Tesoros de las colecciones particulares madrileñas: Pintura desde el siglo 15 a Goya*, May–June 1987.

Madrid 1990, Museo del Prado, *Velázquez*, exhibition cat., 23 January–31 March 1990.

Madrid 1994, Museo del Prado, Palacio Real, Calcografía Nacional, Real Academia de Bellas Artes de San Fernando, Fundación Carlos de Amberes, "La Pintura en el Alcázar", *El Real Alcázar de Madrid. Dos siglos de arquitectura y coleccionismo en la corte de los Reyes de España*, exhibition catalogue, Madrid, September–November 1994.

Madrid 1995, Museo del Prado, *La Belleza de lo real. Floreros y Bodegones españoles en el Museo del Prado*, 1600–1800, 21 July–29 October 1995.

Madrid, 1996, Museo del Prado, *Velázquez, el papa Inocencio X*, exhibition catalogue, January–February 1996.

Magnusson T., *Rome in the Age of Bernini*, Stockholm, 1986, 2 vols.

Maravall José A., *Velázquez y el espíritu de la modernidad*, Madrid, 1960 and 1987.

Maravall José A., *La cultura del barroco: Análisis de una estructura histórica*, 3rd ed., Madrid, 1983; English ed., Minneapolis, 1986.

Marinas Christine, see Baticle, 1981.

Marini Mauricio, *Velázquez*, Art e Dossier, 1994, no. 94.

Martín González Juan J., "El Panteón de El Escorial y la arquitectura barroca", *Boletín del Seminario de Estudios de Arte y Arqueología, Universidad de Valladolid*, 1981, xlvii, pp. 265-84.

Martín González Juan J., *El Artista en la Sociedad española del Siglo 17*, Madrid, 1984.

Martín González Juan J., "Velázquez y la literatura", *Aspectos del Barroco en el ámbito de Carreño*, Avilés, 1985.

Martínez Ripoll Antonio, "El 'San Juan Evangelista en la isla de Patmos', de Velázquez, y sus fuentes de inspiración iconográfica", *Areas, Revista de Ciencias Sociales*, 1983, nos. 3–4, pp. 201–08.

Matilla Tascón Antonio, *Archivo histórico de protocolos de Madrid. Indice de Testamentos y documentos afines*, Madrid, 1980.

Melbourne 1994, National Gallery of Victoria, *Renoir, Master Impressionist*, exhib. cat., 18 September–30 October 1994; see Sydney 1995.

Mena Marqués Manuela, "La imagen de la mujer en la pintura española en comparación con la pintura italiana", *La imagen de la mujer en el arte español*, Madrid, 1984[1].

Mena Marqués Manuela, "La restauración de Las Meninas de Velázquez", *Boletín del Museo del Prado*, 1984[2], v, no. 14, pp. 87-107.

Milan 1993, Palazzo della Permanente, *L'Europa della pittura nel 18 secolo. 80 Capolavori dai musei ungheresi*, exhibition catalogue, April–May 1993.

Mirbeau Octave, *Combats esthétiques*. i : *1872–1892* ; ii : *1893–1914*, Paris, 1993.

Moffitt John F., see Liedtke, 1981.

Moffitt John F., *Velázquez, Práctica e idea: Estudios dispersos*, Málaga, 1991.

Monestier Martin and Poher Alain, *Annuaire international des œuvres et objets d'art volés*, Paris, 1991.

Montagu Jennifer, "Velázquez Marginalia: His Slave Juan de Pareja and His Illegitimate Son Antonio", *The Burlington Magazine*, 1983, cxxv,

no. 968, pp. 683–5.

Móran Miguel and Rudolf Karl, "Nuevos documentos en torno a Velázquez y las Colecciones Reales", *Archivo Español de Arte*, 1992, lxv, nos. 259–260, pp. 289–302.

Morán Turina José Miguel and Checa Fernando, "Las colecciones pictóricas del Escorial y el gusto italiano", Goya, 1984, no. 179, pp. 252–61.

Morán Turina José Miguel and Checa Fernando, *El coleccionismo en España. De la cámara de maravillas a la galería de pinturas*, Madrid, 1985.

Moreno Garrido Antonio and Gamonal Torres Miguel Angel, *La Familia Real a través de un epistolario de Felipe IV*, Madrid, 1988.

Mulcahy Rosemarie, *Spanish Paintings in The National Gallery of Ireland*, Dublin, 1988.

Munich 1982, Hans der Kunst, *Von el Greco bis Goya*, exhibition catalogue, Vienna, 1982.

Museo del Prado, *Catálogo de las pinturas*, introduction de Alfonso E. Pérez Sánchez, Madrid, 1985.

Museo del Prado, *Inventario General de Pinturas, i. La Colección Real*, Madrid, 1990.

Museo del Prado, *Inventario General de Pinturas, ii. El Museo de la Trinidad*, Madrid, 1991.

Nagoya 1992, City Art Museum, *Pintura española de bodegones y floreros*, exhibition catalogue, April-May 1992; see Tokyo, 1992.

Newman Richard and McKim-Smith Gridley, "Observations on the Materials and Painting technique of Diego Velázquez", *The American Institute for Conservation of Historic and Artistic Works. Preprints of Papers Presented at the Tenth Annual Meeting*, Milwaukee (Wisconsin), 26–30 May 1982.

Newman Richard, see Garrido Pérez, 1983.

Newman R., see McKim-Smith, 1988 and 1993.

New York 1981, Wildenstein, *Masterworks from the John and Mable Ringling Museum of Art*, exhibition catalogue, 1 April–8 May 1981.

New York 1987, Wildenstein, *A Selection of Spanish Masterworks from the Meadows Museum*, exhibition catalogue, 30 September–30 October 1987.

New York 1989–1990, The Metropolitan Museum of Art, *Velázquez*, exhibition catalogue, 3 October 1989–7 January 1990.

New York 1993, The IBM Gallery of Science and Art, *Master European Paintings from the National Gallery of Ireland: Mantegna to Goya*, exhibition catalogue, April–June 1993.

Núñez Ortiz de Zárate Dorleta, "*El elogio de la mujer* de Coornhert y su incidencia en las *Hilanderas* de Velázquez", *Archivo Español de Arte*, 1990, lxiii, no. 250, pp. 326–30.

Orso Steven N., "A Lesson Learned: *Las Meninas* and the State Portraits of Juan Carreño de Miranda", *Record of the Art Museum* (Princeton University), 1982, xli (2), pp. 24–34.

Orso Steven N., "On the origin of Velázquez's *Coronation of the Virgin*, Source", *Notes in the*

History of Art, 1984, 4 (1), pp. 36–40.

Orso Steven N., *Philip IV and the Decoration of the Alcázar of Madrid*, Princeton (New Jersey), 1986.

Orso Steven N., *Velázquez. Los Borrachos and Painting at the Court of Philip IV*, Cambridge (Mass.), 1993.

Otras Meninas (collection of articles on various specialisms), Madrid, 1995.

Páez Rios Elena, *Repertorio de grabados españoles*, iii, Madrid, 1983.

Paris 1987–1988, musée du Petit Palais, *Cinq siècles d'art espagnol*, [1], *De Greco à Picasso*, exhibition cat., 10 October 1987–3 January 1988.

Paris 1991, musée du Louvre, *Dessins espagnols. Maîtres des 16e et 17e siècles*, exhibition catalogue, 18 April–22 July 1991, p. 54 ; see Pérez Sánchez Alfonso E.

Paris 1993, Salon des Indépendants, Galeries nationales du Grand-Palais, *Le Triomphe du trompe-l'œil. Histoire du trompe-l'œil dans la peinture occidentale du 6e siècle avant j.-c. à nos jours*, exhibition catalogue, November 1993.

Penny Nicholas, see Haskell, 1981.

Pérez Lozano Manuel, "Fuentes y significado del cuadro 'Cristo en casa de Marta y María' de Diego Velázquez", *Cuadernos de Arte e Iconografía*, 1990, iii. 6, pp. 55–65.

Pérez Sánchez Alfonso E., see Angulo Íñiguez, 1977, 1983[2] and 1983[3].

Pérez Sánchez Alfonso E., "Un lienzo de Vicente Carducho, identificado", *Boletín del Museo del Prado*, 1980[1], i, no. 3, pp. 159–62.

Pérez Sánchez Alfonso E., *El dibujo español de los Siglos de Oro*, Madrid, 1980[2].

Pérez Sánchez Alfonso E., exhibition catalogue, Madrid 1981–1982[2].

Pérez Sánchez Alfonso E., exhibition catalogue, Madrid, 1982[1].

Pérez Sánchez Alfonso E., exhibition catalogue, Madrid, 1983–1984.

Pérez Sánchez Alfonso E., exhibition catalogue, Madrid, 1986[1].

Pérez Sánchez Alfonso E., exhibition catalogue, Madrid, 1986[2].

Pérez Sánchez Alfonso E., *Historia del dibujo en España de la Edad Media a Goya*, Madrid, 1986[3].

Pérez Sánchez Alfonso E., *La Nature morte espagnole du 17e s. à Goya*, Paris, 1987.

Pérez Sánchez Alfonso E., exhibition catalogue, New York, 1989, Madrid, 1990.

Pérez Sánchez Alfonso E., exhibition catalogue, Rome, 1990–1991.

Pérez Sánchez Alfonso E., exhibition catalogue, Paris, 1991.

Pérez Sánchez Alfonso E., "Miscelanea seiscentista", *Cinco siglos de Arte en Madrid* (15–20), Madrid, 1991.

Pérez Sánchez Alfonso E., *Pintura barroca en España*, 1600–1750, Madrid, 1992.

Pérez Sánchez Alfonso E., exhibition catalogue, Madrid, 1994.

Pérez Sánchez Alfonso E., *La Pittura in Europa. La Pittura spagnola*, Milan, 1995, ii, pp. 336–49; Spanish ed., Madrid, 1995.

Pérez Sánchez Alfonso E., 1995–1996, see **Seville** 1995–1996.

Pillsbury Edmund, "Recent painting acquisitions: The Kimbell Art Museum", *The Burlington Magazine*, 1982, cxxiv, no. 946, supplement, pp. i–viii.

Pita Andrade José Manuel, *Velázquez*, Madrid, 1976.

Pita Andrade José Manuel, exhibition catalogue, Paris, 1987–1988.

Pita Andrade José Manuel, **Borobia Guerrero** María del Mar, *Maestros Antiguos del Museo Thyssen-Bornemisza*, Madrid, 1992; English ed., Madrid, 1992.

Poher Alain, see **Monestier**, 1991.

Quesada Luis, *La Vida cotidiana en la pintura andaluza*, Sevilla, 1992.

Rayón Fernando, "El caso J.B. ¿Verdadero o falso?", *Suplemento El Semanal*, 14 January 1996, pp. 35–50.

Reflexiones sobre Velázquez, Curso de Verano de la Universidad complutense (Escurial, 27–31 August 1991), published by the Real Academia de San Fernando, Madrid, 1992.

Rodríguez G. de Ceballos Alfonso, "Fuentes iconográficas y literarias del cuadro de Velázquez 'Cristo y el alma cristiana'", *Coloquios de Iconografía* [31 May–2 June 1990], *Cuadernos de Arte e Iconografía*, 1991, iv, 7, pp. 82–90, Lam. xlii–xliii.

Rome 1990–1991, Accademia Spagnola di Storia, Archeologia e Belle Arti, *Capolavori dal Museo d'Arte della Catalogna*, 22 October 1990–2 January 1991, no. 11, pp. 52-3.

Rome 1991-1992, Palazzo delle Esposizioni, *La Pittura madrilena del secolo xvii*, exhibition catalogue, December 1991–January 1992.

Rome 1994–1995, Villa Medicis, *Roma, 1630. El trionfo del pennello*, exhibition catalogue, October 1994–January 1995.

Rudd Peter, "Reconstructing Monet's *Velázquez in his studio*", *The Burlington Magazine*, 1994, cxxxvi, no. 1100, pp. 747–51.

Rudolf Karl, see **Móran**, 1992.

Salas Vázquez Eduardo, see **Aguerri Martínez**, 1989.

San Francisco (California) 1992, The Fine Arts Museum, September-December 1992, see **Chicago** (Illinois) 1992.

Sánchez Portas Javier, "El Santo Tomás de Velázquez del Museo Diocesano de Orihuela", *Ars Longa. Cuadernos de Arte*, Departamento de Historia del Arte de la Universidad de Valencia, 1990, i, pp. 57–63.

Sancho José Luis, *Monasterio de San Lorenzo El Real de El Escorial. Guía de Visita*, Madrid, 1994.

Sanz María Virginia, see **León Tello**, 1994.

Saragossa 1992, Museo Pablo Gargallo, *Goya*, exhibition catalogue, 18 June–18 October 1992.

Schneider Norbert, *L'Art du Portrait*, Cologne, 1994.

Searle John R., "*Las Meninas* and the Paradoxes of Pictorial Representation", *Critical Inquiry*, 1980, 6, no. 3, pp. 477–88.

Sebastián Santiago, "Lectura iconográfico-iconológica de 'La Fragua de Vulcano'", *Traza y Baza*, 1983, 8, pp. 20–7.

Sebastián Santiago, "Nueva lectura de 'Las Hilanderas'. La emblemática como clave de su interpretación", *Revista Fragmentos*, 1984, no. 1, pp. 45–51.

Sebastián Santiago, "Nueva lectura de *Las Meninas*: un retrato emblemático y pedagógico", *Lecturas de Historia del Arte*, Ephialte, 1989, i, pp. 187-207.

Serrera Juan Miguel, see **Valdivieso**, 1985.

Serrera Juan Miguel, "El Palacio como taller y el taller como Palacio. Una reflexión más sobre las *Meninas*", Actes du congrès *Madrid en el contexto de lo hispánico desde la época de los descubrimientos*, Madrid, 1994, i, pp. 585–601.

Seseña Natacha, "Los Barros y las lozas que pintó Velázquez", *Archivo Español de Arte*, 1991, xliv, no. 254, pp. 171–9.

Seville 1983–1984, Museo de Artes y Costumbres populares, *Sevilla en el siglo 17*, exhibition cat., December 1983–January 1984.

Seville 1991–1992, Hospital de los Venerables Sacerdotes, *La Pintura Sevillana de los Siglos de Oro*, exhibition catalogue, November 1991–January 1992.

Seville 1992, Exposición Universal de Sevilla 1992, Pabellón de España, *Tesoros del Arte Español*, exhibition catalogue, April–October 1992.

Seville 1995–1996, Hospital de Los Venerables, *Tres siglos de dibujo sevillano*, 30 November 1995–11 February 1996.

Sharp Young Mahori, "Santiago: a Golden Legend", *Apollo*, December 1989, vol. cxxx, no. 334, pp. 420–2.

Snyder Joel and **Cohen** Ted, "Critical Response. Reflexions on *Las Meninas*: Paradox Lost", *Critical Inquiry*, 1980, 7, no. 2, pp. 429–47.

Sonnenburg Hubert von, "A note on the Dimensions of *Juan de Pareja*", *The Metropolitan Museum of Art Bulletin*, winter 1993–1994, pp. 26–31.

Sotomayor Roman Francisco, "Materiales para una iconografía de *Las Hilanderas y Los Borrachos*, de Velázquez", *Cuadernos de Arte e Iconografía*, 1990, iii, 5, pp. 55–69.

Stoichita Victor I., "Imagen y aparición en la pintura española del Siglo de oro y en la devoción popular del nuevo mundo", *Norba-Arte*, 1992, xii, pp. 83–101.

Stoichita Victor, *L'Instauration du Tableau: Metapeinture à l'aube des temps modernes*, Paris, 1993.

Stoichita Victor, *Visionary Experience in the Golden Age of Spanish Art*, London, 1995.

Stratton Suzanne, *The Immaculate Conception in Spanish Renaissance and Baroque Art*, Ph.D. Diss., N.Y.U., 1983; Spanish ed. in: *Cuadernos de Arte e Iconografía*, 1988, i, no. 2, pp. 3–127; English ed., *The Immaculate Conception in Spanish Art*, Cambridge, 1994.

Stratton Suzane L., *Spain, Espagne, Spanien. Foreign Artists Discover Spain 1800—1900*, New York, 1993.

Sutton Denys, exhibition cat., New York, 1981.

Sutton Denys, "Velázquez: Magicien du pinceau", *L'Œil*, 1990, no. 416, pp. 28–35.

Sydney 1995, The Art Gallery of New South Wales, 11 May–15 January 1995; see **Melbourne** 1994.

Taylor René, "Juan Bautista Crescencio y la arquitectura cortesana española", *Academia*, 1979, no. 48, pp. 63–126.

Thierry Solange, "À propos d'une Immaculée Conception de Diego Velázquez", *L'Œil*, 1994, no. 464, pp. 36–47.

Tokyo 1983, Isetan Museum of Art, *Masterpieces of European Painting from the Museum of Fine Arts*, Boston, exhibition catalogue, October–December 1983.

Tokyo 1992, The National Museum of Western Art, February–April 1992; see **Nagoya** 1992.

Toledo (Ohio) 1985, Toledo Museum of Art, September–November 1985; see **Fort Worth** (Texas) 1985.

Vahlne Bo, "Velázquez' *Las Meninas*. Remarks on the Staging of Royal Portrait", *Konsthistorisk Tidskrift*, 1982, li, pp. 21–8.

Valdivieso Enrique, *Historia de la Pintura Sevillana*, Seville, 1986.

Valdivieso Enrique, "Pintura", dans *Museo de Bellas Artes de Sevilla*, Seville, 1991.

Valdivieso Enrique, exhibition catalogue, Seville, 1991–1992.

Valdivieso Enrique and **Serrera** Juan Miguel, *Historia de la Pintura Española. Escuela sevillana del primer tercio del siglo 17*, Madrid, 1985.

Valverde Madrid José, "Don Pedro de Berberana retradado por Velázquez", *Boletín del Museo e Instituto "Camón Aznar"*, 1990, xl, pp. 43–53.

Velázquez y el arte de su tiempo, V Jornadas de Arte, colloquium organized by the Departamento de Arte "Diego Velázquez" du Centro de Estudios Históricos du C.S.I.C. (Madrid, 10–14 December 1990), Madrid, 1991.

Véliz Zahira, *Artists' Techniques in Golden Age Spain: Six Treatises in Translation*, New York, 1986.

Venice 1993, Fondazione Giorgio Cini, *Da Velázquez a Murillo. Il "siglo de oro" in Andalusia*, exhibition catalogue, 27 March-27 June 1993.

Vienna 1982, Kunstherhaus; see **Munich** 1982.

Volk Mary C., "On Velázquez and the Liberal Arts", *Art Bulletin*, 1978, lx, pp. 69–86.

Warsaw 1990, Royal Castle, *Opus Sacrum. Catalogue of the Exhibition from the Collection of Barbara Piasecka Johnson*, exhibition catalogue, 1990.

Wilson Juliet, see **Gassier**, 1971 and 1984.

Wind Barry, *Velázquez's Bodegones: A Study in Seventeenth-Century Genre Painting* Fairfax (Virginia), 1987.

Index
of proper names

A

Acedo Don Diego de, 133, 136, 144.
Aertsen Peter, 29, 38, 41.
Aesop, 124, 125.
Aguiar Tomás de, 187.
Alcalá, Duke of, 30.
Alemán Mateo, 129.
Alexander VII, Pope, 220.
Alfaro Juan de, 77, 175, 176, 186, 187, 189.
Algardi Alessandro, 174.
Alisal José Casado del, 96.
Angulo Íñiguez Diego, 160.
Arce Pedro de, 160.
Aretino Pietro, 102.
Arpino Giuseppe d', 218.
Arroyo-Bischop Daniel, 7.
Astalli Cardinal, 178, 183.
Austria Juan de (son of Charles V), 130.

B

Bacon Francis, 183.
Baltasar Carlos Prince, 74, 80, 84, 89, 91, 93, 96, 100, 101, 102, 106, 116, 119, 120, 122, 125, 169, 170, 185, 186, 188, 194, 204, 207, 208, 209, 211, 225.
Barbari Daniello, 82.
Barbarioja, see Castañeda
Barberana Pedro de, 88, 89, 106, 111, 147.
Barberini Cardinal Francesco, 48, 175.
Bardi P.M., 18.
Bassano Jacopo, 29, 46, 80, 169.
Bedmar Marquis of, 175.
Benavente, Count of, 47.

Benavente y Benavides, Don Cristóbal, 71.
Bernini, 57, 149, 175, 176.
Beruete Aureliano de, 82, 89, 101, 106, 125, 155, 163, 183, 203, 211.
Beuckelaer Joachim, 23, 38, 41.
Bocángel Gabriel de, 137, 170, 187.
Borgianni Orazio, 47.
Borja Cardinal Gaspar de, 188.
Boschini Mario, 173, 175, 178, 179.
Bracamonte Gaspar de, 52, 59.
Burgos Mantilla Francisco de, 186, 187, 220.

C

Calabazas, 62, 84, 126, 129, 130, 132.
Calderón de la Barca Pedro, 14, 108.
Callot Jacques, 134.
Cambiaso Luca, 47, 80, 81.
Cano Alonso, 219, 220.
Caravaggio, 22, 29, 30, 31, 47, 48, 66.
Carducho Bartolomé, 47.
Carducho Vincencio, 33, 46, 47, 48, 51, 59, 60, 61, 62, 63, 64, 80, 93, 108, 116, 147, 175, 184, 189.
Carlos Infante Don, 54, 58, 69, 71, 88, 91.
Carpio Marquis of, 133, 134, 140, 169.
Carracci, 47, 48.
Carracci Agostino, 75.
Carreño de Miranda Juan, 100, 185, 220, 222.
Castagno Andrea del, 100.
Castañeda Don Cristóbal de, 132, 134, 147.
Castello Felix, 62, 93, 218.
Castillo Antonio del, 175.
Caturla María Luisa, 160.
Caxés Eugenio, 46, 47, 51, 59, 60, 61, 62, 63, 93, 116.
Caxés Patricio, 47.
Cervantes Miguel de, 35.
Charles I of England, 52, 64, 219.
Charles II of Spain, 110, 119, 125, 185.
Charles V, 58, 100, 102, 130, 200, 222.
Cincinato Diego de Romulo, 219.
Colonna Michele, 178, 222.
Corral Diego del, 88, 89, 91.
Correggio, 173.
Cortona Pietro da, 175.
Cotán, see Sánchez Cotán.
Crescenzi Giovanni Battista, 62.
Cruzada Villaamil Gregorio, 80, 106.

Cueva Cardinal Alonso de la, 174, 175.
Cuevas Pedro de las, 62, 116, 186.
Curtis Charles, 18.

D

Daguerre Louis Jacques Mandé, 211, 214.
Dalí Salvador, 139.
Díaz Diego Valentín, 226.
Díaz del Valle Lázaro, 186, 207, 221.
Dolce Ludovico, 31.
Donatello, 100.
Dürer Albrecht, 150, 153.
Dyck Anthony Van, 186.

E

Eliche Marquis of, 140, 143, 144, 169.
El Primo, see Acedo,
Escorial, 23, 34, 46, 47, 52, 65, 83, 184, 200, 221, 225.
Este Francesco d', 173, 174, 177.
Eyck Jan Van, 207, 214.

F

Fanelli Giuliano, 174.
Faria y Sousa Manuel de, 187.
Felipe Próspero Prince, 225, 226, 228.
Ferdinand III, Emperor, 73, 116, 169, 193.
Feria Duke of, 191.
Fernández Luis, 96.
Fernández de Araoz, 42.
Fernández de Navarrete Juan, 47.
Fernández Noseret Luis, 189.
Fernando Cardinal Infante Don, 52, 59, 91, 119, 120, 122, 125, 169, 173.
Fonseca Juan de, 46, 52, 53, 59, 122.
Foucault Michel, 214.
Fuensalida Don Gaspar de, 72.
Fuente Marquis de la, 173.

G

Gallegos Manuel, 93, 106, 187.
Garrido Pérez Carmen, 18.
Gerstenberg Kurt, 81, 126.

Giordano Luca, 208.
Góngora Luís de, 46, 51.
González Bartolomé, 46, 51, 59, 61, 62.
Goya Francisco de, 7, 132.
Gracián Baltasar, 105, 187, 220.
Gramont Duke of, 221.
Greco El, 28, 29, 46, 48, 49, 51, 60, 61, 88, 149.
Gudiol José, 18.
Guercino, 72.

H

Hals Frans, 88.
Hamen y Léon Juan Van der, 31, 48, 51, 62, 81.
Herrera Francisco de, the Elder, 23, 24.
Herrera Barnuevo Sebastián de, 220.
Hopton Sir Arthur, 173.
Hugo Hermann, 112.

I

Infantado, Duke of, 178.
Innocent X Pope, 175, 176, 178, 179, 180, 181, 183, 184, 188, 191, 219.
Ipeñarrieta Doña Antonia de, 84, 88, 89.
Isabel Infanta Clara Eugenia, 80, 107, 108, 109.
Isabel Queen, (wife of Philip IV), 51, 80, 84, 88, 93, 100, 101, 143, 169, 185, 187, 188, 200, 209.

J

Jordaens Jacob, 119, 125, 207, 211.
Juan de Austria Don (Jester), 81, 128, 129, 130, 131, 132.
Julius II Pope, 175.
Justi Karl, 211.

L

Lanchares Antonio de, 47, 62.
Le Brun Charles, 224, 229.
Lefranchi Jerónimo, 219.
Lefranchi Onofrio de, 219.
Legasca Bartolomé de, 169.
Le Nain Louis, 77.
Leonardo Jusepe, 96, 116, 189.

Leopold I, Emperor, 225.
Leopold-Wilhelm Duke, 193.
Lezcano Francisco, 119, 126, 129, 131, 132, 133, 134, 144.
Loarte Alejandro de, 30, 47.
Lope de Vega, 48, 60, 116.
Lorrain Claude, 153.
Louis XIV, 221, 224, 225, 226, 229.
Lucena Diego de, 186.
Ludovisi Cardinal Ludovico, 72.
Ludovisi Prince, 175.
Luyck Frans, 75.

M

Madrid, Alcázar, or Royal Palace, 10, 46, 51, 52, 53, 64, 67, 77, 91, 108, 133, 134, 140, 143, 160, 161, 163, 169, 170, 174, 184, 185, 186, 208, 209, 219, 221, 223, 226.
Madrid, Buen Retiro (Palace), 88, 91, 93, 96, 100, 101, 106, 108, 116, 119, 122, 140, 142, 151, 153, 170, 191.
Madrid, Church of San Juan Bautista, 228.
Madrid, Church of San Martin, 143.
Madrid, Church of San Salvador, 170.
Madrid, Prado Royal Palace, 184.
Madrid, Plaza de Oriente, 88.
Madrid, Torre de la Parada, 91, 119, 120, 122, 125, 126, 128, 133, 218.
Maino, Fray Juan Bautista, 46, 48, 54, 62, 93, 96, 100, 106, 108, 110, 143.
Maldachini Olimpia, 176.
Malpica Marquis of, 220.
Mancini Giulio, 29, 30.
Manet Edouard, 7, 10, 132, 133, 150.
Marcus Aurelius, 100.
Margarita Infanta, 184, 191, 193, 194, 199, 204, 207, 208, 209, 211, 214, 216, 225, 226.
Margarita Queen (wife of Philip III), 51, 99, 100, 101.
María Infanta, 30, 52, 73, 75, 79, 80, 81, 169.
Mariana Queen (wife of Philip IV), 170, 184, 185, 193, 194, 199, 207, 208, 209, 214, 216, 221, 225, 226.
María Teresa Infanta, 168, 170, 171, 184, 192, 193, 194, 208, 209, 221, 225, 229.
Marino Giambattista, 35, 51, 128.
Martínez del Mazo Gaspar, 219.
Martínez del Mazo Juan Bautista, 77, 81, 163, 170, 185, 186, 187, 188, 189, 190, 191, 204, 207, 208, 209, 211, 219, 221.
Martínez Montañés Juan, 137,

138, 142, 149, 150, 168.
Martínez Jusepe, 116, 142, 169, 175, 176, 207.
Massimi Camillo, 177, 183.
Mateos Juan, 91, 147.
Matham Jacob, 29.
Mayer August L., 18, 167.
Mazo, see Martínez del Mazo Juan Bautista.
Medici Averardo de, 72.
Medici Francesco de , 93.
Medici Lorenzo de, 126.
Melgar Diego de, 33, 185.
Michelangelo, 25, 28, 48, 61, 72, 77, 88, 122, 126, 160, 189.
Mitelli Agostino, 178, 222.
Molière, 9, 35.
Montañés, see Martínez Montañés.
Monterrey Count of, 72, 73.
Monterrey Countess of, 73.
Morra Sebastián de, 133, 139.
Murillo Bartolomé Esteban, 168, 219.

N

Nájera Duke of, 170, 173.
Nardi Angelo, 60, 61, 62, 63, 116, 220.
Nassau Justinus of, 105, 107, 108, 110, 111, 112.
Navarrete, see Fernández de Navarrete.
Neri Pietro Martire, 176, 184, 185, 191.
Nieto Velázquez José, 209.
Núñez del Valle Pedro, 62.

O

Ojeda Pablo de, 21.
Olivares Count-Duke of, 46, 51, 52, 53, 57, 58, 64, 65, 71, 72, 73, 91, 96, 105, 108, 116, 140, 142, 169, 181, 187, 189, 190, 221.
Oñate Count of, 174, 177.
Orrente Pedro de, 46, 47.
Ortega y Gasset José, 119.
Osuna Duke of, 53.
Ovid, 119, 160, 161, 163, 164, 167, 211.

P

Pacheco Francisco, 21, 22, 23, 24, 25, 28, 29, 30, 31, 33, 34, 35, 41, 43, 45, 46, 51, 52, 54, 59, 60, 61, 62, 64, 65, 71, 72, 73, 75, 77, 79, 80, 81, 100, 101, 102, 111, 122, 190, 219.
Pacheco Juana, 33, 173.
Palacios Francisco de, 186.
Palomino Antonio, 23, 65, 66, 75, 77, 80, 156, 173, 174, 175, 176, 180, 187, 208, 211, 226.
Pamphili, Cardinal, 175.
Pantoja de la Cruz Juan, 34, 59, 83.
Paravicino, Fray Hortensio Félix, 46, 51.
Pareja Juan de, 147, 173, 174, 175, 176, 180, 181, 183, 187.
Pareja Jusepe, 187.
Patinir Joachim, 150, 153.
Pereda Antonio de, 93, 109.
Pérez de Araciel García, 53.
Pérez de Guzmán, Archbishop Alfonso, 228.
Pérez de Moya Juan, 164.
Pertusato Nicolás de, 209.
Phidias, 171.
Philip II, 47, 59, 83, 100, 102, 222.
Philip III, 10, 46, 47, 51, 61, 98, 100, 101, 116, 130, 143, 175, 222, 223.
Philip IV, 34, 46, 50, 51, 52, 53, 54, 56, 57, 58, 61, 62, 63, 64, 65, 69, 72, 74, 77, 80, 84, 88, 89,91, 93, 96, 98, 100, 101, 102, 105, 106, 107, 108, 116, 119, 122, 125, 130, 137, 140, 143, 144, 149, 153, 169, 170, 173, 174, 175, 176, 177, 178, 179, 180, 184, 185, 186, 187, 188, 191, 194, 200, 203, 204, 207, 208, 209, 211, 216, 219, 220, 221, 222, 223, 224, 225, 226, 228, 229.
Picasso Pablo, 7, 211.
Pinturicchio, 153.
Poggi Gemignano, 178.
Pontius Paul, 65.
Porta Giovanni Battista, 126,128.
Poussin Nicolas, 175.
Pozzo Cassiano dal, 51.
Preti Mattia, 175.
Puga Antonio, 96.

Q

Quevedo Francisco de, 35, 69, 71, 109, 187.

R

Raphael, 25, 60, 72, 77, 88, 169, 179, 189.
Ravesteyn Jan Anthonisz Van, 112.
Rembrandt, 88, 128.
Renoir Jean, 7, 88.
Ribera José de, 29, 30, 67, 73, 100, 125, 128, 219, 222.
Rioja Francisco de, 33, 46, 80.
Ripa Cesare, 129, 163, 167, 168.
Rizi de Guevara Francisco, 222.
Rodríguez María, 21.
Rodríguez de Silva Diego, 21.
Rodríguez de Silva Fernando, 21.
Rodríguez de Silva Francisco, 21.
Rodríguez de Silva Juan, 21, 33.
Rodríguez de Silva Roque, 21.
Rodríguez de Silva Silvestre, 21.
Rome, Farnese collection, 81.
Rome, Vatican, 25, 72, 77, 153, 160, 189.
Rome, Villa Ludosivi, 126.
Rome, Villa de' Medici, 25, 70, 72, 73, 77, 81.
Rosa Salvatore, 175, 179.
Rospigliosi Giulio, 179.
Rubens Peter Paul, 47, 53, 58, 62, 64, 65, 66, 77, 88, 100, 101, 102, 119, 125, 126, 128, 143, 144, 161, 163, 186, 207, 209, 211, 219, 222.
Ruis Magdalena, 80.

S

Saavedra Fajardo Diego de, 57, 187, 188.
Sachetti Cardinal Giulio, 71, 72.
Salcedo Corenel García de, 187.
Salomon Bernard, 93.
Sánchez de Viana Pedro, 164.
Sánchez Coello Alonso, 47, 51, 80.
Sánchez Cotán Juan, 29, 46, 48.
Santos Fray Francisco de los, 81.
Sarmiento María, 209.
Segni Cristoforo, 176.
Shakespeare William, 35.
Silva Velázquez Inés de, 219.
Siruela Count of, 187.
Smidt Andrie, 176.
Soplillo, 51, 84.
Sorano Commendatore de, see Medici, Francesco de.
Spada Cardinal Bernardino, 72.
Spínola General Ambrosio, 107, 108, 110, 111, 112, 116.
Stevenson R.A.M., 88.
Stirling William, 211.

T

Tacca Pietro, 88, 137.
Testi Count Fulvio, 173, 174.
Tintoretto, 75, 77, 82, 88, 173, 178, 179, 222.
Titian, 9, 25, 31, 33, 58, 59, 60, 61, 62, 64, 65, 75, 77, 79, 80, 81, 88, 100, 102, 119, 161, 163, 165, 167, 169, 175, 176, 178, 179, 186, 189, 190, 207, 222.
Toledo Fadrique de, 93, 96.
Tolnay Charles de, 164.
Tormo Elías, 93.
Triunfi Flaminia, 176.

U

Uccello Paolo, 100.
Uceda Juan de, 33.
Ulloa Marcela de, 209, 214.
Urban VIII Pope, 72, 108.

V

Vaca de Alfaro Enrique, 187.
Valladolid, Pablo de, 129, 132, 133, 147.
Velasco Isabel de, 209.
Velázquez Francisca, 33, 81, 204, 207.
Velázquez Ignacia, 33.
Velázquez Jerónima, 21.
Velilla Juan de, 71.
Veronese Paolo, 169, 173, 179, 222.
Verrochio, 100.
Viana, see Sánchez de Viana.
Vidal Pedro Antonio, 101, 130.
Villacis Nicolás de, 186.
Villafranca Pedro de, 160, 188, 189, 200, 203.
Villandrando Rodrigo de, 46, 47, 51, 52, 62, 63, 81, 84.
Villanueva Jerónimo de (Protonotary of Aragon), 80.
Vos Paul de, 119, 125.

Z

Zuccaro Federico, 47, 72.
Zurbarán Francisco de, 93, 113, 116, 219, 220.

Photo credits

Summary catalogue

Unless otherwise stated, all works are in oil on canvas.

1 Musical Trio, *1617–1618*
87 x 110 cm
Berlin, Staatliche Museen zu
Berlin – Preussischer Kultur-
besitz, Gemäldegalerie – Inv. 413F

(2) Head of a Young Boy,
1617–1618
Drawing, 21.8 x 16.8 cm
Madrid, private collection
Removed by López-Rey.

3 Three Men at Table, *c. 1618*
108.5 x 102 cm. Saint Petersburg,
Hermitage – Inv. 389

4 Portrait of a Girl, *c. 1618*
Drawing, 20 x 13.3 cm
Madrid, Biblioteca Nacional –
Inv. B 492

5 Head of a Girl, *c. 1618*
Drawing, 15 x 11.7 cm
Madrid, Biblioteca Nacional –
Inv. B 493

6 Old Woman Frying Eggs, *1618*
100.5 x 119.5 cm
Edinburgh, National Gallery of
Scotland – Inv. 2180

**7 Christ in the House of
Martha and Mary,** *1618*
60 x 103.5 cm
London, The Trustees of the
National Gallery – Inv. 1375

**8 Head of a Young Man in
Profile,** c. *1618–1619*
39.5 x 35.8 cm. Saint Petersburg,
Hermitage – Inv. 295

9 Peasants at Table, *1618–1619*
96 x 112 cm
Budapest, Szépmuvészeti
Múzeum – Inv. 3280

10 St. Thomas, *1618–1620*
95 x 73 cm
Orléans, Musée des Beaux-Arts
d'Orléans – Inv. 1556 A

**11 The Immaculate Conception
of the Virgin,** *c. 1619*
135 x 101.6 cm
London, The Trustees of the
National Gallery – Inv. 6424

12 St. John at Patmos, *c. 1619*
135.5 x 102.2 cm
London, The Trustees of the
National Gallery – Inv. 6264

13 The Adoration of the Magi,
1619. 204 x 126.5 cm
Madrid, Museo del Prado –
Inv. 1166

14 St. Paul, *c. 1619–1620*
99 x 78 cm. Barcelona, Museu
Nacional d'Art de Catalunya –
Inv. MNAC/MAC 24242

15 St. Paul (?), *c. 1619–1620*
38 x 29 cm
Madrid, private collection

16 The Waterseller, *c. 1620*
106.7 x 81 cm
London, Apsley House, Welling-
ton Museum, Trustees of the
Victoria and Albert Museum –
Inv. W M 1600–1948

17 The Supper at Emmaus,
c. 1620. 55 x 118 cm
Dublin, National Gallery of
Ireland – Inv. 4538

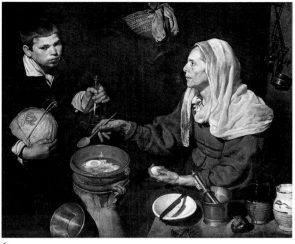
1

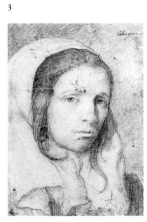
2

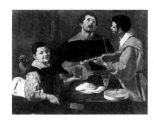
3

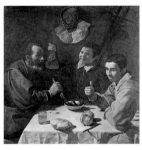
4

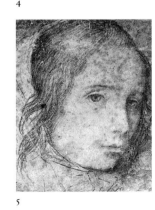
5

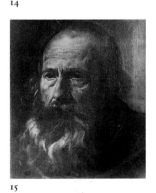
6

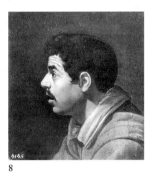
7

8

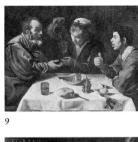
9

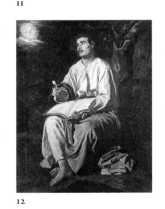
10

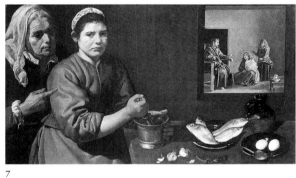
13

14

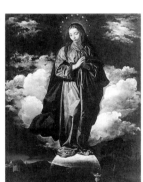
15

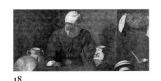
11

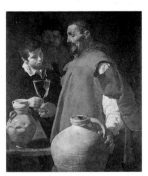
12

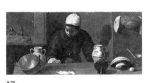
16

17

18

18 The Kitchen Maid, *c. 1620*
55.5 x 104.5 cm
Chicago, The Art Institute of
Chicago, Robert Waller Memor-
ial Fund – 1935–380

19 Don Cristóbal Suárez de
Ribera, *1620*. 207 x 148 cm
Seville, Museo de Bellas Artes
(Depot of the Hermandad de
San Hermenegildo) – Inv. 85

20 Mother Jerónima de la
Fuente, *1620*. 162 x 107.5 cm
Madrid, Museo del Prado –
Inv. 2873

21 Mother Jeronima de la
Fuente, *1620*. 162.5 x 105 cm
Madrid, Fernández de Araóz
collection

22 St. Ildefonso Receiving the
Chasuble from the Virgin,
c. 1620 (?). 166 x 120 cm
Seville, Museo de Bellas Artes
(Depot of Excmo. Ayunta-
miento)

23 Portrait of a Man with a
Goatee (Francisco Pacheco ?),
1620–1622. 41 x 36 cm
Madrid, Museo del Prado –
Inv. 1209

24 Two Young Men at Table,
c. 1622. 65.3 x 104 cm
London, Apsley House, Welling-
ton Museum, Trustees of the
Victoria and Albert Museum –
Inv. 1593

25 Don Luís de Góngora y
Argote, *1622*. 50.3 x 40.5 cm
Boston, Museum of Fine Arts,
Maria Antoinette Evans Fund –
Inv. 32.79

26 Portrait of a Cleric,
1622–1623. 66.5 x 51 cm
Madrid, collection of the heirs
of Joaquín Payá

27 A Young Man (Self-
Portrait ?), *1623–1624*
55.5 x 38 cm
Madrid, Museo del Prado –
Inv. 1224

28 Philip IV, *1623–1624*
61.6 x 48.2 cm
Dallas, Meadows Museum,
Southern Methodist University –
Inv. 67.23

29 Philip IV, Standing, *1624*
200 x 102.9 cm
New York, The Metropolitan
Museum of Art, Bequest of Ben-
jamin Altman – Inv. 14.40.639

30 Count-Duke of Olivares,
1624. 206 x 106 cm
São Paulo, Museu de Arte

31 Portrait of a Lady, *c. 1625*
32 x 24 cm
Unknown location

32 Count-Duke of Olivares,
1622–1627 (?)
216 x 129.5 cm
New York, The Hispanic Soci-
ety of America – Inv. A 104

33 Head of a Stag, *1626–1627*
58 x 44.5 cm
Madrid, Museo del Prado –
Inv. 3253

34 Portrait of a Man,
1626–1628 (?)
104 x 79 cm
Princeton (New Jersey), private
collection

19

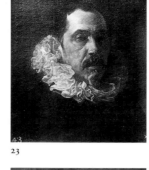

20

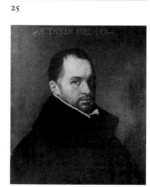

21

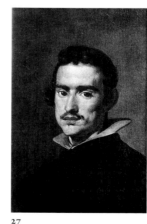

22

23

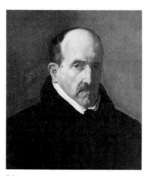

24

25

26

27

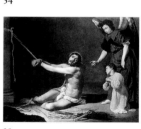

28

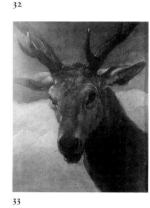

29

30

31

32

33

34

35

35 **Christic and the Christian Soul**, *1626–1628*
165.1 x 206.4 cm
London, The Trustees of the National Gallery – Inv. 1148

36 **Philip IV, Standing,**
painted 1623, painted out 1628
198 x 101.5 cm
Madrid, Museo del Prado – Inv. 1182

37 **The Infante Don Carlos,** *1628*
210.5 x 126.5 cm
Madrid, Museo del Prado – Inv. 1188

38 **Philip IV in Armour,** *c. 1628*
57 x 44.5 cm
Madrid, Museo del Prado – Inv. 1183

39 **The Buffoon Calabazas (Calabacillas),** *c. 1628–1629*
175.5 x 106.7 cm
Cleveland, The Cleveland Museum of Art, Leonard C. Hanna Jr. Bequest – Inv. 65.15

40 **Democritus,** *1628–1629*
101 x 81 cm
Rouen, Musée des Beaux-Arts et de la Céramique – Inv. 822.1.16

41 **Bacchus,** *1628–1629*
165.5 x 227.5 cm
Madrid, Museo del Prado – Inv. 1170

42 **The Supper at Emmaus,** *1628–1629*
123.2 x 132.7 cm
New York, The Metropolitan Museum, Bequest of Benjamin Altman – Inv. 14.40.631

43 **Joseph's Bloody Coat Brought to Jacob,** *1630*
223 x 250 cm
Patrimonio Nacional, Monasterio de San Lorenzo de El Escorial

44 **The Forge of Vulcan,** *1630*
222 x 290 cm
Madrid, Museo del Prado – Inv. 1171

45 **Study for the Head of Apollo in "The Forge of Vulcan",** *1630*
36.3 x 25.2 cm
Japan, private collection

46 **Villa Medici in Rome (Pavillon of Ariadne),** *1630*
44.5 x 38.5 cm
Madrid, Museo del Prado – Inv. 1211

47 **Villa Medici in Rome (Façade of the Grotto-Logia),** *1630*
48.5 x 43 cm
Madrid, Museo del Prado – Inv. 1210

48 **Infanta Doña María, Queen of Hungary,** *1630 (?)*
59.5 x 45.5 cm
Madrid, Museo del Prado – Inv. 1187

49 **A Sibyl (?),** *1630–1631*
62 x 50 cm
Madrid, Museo del Prado – Inv. 1197

50 **Portrait of a Young Man,** *1630–1631*
89.2 x 69.5 cm
Munich, Bayerische Staatsgemäldesammlungen, Alte Pinakothek – Inv. 518

36

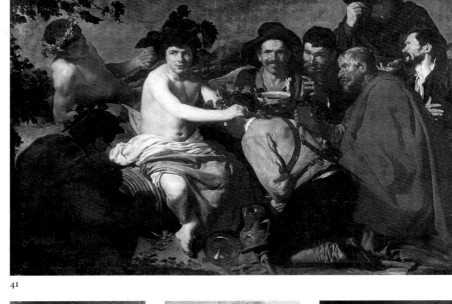

41

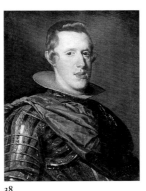

37

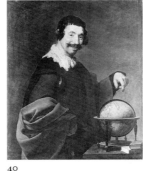

40

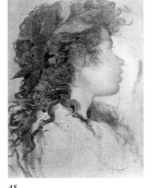

42

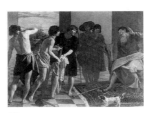

43

44

38

39

45

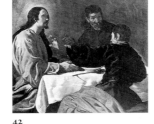

48

46

49

47

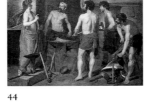

50

51 Prince Baltasar Carlos with a Dwarf, *1631*
128.1 x 102 cm
Boston, Museum of Fine Arts, Henri Lillie Pierce Foundation – Inv. 01.104

52 Philip IV in Brown and Silver, *1631–1632*
199.5 x 113 cm
London, The Trustees of the National Gallery – Inv. 1129

53 Queen Isabel, Standing, *1631–1632*
207 x 119 cm
New York, private collection

54 Doña Antonia de Ipeñarrieta y Galdós with One of her Sons, *1631–1632*
205 x 115 cm
Madrid, Museo del Prado – Inv. 1196

55 Don Diego de Corral y Arellano, *1631–1632*
205 x 116 cm
Madrid, Museo del Prado – Inv. 1195

56
Hand of a Man,
c. 1630
27 x 24 cm
Unknown location

57 Don Pedro de Barberana y Aparregui, *1631–1632*
198.1 x 111.4 cm
Fort Worth, Kimbell Art Museum – Inv. 81.14

58 Don Juan Mateos, *c. 1632*
108.5 x 90 cm
Dresden, Staatliche Kunstsammlungen Dresden, Gemäldegalerie Alte Meister – Inv. 697

59 Christ on the Cross, *c. 1632*
250 x 170 cm
Madrid, Museo del Prado – Inv. 1167

60 Prince Baltasar Carlos, *1632*
117.8 x 95.9 cm
London, Hertford House, Wallace Collection – Inv. P 12

61 Philip IV, *1632*
Velázquez & Atelier
127.5 x 86.5 cm
Vienna, Kunsthistorisches Museum – Inv. 314

62 Queen Isabel, *1632*
Velázquez & Atelier
132 x 101.5 cm
Vienna, Kunsthistorisches Museum – Inv. 731

63 Philip IV as a Hunter,
c. 1632–1633
189 x 124.5 cm
Madrid, Museo del Prado – Inv. 1184

64 The Cardinal Infante Don Fernando as a Hunter,
c. 1632–1633
191.5 x 108 cm
Madrid, Museo del Prado – Inv. 1186

65 The Buffoon Don Juan de Austria, *1632–1633*
210 x 124.5 cm
Madrid, Museo del Prado – Inv. 1200

66 Count-Duke of Olivares on Horseback, *1634*
314 x 240 cm
Madrid, Museo del Prado – Inv. 1181

51

52

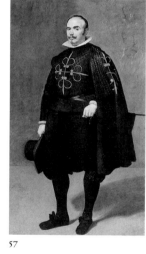

53

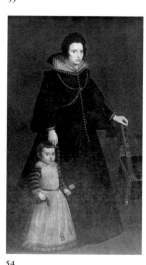

54

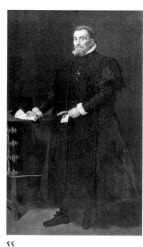

55

56

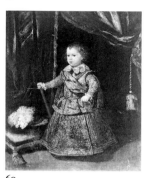

57

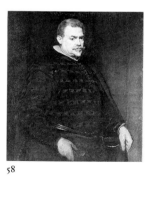

58

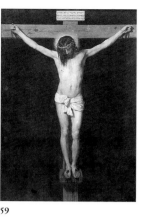

59

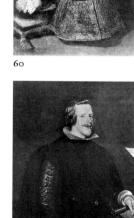

60

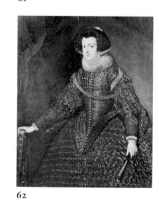

61

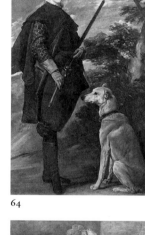

62

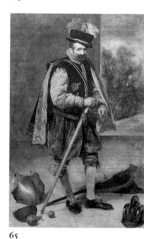

63

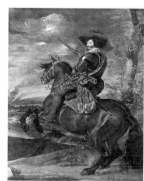

64

65

66

67 A White Horse, *c. 1634–1635*
310 x 245 cm
Madrid, Patrimonio Nacional,
Palacio Real

68 Philip III on Horseback,
c. 1634–1635. 305 x 320 cm
Madrid, Museo del Prado –
Inv. 1176

**69 Queen Margarita on Horse-
back,** *1634–1635.* 302 x 311.5 cm
Madrid, Museo del Prado –
Inv. 1177

**70 Queen Isabel on Horse-
back,** *1634–1635.* 304.5 x 317.5 cm
Madrid, Museo del Prado –
Inv. 1179

71 Philip IV on Horseback,
1634–1635. 303.5 x 317.5 cm
Madrid, Museo del Prado –
Inv. 1178

**72 Prince Baltasar Carlos on
Horseback,** *1634–1635*
209.5 x 174 cm
Madrid, Museo del Prado –
Inv. 1180

**73 The Surrender of Breda
(Las Lanzas),** *1634–1635*
307.5 x 370.5 cm
Madrid, Museo del Prado –
Inv. 1172

**74 Study for "The Surrender of
Breda",** *1634–1635*
Drawing, 26.2 x 16.8 cm
Madrid, Biblioteca Nacional –
Inv. B. 491

**75 Study for the Figure of
Spinola in "The Surrender of
Breda",** *1634–1635*
Drawing, 26.2 x 16.8 cm
Madrid, Biblioteca Nacional –
Inv. B. 491

**76 The Sculptor Martínez
Montañés,** *June 1635–January
1636.* 110.5 x 87.5 cm
Madrid, Museo del Prado –
Inv. 1194

**77 Prince Baltasar Carlos as a
Hunter,** *1635–1636.* 191 x 102 cm
Madrid, Museo del Prado –
Inv. 1189

**78 Prince Baltasar Carlos with
the Count-Duke of Olivares at
the Royal Mews,** *c. 1636*
Velázquez & Atelier
144 x 96.5 cm
London, His Grace the Duke of
Westminster

79 Lady with a Fan, *c. 1635*
95 x 70 cm
London, Hertford House,
Wallace Collection – Inv. P. 88

80 A Young Lady, *c. 1635*
98 x 49 cm
Chatsworth, His Grace the
Duke of Devonshire

81 The Needlewoman,
c. 1635–1643. 74 x 60 cm
Washington, National Gallery of
Art, Andrew W. Mellon Collec-
tion – Inv. 1931.1.81

**82 The Buffoon Pablo de Val-
ladolid,** *c. 1636–1637*
213.5 x 125 cm
Madrid, Museo del Prado –
Inv. 1198

**83 The Buffoon Calabazas
(Calabacillas),** *1637–1639*
105.5 x 82.5 cm
Madrid, Museo del Prado –
Inv. 1205

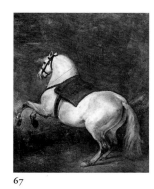
67

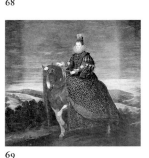
68

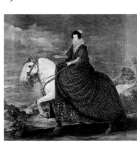
69

70

71

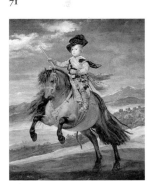
72

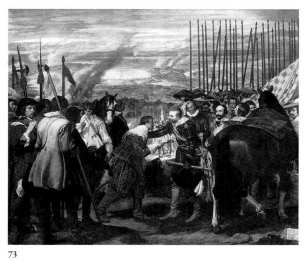
73

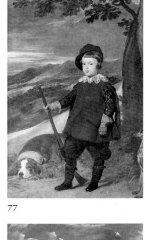
74

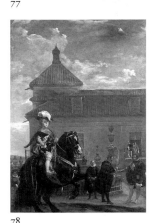
75

76

78

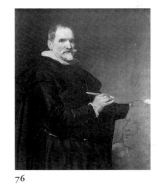
79

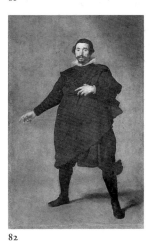
77

80

81

82

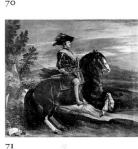
83

84 The Buffoon Don Cristobal de Castañeda y Pernia (Barbarroja), *1637–1640*. 200 x 121.5 cm
Madrid, Museo del Prado – Inv. 1199

85 St. Anthony Abbot and St. Paul the Hermit, *c. 1635–1638*
261 x 192 cm
Madrid, Museo del Prado – Inv. 1169

86 St. Anthony Abbot, *c. 1635–1638*. 55.8 x 40 cm
New York, private collection

87 Count-Duke of Olivares, *c. 1638*. 67 x 54.5 cm
Saint Petersburg, Hermitage – Inv. 300

88 Count-Duke of Olivares, *c. 1638*
Oil on copper, 10 x 8 cm (ovale)
Madrid, Patrimonio Nacional, Palacio Real

89 Francesco II d'Este, Duke of Modena, *autumn 1638*
68 x 51 cm
Modena, Galleria e Museo Estense

90 Prince Baltasar Carlos, *c. 1639*
Velázquez & Atelier
128.5 x 99 cm
Vienna, Kunsthistorisches Museum – Inv. 312

91 Portrait of a Man (José Nieto ?), *c. 1635–1645*
76 x 64.8 cm
London, Apsley House, Wellington Museum, Trustees of the Victoria and Albert Museum – Inv. 159

92 Aesop, *c. 1639–1641*
179.5 x 94 cm
Madrid, Museo del Prado – Inv. 1206

93 Menippus, *1639–1641*
178.5 x 93.5 cm
Madrid, Museo del Prado – Inv. 1207

94 Mars, *c. 1639–1641*
181 x 99 cm
Madrid, Museo del Prado – Inv. 1208

95 Francisco Bandrés de Abarca, *c. 1638–1646*
64.5 x 53 cm
Private collection

96 Self-Portrait, *c. 1640*
45.8 x 38 cm
Valencia, Museo de Bellas Artes de San Pío V

97 Portrait of a Little Girl, *c. 1640*. 51.5 x 41 cm
New York, The Hispanic Society of America – Inv. A 108

98 Study for the Head of Cardinal Borja, *1643–1645*
Drawing, 18.8 x 11.6 cm
Madrid, Real Academia de Bellas Artes de San Fernando – Inv. 2211

99 The Dwarf Francisco Lezcano (El Niño de Vallecas), *c. 1643–1645*. 107.5 x 83.5 cm
Madrid, Museo del Prado – Inv. 1204

100 Philip IV at Fraga, *June 1644*
129.8 x 99.4 cm
New York, The Frick Collection – Inv. 11.1.123

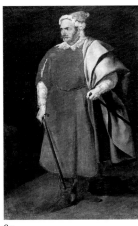

84

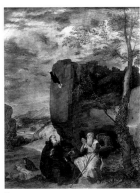

85

86

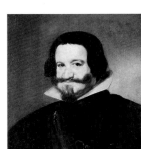

87

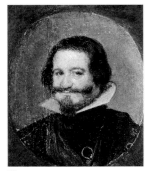

88

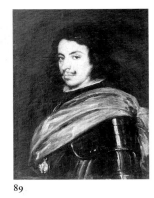

89

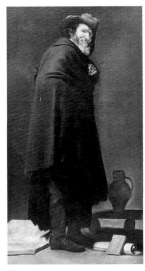

90

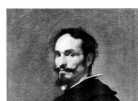

91

92

93

94

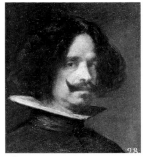

95

96

97

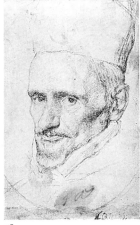

98

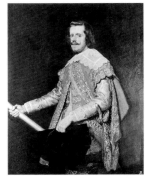

99

100

101 **Allegorical Portrait of Philip IV**, *c. 1645*
Velázquez & Atelier
393 x 267 cm
Florence, Galleria degli Uffizi

102 **A Dwarf Holding a Tome on his Lap (Don Diego de Acedo, el Primo)**, *c. 1645*
106 x 82.5 cm
Madrid, Museo del Prado – Inv. 1201

103 **A Dwarf Sitting on the Floor (Don Sebastián de Morra ?)**, *c. 1645*
106.5 x 81.5 cm
Madrid, Museo del Prado – Inv. 1202

104 **A Dwarf Sitting on the Floor by a Pitcher (Don Sebastián de Morra ?)**, *c. 1645*
106 x 84.5 cm
Switzerland, private collection

105 **The Coronation of the Virgin**, *c. 1645*. 178.5 x 134.5 cm
Madrid, Museo del Prado – Inv. 1168

106 **Venus at her Mirror**, *c. 1644–1648*. 122.5 x 177 cm
London, The Trustees of the National Gallery – Inv. 2057

107 **The Fable of Arachne (Las Hilanderas)**, *c. 1644–1648*
[167 x 252 cm] 222.5 x 293 cm (with addition)
Madrid, Museo del Prado – Inv. 1173

108 **Arachne (A Sibyl ?)**, *c. 1644–1648*. 64 x 58 cm
Dallas, Meadows Museum, Southern Methodist University

109 **Infanta María Teresa**, *1648*.
48.3 x 36.8 cm
New York, The Metropolitan Museum of Art, Robert Lehmann Collection – Inv. 1975.1.147

110 **A Knight of the Order of Santiago**, *c. 1645–1650*. 67 x 56 cm
Dresden, Staatliche Kunstsammlungen Dresden, Gemäldegalerie Alte Meister – Inv. 698

111 **A Country Lass**, *1645–1650*
65 x 51.3 cm
Japan, private collection

112 **Juan de Pareja**
July 1649–March 1650
81.3 x 69.9 cm
New York, The Metropolitan Museum of Art, Fletcher Fund, Rogers Fund, and Bequest of Miss Adelaide Milton de Groot (1876–1967), by exchange supplemented by gifts from friends of the Museum – Inv. 1971.86

113 **So-Called Barber to the Pope**, *1650*. 50.5 x 47 cm
New York, private collection

114 **Innocent X**, *1650*
140 x 120 cm
Rome, Galleria Doria-Pamphilj

115 **Innocent X**, *1650*
Velázquez & Atelier
82 x 71.5 cm
London, Apsley House, Wellington Museum, Trustees of the Victoria and Albert Museum – Inv. 1590-1948

116 **Camillo Massimi**, *1650*
73.6 x 58.5 cm
London, The National Trust, Kingston Lacy (Bankes Collection)

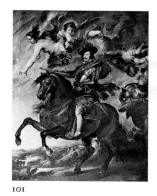
101

102

103

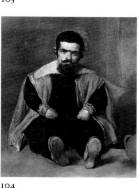
104

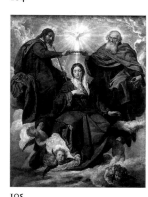
105

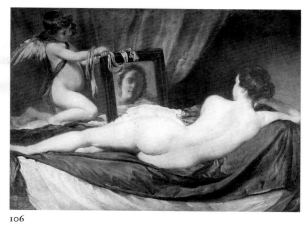
106

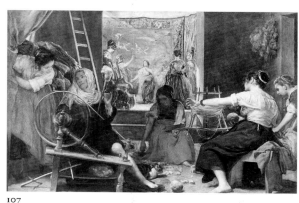
107

108

109

111

112

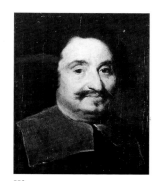
110

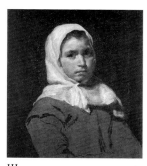
113

114

115

116

117

118

117 **Cardinal Astalli (Pamphilj)**,
1650–1651. 61 x 48.5 cm
New York, The Hispanic Society of America – Inv. A 1010

118 **Infanta María Teresa**,
1651–1652. 44.5 x 40 cm
New York, The Metropolitan Museum of Art, The Jules Bache Collection – Inv. 49.7.43

119 **Infanta María Teresa**,
1652–1653
127 x 98.5 cm
Vienna, Kunsthistorisches Museum – Inv. 353

120 **Philip IV**, *1652–1655*
69 x 56 cm
Madrid, Museo del Prado – Inv. 1185

121 **Queen Mariana**, *1652–1653*
234 x 131.5 cm
Madrid, Museo del Prado – Inv. 1191

122 **Infanta Margarita**, *1653*
128.5 x 100 cm
Vienna, Kunsthistorisches Museum – Inv. 321

123 **Infanta Margarita**, *c. 1656*
105 x 88 cm
Vienna, Kunsthistorisches Museum – Inv. 3691

124 **Velázquez and the Royal Family (Las Meninas)**, *1656–1657*
318 x 276 cm
Madrid, Museo del Prado – Inv. 1174

125 **Queen Mariana**,
c. 1655–1656
46.5 x 43 cm
Dallas, Meadows Museum, Southern Methodist University

126 **Queen Mariana**,
c. 1656–1657
64.7 x 54.6 cm
Madrid, Fundación Colección Thyssen-Bornemisza – Inv. 416 (1935.15)

127 **Mercury and Argus**, *c. 1659*
128 x 250 cm
Madrid, Museo del Prado – Inv. 1175

128 **Infanta Margarita**, *1659*
127 x 107 cm
Vienna, Kunsthistorisches Museum – Inv. 2130

129 **Prince Felipe Próspero**,
1659
128.5 x 99.5 cm
Vienna, Kunsthistorisches Museum – Inv. 319

130 **The Temptation of St. Thomas Aquinas**, *1631–1632*
244 x 203 cm
Orihuela, Museo Diocesano

119

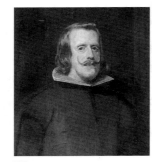

120

121

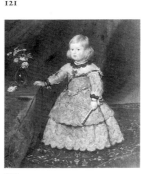

122

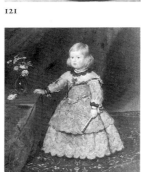

123

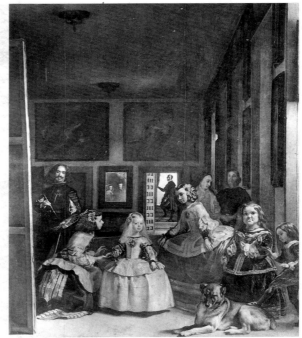

124

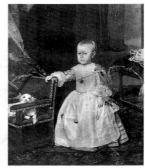

129

125

126

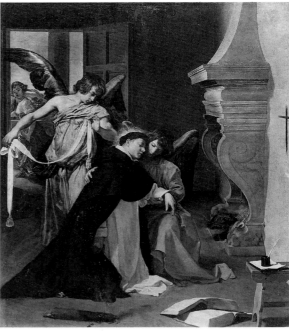

127

128

130